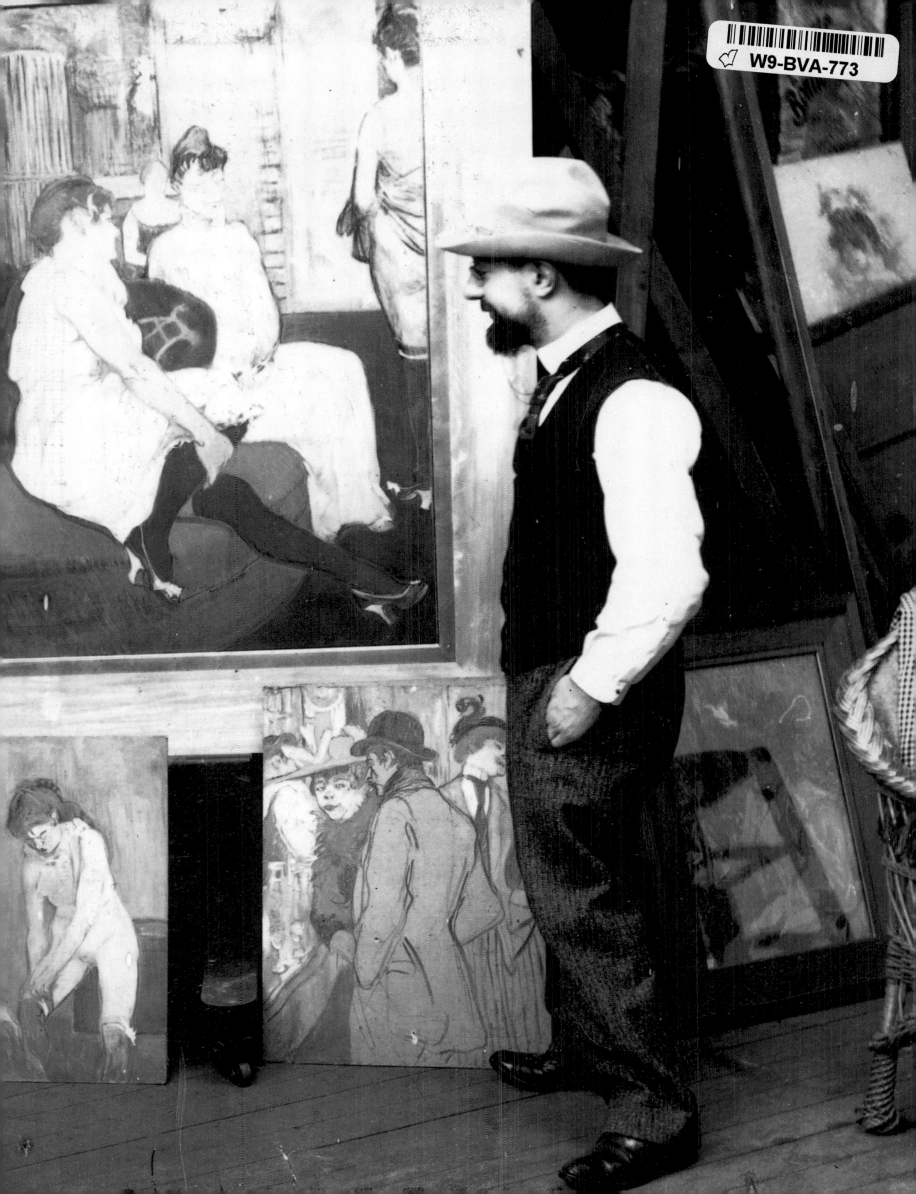

TOULOUSE-LAUTREC

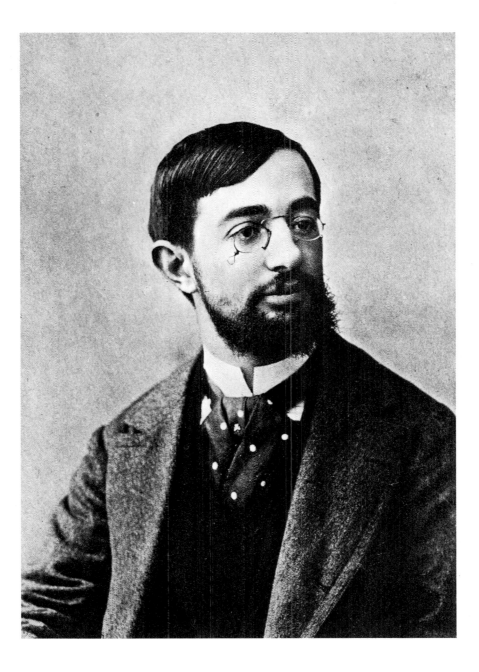

HENRI DE TOULOUSE-LAUTREC

TOULOUSE-LAUTREC

GÖTZ ADRIANI

With 217 illustrations, 95 in color

THAMES AND HUDSON

Endpapers:
Lautrec in his studio, 1894

This book was originally published as the catalogue for a major
retrospective exhibition, TOULOUSE-LAUTREC, GEMÄLDE UND
BILDSTUDIEN, held at the Kunsthalle, Tübingen, West Germany,
8 November 1986 – 15 March 1987. Götz Adriani organized the
exhibition and planned the catalogue.

Translated from the German by Sebastian Wormell.

©1986 DuMont Buchverlag, Cologne
English translation ©1987 Thames and Hudson Ltd, London

Library of Congress Catalog Card Number 87–50249

First published in the United States in 1987 by
Thames and Hudson Inc., 500 Fifth Avenue,
New York, New York 10110

Printed and bound in Italy

CONTENTS

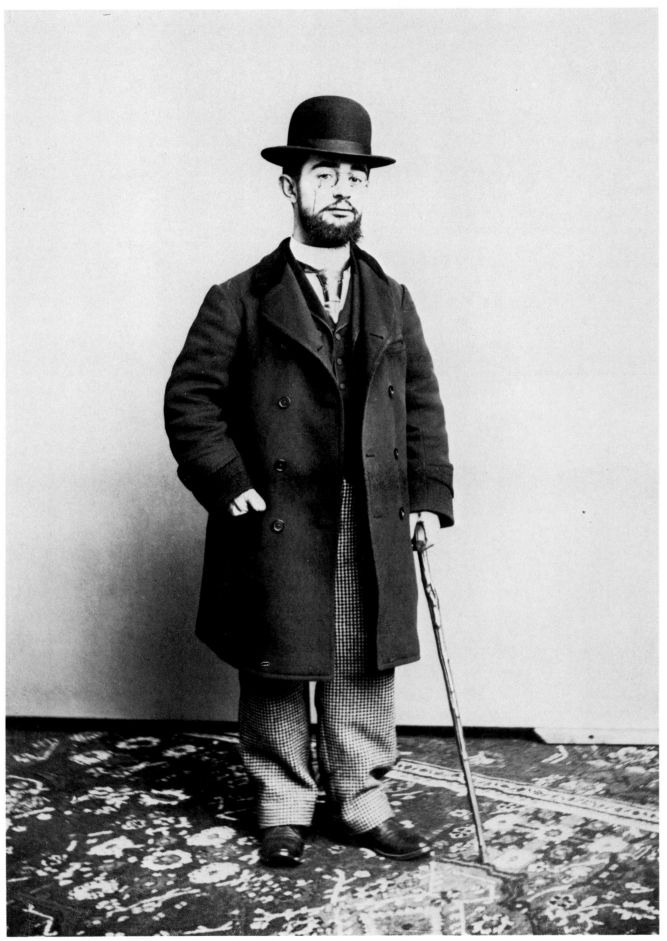

Henri de Toulouse-Lautrec, 1892

'In our time there are many artists who do something because it is new; they see their value and their justification in this newness. They are deceiving themselves; novelty is seldom the essential. This has always to do with one thing only: making a subject better from its intrinsic nature.'

Toulouse-Lautrec

FOREWORD

More than any other artist of his time Lautrec was a painter of portraits. His subject was the individual – never the crowd. In Kurt Tucholsky's words, this aristocrat from the provinces of southern France 'achieved an exact balance between quantities of decadence, of healthy human understanding, and even of something like a decent heart'.[1] Neither landscape, nor still-life, nor the outworn genre of nineteenth-century history painting – in which baroque variety had been reduced to the reconstruction of historical anecdote – were of any interest to him. 'Only the figure exists,' declared the artist to his friends in 1896; 'landscape is nothing more and should be nothing more than an extra; the painter who paints purely landscape is a ruffian. Landscape should only be used to make the nature of a figure more understandable. Corot is only great in his figures; the same goes for Millet, Renoir, Manet, Whistler; as soon as figure painters depict landscape they treat it like a face; Degas's landscapes are extraordinary because they are dream landscapes; Carrière's are like human masks! If he had not neglected the figure so much, Monet would be even greater.'[2]

In contrast to Cézanne's methodical approach, in contrast to his friend Vincent van Gogh's passionate adoption of ideas or the calculated approach of Seurat, Lautrec made the essence of life as he experienced it the explicit phenomenon of his art. He sought the proximity of people, and his curiosity for the unusual was combined with a sure instinct for the smallest detail. His creative intelligence needed an external stimulus; he had to experience his environment directly and work in immediate communion with it. Like his predecessors Daumier, Manet and Degas, whom he deeply admired, Lautrec stuck to the outward appearance of his own times without becoming a mere chronicler of the passing moment.

The descendant of a feudal house dating back more than a thousand years, he established his Parisian domain within the narrow boundaries of the grand theatres and flea-pits, circuses and second-rate nightclubs, the fairs and *cafés-concert*, and the *grands quartiers d'amour*; and he dominated the area just as his ancestors, the Counts of Toulouse – and from 1196, Viscounts of Lautrec – had dominated southern France. In the High Middle Ages they had been related to the royal houses of France, England and Aragon; eventually embroiled in the terrible Albigensian wars, they were consequently excommunicated almost a dozen times by various popes, and in 1229 they had left the world political stage after a period of more than four centuries in power.

Montmartre – 'the hill of the martyrs' – became the seat of Henri Marie Raymond de Toulouse-Lautrec-Monfa; he hardly ever looked beyond these self-imposed topographical limits. They essentially determined the nature of his expression, and he used them in the service of a lasting artistic vision, which the young Picasso first discovered and then adapted for his own use.[3]

Lautrec insisted on his ancestry because it gave him a detachment from the garish theatrical sensations around him. He was by no means the first to discover this extremely stimulating milieu; others had explored it before him: Jean Louis Forain, for instance, had done this from a specifically voyeuristic perspective; then there was the social criticism of Théophile Alexandre Steinlen, and the works of such popular celebrities of the day as Félicien Rops and Adolphe Willette. But where Lautrec excelled was in his urge to observe; he could analyze what he saw and distil from it a synthesis of human life. He did away with the concept of realism based on factual truth, intensifying his figures so that, released from their immediate circumstances, even in their fragmentary state, they represent timelessness in a contemporary setting. In this way he created the true history paintings – at once factual and allegorical – of an epoch that was drawing to its close. Instead of the supposedly eye-witness nature of history painting which suggested historical reliability by means of a sophisticated conglomeration of styles, he introduced forms taken from real life. The world of illusion of the theatre, bar, dance-hall and brothel, which sought to institutionalize the *fin-de-siècle* desire to drive out reality, was central to his artistic concern with the real world. Direct experience was transformed into art and not, as in the case of many of his contemporaries, illustrated by means of art. He was not merely an eye-witness, tied to a particular time and portraying a particular milieu, but a great artist who portrayed humanity.

The renown of his family, which had been among the leaders of Europe since Carolingian times, reached its peak in this 'bizarre and malformed person',[4] who hardly conformed to the role of titanic creator which the questionable spirit of the age so much admired. With the exception of Van Gogh, none of his friends and colleagues was driven by his personal destiny to seek stimulation among the despised figures on the margin of society. What the vulnerable Cézanne had hoped for from his friendship with Zola, what the zealously trusting Van Gogh had yearned for in the fellowship of like-minded people, and what Gauguin had looked for in the exoticism of his surroundings, Lautrec found in the sympathy of those who had no advantages over him; yet his detached attitude towards them was completely without arrogance. His depiction of individuals who interested him, in surroundings of a tinsel splendour that reflected a world of dreams without illusions, was the inevitable result of the tragic circumstances of his life. He was contemptuous of the *parvenus* who had risen under the Second Empire, and of the bourgeois who emulated them and adopted the style of *flâneurs* and dandies. Lautrec set his puny life against conventions which were not prepared to regard as socially acceptable the extremes from which he drew his strength. By birth a member of the ancient aristocracy with the right to marry daughters of the royal house, Lautrec was at the same time an *habitué* of the lowest dives, where he was drawn into Bohemian life and recklessly abandoned himself to a hectic vicious circle of self-deception and self-destruction, which led to physical and mental collapse after a career of just twenty years.

Lautrec's instinct was that of a collector. He had a precise sensitivity to the particularities of an individual and stalked his prey long and persistently, making many preparatory studies until his subject could be captured in a moment of intense concentration. It is from these definitive moments – from his heightened perception of the momentary – that the authenticity of his vision derives. This is true even of the fleeting appearance of marginal figures whose individuality is revealed by particular details. Nobody remains anonymous, although the more or less fine-sounding names of his various models are long forgotten. His method of characterization is highly acute in the meticulous way it hints at complex emotions; sometimes external appearances are only incidentally the most important feature, as is appropriate for the world of ephemeral themes to which he was attuned. The strokes needed to form an image are only taken as far as the attention given to the object demands.[5]

Driven on by an incorruptible curiosity, the artist sought to discover in the individual the authentic character of the life he loved so much. His use of the human form went beyond mere social criticism or homage to some distant ideal image, and so he placed himself in the risky position of seeing right through his models, and being left without illusions. The results may be perfidious or depraved, obtrusive, bizarre, comic and loud – but they are above all believable; they never threaten to degenerate into the indiscreet or wounding. As a cool diagnostician (the equal of Degas in his understanding of form), wholly concentrated on the human figure, he followed the bending of a body or the line of an expressive profile down to his very fingertips with the same thirst for knowledge that he brought to a bizarre style of hat or the delicate stepping of a horse. With a few exceptions, his interest in a particular theme or person did not last long, which means that the dates of a preliminary sketch, its elaboration and the execution of a finished work are usually not very far apart.

Lautrec saw with a more critical intelligence than most of his contemporaries, none of whom managed to stylize their experiences so tellingly. The environment only interested him to the extent that it was related to personalities, and its function was dependent on them. Even his painting style, mostly on unprimed cardboard, and his endeavours to create believable spatial settings become summary when they are not associated with the quintessence of his work: the human figure. Not without reason did Gustave Moreau recommend his pupils to impress Lautrec's absinthe-painted figures on their minds. Lautrec was fascinated equally by the pompous gesture of a mime, a funny hair ribbon, the tired expression of a barman or the luxurious arrangement of a feather boa. Since he could survive without patrons he could concentrate exclusively on those people whose individuality attracted him.[6] He knew that a person's character was often shown more clearly in a *petit rien* – a distinctive way of spreading the fingers or controlling the legs in a frenzied dance – than in a meticulously executed physiognomy. 'There is nothing easier than painting pictures that are finished in an outward sense; one never lies more cleverly than then'[7]: this was one of his basic principles.

The short-sighted artist's forte was the fragmented close-up, seen from his own particular viewpoint; drawing was his way of thinking. Everything that was not essential was left unclear, open, improvised. The fascination of the passing moment has hardly ever been described so insistently. It was from this moment alone that he drew his inspiration, and his distinctive sensitivity was directed towards it. Once the moment had passed, his imagination could grasp it only with the greatest effort and he sometimes used photographs to jog his memory. The emphasis he gave to the momentary had to be matched by a photographic objectivity, which clarified spatial organization without undermining the rules of the surface. Lautrec's liking for drastic spatial abbreviations, using a deliberately distorted perspective, in which space is compressed and the foreground and background are brought close together, can be explained by his photographic activities. Photography accorded with his own ideas; it is directed at individual segments of reality within a field of vision determined more or less by chance, and it shows synchronously what the eye can only realize sequentially.

The truthfulness of Lautrec's panorama adds to the studied compositions of his contemporaries the nuance of the passing moment; that is to say, a very high degree of spiritual expression and intensity of life. His vision is believable because of its renunciation of any form of mood, feeling or poetic transfiguration. It was Manet who first recognized the danger of cosy familiarity which threatened to subvert the work of many of the Realists; and Lautrec, whose early works were influenced by Manet, withstood the temptation to fill out the inter-relationships of reality with material details. He had too little respect for any sort of educational padding. His art is devoid of all the historical, genre-like or anecdotal features that were so dear to the heart of the nineteenth century. Instead, he addressed himself to those symptoms which demonstrated the individualistic, disillusioned, analytical and spontaneous aspects of an age nearing its close. It was no longer a matter of confronting man with the infinity of nature or of integrating him into a stylistically correct milieu, but of showing him in his own time, exposed to an alien environment.

In an age when anarchist activities, political assassination and bombings were the order of the day and the Dreyfus Affair split public opinion into two opposing camps, the aristocratic artist looked on social issues with an indifference that came from privilege. He regarded the monarchy as the only possible way 'to restrict the power of officials over the citizen's everyday life'.[8] As both a rationalist and a sceptic he mistrusted generalizations about social questions. Zola had demanded that Realism concern itself with the representation of the conditions of *petit bourgeois* existence in a way that everyone could understand, but this was incomprehensible to Lautrec, the aristocrat in the role of bohemian, who was interested in people, not their milieu. What he depicted may seem sad but it is never sentimental. The boisterous activity of performers and chorus girls has never been presented with such inaccessible restraint and such complete passivity. Rarely have greasepainted figures appeared with so little make-up, has baseness seemed so innocent, or sensuality so unusual. Lautrec moved away from the Impressionists' comprehensive view of nature and unmasked human nature in all its unnaturalness, its alienation and existential doubt. He refused it any elegant cheerfulness or draperies. His 'Golden Age' is set in the theatre, in those shrines of an imagined enjoyment of life, dedicated to the triumph of artificiality – a monstrous result, in its shabbiest form, of a separation from nature that could be called tragic. He transformed the poetry of the Impressionists into a prose devoid of the richness of nature. The possible ways of treating the figures enclosed in the picture space are restricted to a minimum. There are only a few attempts to make contact with the viewer by means of looks and gestures. The Impressionists cast a magic spell of colour over the human figure, incorporating it informally into a natural paradise, while in Lautrec's work, characterized as it is by the theatre, there is an ambivalence in the forced relationship between actor and spectator, performer and what is being performed, the stalls and the stage.

This loss of naturalism, this concentration on artificial refuges in a world apart, could be explained by the handicapped artist's awareness that he did not conform to nature. But to suspect him therefore of a sarcastic contempt for mankind, to condemn him for choosing vulgar themes, would be to misunderstand his intentions, his profoundly positive attitude to life, and indeed, his whole character as it has been presented by Maurice Joyant, the artist's friend and tireless promoter. Lautrec's certainty was too unequivocal to succumb to the awkwardness of ambiguity; his cynicism denied his sadness any romanticism, but his sarcasm was only a means of forestalling the feelings of sympathy which rose within him. With the words 'one must know how to put up with oneself', he mobilized all his defences – *joie de vivre*, humour, sympathy, skill and enthusiasm for his work – to get through his short life.

He remained unimpressed by the much discussed rebellious aspirations of some of his artist friends, and never felt any desire to revolutionize the artistic vision of the world – let alone experience Van Gogh's desperately tormented socio-religious sense of mission. It was enough for him to depict a few small fragments of the world, and the people who – with varying degrees of enjoyment – had made their home in them. Overturning aesthetic conventions did not seem to him worth the effort. Lautrec had an aversion to theoretical perspectives and they are never mentioned in his letters, which are filled with family news and repeated requests for money. He loathed the self-satisfied partisanship of society circles, and his intellect was too sharp to allow him to be fooled by disobliging worldliness and distorted defeatism. He relied only on his skill, which he had acquired in the same way as one would learn a handicraft.

Lautrec regarded precisely calculated draughtsmanship as his primary means of expression – and this applies not only to his works in chalk or pencil but also to his handling of the brush (as it developed fully in the years between 1885 and 1887), which has more of the features of drawing than of painting. With some exceptions, he was to use this technique throughout his career. He thinned the paint with turpentine so that it dried quickly on the unprimed ground to give a matt, pastel-like tone, and used it succinctly with an effect that is hard and sometimes dry, like Degas's late work. Delacroix and the Impressionists, and especially Cézanne, rejected the dominance of line, whereas for Lautrec line was the most important

means of consolidating and clarifying his images. His treatment of his subject matter had an immediacy that never made things seem better than they were. It is as if there were an element of time, a form of spiritual texture, underlying the nervous liveliness of their structure. The transience of modern life is expressed in the openness of the forms and the swiftness of the line. The graphic stylization, which never detracts from the objective legibility of the image, is developed from the centre outwards; towards the edges the image becomes less dense, thus laying the subject bare rather than embedding it.

The versatile Lautrec never refused any commission, no matter how trivial; he understood his ability in the field of effective publicity. The difference between fine and applied art had no relevance to him; he would devote the same care to producing congratulatory cards for his friends and relations and drawing menus or invitations on his lithographic stone. Song titles, theatre programmes and book jackets, posters and magazine illustrations, frescoes in a village pub, wall decorations in the Rue d'Amboise brothel or the decoration of a booth for the dancer La Goulue: they all had the same status as a work executed according to the rules of fine art – especially when they were for the quasi-public sphere.

Any arrangement of his work, which was so much the product of the intensity of life, into defined stylistic categories would reveal only superficial analogies. Impressionist and Neo-Impressionist styles certainly play a part, but they are as marginal as certain modern features of Art Nouveau, or forms of expression which were to be taken up by Fauvism and Expressionism. Lautrec's works are more subtle in their execution and more discriminating in their grasp of psychology. The 'great little man' (Tristan Bernard)[10] created character studies – even in his posters – with an empathy that has never been equalled. His vision of humanity has a compelling power of suggestion. He depicted the ugly, the frivolous, even the obscene, without presumptuousness and without losing sight of the plausible, and this is what makes his figures credible. Their persuasive power made the *basse humanité* part of the human race; it did not really lead the artist, as it did the comprehensive genius of Daumier, to the cynicism of parody or the naked pathos of despair. Even at the age of sixteen he mistrusted ideal beauty as an aesthetic commonplace because he thought he saw in it the danger of falsity: 'I have set myself the task of being true and not ideal,' he wrote in 1881. 'Perhaps that is a mistake, for the warts find no mercy with me; I love to decorate them with mischievous little hairs, to round them off and put a shining tip on them.' This statement of intent to which he would remain true throughout his short life, is signed 'A promising painter, H. De T.L.'[11]

Although he liked to appear sarcastic, there is seldom any sign of bitterness, which would have impaired the truth of his images. He was too well bred to be openly at odds with his destiny; he became a mocker out of his desire to thwart the mockery of others. By making himself the chief victim of his mockery he skilfully countered any sympathy others might feel out of duty. For one who wishes nothing so much as not to attract attention, caricature is the only suitable means of self-definition. His self-caricatures are usually drawn in only a few lines and are in the truest sense incomplete, independent of any inherited background, in constant conflict with his own nature. But this ironic play on self-abasement can hardly disguise the deeply hidden disappointment in life on the part of someone who lived his life so passionately, enjoying it to the full with an intensity that was all too fleeting, immoderate and reckless. *Vive la vie* was always Lautrec's maxim – *Diex lo volt* ('God wills it') was the old Provençal motto of his family.

The Counts of Toulouse and Viscounts of Lautrec made history as successful military commanders, crusaders and leaders of the Albigensian movement, but their name has gone down in history because of a late descendant, who could scarcely have satisfied his forebears' sense of social standing, but whose genius created authentic images of humanity.

1 Self-Portrait in front of a Mirror (Portrait de Lautrec devant une Glace) 1880–1883

Dortu II, P. 76
Oil on cardboard, 40.3 × 32.4 cm
Musée Toulouse-Lautrec, Albi

Lautrec's portraits of the age in which he lived were unequalled and have a validity that goes beyond their temporal circumstances, yet he painted only this one self-portrait. He can be recognized in eleven other pictures, where he is usually a secondary figure at the edge, sometimes seen from behind, an unobtrusive addition to the groups of figures.[1] The artist apparently regarded caricature as the only possible means of depicting himself (see Nos. 32, 33, 108). His output between 1881 and 1899 includes more than seventy such caricature studies.[2] They have one thing in common: a sarcastic detachment in his observation of himself, a grotesque figure, barely five foot tall.

This detachment is also present in the mirror image, in which the subject is presented only in a transferred sense. Throughout history most self-portraits have created the illusion of a direct confrontation between the person depicted and the viewer. Lautrec, however, leaves no doubt about the actual circumstances involved: the surface of the mirror necessarily intervenes. He probably stood in front of a console or mantelshelf with a wall mirror placed above it. The portion of mirror shows only his head, turned slightly to the left, and the upper part of his body against a neutral ground painted in delicate shades of grey. While the relatively small figure occupies the centre of the picture, the foreground is dominated by a few objects arranged to form a still-life. Behind this barrier composed of almost tangible utensils the artist is withdrawn from the viewer, to almost the same extent as the young Parmigianino in his famous 1523 self-portrait in a convex mirror in Vienna. The light coming from the right leaves much of the face in darkness and eye contact with the viewer is practically impossible because of the lenses of the pince-nez. The only colour accent is the red of his thick lips. The painter exposed to the curious gaze neither the ugly coarsening of his facial features that occurred after puberty, nor his body with its relatively normal torso supported on fragile, thin short legs. After his two accidents in 1878 and 1879 he had had to come to terms with living in a body which could be moved only stiffly and with difficulty. The isolation caused by his being different and completely cut off from normal possibilities of development, must certainly have contributed to the formation of that unique sensibility by which he depicted people.

Maurice Joyant, a friend of Lautrec's youth and perhaps the best connoisseur of his work, first dated the portrait to 1880, then revised this to 1883.[3] Dortu accepted the earlier dating, but it is arguable that the later date corresponds better to the appearance of the nineteen-year-old young man. The sureness of the composition and the experienced painterly handling, clearly derived from Manet, also suggest the later dating.

1 Dortu II, P. 10, P. 232, P. 238, P. 242, P. 260, P. 300, P. 427; Dortu III, P. 591; Dortu VI, D. 4116, D. 4359.
2 Dortu I, pp. 72 ff.
3 Joyant 1926, p. 254; Joyant 1927, p. 246.

SOURCES: Comtesse Adèle Zoë de Toulouse-Lautrec, Toulouse.
BIBLIOGRAPHY: Joyant 1926, p. 254; Joyant 1927, p. 246; Frankfurter 1951, p. 88 Ill.; Jourdain-Adhémar 1952, p. 109; Julien (1959), Ill. (Frontispiece); Toulouse-Lautrec 1962, p. 6 Ill.; Bouret 1963, p. 40 Ill.; Zinserling 1964, Ill. 1; Fermigier 1969, p. 19 Ill.; Zenzoku 1970, Ill. 1; Dortu I, p. 70 Ic. 2 Ill.; Dortu II, pp. 34f. P. 76 Ill.; Cat. Musée Toulouse-Lautrec 1973, p. 6 No. 20, p. 9 Ill.; Huisman-Dortu 1973, p. 2 Ill.; Caproni-Sugana 1977, Ill. I, No. 29 Ill.; Adriani 1978, pp. 20f. Ill. 1; Dortu-Méric 1979, I, p. 26 No. 61 Ill., p. 31 Ill.; Arnold 1982, p. 17 Ill.; Cat. Musée Toulouse-Lautrec (1985), p. 50 No. 20, p. 52 Ill.; Munich 1985, p. 11.
EXHIBITIONS: Albi 1951, No. 9; London 1961, No. 3; Munich 1961, No. 10; Cologne 1961–1962, No. 10; Albi-Paris 1964, No. 189; Stockholm 1967–1968, No. 1; Humleback 1968, No. 1; Kyoto-Tokyo 1968–1969, No. 1; Paris 1975–1976, No. 4; Liège 1978, No. 3; Chicago 1979, p. 28, No. 3; Tokyo (etc.) 1982–1983, No. 4.

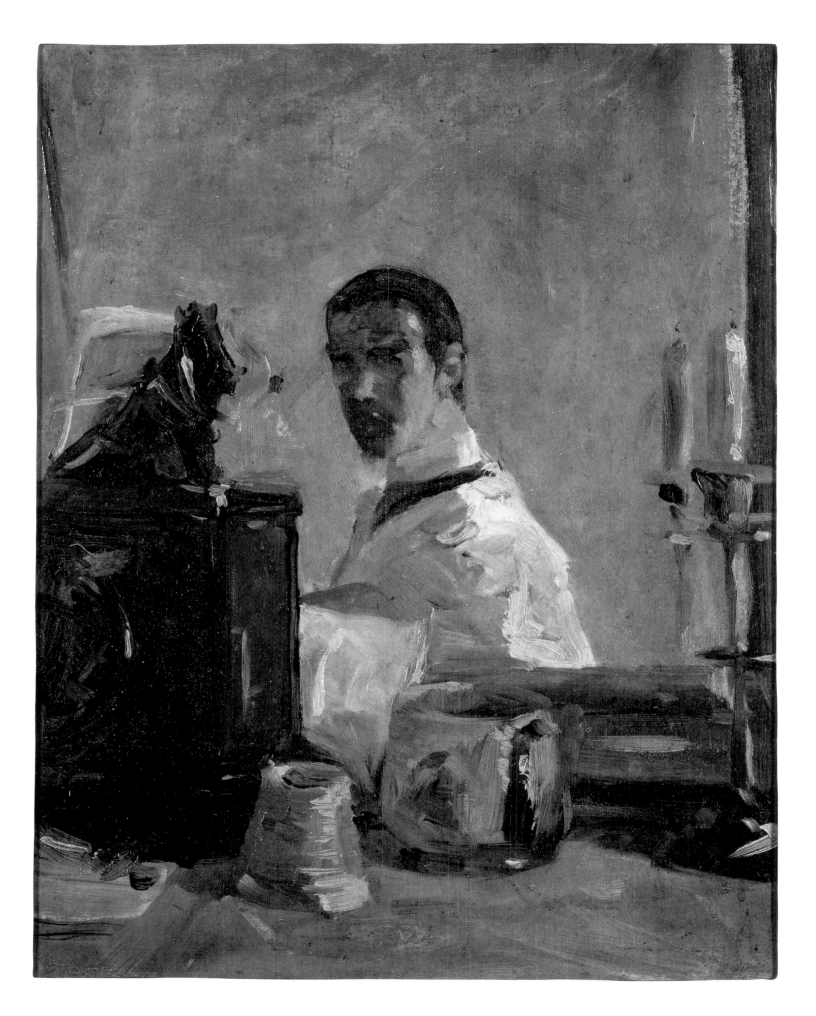

2 COMTE ALPHONSE DE TOULOUSE-LAUTREC AS A FALCONER (COMTE ALPHONSE DE TOULOUSE-LAUTREC EN FAUCONNIER) 1879–1881

Dortu II, P. 91
Oil on wood panel, 23.4 × 14 cm
Verso: BUGGY AT THE SEA-SIDE (BUGGY AU BORD DE LA MER) 1879–1881
Dortu II, P. 92
Oil on wood panel
Musée Toulouse-Lautrec, Albi

This narrow panel painting shows the artist's father, Comte Alphonse Charles Jean Marie de Toulouse-Lautrec-Monfa (1838–1913), on horseback. Dressed in the exotic costume of a Cherkess and with a bridle made for the legendary Caucasian Imām Shāmyl-Effendi, he holds a falcon on his raised left fist. He would have been observed hunting in the region around the Château du Bosc. What especially interested the young artist in this swiftly painted picture was the representation of the combined movement of horse, rider and falcon in a diagonally arranged composition. The fact that some of the anatomical details are still very awkward in no way detracts from the intended impetus of movement.

Two comparable watercolours, one of which is dated 1879, also show the Count hunting with a falcon, but seen from behind.[1] Moreover, some inconsistencies in the present picture – such as the over-sized figure of the horseman – indicate that a date earlier than that proposed by Joyant (1881) should be considered.[2]

This early work of 1879–1881 reflects very clearly his family milieu, characterized by hunting, horses, packs of hounds, falcons specially bred for the Count (see No. 5), whippers-in and coaches. It was natural that when he began painting Lautrec should seek guidance from two artists with similar preferences, who were friends of his father and very successful specialists in horses and hunting scenes: René Princeteau and John Lewis Brown. Both of them knew how to make skilful use, for their own purposes, of the stylistic traits of the Impressionists, which had only recently been frowned on. Princeteau in particular was a tireless mentor, doing his best to push the 'baby of the atelier' towards what Zola had ironically described in 1880 as a 'weak, watered-down Impressionism',[3] which now dominated the annual Salon exhibitions.

For centuries the Counts of Toulouse had successfully evaded all social constraints, and the idiosyncratic Alphonse, a brilliant horseman, complete *grand seigneur* and huntsman (who usually gave his falcons holy water to drink) was a perfect example of this. After leaving the Ecole Militaire de Saint-Cyr he served for a short time as a lieutenant in the noble 6th Regiment of the Lanciers de l'Impératrice in Mabeuge, but left the service at the age of 25 – a Toulouse-Lautrec should not be in the pay of some jumped-up Bonaparte. The Count seems to have regarded all bourgeois conventions as of no importance; all his extravagances were justified by being based on the best tradition. He was just living in the wrong age. Fascinated by the manners and customs of the peoples of the Near and Far East, he collected their weapons and armour; in Albi and Paris he would dress as a Kirghiz or a trapper.[4] Remembering his ancestors in their historical costumes, he would ride through the Bois de Boulogne clad as an armed crusader in chainmail and helmet; or else he would do his washing in the gutter of the Rue Royale, because he believed that the Parisian laundresses had never been much good since the beheading of Louis XVI. Such behaviour must have contributed not inconsiderably to the amusement of Parisian society. Count Alphonse loved to make grand theatrical gestures as an expression of the heroic in an age of mediocrity which was no longer quite prepared to tolerate such arrogant behaviour on the part of an outmoded social class – not that it bothered him whether his conduct attracted admiration or ridicule.

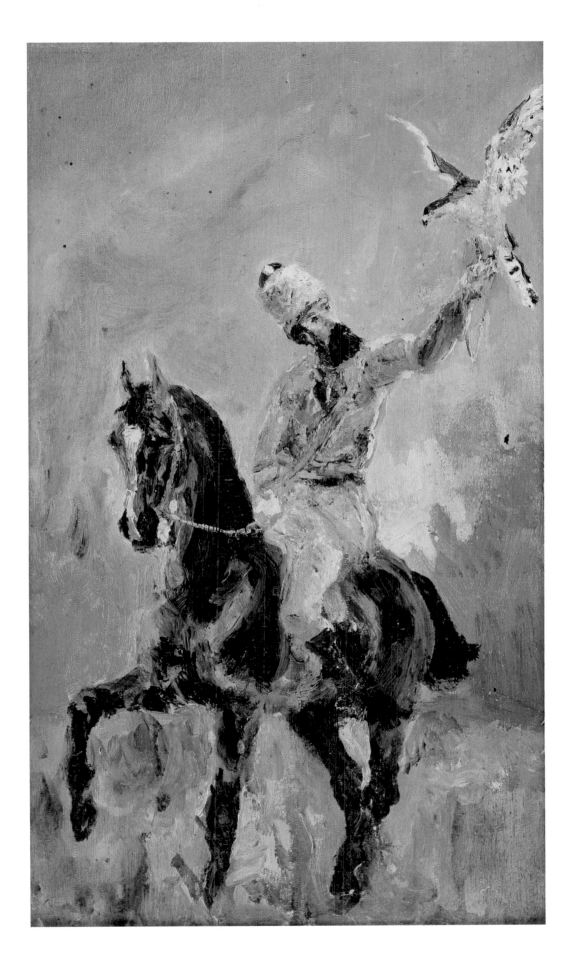

He was always on the move between his numerous hunting grounds, dreaming of the past when 'the Counts of Toulouse could violate a monk and then string him up if they so pleased'.[5]

As a New Year's present for 1876 the Count had given his son a book on *Ancient and Modern Falconry* (Paris, 1862) with the following dedication: 'Always remember, my son, that only life in the open air and daylight is really healthy; once anything is deprived of liberty it withers and soon dies. This little book on falconry teaches you to appreciate life in the country and if you should ever come to know the bitterness of life, the horse especially, but also hounds and falcons, will be precious companions who will help you to forget a little.'[6] Nobody could guess how bitterly in need of such help Lautrec would be. In 1899 when acute delirium tremens forced him to enter a closed institution, Lautrec reminded his father of the dedication twenty-three years before: 'Papa, you have the opportunity for an honest, manly attitude. I am locked in, and anything that is trapped dies!'[7]

1 Dortu III, A. 78, A. 164; *cf.* also the pencil sketch of a rider with raised arm, Dortu IV, D. 1117.
2 But a similar composition, though with more convincing movement, LE MAÎTRE D'EQUIPAGE (Dortu II, P. 186), must have been painted later.
3 Emile Zola, 'Le naturalisme au Salon', *Le Voltaire*, 21 June 1880.
4 *Cf.* Dortu III, P. 636; Dortu IV, D. 1815; Dortu V, D. 2831.
5 Perruchot 1960, p. 28.
6 Joyant 1926, pp. 31 f.
7 *Ibid.*, p. 217.

SOURCES: Comtesse Adèle Zoë de Toulouse-Lautrec, Toulouse.
BIBLIOGRAPHY: Astre (1926), p. 71; Joyant 1926, p. 31 Ill., pp. 254 f; Schaub-Koch 1935, p. 168; Mack 1938, p. 259; Mac Orlan 1941, p. 119; Cooper 1955, pp. 58 f. Ill.; Perruchot 1958, p. 65; Bouret 1963, p. 28; Huisman-Dortu 1964, p. 17 Ill.; Cionini-Visani 1968, Ill. 4; Fermigier 1969, p. 11 Ill.; Zenzoku 1970, No. 2; Dortu II, pp. 42 f. P. 91, P. 92 Ill.; Polasek 1972, p. 18; *Cat. Musée Toulouse-Lautrec* 1973, p. 13 Ill., pp. 14 f. Nos. 58, 59; Huisman-Dortu 1973, p. 12 Ill.; Caproni-Sugana 1977, No. 75 Ill.; Dortu-Méric 1979, I, p. 30 No. 76 Ill., p. 35 Ill; Chicago 1979, with No. 19; *Cat. Musée Toulouse-Lautrec* (1985), pp. 68 f. No. 58 Ill.
EXHIBITIONS: Paris 1931, No. 18; Albi 1951, No. 14; Albi-Paris 1964, No. 9; Kyoto-Tokyo 1968–1969, No. 3; Paris 1975–1976, No. 6; Liège 1978, No. 6.

3 A MUNICIPAL GUARD (UN GARDE MUNICIPAL) *c.* 1880

Dortu III, S. A. 4
Watercolour over pencil on white paper, 25.4 × 17.8 cm
Signed in pencil, lower right: 'T-Lautrec'
Private Collection

The signature was probably added by the artist later. This watercolour shows the municipal guard riding out, with a row of houses in the background. There are stylistically comparable watercolours of almost identical dimensions, with the monogram in the lower left, and dated 1880.[1]

1 Dortu III, A. 143, A. 144; *cf.* also the ink drawing Dortu V dated 1881, D. 2086 or the pencil drawing D. 2657.

SOURCES: Vente *Collection M. B.*, Hôtel Drouot, Paris 20 March 1923, No. 38; Gustave Pellet, Paris; Joseph Hessel, Paris; Arthur Hahnloser, Winterthur.
BIBLIOGRAPHY: Joyant 1927. p. 244, p. 263; Dortu III, p. 528 S. A. 4.
EXHIBITIONS: Galerie Théophile Briant, Paris 1929, No. 36; Munich 1972–1973, No. 280.

4 EQUESTRIAN STUDY (CAVALIER) 1880 (?)

Dortu II, P. 77
Oil on cardboard, 51 × 34.9 cm
Musée Toulouse-Lautrec, Albi

No comparable sketch can be found among Lautrec's early works. Joyant dated this study to 1880, but on stylistic grounds a later date cannot be ruled out for this study of a rider.

SOURCES: Comtesse Adèle Zoë de Toulouse-Lautrec, Toulouse.
BIBLIOGRAPHY: Joyant 1926. p. 254; Dortu II, pp. 34f. P. 77 Ill.; *Cat. Musée Toulouse-Lautrec* 1973, p. 11 No. 51; Caprons-Sugana 1977, No. 62 Ill.; Dortu-Méric 1979, I, p. 28 No. 62 Ill.; *Cat. Musée Toulouse-Lautrec* (1985), pp. 64f. No. 51 Ill.
EXHIBITIONS: Paris 1975–1976, No. 3; Tokyo (etc.) 1982–1983, No. 5.

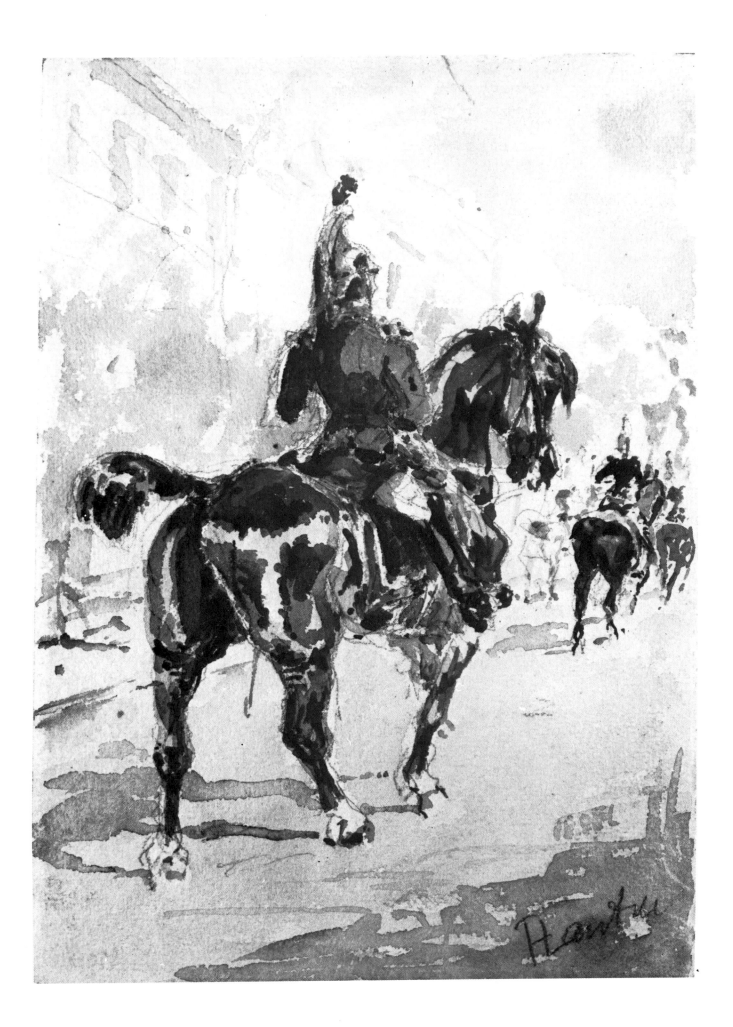

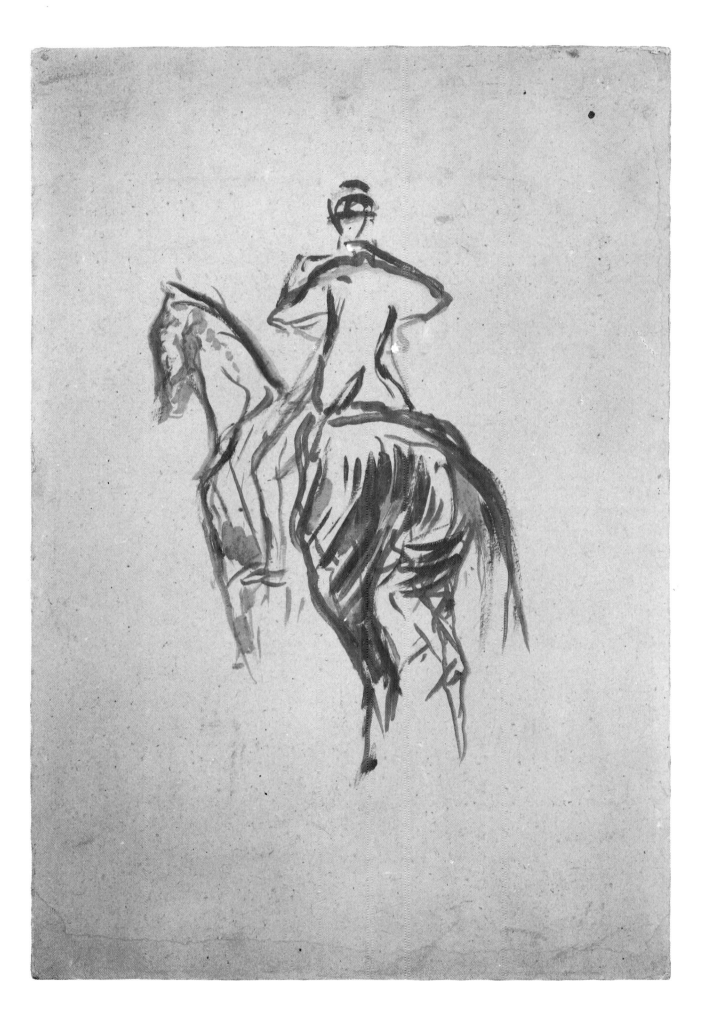

5 PEREGRINE FALCON (FAUCON PÈLERIN) 1881

Dortu II, P. 108
Oil on canvas, 40.7 × 32.5 cm
Monogram and date in dark brown paint, upper right;
red monogram stamp (Lugt 1338), lower left
Private Collection

From his childhood the artist would have been familiar with the peregrine falcons that were bred by the peasant family of Martin from Rabastens to satisfy the passion of his father and grandfather for hunting.[1] In a letter written in December 1872 to his grandmother, the eight-year-old Lautrec mentions an English book on falconry from which his father had asked him to translate a chapter. In early 1876 he wrote about a falconer whom his father admired and who was then staying in Ireland.[2] It is no surprise that he should have created such a splendid memorial to one of these birds of prey, using subtle gradations of brown, yellow and grey for its particularly fine plumage.[3]

1 *Cf.* the early watercolour and pencil studies Dortu III, A. 23, A. 28, A. 45, A. 46, A. 56, A. 78, A. 164; Dortu IV, D. 115, D. 164, D. 204, D. 591, D. 1045, D. 1319, D. 1320; Dortu V, D. 1891.
2 Goldschmidt-Schimmel 1969, pp. 31 [247], 39 [249].
3 *Cf.* the similar version painted on a small wood panel Dortu II, P. 47.

SOURCES: Alexis Tapié de Céleyran, Albi; Peter Nathan, Zurich.
BIBLIOGRAPHY: Joyant 1926, p. 255; Jourdain-Adhémar 1952, p. 109; Dortu II, pp. 52f. P. 108 Ill.; Caproni-Sugana 1977, No. 86; Dortu-Méric 1979, I, p. 34 No. 92 Ill.
EXHIBITIONS: Paris 1914, No. 166; Paris 1931, No. 14; Paris 1931 (Galerie Castel).

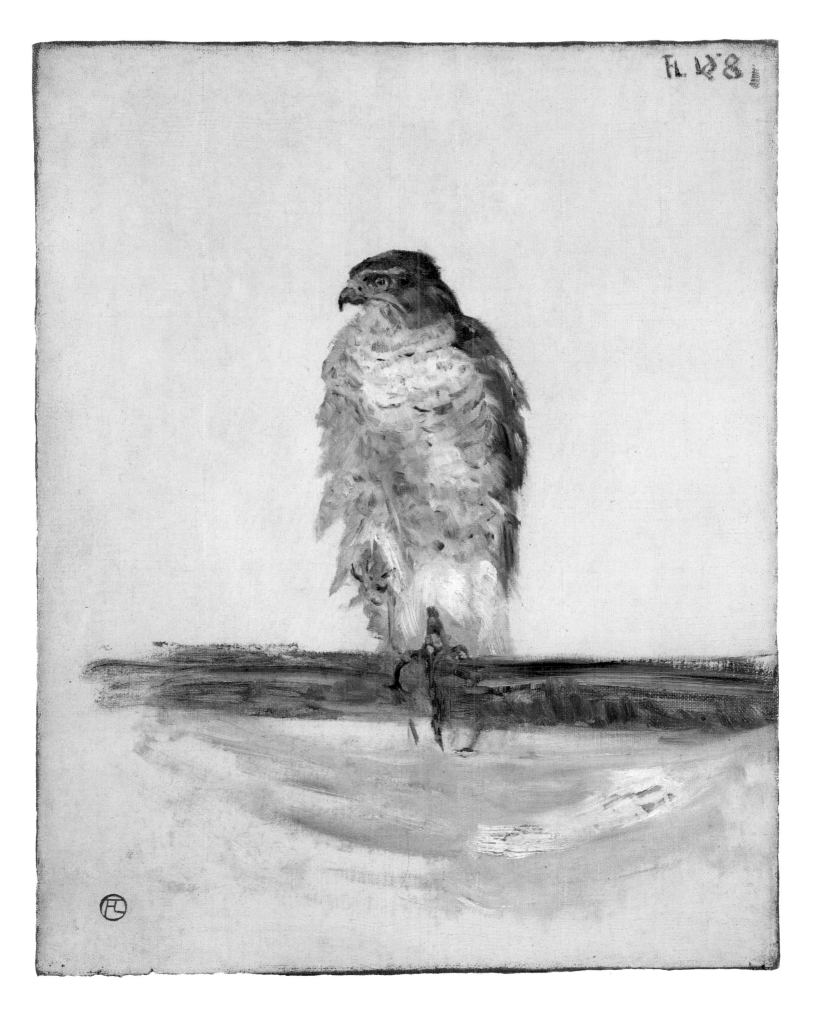

6 Equestrian Portrait, Monsieur du Passage (Cavalier, M. du Passage) 1881

Dortu II, P. 93
Oil on canvas, 73.2 × 54.3 cm
Monogram and date in dark paint, lower left
Private Collection, Munich

Joyant identified this horseman as Monsieur du Passage. Some small sheets of sketches by Lautrec dating from the late 1880s show a certain Monsieur du Passage, but he is shown as immensely stout.[1] This obesity is also mentioned in no uncertain terms in a letter to the artist's mother written in September 1889: 'I had lunch today with Papa. We went to call on du Passage, who dribbled his healing spittle on my young brow. So, I'm saved, by the laying on of hands by that fat giant.' In another letter written in the same month Lautrec says he has made an appointment with Charles du Passage to see his paintings.[2] Thus the fat man shown in the caricatures and mentioned in the letters must be Viscount Charles Marie du Passage who was active as an animal sculptor and illustrator in Paris.

The slim horseman in this portrait, however, probably represents Count Arthur Marie Gabriel du Passage (1838–1909). He had been trained by Antoine Barye and also worked as a sculptor of animals. The two brothers were acquainted with Count Alphonse and were members of the circle of artists around René Princeteau in the Rue du Faubourg Saint-Honoré. On 17 April 1882 Lautrec wrote to his father from Paris: 'Yesterday I saw du Passage, who asked me how things were with you. Yesterday, for *La Vie Moderne*, he drew the different ways a horse jumps.'[3]

It was obvious that a specialist in portraying horses and a collector of hunting and horse paintings should be depicted on horseback, probably out riding in the Bois de Boulogne. The painting is one of those masterly works of the painter's youth when he was using a bright palette and was still very much under the influence of Princeteau. It was certainly not painted on the spot but from preparatory studies, such as the watercolour Le Salut (Dortu III, A. 162), or from detail sketches such as the studies of horses (Dortu IV, D. 1089, D. 1136).

What is clearly revealed by this early work, with its sureness in the representation of sequences of movement, is the artist's precise observation of a momentary situation. The elegant rider has just brought his restlessly forward-pressing horse to a standstill, and turns to the left, where a little dog jumps out of the undergrowth; the man's attention is directed at something outside the picture.

1 Dortu V, D. 2383, D. 3013-D. 3015.
2 Goldschmidt-Schimmel 1969, p. 113 [268].
3 *Ibid.*, p. 65 [255].

SOURCES: H. Bühler, Winterthur; Peter Nathan, Zurich.
BIBLIOGRAPHY: Joyant 1926, p. 21 Ill., p. 254; Jedlicka 1929, pp. 50f.; Schaub-Koch 1935, p. 167; Jedlicka 1943, p. 41, p. 313; Perruchot 1958, p. 59; Dortu II, pp. 44f. P. 93 Ill.; *Dr Fritz Nathan – Dr Peter Nathan 1922–1972*, Zurich 1972, No. 98 Ill.; Caproni-Sugana 1977, No. 67 Ill.; Dortu-Méric 1979, I, p. 30 No. 77 Ill.
EXHIBITIONS: Paris 1903, No. 16; Winterthur 1924, No. 244; Basel 1947, No. 170; Munich 1985, p. 12, No. 1.

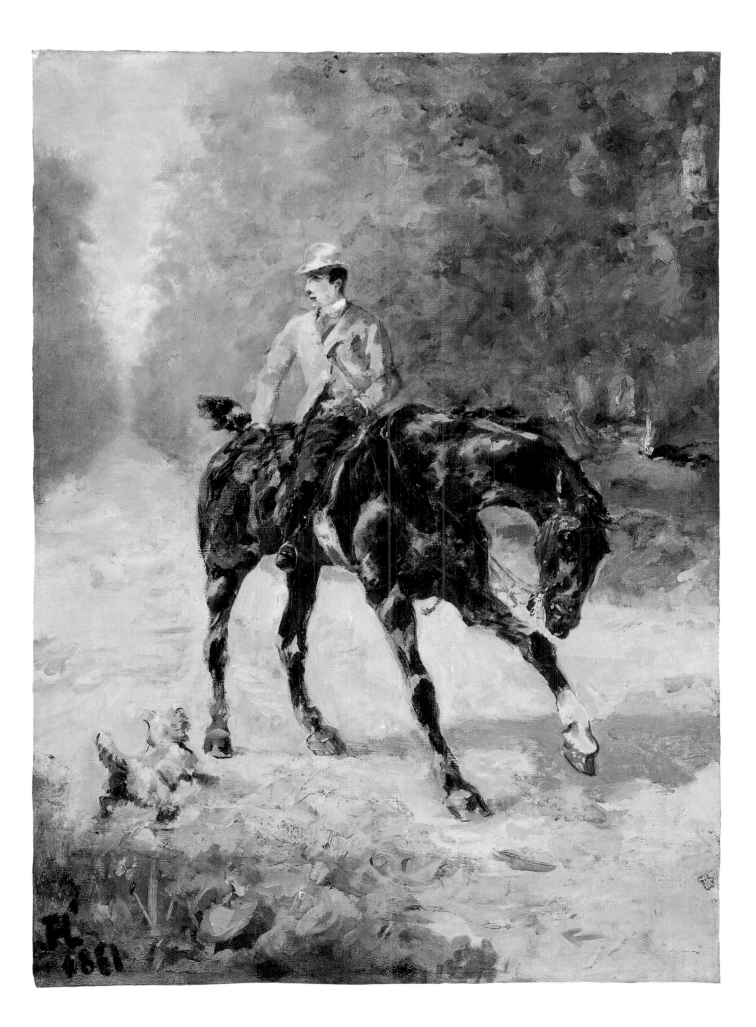

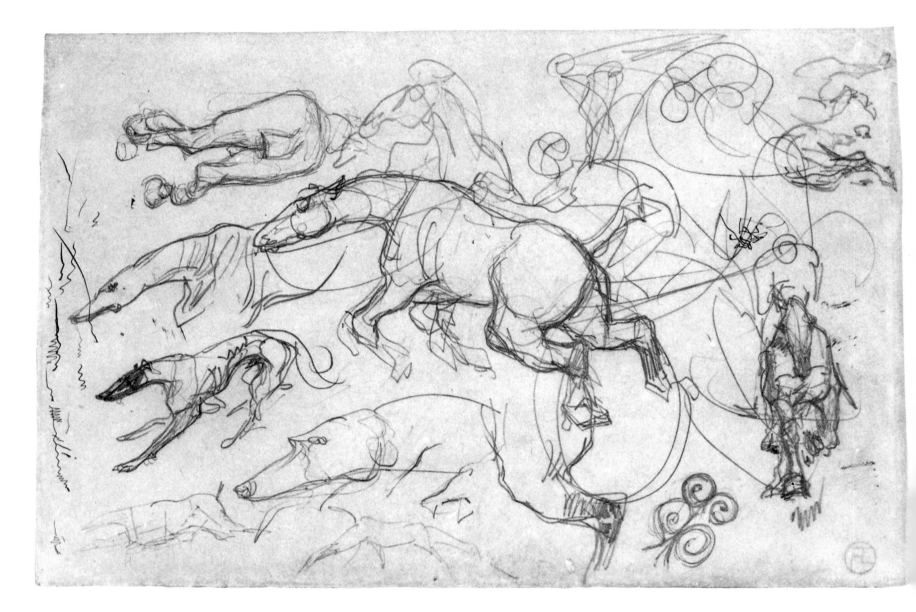

7 Sheet of Sketches with Horses, Riders and Greyhounds (Chevaux et Chiens Lévriers) 1881

Dortu V, D. 2063
Pencil, pen and black ink on white paper, 20 × 31 cm
Red monogram stamp (Lugt 1338), lower right
Private Collection, Hamburg

Everything is in motion on this sheet, which is filled to the edges with detail studies. The leaping horses and greyhounds are made to resemble each other as if undergoing a sort of metamorphosis.

SOURCES: Gustave Pellet, Paris; Maurice Exsteens, Paris; Alfred Flechtheim. Berlin; Robert von Hirsch, Basel; Auction *The Robert von Hirsch Collection*, Sotheby Parke Bernet, London 26–27 June 1978, No. 849 Ill.
BIBLIOGRAPHY: Joyant 1927, p. 182; Joyant 1930, No. 16 Ill.; Dortu V, pp. 342f. D. 2063 Ill.
EXHIBITIONS: Paris 1928, No. 90.

8 Comte Charles de Toulouse-Lautrec 1882

Dortu V, D. 2621
Charcoal on white paper, 59.5 × 46 cm
Signed (TLM joined together) and dated in charcoal, lower left: 'T-L-Monfa / 82'
Musée Toulouse-Lautrec, Albi

The artist's uncle is drawn sitting on a high-backed chair, reading. This full-length portrait in strict profile is one of a number of large charcoal portrait drawings dating from 1882–1883 (*cf.* Nos. 9, 13, 14).

When he entered Léon Bonnat's studio in April 1882 Lautrec was forced to conform to the academic teaching methods practised by this Salon portrait-painter who had enjoyed enormous success since the 1870s. He wrote to his father on 17 April: 'I was taken in this morning by the students of the Bonnat studio. Thanks to the recommendation of Rachou, a friend of Ferréol, I had a good reception. . . . So, here I am, one of the boys, absolutely. Draw, draw, there's the rub.'[1] The most important thing now was to discipline his drawing style and to concentrate it on the poses of a given model. Bonnat, who based himself on Bolognese and Spanish baroque painting, and Cormon, to whose studio Lautrec moved in the autumn of 1882, both laid great emphasis on the accurate modelling of the figure and clear contrasts between areas of light and shade.

Whereas in the preceding years the budding draughtsman had concentrated mainly on smaller sheets of sketches, now, at the start of his training – besides the numerous drawings of male and female nude models and occasional plaster casts[2] – he also discovered portrait drawing. He experimented with a simple compositional structure and clear proportions even for difficult poses, and he also practised sureness of line, economical use of diagonal hatching and employed the medium of charcoal, which had long been neglected. These carefully

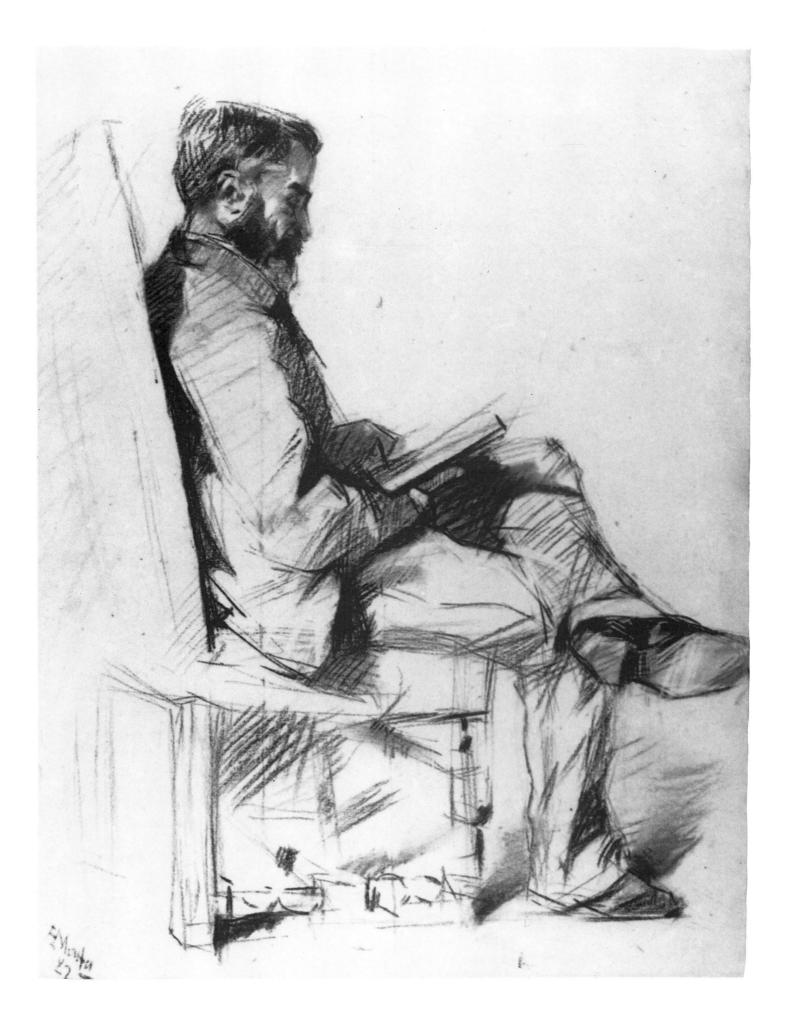

executed sheets, mostly dated, are signed 'T-L-Monfa', a signature not used later; they are evidence of the self-confidence of the artist at barely eighteen years of age.

It was his uncle who sat most frequently as his model in this period because the adolescent Lautrec had found him to be the most stimulating member of the family to talk to and a strong supporter of his plans to be an artist. Charles de Toulouse-Lautrec, Count Alphonse's younger brother, was himself a very gifted draughtsman and knew his way around the Parisian art world. Particularly significant are the letters Lautrec wrote to his favourite uncle with remarks about exhibitions in Paris and about his own artistic training.[4] For example, he reported some rather odd encouragement he had had from Bonnat: 'Your painting isn't bad, it has a certain flair; in short it isn't bad, but your drawing is frankly atrocious.'[5]

1 Goldschmidt-Schimmel 1969, p. 64 [255].
2 Dortu V, D. 2427–D. 2619.
3 *Cf.* the painting Dortu II, P. 192 and the charcoal drawings Dortu V, D. 1907, D. 2629, D. 2630, D. 2658, D. 2659.
4 Goldschmidt-Schimmel 1969, p. 64 [255]; Joyant 1926, pp. 53f., 56ff.; Huisman-Dortu 1964, pp. 45f.
5 Joyant 1926, p. 58.

SOURCES: Comtesse Adèle Zoë de Toulouse-Lautrec, Toulouse.
BIBLIOGRAPHY: Joyant 1927, p. 183; Julien 1942, p. 29 Ill.; Focillon 1959, No. 2 Ill.; Bouret 1963, p. 16; Novotny 1969, p. 8 Ill., p. 13; Dortu V, pp. 422f. D. 2621 Ill.; Polasek 1972, p. 20, No. 4 Ill.; *Cat. Musée Toulouse-Lautrec* 1973, pp. 110f. No. D. 32 Ill.; *Cat. Musée Toulouse-Lautrec* (1985), p. 176 Ill., p. 183 No. D. 45.
EXHIBITIONS: Albi 1951, No. 150; Albi-Paris 1964, No. 88; Stockholm 1967–1968, No. 44; Humlebaek 1968, No. 43; Paris 1975–1976, No. 45; Liège 1978, No. 41; Tokyo (etc.) 1982–1983, No. 57.

9 COMTESSE EMILIE DE TOULOUSE-LAUTREC 1882

Not in Dortu
Charcoal on white paper, 63 × 47.8 cm
Signed in charcoal (TLM joined together) and dated, below right: 'T-L-Monfa 82'
Staatliche Graphische Sammlung (Cat. No. 1981:50), Munich

Emilie de Toulouse-Lautrec, *née* d'Andoque de Seriège, was the wife of Charles de Toulouse-Lautrec (No. 8). The childless couple lived at the Château de Bosc near Albi, and it was there that these portraits of the two of them must have been drawn, while their nephew was staying with them in the summer of 1882. In August 1882 he wrote to his grandmother from Le Bosc, telling her that it was raining cats and dogs, that Aunt Emilie was making curtains with a sewing machine and that Uncle Charles was busy looking for transparent excuses for his laziness; he himself was dividing his leisure between painting and toothache.[1]

He would thus have had plenty of opportunity in the summer months to give proof of his artistic skill to his family circle. And he did so, particularly in this quarter-length portrait of his aunt, in which he pulled out all the stops to demonstrate what he had learnt under the guidance of Princeteau and especially Bonnat, who was an experienced specialist in portraits and had quickly been raised to the position of almost official portrait-painter to the Third Republic.[2] The consciously mature graphic effects – the smuding of the deep areas of shadow or the flickering play of the highlights, achieved by the simplest means using a rubber – in no way detract from the concentration on the shaded facial features. Quite the reverse: the lively lines form an extremely exciting contrast with the withdrawn stillness of the half-veiled face.

The fact that 'notre futur Michel-Ange', as his mother called him at that time with affectionate irony,[3] should have attempted such a difficult motif as the veil – inspired by contemporary ladies' fashions but only occasionally taken up by artists (such as Degas, Manet and de Nittis) – indicates Lautrec's assurance as a draughtsman, as well as his close familiarity with the sitter.

1 Goldschmidt-Schimmel 1960, pp. 65–67 [256].
2 *Cf.* similar handling in the portraits of his two grandmothers, Dortu V, D. 2636, D. 2637.
3 Goldschmidt-Schimmel 1960, p. 306.

SOURCES: Peter Nathan, Zurich.
EXHIBITIONS: *Neuerwerbungen, Ankäufe – Geschenke – Dauerleihgaben, Staatliche Graphische Sammlung München*, Neue Pinakothek, Munich 1982, p. 7, No. 61; Munich 1985, No. 14.

10 YOUNG ROUTY AT CÉLEYRAN (LE JEUNE ROUTY À CÉLEYRAN) 1882

Dortu II, P. 150
Oil on canvas, 61 × 49.8 cm
Red monogram stamp (Lugt 1338), lower left
Bayerische Staatsgemäldesammlungen, Neue Pinakothek (Cat. No. 14928, acquired with the support of the Ernst von Siemens-Kunstfond), Munich

Of all his models Lautrec seems to have been most occupied with Routy, an agricultural labourer of about his own age from the château farm at Céleyran. Besides three paintings (see No. 11), no fewer than seven large-scale portrait drawings and one smaller tracing have survived.[1] However, only one charcoal drawing, a carefully executed study of a head (Dortu V, D. 2646), can be directly related to this head-and-shoulders portrait.

During his short time in Léon Bonnat's studio, the budding portrait-painter had learnt how to analyze his sitters in depth and to make precise preparatory drawings of his motifs. But neither at Bonnat's nor later at Cormon's studio was he able to perfect a spontaneous transposition of these studies into the type of painting with light colouring that is already convincingly expressed in this important early work. It has the stylistic hallmarks of *plein-air* painting, qualities which in 1882 (the portrait was probably painted in the summer of that year) were regarded by the Salon officials – who included Bonnat and Cormon – as well as by a large section of the public as not really having much to do with painting. On 7 May Lautrec himself had written to his Uncle Charles in almost enthusiastic terms about some of the quite conventional exhibits at that year's Salon. He mentioned in particular Bonnat's PORTRAIT DE PUVIS DE CHAVANNES, Roll's FÊTE DU 14 JUILLET and LES DERNIERS MOMENTS DE MAXIMILIAN by J.-P. Laurens.[2]

There is no mention in this letter of the one painting at the exhibition which was among the few works of the period that could have served as a model for him: Edouard Manet's BAR AUX FOLIES BERGÈRE; nor does Lautrec mention the seventh Impressionist Exhibition which was being held at the same time in the gallery of the art dealer Paul Durand-Ruel at 251 Rue Saint-Honoré. However, the picture of young Routy shows clearly enough that

Lautrec as a portrait-painter was now seeking to adapt himself to the painting technique and light palette of the Impressionists. In particular, it was the characteristics of Manet's later paintings that now gained the upper hand over the rather pastose, blotchy and contrasty application of paint derived from Princeteau. Not only the light, sketchy brushwork in which finely rubbed passages complement long strokes of paint – this is incidently very similar in form to the contemporary charcoal drawings (*cf.* No. 9) – but also the hardness, indeed the abruptness, with which Lautrec juxtaposes the light colour modulations with dark grey or almost unbroken black, are reminiscent of Manet, whose ability to handle black had only been equalled by Velázquez and Goya.[3]

By basing himself on his experience of *plein-air* painting, Lautrec succeeded in his portrait of Routy in convincingly translating light into paint. He was obviously interested in depicting light coming from a difficult direction; the sunlight enters the picture space from behind and illuminates the back of the farm-hand who is squatting on the ground in front of a bench. The direction of the light is revealed by a strip of light on his shoulders, making the steeply rising background above him appear as a sun-drenched scrubby landscape foil, while the head and upper part of the body of the self-absorbed young man, who gazes pensively into the distance, are bathed in a diffuse, indirect light.

1 Dortu V, D. 1909, D. 2643–D. 2649.
2 Joyant 1926, p. 58.
3 E.g., Manet's 1881 PORTRAIT D'HENRY BERNSTEIN in a white sailor costume with a black collar and a similar round black hat (Denis Rouart – Daniel Wildenstein, *Edouard Manet, Catalogue Raisonné*, Lausanne-Paris, 1975, I, 371).

SOURCES: Comtesse Germaine d'Anselme, *née* Tapié de Céleyran, Paris; F. von Mendelssohn-Bartholdy, Berlin; Peter Nathan, Zurich.
BIBLIOGRAPHY: Joyant 1926, p. 17 Ill., p. 256; Schaub-Koch 1935, p. 170, p. 175, p. 207; Schmidt 1948, pp. 5f., pp. 8ff., p. 15, Ill. 1; Lassaigne 1953, p. 25; Colombier 1953, Ill. 9; Hunter 1953, Ill. 9; Cooper 1955, p. 20, pp. 60f. Ill.; Dortu II, pp. 68f. P. 150 Ill.; Dortu V, p. 428 with D. 2646; Dortu-Méric 1975, No. 11; Caproni-Sugana 1977, No. 118 Ill.; Dortu-Méric 1979, I, p. 42 No. 124 Ill.; Arnold 1982, p. 97; *Cat. Musée Toulouse-Lautrec* (1985), p. 76 with No. 74; *Bayerische Staatsgemäldesammlungen Jahresbericht 1985*, Munich 1985, p. 11, pp. 14ff. Ill. (also jacket illustration).
EXHIBITIONS: Paris 1914, No. 175; Paris 1931, No. 28; Paris 1931 (Galerie Castel), No. 5; Basel 1947, No. 173; Tokyo (etc.) 1982–1983, No. 7; Munich 1985, pp. 12f., No. 13, with Nos. 7, 14.

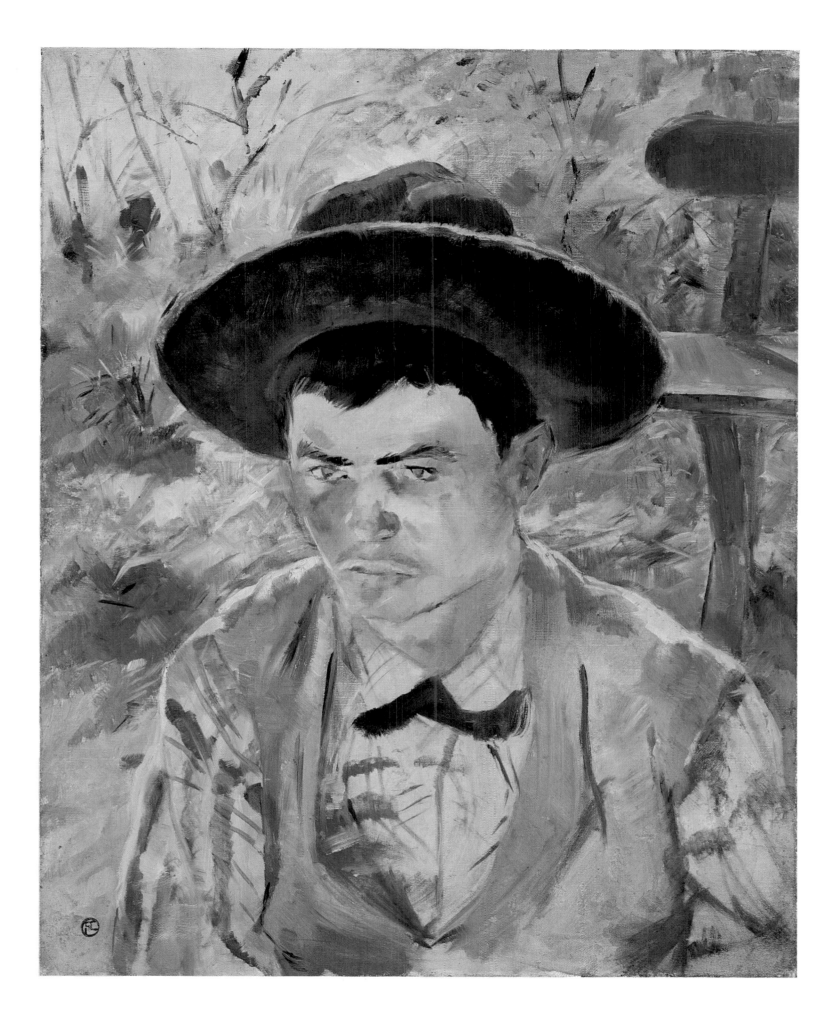

11 Young Routy at Céleyran (Le Jeune Routy à Céleyran) 1882

Dortu II, P. 149
Oil on canvas, 61 × 51 cm
Red monogram stamp (Lugt 1338), lower left
Musée Toulouse-Lautrec, Albi

In the previous portrait (No. 10) the artist's attention is directed to Routy's head and the facial features, which reveal the reserved character of the young farm-hand. The present picture, however, is concerned with the tense integration of the shepherd boy into the fragment of landscape, as he sits on the remains of a low wall totally absorbed in what he is doing. It is one of the few examples in Lautrec's work where the surrounding landscape is not completely dominated by the human figure. Instead, a subtle equilibrium of the two elements in the picture is achieved, and the figure whittling at a stick is made part of an atmospheric landscape which spreads out into space; only in the upper part of the body set against the high horizon does the figure come into its own.[1]

The young aristocrat's short-lived interest in peasants and agricultural labourers in 1882 was certainly not inspired by any social concern – it occurred, incidentally, immediately before Vincent van Gogh (later to become a student friend of Lautrec's) was driven by a deeply felt commitment to make his first awkward attempts at depicting the lives of weavers and peasants in his native Brabant. Lautrec found the workers on his family's estates to be welcome models who, for 75 centimes, would patiently do all that he asked. He could try out on them his technical skill and progressive conviction of his vision of people. In no way did he feel called upon to emulate an artist such as Bastien-Lepage, the painter of country life who had made the image of the peasant suitable for the salon by sentimentalizing it. Lautrec's vision was too straightforward and too impartially concerned for the truth of the motif, to follow such an approach.

1 A rejected version of the subject (Dortu II, P. 177) is treated in very much darker tones; *cf.* also two drawings Dortu V, D. 2644, D. 2645. However, a letter to his student friend Eugène Boch shows how uneasy he still felt at that time about painting in the open air: 'I'll spare you the recital of my ruminations in the sun with brush in hand and spots of more or less spinachy green, pistachio, olive or shit colour on my canvas' (Goldschmidt-Schimmel 1969, p. 73 [257]).

SOURCES: Comtesse Adèle Zoë de Toulouse-Lautrec, Toulouse.
BIBLIOGRAPHY: Astre (1926), p. 81; Joyant 1926, p. 256; Lapparent 1927, p. 15 Ill. 3; Jedlicka 1929, pp. 51 f.; Jedlicka 1943, p. 41, pp. 42–43 Ill., p. 313; Kern 1948, p. 24, Ill. 2; Jourdain 1948, Ill. 2; Lassaigne 1953, p. 25; Dortu-Grillaert-Adhémar 1955, p. 35; Fermigier 1969, p. 33 Ill.; Zenzoku 1970, Ill. 7; Dortu II, pp. 68 f. P. 149 Ill., p. 76 with P. 177; Dortu V, p. 428 with D. 2645; Devoisins 1972, p. 8; Josifovna 1972, Ill. 3; *Cat. Musée Toulouse-Lautrec* 1973, p. 17 Ill., p. 19 No. 74; Dortu-Méric 1975, No. 7; Camproni-Sugana 1977, Ill. III, No. 104 a Ill.; Dortu-Méric 1979, I, p. 40 No. 123 Ill., p. 47 Ill.; *Cat. Musée Toulouse-Lautrec* (1985), p. 74 Ill., p. 76 No. 74.
EXHIBITIONS: Paris 1914, No. 168; Paris 1931, No. 27; Basel 1947, No. 172; Amsterdam 1947, No. 6; Brussels 1947, No. 6; Albi 1951, No. 21; Amsterdam-Otterlo 1953, No. 18; Dallas 1957; London 1961, No. 8; Munich 1961, No. 18; Cologne 1961–1962, No. 18; Albi-Paris 1964, No. 12; Stockholm 1967–1968, No. 4; Humlebaek 1968, No. 3; Kyoto-Tokyo 1968–1969, No. 5; Albi 1969, No. 11; Paris 1975–1976, No. 7; Paris 1976; Liège 1978, No. 8; Chicago 1979, No. 11; Tokyo (etc.) 1982–1983, No. 6; Munich 1985, No. 9, with No. 7.

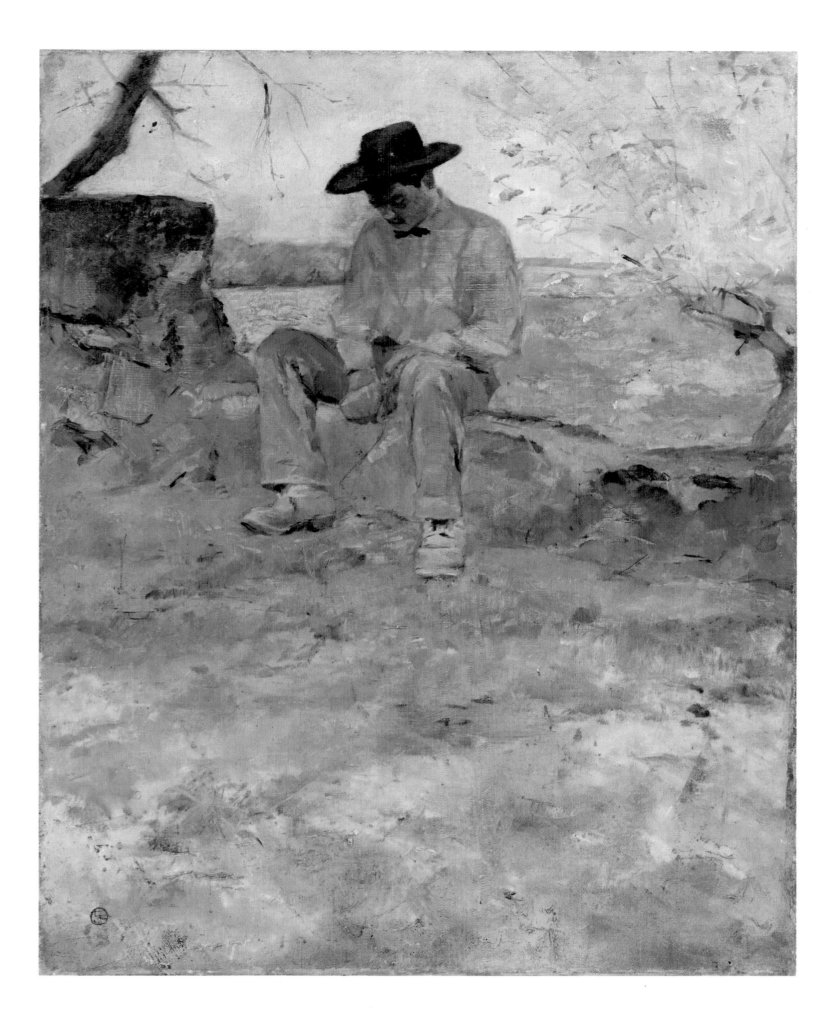

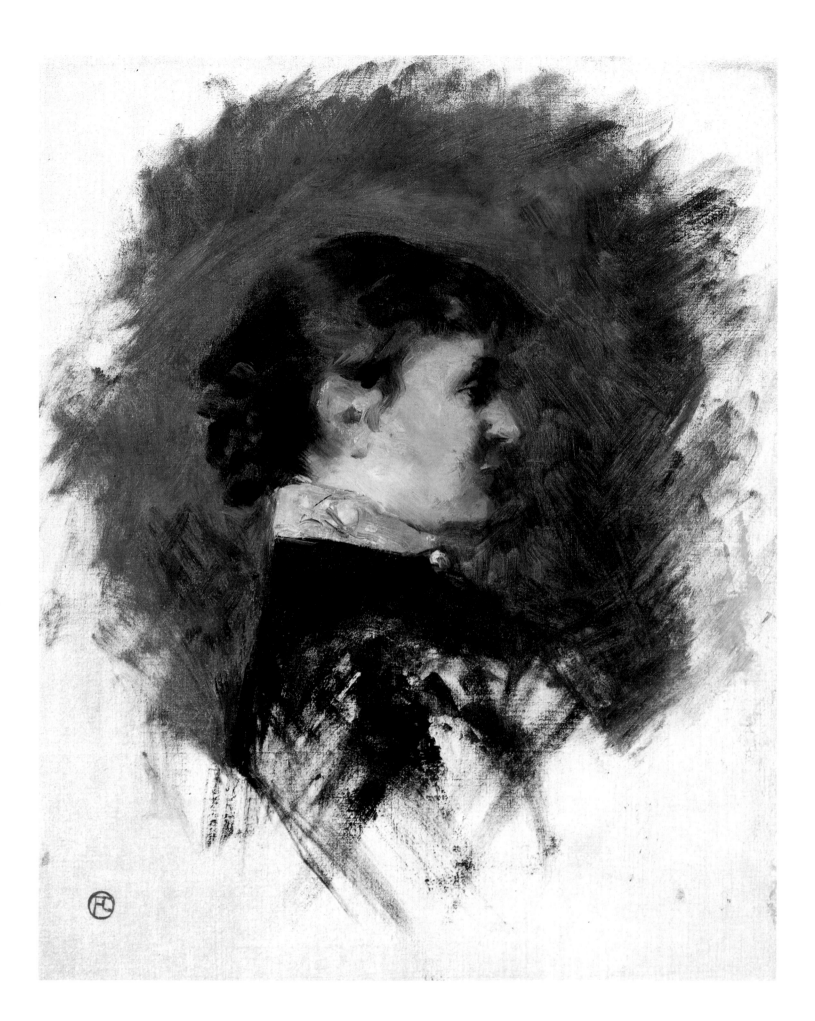

12 Woman's Head in Profile, Madame la Comtesse A. de Toulouse-Lautrec (Tête de Femme de Profil, Madame la Comtesse A. de Toulouse-Lautrec) 1882

Dortu II, P. 155
Oil on canvas, 43 × 35 cm
Red monogram stamp (Lugt 1338), lower left
Private Collection (by arrangement with Galerie Schmit, Paris)

The artist's mother, Countess Adèle Zoë Marie Marquette de Toulouse-Lautrec-Monfa, *née* Tapié de Céleyran (1841–1930), had married her cousin Alphonse in May 1863. A gentle, retiring heiress from a wealthy family with a slight tendency to bigotry, she had to accept her fate when her husband decided after the early death of their second child Richard Constantine in 1868 that they should separate and that their relationship should be one of cousins only. She was left with the care of her son Henri, to whom she was closer than anybody else and whom she survived by almost three decades.

She is the subject of Lautrec's most penetrating early portraits (*cf.* Nos. 13, 25). In all, six paintings and seven drawings of her between 1880 and 1887 are known.[1] Unlike the portraits of his father, who is usually shown in action as a falconer (No. 2), a wild horseman or seated on the coachman's box (Ill. p. 291), the emphasis in all the portraits of his mother is strongly on contemplation. She is always shown seated, her eyes downcast, lost in thought or reading, and her face seems serious and reserved.

1 Dortu II, P. 90, P. 125, P. 155, P. 180, P. 190, P. 277; Dortu IV, D. 1627; Dortu V, D. 2338, D. 2771, D. 2793, D. 2794, D. 2849.

SOURCES: Comtesse Adèle Zoë de Toulouse-Lautrec, Toulouse; Comtesse Germaine d'Anselme, *née* Tapié de Céleyran, Paris; Mme Lobreau, Paris.
BIBLIOGRAPHY: Joyant 1926 p. 256; Dortu II, pp. 70f. P. 155 Ill.; Caproni-Sugana 1977, No. 126; Dortu-Méric 1979, I, p. 42 No. 129 Ill.
EXHIBITIONS: Paris 1914, No. 170; Paris 1931 (Galerie Castel), No. 3; *Maîtres Français XIXe – XXe Siècles*, Galerie Schmit, Paris 1986, No. 59.

13 Comtesse Adèle Zoë de Toulouse-Lautrec c. 1883

Dortu V, D. 2849
Charcoal on white paper, 61.1 × 44.4 cm
Monogram in charcoal, presumably added later, lower right
Musée Toulouse-Lautrec, Albi

Joyant and, following him, Dortu dated this portrait drawing of the artist's mother
(*cf.* Nos. 12, 25) to 1885. However, the stylistic details – in particular the line drawing
concentrated on the soft modelling of the head – relate the drawing to the group of charcoal
portraits characteristic of the years 1882–1883 (Nos. 8, 9, 14).[1] A similar upright posture and
strict profile view are also found in the paintings which portray the Countess sitting on a
garden bench (Dortu II, P. 190) and in her salon (No. 25).

1 *Cf.* the portrait drawing Dortu IV, D. 1625 (verso: Dortu V, D. 2787), which is probably later than 1880, or the portrait
 of his friend and fellow student Gustave Dennery (Dortu V, D. 2795) which is dated 1883.

SOURCES: Comtesse Adèle Zoë de Toulouse-Lautrec, Toulouse.
BIBLIOGRAPHY: Joyant 1927, p. 186; Joyant 1930, No. 21 Ill.; Julien 1942, Ill. 31; Jedlicka 1943, pp. 32–33 Ill.; Cooper
1955, p. 26 Ill., p. 66; Dortu-Grillaert-Adhémar 1955, p. 37; Focillon 1959, No. 15 Ill.; Bouret 1963, p. 29; Dortu V,
pp. 466f. D. 2849 Ill.; Polasek 1972, No. 13 Ill.; *Cat. Musée Toulouse-Lautrec* 1973, p. 109 No. D 26, p. 111 Ill; *Cat. Musée
Toulouse Lautrec* (1985), p. 176 Ill., p. 180 No. D 32.
EXHIBITIONS: New York 1937, No. 28; London 1938, No. 32; Paris 1938, No. 2; Amsterdam 1947, No. 65; Brussels
1947, No. 65; Brussels 1949, No. 211; Paris 1951, No. 88; Albi 1951, No. 144; Albi-Paris 1964, No. 89; Ingelheim 1968,
No. 15; Paris 1975–1976, No. 46; Liège 1978, No. 42; Tokyo (etc.) 1982–1983, No. 61.

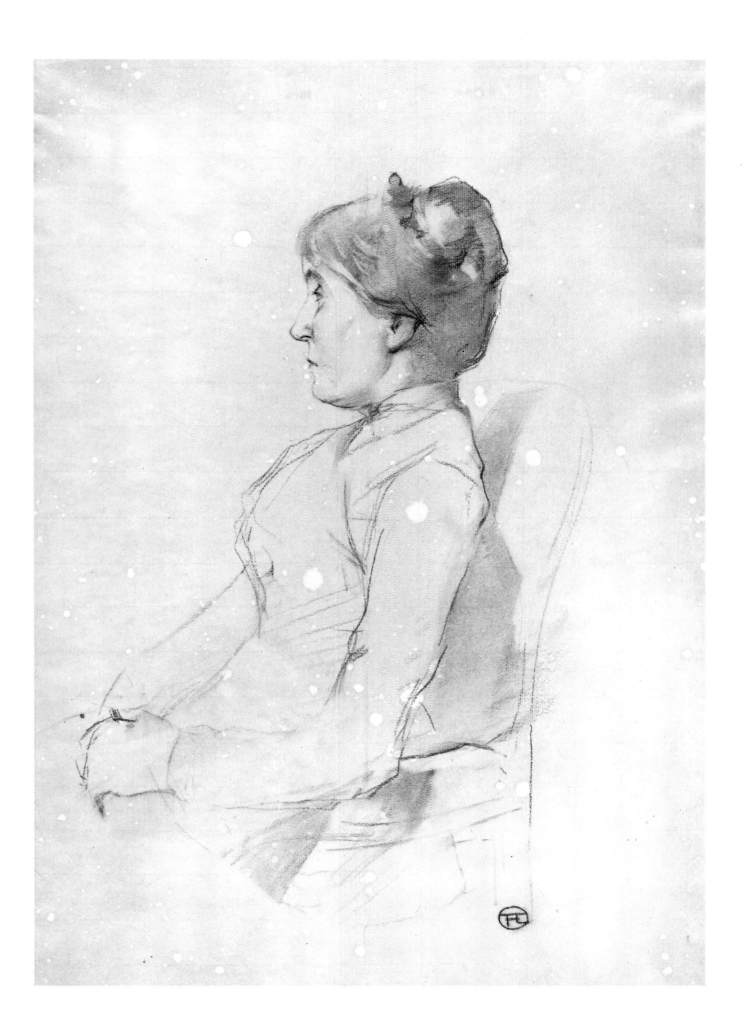

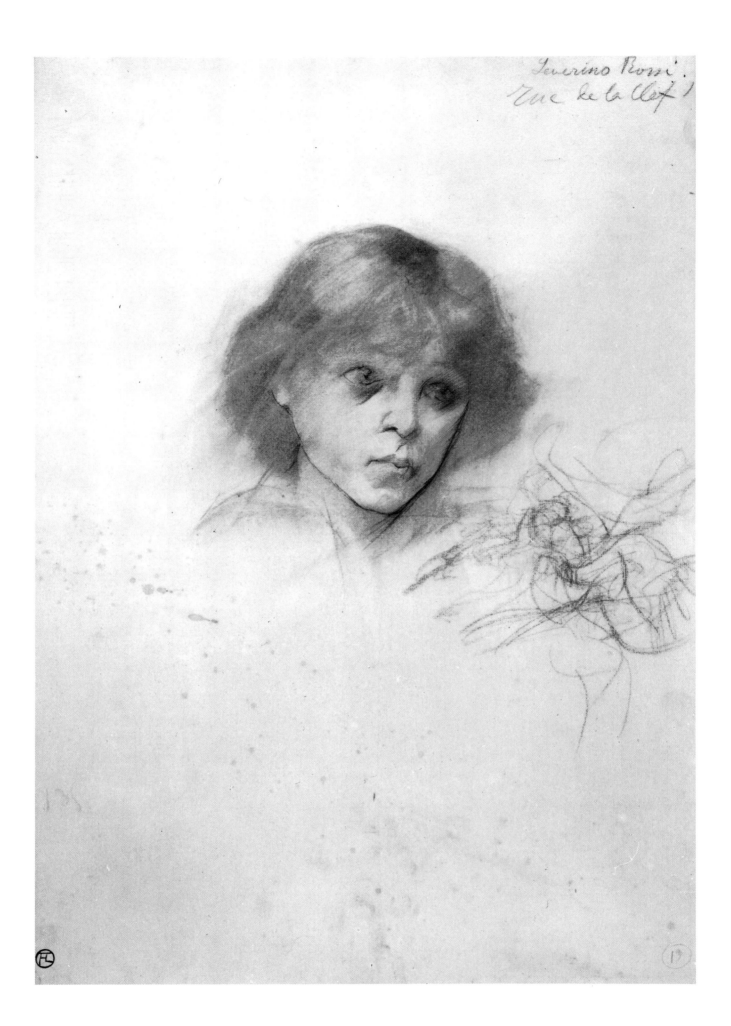

Severino Rossi.
Rue de la Clef

14 Child's Head, Severino Rossi (Tête d'Enfant, Severino Rossi) 1883

Dortu V, D. 2757
Charcoal on white paper, 62 × 47 cm
Inscribed in charcoal, upper right: 'Severino Rossi / rue de la Clef 14';
red monogram stamp (Lugt 1338), lower left
Musée Toulouse-Lautrec, Albi

The name and address in the upper right-hand corner of this sensitively handled portrait are presumably of the boy depicted. Perhaps Lautrec made a note of this so as to be able to return to the same boy at a later date. He was probably one of the children – mostly Italians – who offered their services as models around the fountain in the Place Pigalle, where prostitutes could also be found to act as models for Madonnas. They all used this as a means of supplementing their earnings. The fact that the model's head is drawn on a large sheet of paper, like those used for the numerous nude studies, seems to indicate that the boy posed in Cormon's studio and was drawn there.[1]

The pretty, slightly tilted head with its expressive eyes is sketched in softly smudged charcoal areas. Only in places are outlines and the edges of shadows picked out. The eyes and the mouth in particular give the portrait something of an emotionally charged virtuosity which one seeks in vain elsewhere in Lautrec's work – even his early work is distinguished by its sharpness and succinctness of characterization. This can be seen as a fully mature drawing in the sense of a quasi-academic training by a pupil who had taken the advice and corrections of his teachers to heart and was now in a position to make full use of what he had learnt.

1 *Cf.* the nude studies Dortu II, P. 197; Dortu V, D. 2514, D. 2523.

SOURCES: Comtesse Adèle Zoë de Toulouse-Lautrec, Toulouse.
BIBLIOGRAPHY: Joyant 1927, p. 185; *Toulouse-Lautrec* 1951, Ill.; Julien (1959), p. 6 Ill.; Cionini-Visani 1968, Ill. 7; Dortu V, pp. 450f. D. 2757 Ill.; Polasek 1972, p. 20, No. 10 Ill.; Devoisins 1972, p. 9; *Cat. Musée Toulouse-Lautrec* 1973, p. 114 No. D 48; Adriani 1978, p. 31 Ill. 3; Devoisins 1980, p. 29 Ill.; Henze 1982, p. 17 Ill.; *Cat. Musée Toulouse-Lautrec* (1985), pp. 186f. No. D 60 Ill.
EXHIBITIONS: Albi-Paris 1964, No. 90.

15 Nude Study (Etude de Nu) 1883

Dortu II, P. 170
Oil on canvas, 55 × 46 cm
Musée Toulouse-Lautrec, Albi

Since early 1882 Lautrec had had the opportunity of working from a live model, first at Bonnat's, and then at Cormon's studio. This resulted in a large number of dry academic nude drawings in charcoal and chalk,[1] as well as a few paintings, including this one of a female nude seen in profile, facing left and seated on a divan (cf. No. 16). The model appears pensive, with the index finger of her left hand lightly touching her lower lip. This mundane pose contributes to the rather genre-like character of the total impression. There is none of the natural freedom and fullness of life which Degas – whom Lautrec so much admired – was able to give his nudes at their toilette, which he was creating at about the same time. Degas's nudes in action, which Renoir said were like a piece of the Parthenon,[2] have no sense of being observed. Here, however, Lautrec has depicted a defenceless, timid human figure, who is exposed to view and at the mercy of an unfamiliar environment. Female nudes played a central role in the work of Manet, Degas, Renoir, and equally in that of Cézanne or Seurat, but although women were at the centre of Lautrec's interests, nudes make only a sporadic and marginal appearance in his work.

The sensual attraction of this small, strictly co-ordinated picture derives more from the skilful handling of the paint than from the subject depicted. The harsh contrast between the exposed flesh tones and the black stockings and shoes is moderated by the intervening richly differentiated grey tones. The daylight palette of the Routy portraits (Nos. 10, 11) has been replaced in this painting – one of the eighteen-year-old artist's earliest interiors – by tones which are in keeping with the muted colouring of an interior. His already highly developed sense of colour is evident in the way the darker areas are painted in the most varied values of grey, and the delicate flesh tones are brought out by the pale red of the patterned rug on the divan.

The portrait of Gustave Dennery (Ill. p. 293) could almost be seen as a pendant to this nude study. They are the same size and the studio props used are the same.[3] Moreover, they resemble each other in their strongly painterly qualities and in the uncompromising orthogonal composition. Lautrec had got to know Dennery as a fellow student at Cormon's studio. He wrote in 1883 to his mother: 'My work is progressing. I'm finishing the portrait of d'Ennery, who very obligingly posed for me.'[4] The similarity between the two paintings, both in subject and form, suggests that they were done in 1883, using the same divan with its rug and cushion, possibly in Cormon's studio or at the lodgings of one of the two friends,[5] and that Joyant and Dortu were wrong to date the nude 1882 and the portrait c. 1883.

1 Dortu V, D. 2427–D. 2431, D. 2433–D. 2463, D. 2466, D. 2467, D. 2469–D. 2523, D. 2526, D. 2528, D. 2529, D. 2531–D. 2557, D. 2559–D. 2602, D. 2613–D. 2617, D. 2619, D. 2747, D. 2752–D. 2754, D. 2756, D. 2763.
2 Ambroise Vollard, *Degas, an Intimate Portrait*, London, 1928, p. 114.
3 Comparable props are found in the painting Danseuse Assise sur un Divan Rose (Dortu II, P. 248).
4 Goldschmidt-Schimmel 1969, p. 72 [257]; a charcoal drawing of Dennery is dated 1883 (Dortu V, D. 2795).
5 According to Bernard 1952, p. 13, the equipment in Cormon's studio included a divan. Lautrec himself posed on a rather similar rug when he was painted by Henri Rachou in 1883 (Goldschmidt-Schimmel 1969, Ill. 20; this portrait is now in the Musée des Augustins, Toulouse).

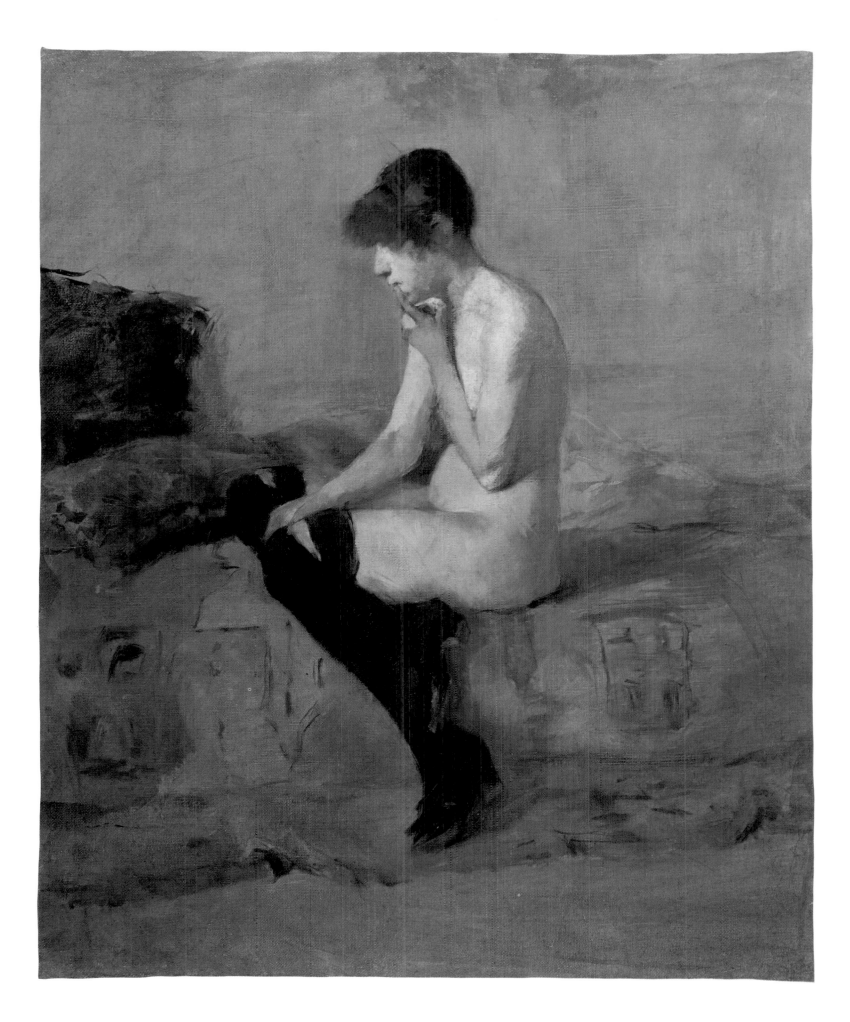

SOURCES: Comtesse Adèle Zoë de Toulouse-Lautrec, Toulouse.
BIBLIOGRAPHY: Joyant 1926, p. 258; Cooper 1955, p. 19 Ill.; *Toulouse-Lautrec* 1962, p. 19 Ill.; Bouret 1963, p. 37 Ill.; Cionini-Visani 1968, Ill. 6; Zenzoku 1970, Ill. 5; Dortu II, pp. 74f. P. 170 Ill.; Devoisins 1972, p. 7; *Cat. Musée Toulouse-Lautrec* 1973, pp. 20f. No. 78 Ill.; Caproni-Sugana 1977, No. 107 Ill.; Dortu-Méric 1979, I, p. 44 No. 139 Ill., p. 51 Ill.; *Cat. Musée Toulouse-Lautrec* (1985), pp. 78f. No. 78 Ill.
EXHIBITIONS: Albi 1951, No. 23; Paris 1958–1959, No. 1; London 1961, No. 10; Munich 1961, No. 19; Cologne 1961–1962, No. 19; Albi-Paris 1964, No. 13; Paris 1975–1976, No. 8; Liège 1978, No. 11; Chicago 1979, p. 20, No. 13, with Nos. 97, 108; Tokyo (etc.) 1982–1983, No. 8.

16 JEANNE 1884

Dortu II, P. 231
Oil on canvas, 69 × 55 cm
Rijksmuseum Kröller-Müller (Cat. No. 1344–57), Otterlo

The year 1884 saw an intensification of Lautrec's desire to apply his pictorial imagination directly to the real life of Paris around him. It became apparent that he could not do this by relying on the Impressionists' experience of nature, although he regarded Pissarro's draughtmanship and Renoir's use of colour as exemplary. He must have realized this, at the very latest, as soon as he became familiar with Edgar Degas's work, which he could have seen at seven of the eight Impressionist Exhibitions. Degas achieved exactly what Lautrec was aiming at: he kept close to people, to the world as it was experienced, with dancers and scenes from the *cafés-chantant*, with milliners depicted exactly as they could be seen every day in the street, and superbly drawn nudes at their toilette.

Degas, however, never went as far as Lautrec's early images of nudes, which present the human figure to the viewer without any shimmering coloured decoration or atmospheric aura (*cf.* No. 15 and the nude, also shown in a wickerwork chair, Dortu II, P. 229). Joyant mentions that the portrait of Jeanne was painted in the studio of either Grenier or Rachou, who were friends and fellow pupils. This painting, which has a balanced, brownish gallery-tone, seems to have stayed in Lautrec's studio. This painting of a nude figure can be recognized, facing the sitter in a meaningful confrontation,[1] on the pile of canvases leaning against the wall in the background of a pastel portrait of the writer Georges-Henri Manuel (Ill. p. 312), painted seven years later.

1 It can also be seen, though less clearly, in the full-length portrait of Georges-Henri Manuel (Dortu III, P. 377).

SOURCES: M. Ackerman, Paris; O. Skaller, Berlin; B. Houthakker, Amsterdam; W. Weinberg, Scarsdale.
BIBLIOGRAPHY: Joyant 1926, p. 260; E. J., 'Toulouse-Lautrec, Jeanne', in: *Museumjournaal*, III, 3 September 1957, p. 64, pp. 66f.; Dortu II, pp. 100f. P. 231 Ill.; Caproni-Sugana 1977, No. 159 Ill.; Dortu-Méric 1979, I, p. 58 No. 189 Ill.; Arnold 1982, p. 97.
EXHIBITIONS: Paris 1903, No. 12; *Le Groupe de XX et son Temps*, Musées Royaux des Beaux-Arts, Brussels 1962, No. 154; Vienna 1966, No. 5; Kyoto-Tokyo 1968–1969, No. 57; Brussels 1973, No. 5; Chicago 1979, No. 20.

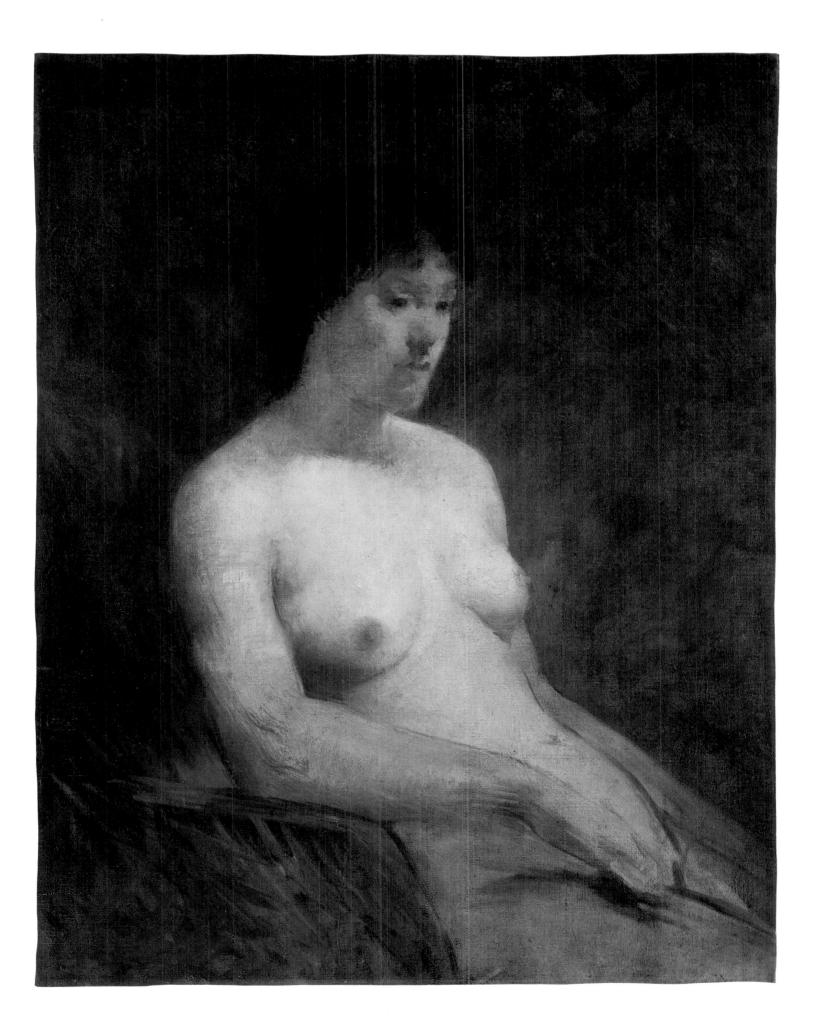

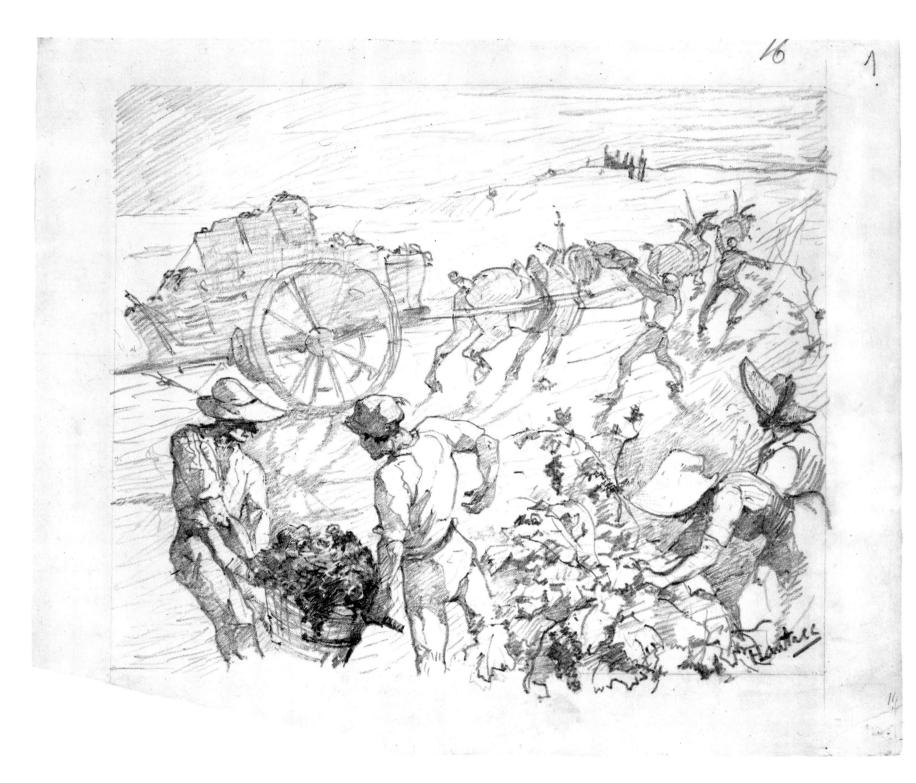

17 THE WINE HARVEST (LES VENDANGES) c. 1885

Dortu V, D. 2925
Pencil, black and blue chalks on Gillot paper, 31 × 37 cm
Signed in black chalk, lower right: 'T–Lautrec'
Den kongelige Kobberstiksamling, Statens Museum for Kunst (Cat. No. HM 1976–413), Copenhagen

This drawing, showing wine harvesters in the foreground and a two-wheeled cart laden with baskets behind, is one of a bundle of six especially made for reproduction in magazines. They were later sold without the artist's knowledge in June 1891 by the magazine *Le Courrier Français*, which had been founded in 1884.[1] Lautrec had let the magazine have the drawings for the purpose of publication (*cf.* No. 18). To achieve the best effect in a small-scale print and to keep costs within reasonable limits, these preparatory drawings intended for mechanical reproduction were restricted to uncomplicated arrangements of surfaces and lines, without much fine modelling of the figures and with little regard for natural effects of light and shade.

Both the BATAILLE DE FLEURS, MAIL-COACH À NICE (No. 18) and this rural WINE HARVEST on the château farm at Céleyran, which had 1500 hectares of vineyards, recall impressions of Lautrec's childhood, before the artist turned his attention entirely to the scenery of the metropolitan life around him. Neither of the illustrations – both of which have cart motifs placed diagonally across the picture space and groups of figures cut off by the lower edge – was published, although the artist had taken trouble to draw them with strong contrasts in a manner suitable for magazine reproduction. This was probably because the *Courrier Français* was interested only in events on Montmartre.

A quick study (Dortu IV, D. 1630) for the picture was dated by Joyant and Dortu to 1880 for reasons that are unclear, while they dated the preparatory drawings for the prints to *c.* 1885–1886, although it is certain that the two closely related works must have been produced at the same time.

1 Joyant 1927, p. 187.
2 *Cf.* the painting Dortu II, P. 98 and the drawings Dortu IV, D. 1631–D. 1633; Dortu V, D. 2926, D. 2992.

SOURCES: *Le Courrier Français* Paris; I. Vente *Dessins Originaux du Courrier Français*, Hôtel Drouot, Paris 1 June 1891, No. 122; Le Garrec, Paris; Herbert Melbye, Copenhagen.
BIBLIOGRAPHY: Joyant 1927 p. 187, p. 258; Dortu V, pp. 476f. D. 2925 Ill.; *Herbert Melbyes Samling*, Den kongelige Kobberstiksamling, Copenhagen 1977, p. 37, p. 44 Ill.
EXHIBITIONS: *Contemporary French Prints and Drawings*, The Whitworth Art Gallery, Manchester 1928, No. 429; Statens Museum for Kunst, Copenhagen 1951; Oslo 1953. No. 2.

18 Battle of Flowers with Coach and Four in Nice (Bataille de Fleurs, Mail-Coach à Nice) *c.* 1885

Dortu V, D. 2844
Charcoal, pen and ink, white body-colour on grey Gillot paper, 32 × 50 cm
Signed in ink, lower right: 'T-Lautrec'
Musée Toulouse-Lautrec, Albi

Datings for this drawing range between 1881 (Cooper) and 1885 (Joyant). The subject matter suggests an early date around 1880; from 1879 to 1881 Lautrec and his mother spent the first weeks of each year in Nice.[1] Among the works produced to commemorate one of these visits was the extremely convincing picture of Count Alphonse seated on the coachman's box, driving four-in-hand (Ill. p. 291), which has an inscription on the lower right: 'Souvenir/de la Promenade des Anglais/Nice 1881'. The motif of a wild coach-ride which occurs frequently around 1880, is taken up again in very similar form in the present drawing.

On balance, however, there is more evidence to support the later date, in the mid-1880s, suggested by Joyant for this pen-and-ink drawing. There are three reasons for accepting it. Firstly, the close stylistic similarity to the illustration sketch Le Quadrille de la Chaise Louis XIII (Ill. p. 300), which is in the style of Henri Rivière and was no doubt done in 1885–1886; both works are identical in technique and are drawn on sheets of Gillot paper of identical size. Secondly, Lautrec only used this sort of paper, which was specially made for reproduction, from the middle of the decade, after he had got to know Jules Roques, editor of *Le Courrier Français* and was invited by him to provide preliminary drawings for publication (see No. 17). Lastly, the signature that appears in the lower right of the sheet is not found in this form before the mid-1880s.

In short, one can assume that this large-scale carriage procession with its unusually large number of figures was sketched around 1885, and clearly refers back to the motif of the four-in-hand of four years earlier (Ill. p. 291). Here the artist has turned it into a flower coach and combined it with a coulisse-like group of spectators, which is cut off by the lower edge of the picture – a feature that anticipates later compositions.

Lautrec was at this time very concerned to make a name for himself and he welcomed any publication that could give his works a wide circulation. The style and technique of this drawing suggest that we can assume it was intended as a magazine illustration, though it was never published. Apparently a similar project had already come to grief in 1884 because of the artist's scruples. He told his mother about it in a letter from Paris on 15 August: 'If I haven't written to you sooner it's because I've been snowed under by work. I've worked as much as I could on my drawing for *Le Figaro [Illustré]* but, as Rachou [his friend and mentor] is not satisfied with it, I haven't sent it off. He pointed out to me that only the very best one can do should be submitted to the public. Well, my drawing really could have been better. . . . Since I'd had my nose to the grindstone right up to the deadline I went to work at night at the Bar. After all. . . . I kiss you . . . Shall swallow a quick Mass and then reclimb the heights, where my model is waiting for me.'[2] Two letters of 1886 also mention magazine illustration: 'My model is threatening to leave me. What a rotten business painting is. If she doesn't respond to my ultimatum the only thing I can do is bang out a few illustrations' And shortly afterwards: 'I'm going to do some sketches for the *Courrier Français*.'[3]

In the years before 1897 Lautrec did 83 drawings and drawn copies of paintings for magazines (*cf.* Nos. 20, 22, 27, 28, 34, 77, 79, 85, 86, 89, 95). This area of graphic reproduction, with its simplified lines intended exclusively for mechanical printing processes, was kept separate from his lithographic work which began in 1891. He used it primarily for publicity purposes. His illustrations did not produce the response he had hoped for, and this was because most readers of magazines preferred the trivial, sometimes satirically frivolous

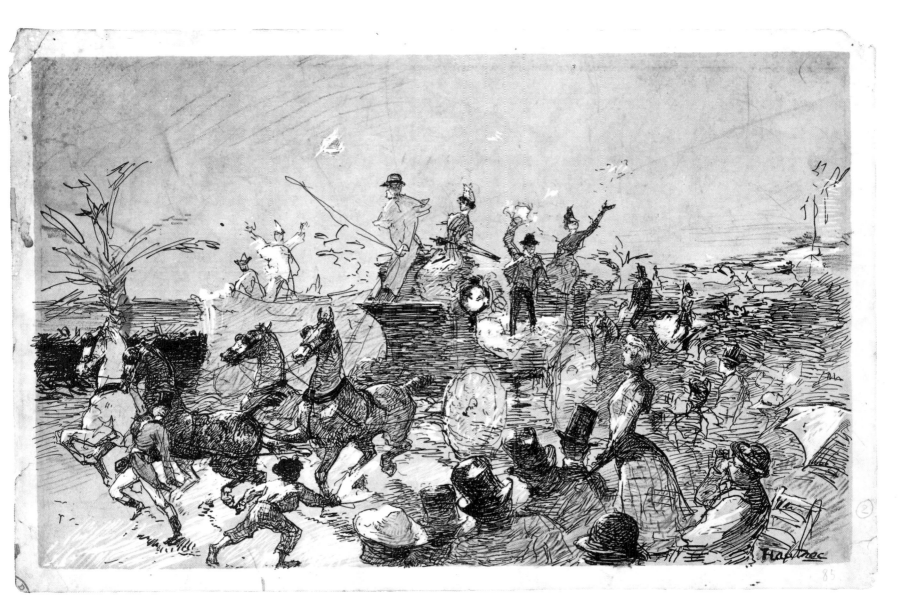

outpourings of illustrators like Willette, Félicien Rops, Louis Legrand, Steinlen, Forain, Henry Somm, Raffaëlli and Henri Gabriel Ibels.

1 His detailed reports from the holiday resort are quoted in Joyant 1926, pp. 42 ff., and Goldschmidt-Schimmel 1969, pp. 58 ff [251 ff.].
2 *Ibid.*, p. 81 [259].
3 *Ibid.*, pp. 98 f. [264].

SOURCES: Comtesse Adèle Zoë de Toulouse-Lautrec, Toulouse.
BIBLIOGRAPHY: Joyant 1927, p. 186; Julien 1942, p. 30 Ill.; Cooper 1955, p. 16 Ill.; Dortu-Grillaert-Adhémar 1955, p. 37; Dortu V, pp. 464 f. D. 2844 Ill.; *Cat. Musée Toulouse-Lautrec* 1973, pp. 108 f. No. D. 25; Devoisins 1980, p. 33 Ill.; Henze 1982, pp. 20 f. Ill., p. 28; *Cat. Musée Toulouse-Lautrec* (1985), pp. 179 f. No. D. 31.
EXHIBITIONS: Amsterdam 1947, No. 64; Brussels 1947, No. 64; Nice 1957, No. 32; London 1961, No. 73; Munich 1961, No. 97; Cologne 1961–1962, No. 97.

19 ELYSÉE MONTMARTRE 1885

Dortu V, D. 2843
Charcoal, black and white chalk on blue-grey paper, 47.9 × 62.6 cm
Musée Toulouse-Lautrec, Albi

In pictures like this in the mid-1880s Lautrec discovered his own special area of subject matter: people in the music-halls and dance-halls on Montmartre, in the cabarets, bars, brothels and theatres.[1] It was Degas above all who pointed the way for Lautrec's interest in the Parisian world he experienced directly around him, and it had also been depicted by Daumier, Constantin Guys, Manet and Forain. Degas's formal and thematic studies were closest to Lautrec's own conception of reality. The years 1884 and 1885 were for him a time of transformation and new beginning; not only was he seeking a suitable way of life for himself in his circle of studio friends, but he was also looking for the most apt and succinct formula for the depiction of this world. Important guidelines for this were provided by Degas with his images of cafés, divas of the theatre and the *cafés-concert*, dancers, milliners, laundresses and brothel scenes.

According to Joyant, the present drawing, with its cubically simplified figures composed of lines and hatching, shows a scene in the Elysée Montmartre at 80 Boulevard Rochechouart, one of the enormous dance-halls that Lautrec frequented. It is a chance view, presumably sketched on the spot, in which some of the figures are rigorously truncated. The large seated figure in front with his back to the viewer and the groups of figures in the middle and background intersect each other abruptly.

1 His mother was also informed about this, for example in a letter written in the summer of 1886: 'I've been having a very good time lately here at the Chat Noir [a cabaret]. We organized an orchestra and got the people dancing. It was great fun, only we didn't get to bed until five in the morning, which made my work suffer a little the next day.' In the autumn he wrote: 'I have an appointment with Roques [editor of the magazine *Le Courrier Français* which Lautrec worked for] and have nearly got an entrée to the Eden [a *café-concert*]' (Goldschmidt-Schimmel 1969, pp. 101 f. [264 f.]).

SOURCES: Comtesse Adèle Zoë de Toulouse-Lautrec, Toulouse.
BIBLIOGRAPHY: Joyant 1927, p. 186; Dortu V, pp. 464 f. D. 2843 Ill.; *Cat. Musée Toulouse-Lautrec* 1973, p. 116 No. D. 55; *Cat. Musée Toulouse-Lautrec* (1985), p. 189 No. D. 67.
EXHIBITIONS: Tokyo (etc.) 1982–1983, No. 59.

20 GIN COCKTAIL 1886

Dortu V, D. 2964
Charcoal and white chalk on blue-grey paper, 47.5 × 62 cm
Red monogram stamp (Lugt 1338), lower left;
dated and inscribed in an unknown hand, lower right
Musée Toulouse-Lautrec, Albi

This is a study for a preparatory drawing, executed in ink and intended for reproduction, which appeared as Lautrec's first published work on 26 September 1886 in the magazine *Le Courrier Français* (Ill. p. 299). Clearly, a bar scene such as this met the expectations of the magazine's editorial staff who were much more interested in the goings-on at Montmartre than in such illustrations as the BATTLE OF FLOWERS IN NICE (No. 18) or the WINE HARVEST at Céleyran (No. 17), which the artist had also drawn for reproduction.

The drawing shows an environment to which the young artist felt himself increasingly drawn. A top-hatted gentleman, whose image is reflected in a tall wall mirror on the left, has seated himself at the bar to be served by two barmaids.[1] In the final version for publication the emphasis is on illustrative detail, but in this study Lautrec has succeeded brilliantly in evoking the atmosphere of this type of milieu, which in later years was to inspire a number of drawings and paintings (*cf.* Nos. 106, 107). The place is not given a name; the characters are impersonal. The alienation peculiar to such places is expressed by a certain angularity and hardness in the handling of the forms.

1 *Cf.* the bar scene Dortu V, D. 2982 and the charcoal drawing Dortu VI, S. D. 14, although admittedly, the attribution to Lautrec seems questionable.

SOURCES: Comtesse Adèle Zoë de Toulouse-Lautrec, Toulouse.
BIBLIOGRAPHY: Joyant 1927, p. 188; Mack 1938, p. 292; *Toulouse-Lautrec* 1951, Ill.; Cooper 1955, p. 40 Ill.; Julien (1959), p. 15 Ill., p. 29; Focillon 1959, No. 46 Ill.; Bouret 1963, p. 33; Cionini-Visani 1968, Ill. 9; Fermigier 1969, p. 42 Ill.; Dortu V, pp. 482f. D. 2964 Ill.; Polasek 1972, p. 25, No. 16 Ill.; Josifovna 1972, Ill. 46; *Cat. Musée Toulouse-Lautrec* 1973, p. 117 No. D. 60, p. 119 Ill.; *Cat. Musée Toulouse-Lautrec* (1985), p. 191 No. D. 72.
EXHIBITIONS: New York (etc.) 1950–1951, No. 32; Paris 1951, No. 89; Albi 1951, No. 145; Marseilles 1954, No. 22; Philadelphia-Chicago 1955–1956, No. 81; Paris 1975–1976, No. 49; Liège 1978, No. 43; Tokyo (etc.) 1982–1983, No. 65.

21 Emile Bernard 1886

Dortu II, P. 258
Oil on canvas, 54 × 44.5 cm
The Trustees of the Tate Gallery (Cat. No. T.465), London

Lautrec had met Emile Bernard (1868–1941) in 1885 when he was a fellow pupil at Cormon's studio. Until he left in the summer of 1886 to visit Gauguin at Pont-Aven in Brittany, Bernard played a stimulating role at the studio as an intermediary. At that time he was still an enthusiastic supporter of the Impressionists and it was through him that his friends Anquetin and Lautrec became acquainted with the works of Cézanne, which were occasionally exhibited at the premises of the paint dealer Tanguy in the Rue Clauzel. By the 1880s the Provençal painter had been almost forgotten in Paris and he was regarded by the young men as their own secret; the seventeen-year-old Bernard never tired of holding forth on the subject of the revolutionary power of Cézanne's painting. Cézanne himself did not have a very high opinion of his admirer's many-sided ambitions, as is shown by various passages from letters written in the years 1904–1906, where he told Bernard in no uncertain terms that 'gossiping about art is almost pointless', that one should not be 'right in theory' but 'in the view of nature'; the advice he gave the 'distinguished aesthete' was: 'Don't be an art critic, paint!', and he mockingly called him a 'rationalist temperament' with whom one could 'develop theories into infinity'.[1]

Nor could Bernard's receptivity to all new artistic ideas make much impression on Lautrec – but it did influence Vincent van Gogh, who arrived in Paris from Antwerp in February 1886 and was also received into Cormon's class. Van Gogh quickly became a friend of Bernard and proved to be a much more suitable partner for discussions than Lautrec, who loathed all 'conversations about art'. Lautrec's dialogue with his fellow student took place only on the canvas. There he attempted to do justice to the young man with his thick fair hair, his sparse attempt at a beard and pale complexion. He set the head and upper part of the body, painted in browns of varying tone, against the thin and feathery painting of the matt blue background. The face is distinguished by short, narrow brushstrokes, precisely following its curves, while the brushwork elsewhere remains relatively broad and summary. A few accents of red strengthen the subtly muted colouring. The impressiveness of this bust portrait, composed according to principles that had been accepted since the Early Renaissance, derives from its simple, unpretentious beauty. The painter took great care over its execution; the sitter had to submit to numerous sittings before this harmonious accord between the figure and the blue background was eventually achieved.

When in his memoirs Bernard wrote about his time as a student and his rebellion against the old traditional training methods, he also mentioned his relationship with Lautrec and Van Gogh: 'I began to form my own opinions about art and to express them in the studio. I said that what we were taught there was based on nothing, that the old masters knew more, that the Impressionists had brought us the doctrine of colour, that their work was full of truth, observation and feeling and that we should all seek to develop a personal style through theoretical study and contact with nature. I put up with the coarseness that prevailed in the studio, where almost all you heard were obscenities, where every joke was an insult. Lautrec did my portrait. He needed twenty sittings [elsewhere he speaks of thirty-three sittings], because he could not manage to harmonize the background and the face. So I frequently visited him at his studio in the Rue Tourlaque, which was a meeting place for night owls and vagabonds. There I saw La Goulue and Aristide Bruant.... Van Gogh worked without a break, in the mornings from the nude model with the others, and in the afternoons from classical gods, alone in the empty studio where there was nobody apart from him, Toulouse-Lautrec, Anquetin and myself.'[2]

60

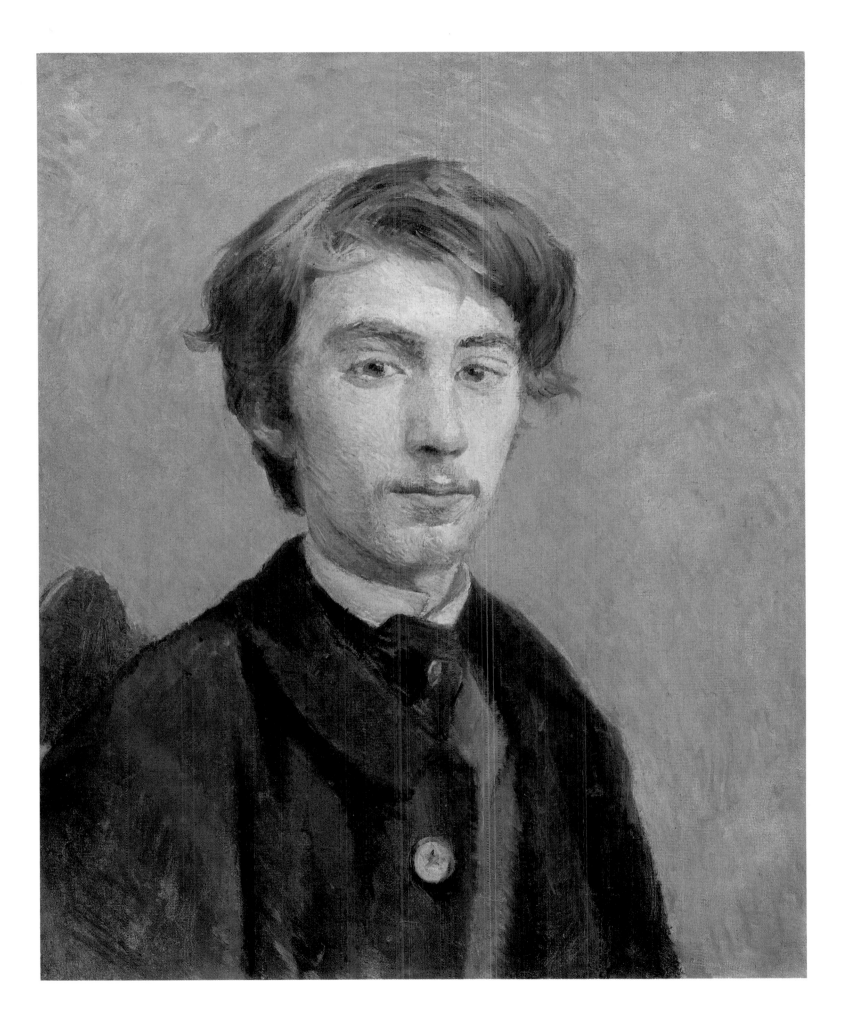

A hitherto unnoticed remark in this passage sheds light on the dating of the portrait: Bernard says that he visited the studio in the Rue Tourlaque to sit for his friend. If Bernard's memoirs are to be believed, the date of the painting cannot be 1885, as has been accepted up to now, but 1886. It was only in the course of that year, probably in the autumn when Cormon temporarily closed down his studio, that Lautrec rented a studio of his own on the top floor of 27 Rue Caulaincourt (at the corner of 7 Rue Tourlaque) on Montmartre, which he was to use until 1897. Hence, the portrait could not have been painted before the autumn of 1886 when Bernard returned to Paris from Pont-Aven after his meeting with Gauguin.

1 John Rewald, *Paul Cézanne – Letters*, London, 1941, pp. 233ff., 242f., 249ff., 265f.
2 Bernard 1952, pp. 13ff.

SOURCES: Ambroise Vollard, Paris; Robert de Galéa, Paris; Lefevre, London; Arthur Jeffress, London.
BIBLIOGRAPHY: Douglas Lord, *Vincent van Gogh, Lettres à Emile Bernard*, New York 1938, p. 12 Ill. 2; Bernard 1952, pp. 13f. Ill.; Jourdain-Adhémar 1952, p. 26, No. 9 Ill., p. 88, p. 110; Gauzi 1954, p. 27; Cooper 1955, pp. 64f. Ill.; Perruchot 1958, pp. 32–33 Ill., pp. 129f.; Rewald 1967, p. 23, p. 62 Ill. 7; Fermigier 1969, p. 36 Ill.; Dortu II, pp. 112f. P. 258 Ill.; Josifovna 1972, Ill. 9; Polasek 1972, p. 27; Adriani 1976, p. 22; Caproni-Sugana 1977, No. 180 Ill.; Adriani 1978, pp. 44f. Ill. 5; Dortu-Méric 1979, I, p. 64 No. 211 Ill.; Chicago 1979, with No. 107; Alley 1981, pp. 726f. Ill.; Arnold 1982, pp. 26f. Ill.; Lucie-Smith 1983, p. 7, No. 2 Ill.; New York 1985, p. 53.
EXHIBITIONS: Paris 1931, No. 41; London 1951, No. 34; London 1961, No. 15; Albi-Paris 1964, No. 16; Kyoto-Tokyo 1968–1969, No. 58.

22 ELYSÉE MONTMARTRE, QUADRILLE 1886

Dortu V, D. 2974
Black chalk on tracing paper, 45 × 57 cm
Red monogram stamp (Lugt 1338), lower left
Musée Toulouse-Lautrec, Albi

The purpose of this tracing, stamped with the red monogram, cannot be explained with any certainty. In 1886 Lautrec painted the grisaille QUADRILLE DE LA CHAISE LOUIS XIII À L'ELYSÉE MONTMARTRE (Dortu II, P. 261; see Ill. p. 301). The outlines of the main figures were transferred to the paper from the painting, which is the same size as the drawing. It cannot therefore be a figure study for the composition of the painting as Dortu assumed, but a copy whose function was to reduce the many-figured scene to its most striking participants.

This method of working is not unique in Lautrec's work. In earlier years, even at Cormon's studio, he had made tracings from paintings and drawings.[1] In the years between 1885 and 1888 examples of this procedure increase in number, and it is noticeable that only the outlines of the figures seemed to be of interest to the artist.[2] Presumably he used the tracings – as, incidentally, Degas also did in many instances – to experiment or to repeat the same subject using a different technique more suitable for the purposes of reproduction. The grisaille mentioned above was reproduced by photo-mechanical means in the magazine *Le Mirliton* of 29 December 1886 (Ill. p. 301). It is possible that the magazine originally considered using a drawing copied by Lautrec from his painting for reproduction in the magazine, and he could have made the tracing for this. He was later to make similar copies from some of his pictures that were already well known in Montmartre circles, for publication in the magazine *Le Courrier Français* (see No. 34).[3]

The subject matter is easier to explain than the purpose of the drawing. There is a story behind the unusual title which refers to a quadrille performed in the Elysée Montmartre. In the summer of 1885 Rodolphe Salis, the founder of the *cabaret artistique*, Le Chat Noir, which was situated next door to the Elysée Montmartre at 84 Boulevard Rochechouart, decided to leave his old established quarters, a former post office, and move to the Rue de Laval. This removal was organized as a festival procession through the streets of Montmartre. Apparently, however, a baroque chair in Louis XIII style was left behind. The new tenant, Aristide Bruant, who turned Le Chat Noir into his own legendary cabaret, Le Mirliton, refused to hand over this relic to Salis. When Salis insisted, Bruant ridiculed him about the piece of furniture in a comic *chanson* that quickly became popular: 'Ah! Mesdames qu'on est à l'aise/quand on est assise sur la chaise Louis XIII.'

In the neighbouring Elysée Montmartre this incident was alluded to in a wild quadrille (Ill. pp. 300f.). The main protagonists in the famous dance are recognizable as La Goulue (1870–1929), on the left of the drawing, and Grille d'Egoût.[4] Turning away from the scene, as if struck by the senselessness of his task, is old Commissar Coutelat du Roché, known as Le Père la Pudeur, whose task it was to act as guardian of morals in the various Montmartre establishments, while two of Lautrec's friends and fellow pupils, François Gauzi (1861–1933) and Louis Anquetin (1861–1932) are shown as spectators. Aristide Bruant (1851–1925), wearing a floppy, broad-brimmed hat, his hands buried deep in his pockets, watches the boisterous activity. Bruant was incidentally the first to appreciate the artistic ability of the 'petit marquis' and did what he could to make him better known. He hung up the QUADRILLE DE LA CHAISE LOUIS XIII grisaille in the Mirliton, as well as publishing that early and characteristic work as a double-page spread in his magazine (Ill. p. 301).[5]

1 Dortu II, P. 197 after Dortu V, D. 2514; P. 198 after D. 2547; P. 199 after D. 2583; P. 200 after D. 2452; P. 254 after D. 2891; Dortu V, D. 2644 after Dortu II, P. 149; Dortu V, D. 2652 after Dortu IV, D. 1637; Dortu V, D. 2770 after Dortu II, P. 74. In the case of these last two examples neither Joyant nor Dortu recognized the relationship between the original pictures and their tracings; indeed, there is a difference of two or three years between the rather arbitrary dates given for each of the works.
2 Dortu V, D. 2898 after D. 2899; D. 2960 after Dortu II, P. 283; Dortu V, D. 2969 after D. 2970; D. 3002 after D. 3003; D. 3012 and Dortu II, P. 290 after Dortu V, D. 3011; Dortu II, P. 268, P. 270–P. 272 after P. 269; P. 292 after P. 301; P. 293 after Dortu V, D. 3044; Dortu II, P. 294 after Dortu V, D. 3030. Not until 1893 do any further tracings from paintings occur: Dortu II, P. 476 after P. 475; Dortu V, D. 3336 after Dortu II, P. 463; Dortu V, D. 2971 after P. 490 (in this last instance Joyant and Dortu assigned the not very plausible date of 1893 to the painting and dated the tracing 1886!) Finally, various tracings were made in 1896 after lithographs in the ELLES series: Dortu VI, D. 4268, D. 4280 and others.
3 Dortu V, D. 3089 after Dortu II, P. 307; D. 3090 after P. 305; D. 3091 after P. 335.
4 *Cf.* the studies of dancers Dortu V, D. 2977, D. 3018, D. 3019, D. 3021.
5 Also depicting the lively performance at the Elysée Montmartre is a sheet of studies which Lautrec had drawn very much in the style of the popular illustrator Henri Rivière (Ill. p. 300). In addition, there is a drawing (not listed by Dortu) which to a large extent follows the composition of the painting, in the collection of the National-Galerie, East Berlin (Ill. p. 301). It is in charcoal, measures 47.2 × 61.8 cm, and is signed and dated in a clumsy script in the lower right: 'Lautrec 86'. As well as his friends Gauzi and Anquetin, on the right, a full-length self-portrait – unusually prominent for Lautrec – has been added. Apart from a certain weakness in the arrangement of the figures, and the modelling of their bodies by means of arbitrary hatching, the presence of the self-portrait and the large signature seem to point rather too obviously to Lautrec's authorship, giving rise to doubts about the authenticity of the drawing. (Six little ink sketches attributed to Lautrec, also in the National-Galerie, East Berlin, may also be forgeries.)

SOURCES: Comtesse Adèle Zoë de Toulouse-Lautrec, Toulouse.
BIBLIOGRAPHY: Joyant 1927, p. 189; Delaroche 1948, pp. 10f.; *Toulouse-Lautrec* 1951, Ill.; Focillon 1959, No. 30 Ill.; Longstreet 1966, Ill.; Keller 1968, p. 6 Ill.; Dortu V, pp. 484f. D. 2974 Ill.; Dortu II, p. 112 with P. 261; *Cat. Musée Toulouse-Lautrec* 1973, p. 111 Ill., p. 117 No. D. 59; *Cat. Musée Toulouse-Lautrec* (1985), pp. 190f. No. D. 71.

23 At the Moulin de la Galette, la Goulue [the Glutton] and Valentin the Double-jointed (Au Moulin de la Galette, la Goulue et Valentin le Désossé) 1887

Dortu II, P. 282
Oil on cardboard, 52 × 39.2 cm
Red monogram stamp (Lugt 1338), lower left
Musée Toulouse-Lautrec, Albi

Here, La Goulue and Valentin le Désossé (*cf.* No. 47), two of the leading protagonists in the world of Lautrec's images, make their first appearance together. The latter had been one of the main attractions in the dance-halls of Montmartre since the 1860s. By day he was the respectable Etienne Renaudin (1843–1907), earning his living as a wine merchant and lessee of a bar in the Rue Coquillière. He had a genius for improvisation; a moper with a serious, immobile face, half-closed eyes and a top hat that never fell off, he would perform the quadrille all evening for his own amusement. Because of his gaunt figure, unusually long arms and spindly legs, combined with a remarkable suppleness, he became famous as Valentin the Contortionist. His protégée Louise Weber, called La Goulue, was a laundress who had come to Paris from Alsace and from 1886 had a short-lived triumph as a dancer, first at the Médrano, then at the Moulin de la Galette, the Elysée Montmartre, the Jardin de Paris and finally at the Moulin Rouge, where her performances towards the end of her comet-like career were unprecedented in their vivacious perfection.[1]

According to Joyant, the two dancers are shown in the Moulin de la Galette, one of the last of the once numerous windmills on the hill of Montmartre. The dance-hall with its garden was run by Père Debray. It had been in existence since 1830 at the top end of the Rue Lepic, where it still survives in its grounds today. In the 1870s it was particularly popular with artists. It was there that Renoir painted his famous Le Moulin de la Galette in 1876, a major example of the Impressionists' view of humanity. In this work everything is happening in the open air; people dance or converse under trees, in the shimmering sunlight. Lautrec, on the other hand, places his dance in an interior, on floorboards which almost seem to shake under the rhythmic force of the dance steps.

As in a grisaille, the colours are restricted to unbroken black and white with a few shades of grey. The artist experimented several times with this technique, presumably because it suited his gifts as a draughtsman and enabled him to reproduce in a particular way the spot-lighted chiaroscuro and stuffy atmosphere of the enormous dance-halls. Apart from an early study of a head dating from 1882, a total of six grisailles have survived, painted between 1886 and 1888.[2] They all depict interior rooms with many figures, and the theme of five of them is dancing. All are composed according to the same scheme with the main protagonists set off against a dark group of figures in the background.

The stylistic and technical features of the present sketch – for which there exists a pendant in colour (Dortu II, P. 281) – show that Lautrec had achieved that succinct means of representation, unassuming in its materials and style, which he was to retain with minor modifications until his late period. It is characterized firstly by being painted on cardboard, a light-weight card with a high wood content (which over the years has usually become foxed) and with a pale brown colour that in many cases has darkened somewhat. At first he used cardboard only occasionally, then increasingly from the mid-1880s onwards; after 1890 – except for a few large figure compositions on canvas – it became almost his only material. Only in his last works did Lautrec return more frequently to canvas and wood panels.

The years 1886–1887 also saw the beginning of the development of a graphic sketching technique in his painting, using short energetic brushstrokes and combinations of strokes,

held within a definite linear framework. In this particular instance it is especially fascinating to observe how elaborated details, such as the face of the woman, relate to the dark area of the sketchily painted audience in the background, and how the harsh white wave of her skirts with the grey shadow below and the independent play of the undergarments are inserted between areas of black, thus accentuating La Goulue's dress and stockings. In the Futurists' pictures movement all too often coagulated in laborious, abstracted mobility; here, however, is an infectious movement drawn entirely from observation. The woman dances with a lively twist of the body, only her toes touching the steeply rising floorboards, while the nimble figure of Valentin, who is almost a jumping-jack caricature, is expressed merely by means of swiftly executed zig-zag lines.

Following Degas's example Lautrec usually thinned down his oil paints with turpentine so that he could handle them more easily and fluidly. He also left the cardboard in its original state – it was not primed or prepared in any way – so that the paint could penetrate deep into the card and create the characteristic, pastel-like matt surface texture.

Lastly, this is an early example of experimentation with an unusual spatial arrangement, which was to become particularly important in the graphic works of the 1890s. Inspired by Degas, who of all the Impressionists was the most interested in the sense of space of Japanese woodcut makers, Lautrec endeavoured to integrate Degas's bold foreshortenings into his own stylistic aims and bind his compositions even more closely to the picture surface than Degas's. It must be emphasized that the restricted space thus indicated no longer existed for its own sake; it was entirely subordinate to the subject of the picture. The stability which Degas had continued to give his figures was no longer possible on such steeply sloping surfaces, which appear as if seen through a distorting mirror. A space in which equilibrium has been lost in this way can no longer be entered, because an important feature of the composition are the diagonals which cause the foreground and distance to meet abruptly.

In 1895 the same subject, in a slightly altered form, was re-used for part of the nine square metres of decoration on La Goulue's booth at the Trône fair (Ill. p. 317), which is an indication of the status of this early – and in many respects exemplary – work.[3] In it Lautrec achieved the style which Matisse described in a conversation in 1952: 'You see, one must break with convention, with the conformist routine. One day Toulouse-Lautrec cried, "At last I don't know how to draw." That meant he had found his true line, his true drawing, his own draughtsman's language. That also meant that he had abandoned the means used to learn to draw.'[4]

1 The magazine *La Vie Moderne* of 23 January 1886, p. 51, commented that La Goulue was more popular than the President of the Republic.
2 Dortu II, P. 175, P. 261 (Ill. p. 301), P. 282 (No. 23), P. 286 (No. 24), P. 301, P. 311, P. 321.
3 The only surviving figure study is a small pen drawing of La Goulue (Dortu V, D. 3476), which Dortu dated *c*. 1893, though it was no doubt sketched as a preparatory study for the grisaille painted six years earlier.
4 Henri Matisse, *Matisse on Art* (ed. J. D. Flam), London, 1973, p. 145.

SOURCES: Comtesse Adèle Zoë de Toulouse-Lautrec, Toulouse.
BIBLIOGRAPHY: Joyant 1926, p. 81 Ill., p. 262; Jedlicka 1929, p. 63 Ill.; Joyant 1930, Ill. 5; *Arts et Métiers Graphiques*, 57, 15 March 1937, p. 10 Ill.; Mack 1938, p. 122; Landolt 1954, p. 23, p. 25, No. 2 Ill., with Nos 5, 13: *Toulouse-Lautrec* 1962, p. 81 Ill.; Huisman-Dortu 1964, p. 70 Ill.; Zinserling 1964, p. 34, Ill. 36; Cionini-Visani 1968, Ill. 56; Fermigier 1969, p. 81 Ill.; Zenzoku 1970, Ill. 2; Devoisins 1970, p. 50; Dortu II, pp. 126f. P. 282 Ill.; *Cat. Musée Toulouse-Lautrec* 1973, pp. 31 ff. No. 122 Ill.; Muller 1975, Ill. 16; Adriani 1976, p. 26 Ill.; Caproni-Sugana 1977, No. 191 Ill.; Chicago 1979, with No. 25; Dortu-Méric 1979, I, p. 70 No. 230 Ill.; *Cat. Musée Toulouse-Lautrec* (1985), p. 99 Ill., p. 101 No. 123.
EXHIBITIONS: Paris 1914, No. 186; New York (etc.) 1950–1951, No. 5; Paris 1951, No. 15, with Nos. 32, 33, 60; Albi 1951, No. 39; Marseilles 1954, No. 5; Philadelphia-Chicago 1955–1956, No. 13; Nice 1957, No. 10; Dallas 1957; Paris 1958–1959, No. 5; Paris 1960–1961, No. 704; London 1961, No. 18; Munich 1961, No. 35; Cologne 1961–1962, No. 35; Kyoto-Tokyo 1968–1969, No. 10; Paris 1976; Tokyo (etc.) 1982–1983, No. 20.

24 At the Ball at the Elysée Montmartre (Au Bal de l'Elysée Montmartre) 1887

Dortu II, P. 286
Oil on paper (transferred to canvas), 81 × 65 cm
Red monogram stamp (Lugt 1338), lower left
Musée Toulouse-Lautrec, Albi

There are a number of sketches and paintings for the years 1886–1888 which have a texture more like drawing than painting. Only the most essential features are outlined so that the hastiness of the ductus leaves much of the definition of form unclear (*cf.* No. 23). The emphasis is not so much on the problem of spatial relationships as on a temporal element expressed through the nervous movement and strong contrasts in the density of the figures.[1] In the apparent arbitrariness of the choice of view and the immediacy with which Lautrec captured the scene, the momentary event becomes the expression of a spiritual state. The effortlessness of the visual language, a formal shorthand with vehement strokes and powerful hatching, is made possible by the artist's ability never to lose sight of the simple legibility of his objects.

It now became increasingly common for the artist to note down the crush in the dance-halls, the pounding or rocking rhythm of the couples, and the isolated spectators, for whose consolation a bottle has pointedly been provided.

1 See Dortu II, P. 260–P. 263, P. 281 – P. 286 (Nos. 23, 24), P. 298 (No. 28) – P. 301, P. 310 – P. 312, P. 314 – P. 316.

SOURCES: Comtesse Adèle Zoë de Toulouse-Lautrec, Toulouse.
BIBLIOGRAPHY: Joyant 1926, p. 262; Cabanne 1959, p. 17 Ill.; Paret 1969, p. 38; Fermigier 1969, p. 38 Ill.; Dortu II, pp. 128f. P. 286 Ill.; *Cat. Musée Toulouse-Lautrec* 1973, pp. 32f. No. 123 Ill.; Caproni-Sugana 1977, No. 193 Ill.; Dortu-Méric 1979, I, p. 72 No. 233 Ill.; *Cat. Musée Toulouse-Lautrec* (1985), pp. 101f. No. 124.
EXHIBITIONS: Paris 1914, No. 126; Albi 1951, No. 40; Dallas 1957; Paris 1958–1959, No. 6; London 1961, No. 17; Munich 1961, No. 36; Cologne 1961–1962, No. 36.

25 Comtesse A. de Toulouse-Lautrec in the Salon of the Château de Malromé
(La Comtesse A. de Toulouse-Lautrec dans le Salon du Château de Malromé) 1887

Dortu II, P. 277
Oil on canvas, 55 × 46 cm
Signed in blue paint (anagram), lower left; 'HTreclau'
Musée Toulouse-Lautrec, Albi

In the preceding dance scenes Lautrec used swift brushstrokes to distil an essential chance moment from what he observed; nevertheless, his most important work continued to be portraits which were precisely worked in the course of lengthy sittings. The dance scenes are dominated by fleeting gestures, the noisy ambience, the drumming of the dance steps hammering on the floor; but in this portrait of his mother the artist emphasizes her concentrated gaze and the quiet nobility of her appearance. It is clear that he was just as capable of creating the openness of the sketches as the complex structures of enclosed compositions; he could paint the grey-on-grey of the grisailles as well as finely tuned colouring. He developed two possible extremes: on the one hand capturing the passing moment, and on the other wishing to give definite form to more lasting themes.

Two works (No. 13; Dortu II, P. 190) show the development of Lautrec's portrait style, which reaches a highpoint in this latest depiction of the artist's mother. The strict profile view, often used by the Italian masters of the Early Renaissance, is transferred to a contemporary context.[1] Everything in this painting is redolent of unobtrusive dignity, and the lowered gaze of the reader suggests a hint of resignation. Seated in an armchair, she turns to the left, towards the viewer, without giving any sense of intimacy, still less of confidentiality. The large-patterned curtains are open to reveal a window at the back of the room, through the panes of which the green of the garden shimmers and the bright sunlight falls on the coloured floor. The muted colours of the interior are in close accord with the matronly figure in her dark blue dress. The room has a fireplace with a sociable in front of it, a round table and the obligatory Louis XVI chair. It is the salon of the Château de Malromé, an estate near Bordeaux which the Countess had acquired in May 1883 as a refuge for herself and her son.

Lautrec's painting technique was now increasingly gaining its own personal character. In various places the coloured surface is created by small brushstrokes. His sensitivity to the expressive powers of colour may have been intensified by discussions about the divisionist discoveries of the Neo-Impressionists – though it is very different from the one-sided methodological approach advocated by Seurat and Signac. A cool blue-and-green colouring, based on Pissarro and Monet, predominates, in keeping with the restrained dignity of the sitter. Only the face, set against the deep red of the furnishings, radiates warmth.

Here, translated into paint is the unspoken dialogue between the son and his mother, whose affection for him, in spite of his later perils, was always based more on love than understanding. His life as an artist and its significance were to remain beyond her scope. One has the impression that the artist used her reticent posture as a measure in structuring his composition. Working from the perpendicular axis of her body, slightly to the left of the centre of the picture, he has created a tight pictorial structure from various horizontal accents. The richness of loosely painted forms in the sunny room directs the gaze all the more forcefully to the tightly composed formal relationships of the figure in the foreground.

The portrait was painted in the summer of 1887 and is signed in the lower left-hand corner with the anagram 'HTreclau'. This coded version of his surname appears several times, particularly on drawings intended for publication (cf. No. 30).[2] Lautrec used it between 1885

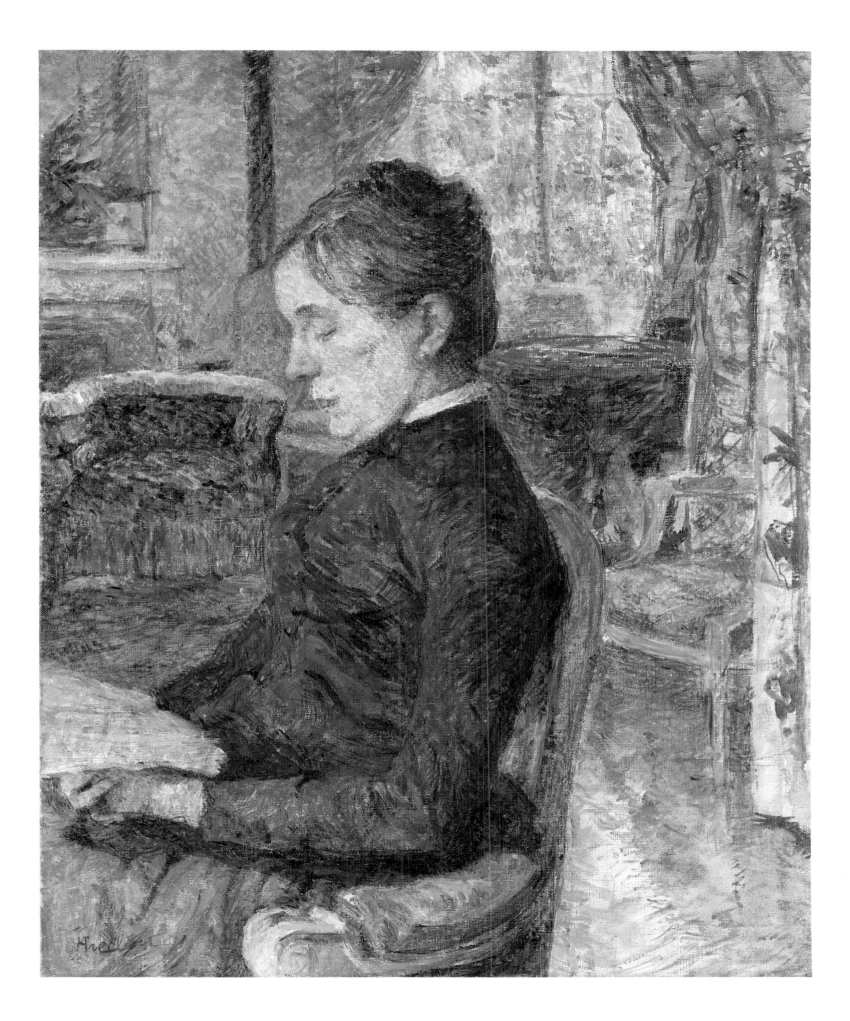

and 1888 at the request of his father, who regarded his heir's activities in Montmartre with mixed feelings and feared that the family honour might be tarnished by them.

The artist was apparently pleased with the result of his labours, since he chose the PORTRAIT DE MME A. DE TL, together with ten other works (see No. 26), for his first official participation in an exhibition, at the Salon des XX in Brussels in February 1888.[3] It is fourth on the list in his draft for his contribution to the catalogue (Dortu V, D. 3034).[4]

1 Joyant 1926, p. 172, mentions the admiration that Lautrec and others felt for the almost heraldic simplicity of the compositional structure of a portrait of a lady, formerly attributed to Piero della Francesca, but now given to Baldovinetti, in the National Gallery, London (Cat. No. 758).
2 *Cf.* Dortu II, P. 260, P. 297, P. 321; Dortu V, D. 2842, D. 2897, D. 2899, D. 3004. A letter from Lautrec to his uncle of 15 May 1887 (Joyant 1926, p. 106) mentions among other things that he had exhibited a painting in Toulouse under the 'finally adopted name of Tréclau'.
3 Previously Lautrec's pictures were only to be seen in Aristide Bruant's cabaret Le Mirliton; besides, reference is made in the letter cited above to a painting also being exhibited in Toulouse in 1887.
4 The list also includes the following paintings: Dortu II, P. 279 (5), P. 295 (6), P. 317 (7), P. 289 (8), P. 348 (9), P. 315 (10), P. 312 (11).

SOURCES: Comtesse Adèle Zoë de Toulouse-Lautrec, Toulouse.
BIBLIOGRAPHY: Coquiot 1921, p. 122; Astre (1926), p. 28 Ill., p. 72; Joyant 1926, p. 33 Ill., p. 262; Joyant 1927, p. 9, p. 186; Joyant 1927 (*L'Art et les Artistes*), p. 146 Ill.; Jedlicka 1929, pp. 69 ff. Ill., p. 275; Schaub-Koch 1935, p. 207; Mack 1938, p. 260; Lassaigne 1939, Ill. 49; Mac Orlan 1941, p. 21 Ill.; Jedlicka 1943, pp. 58 ff. Ill., p. 223, p. 314; Vinding 1947, p. 29; Schmidt 1948, p. 10, p. 15, Ill. 3; Jourdain 1948, Ill. 9; Kern 1948, p. 9 Ill.; Bellet 1951, p. 21 No. 38 Ill.; *Toulouse-Lautrec* 1951, Ill.; Frankfurter 1951, p. 99 Ill.; Jourdain-Adhémar 1952, No. 14 Ill., p. 110; Hunter 1953, Ill. 10; Colombier 1953, Ill. 10; Cooper 1955, pp. 66 f. Ill.; Dortu-Grillaert-Adhémar 1955, p. 35; Perruchot 1958, p. 149; Julien (1959), p. 11 Ill., p. 86; Focillon 1959, p. 68 with No. 15; *Toulouse-Lautrec* 1962, p. 147 Ill.; Bouret 1963, p. 25; Zinserling 1964, p. 12, p. 21, Ill. 5; Cionini-Visani 1968, Ill. 10; Fermigier 1969, p. 15 Ill.; Zenzoku 1970, Ill. 14; Dortu II, pp. 122 f. P. 277 Ill.; Josifovna 1972, Ill. 14; *Cat. Musée Toulouse-Lautrec* 1973, p. 31 No. 121, p. 33 Ill.; Muller 1975, Ill. 3; Caproni-Sugana 1977, No. 190 Ill.; Dortu-Méric 1979, I, p. 70 No. 225 Ill.; Arnold 1982, p. 97; *Cat. Musée Toulouse-Lautrec* (1985), pp. 98 f. No. 122 Ill. p. 180 with No. D. 32.
EXHIBITIONS: Brussels 1888, No. 4; Paris 1902, No. 31; Toulouse 1907; Paris 1914, No. 90; Paris 1931, No. 44; Basel 1947, No. 164; Amsterdam 1947, No. 10; Brussels 1947, No. 10; New York (etc.) 1950–1951, No. 4; Paris 1951, No. 14; Albi 1951, No. 38; Philadelphia-Chicago 1955–1956, No. 8; Dallas 1957; Paris 1958–1959, No. 4; London 1961, No. 16; Munich 1961, No. 34; Cologne 1961–1962, No. 34; Albi-Paris 1964, No. 22; Chicago 1979, p. 20, No. 31, with Nos. 12, 28; Tokyo (etc.) 1982–1983, No. 21.

26 RICE POWDER
(POUDRE DE RIZ) 1887–1888

Dortu II, P. 348
Oil on canvas, 56 × 46 cm
Signed in dark paint, lower left: 'T-Lautrec'
Rijksmuseum Vincent van Gogh (Cat. No. S.274 V/1962, Vincent van Gogh
Foundation), Amsterdam

This portrait of a young woman seated at a small table is one of the eleven works that
Lautrec thought good enough to send to Brussels for his first official participation in an
exhibition, at the Salon des XX (see No. 25). He listed it as No. 9 under the title POUDRE DE
RIZ with the note 'à M. van Gogh' (i.e., Theo van Gogh) in the draft for his contribution to
the catalogue (Dortu V, D. 3034). Dortu mentions this Brussels exhibition, which took place
in February 1888, yet follows Joyant in giving 1889 as the date of the painting – another
indication that, despite the great debt owed to these two authors, several of their statements
are in need of revision.

It was at the latest after the second Impressionist Exhibition, when Degas showed his 1876
painting L'ABSINTHE (Ill. p. 298), that the motif of a young woman sitting lost in thought at a
café table became a theme that particularly appealed to artists concerned with contemporary,
that is, Parisian subject matter. One has only to think of Manet's café scene LA PRUNE of 1878
(National Gallery, Washington), Van Gogh's AT THE CAFÉ DU TAMBOURIN (see Ill. below) or
similar figure pictures by the young Picasso However, none of these treated the theme as
emphatically as Lautrec did in the years 1888 to 1889 (cf. No. 34). He executed four variations
on the subject of a woman drinking[1] – and strictly speaking the early portrait of his mother
sitting at a table (Dortu II, P. 90) should be included with these.

The present painting differs from all the other examples mentioned in that the table
covered with a light-coloured cloth has no glasses on it, but only a red jar of face powder
with its lid removed to reveal a powder-puff inside. Since other toilet articles are missing

Vincent van Gogh, AT THE CAFÉ DU TAMBOURIN,
1887, Rijksmuseum Vincent van Gogh, Amsterdam

(*cf.* No. 103)[2] the only possible function of the powder jar and lid must be to provide accents of colour at a particular place in a picture otherwise composed of shades of pale green, blue-purple, olive green and yellow. The cleverly thought out formal relationships make it clear that Lautrec's aim was not to record a particular café as realistically as possible, but to express a precise psychological understanding of the model and to integrate her in a credible way into the carefully considered composition.

Lautrec may have been inspired by the portrait painted by Van Gogh in February 1887 showing Agostina Segatori (?) in the Café du Tambourin with its decoration of Japanese woodcuts (Ill. p. 73), but he transposed his model into the anonymity of the studio. To leave no doubt about the studio setting he made use of the wickerwork chair and bamboo pole (on the right) which were often employed as props in the Rue Caulaincourt studio between 1886 and 1897.[3] Anything that could give the image a genre-like flavour has been avoided, and there is nothing to suggest a particular ambience. The table which the model is sitting at is neither a dressing-table nor a café table. It is there mainly as a formal element: its slight, almost flexible diagonal counteracts the motionless frontality of the figure. Although the gaze of the unapproachable girl barricaded behind the table is fixed rigidly on the viewer, it passes into space without connecting with his gaze. Her reserved character is further underlined by the defensive position of her crossed arms and hands.

Since his days in Cormon's studio, where the theoretical ideas of Seurat and Signac were discussed, Lautrec was aware of their divisionistic aims, though he had not concerned himself particularly with them. Here, for the first time, he made his own use of Seurat's insights – both in his brushstrokes, which are in the main unusually short, comma-shaped spots of colour, and in the decidedly geometric compositional structure – while simultaneously subordinating them to his own stylistic framework. Seurat's method occasionally threatens to ossify into decorative genre – one has only to think of his pointillist FEMME À SA TOILETTE (Courtauld Institute Galleries, London) – but in Lautrec's work, even in the posed atmosphere of the studio, it is used for a precise psychological expression of the isolation and self-alienation of modern man.

On 20 February 1888 Van Gogh had left Paris to go to live in the south at Arles, probably on Lautrec's advice. From there he wrote in April to his brother Theo in Paris, 'Has Lautrec finished his picture of the woman leaning on her elbows on a little table in a café?'[4] This must have been the POUDRE DE RIZ painting, intended for Brussels, which Theo van Gogh, who as a dealer was also interested in Lautrec's work, had acquired for himself before the exhibition.[5] So the painting, which was to be shown in February at the fifth Exposition des XX in Brussels, had been seen in an incomplete state by Vincent van Gogh before his departure. He mentioned it a second time in a letter to Theo in August 1888, in which he made a very interesting comparison: 'You are shortly to make the acquaintance of Mr Patience Escalier, a sort of "man with a hoe", formerly a cowherd in the Camargue, now gardener at a house in the Crau. . . . I do not think my peasant would do harm to the Lautrec in your possession if they were hung side by side, and I am even bold enough to hope that the Lautrec would appear even more distinguished by the mutual contact, and that on the other hand, my picture would gain by the odd juxtaposition, because that sun-steeped, sunburned quality, tanned and air-swept, would show up still more effectively beside all that face powder and elegance. What a mistake the Parisians make in having no palate for such things.'[6]

He was right to point out the contrast between the two portraits; it is the contrast between man and woman, between age and youth, peasant and city flower, glowing colour and a mask-like cosmetic artificiality, which Lautrec further emphasized by the title which he himself gave the picture.

1 Dortu II, P. 307, P. 308, P. 328, P. 340.
2 *Cf.* the toilette scenes Dortu II, P. 347; Dortu III, P. 710.
3 *Cf.* Dortu II, P. 248 where the bamboo rod appears to the right in the background. Lautrec particularly liked to pose his models in wickerwork armchairs which stood ready to hand in his studio, *cf.* Dortu II, P. 229, P. 231 (No. 16), P. 302, P. 317–P. 320 (No. 29), P. 328, P. 336, P. 347, P. 364, P. 367, P. 368, P. 373, P. 378, P. 464; Dortu III, P. 535, P. 609–P. 611, P. 644, P. 645.
4 Vincent van Gogh, *The Complete Letters of Vincent van Gogh*, London, 1958, II, p. 545.
5 A letter from Lautrec to his mother at the beginning of 1888 mentions that he had the prospect of sales (Goldschmidt-Schimmel 1969, p. 106 [266]).
6 Vincent van Gogh, *op. cit.*, III, p. 6. Van Gogh's quarter-length portrait of the old gardener Patience Escalier (J. B. de la Faille, *The Works of Vincent van Gogh*, Amsterdam, 1970, F444) is now in the Stavros S. Niarchos Collection, London.

SOURCES: Théodore van Gogh, Paris; Johanna van Gogh-Bonger; Vincent Willem van Gogh, Laren.
BIBLIOGRAPHY: Joyant 1926, p. 268; Dortu 1951, p. 3; Dortu-Grillaert-Adhémar 1955, p. 35; Marc Edo Tralbaut, *Vincent van Gogh*, Lausanne 1969, pp. 213f. Ill.; Robert Wallace, *Van Gogh und seine Zeit 1853–1890*, 1971, p. 43 Ill.; Dortu II, pp. 176f. P. 348 Ill.; Caproni-Sugana 1977, No. 243 Ill.; Dortu-Méric 1979, I, p. 88 No. 292 Ill.; New York 1985, p. 54, pp. 56ff. Ill.
EXHIBITIONS: Brussels 1888, No. 9; *Rétrospective d'Art Français*, Stedelijk Museum, Amsterdam 1926, No. 110; *Vincent van Gogh*, Stedelijk Museum, Amsterdam 1930, No. 300; *Honderd Jaar Fransche Kunst*, Stedelijk Museum, Amsterdam 1938, No. 231; Basel 1947, No. 179; Amsterdam 1947, No. 16; Brussels 1947, No. 16; Galerie Bignou, Paris 1949; Paris 1951, No. 21; Albi 1951, No. 126; Philadelphia-Chicago 1955–1956, No. 17; Paris 1960, No. 81; Munich 1961, No. 139; Cologne 1961–1962, No. 139; Albi-Paris 1964, No. 28; Stockholm 1967–1968, No. 12; Chicago 1979, No. 30, with No. 23.

27 THE LAUNDRESS (LA BLANCHISSEUSE) 1888

Dortu V, D. 3028
Charcoal on white paper, 61 × 45 cm
Red monogram stamp (Lugt 1338), lower left
Musée Toulouse-Lautrec, Albi

Toulouse-Lautrec, as a painter of Parisian life, concentrated his view on figures that were isolated from natural space, caught in an artificial atmosphere. One looks in vain in the artist's work for public space, as found in the boulevards and streets, the busy squares and parks, the surrounding buildings, the streams of pedestrians and the crowds in front of the street cafés, the flow of carriages, horse-drawn cabs and omnibuses, the railway stations and the river boats on the Seine – in short, everything in the metropolis that had once so delighted the boy from the country. These were of interest in the Impressionists' view of the world, but they had no relevance for him. There was one exception to this, however: in 1887–1888 Lautrec drew a total of eight street scenes for the magazines *Le Courrier Français*, *Le Mirliton* and *Paris Illustré* (*cf.* No. 28),[1] in which he was required to keep to given themes or follow the wishes of the commissioning publication.

This drawing of a young woman with a washing basket on her left arm was a study for a somewhat wider view of the same scene in a version drawn in ink which was commissioned for reproduction by *Paris Illustré* (Dortu V, D. 3029). The laundress, weighed down by her heavy load, leans forward a little as she is just about to cross the street. In the background the dark silhouette of a cab is moving away past a row of houses. At the curb on the left a horse and cart has stopped, and on it, the back view of a busy figure can be seen. The girl hurries to complete her errand; though her feet are not shown, her pace is suggested by the sharply

descending street level. In 1885 the artist had already expressed the motif of movement by placing a walking figure directly in the foreground and cutting it away below while the ground sloped steeply upwards (*cf.* the theatre scene Dortu II, P. 239). In 1889 he took up the same motif in the portrait of Monsieur Fourcade (Ill. p. 101), and then in 1893 and 1895 adapted it for poster design in his work for the comedian CAUDIEUX (see No. 57) and LA REVUE BLANCHE.[2]

This laundress has little in common with her ironing colleagues, whom Degas had discovered for himself since 1869; but on the other hand, the illustration could have been influenced by one of the women laden with their washing-baskets that Daumier had painted in the 1850s. Lautrec brought a great capacity for empathy to his task, but it is quite clear that this genre, with its touch of social criticism, was fundamentally alien to him. It was left to Théophile Alexandre Steinlen to devote himself to such subjects.

Before succeeding Theo van Gogh as manager of the branch of the art dealers Boussod and Valadon at 19 Boulevard Montmartre in the autumn of 1890, Maurice Joyant also worked for a time as editor of the magazine *Paris Illustré* published by the same firm. It was he who commissioned his former schoolfriend at the Lycée Fontanes to provide four illustrations for an article on 'L'Eté à Paris' by Emile Michelet (*cf.* No. 28). A print of the second version of the present drawing appeared on page 425 of issue 27, on 7 July 1888, and reproductions of the other three drawings, sketched in black and white on cardboard, filled pages 426 and 427.[3]

1 Dortu V, D. 2928, D. 3001, D. 3004, D. 3028, D. 3029; Dortu II, P. 298–P. 300; a drawing for an illustration done in 1893 for *Le Figaro Illustré* (Dortu V, D. 3460) could also be included, as could the poster BABYLONE D'ALLEMAGNE conceived in 1894 (Adriani 1986, p. 58).
2 *Ibid*, pp. 15, 130.
3 On 13 July 1888 Lautrec wrote to his mother from Villiers-sur-Morin: 'I've come here to Grenier's in the country to cheer myself up a bit. Aunt Emilie [see No. 9] must have told you the drawings have appeared. . . . As for me, I'm feeling better since I got away from Paris and my models' (Goldschmidt-Schimmel 1969, p. 110 [267]).

SOURCES: Comtesse Adèle Zoë de Toulouse-Lautrec, Toulouse.
BIBLIOGRAPHY: Astre (1926), p. 96; Joyant 1927, p. 191; Lapparent 1927, Ill. 23; Joyant 1930, No. 22 Ill.; Julien 1951, Ill. 5; Henry S. Francis, La Blanchisseuse by Toulouse-Lautrec', in: *Bulletin of the Cleveland Museum of Art*, 40, 1953, pp. 51 ff.; Focillon 1959, No. 17 Ill.; Julien (1959), p. 13 Ill.; Bouret 1963, p. 53; Zinserling 1964, p. 24 Ill. 38; Vienna 1966, with No. 39; Keller 1968, pp. 26 f. Ill., p. 31; Dortu V, pp. 492 f. D. 3028 Ill.; Polasek 1972, p. 30, No. 23 Ill.; *Cat. Musée Toulouse-Lautrec* 1973, p. 120 No. D. 68, p. 125 Ill.; Muller 1975, Ill. 14; Henze 1982, p. 25 Ill., p. 34; *Cat. Musée Toulouse-Lautrec* (1985), p. 193 No. D. 80; New York 1985, pp. 38 f. Ill. 3.
EXHIBITIONS: Paris 1914, No. 139; Paris 1931, No. 202; Albi 1951, No. 152; Nice 1957, No. 34; Paris 1958–1959, No. 53; London 1961, No. 74; Munich 1961, No. 101; Cologne 1961–1962, No. 101; Stockholm 1967–1968, No. 51; Humlebaek 1968, No. 51; Liège 1978, No. 44.

28 A First Communion Day
(Un Jour de Première Communion) 1888

Dortu II, P. 298
Charcoal and oil on cardboard, 65 × 37 cm
Signed in grey paint, lower left: 'T-Lautrec'
Musée des Augustins, Toulouse

In the few Parisian street scenes that Lautrec drew as magazine illustrations for Jules Roques, Aristide Bruant and Maurice Joyant (see No. 27) it is noticeable that once again the image of the human figure is at the forefront of his considerations; the public space of the street exists only in the service of the persons depicted.

Despite the illustrative nature of the present scene Lautrec's characteristic psychological approach allowed him to deal with the event and its participants with an ironic detachment. At the same time he missed no detail in presenting a convincing Parisian *petit bourgeois* family in their Sunday best. The figure in front dressed *comme il faut* in a frock coat is recognizable as the father – Lautrec has given him the features of François Gauzi.[1] He is pushing the youngest child along in a three-wheeled pushchair designed according to the latest ideas. Conscious of her dignity as the most important person of the day, the first communicant walks in the middle dressed in her white dress and veil. The rearguard is made up of the matronly mother, wearing a high-necked dress with a fashionable bonnet and armed with the obligatory umbrella, accompanied by a little girl in a smart tartan skirt. The juxtaposition of the ample curves of the mother with the suggestion of a well-proportioned dressmaker's dummy in the shop window behind her may be taken as a sarcastic comment on transience. The well-protected festal procession moves along a pavement and across the picture space in a completely secular fashion, passing between a man-hole cover and the tall display windows of a textile shop, in which brilliant white shirt-fronts are laid out in rows.

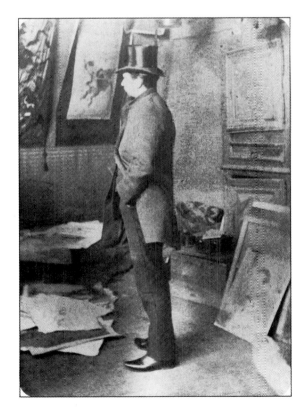

François Gauzi in the studio, 1888

The sketch, drawn in black and white (in every sense) was completed within three hours in the studio, where Gauzi had to stand as a model with his hands on the back of a chair.[2] It was one of the four drawings commissioned by Maurice Joyant as illustrations for Emile Michelet's article 'L'Eté à Paris' (see No. 27).[3] It appeared, reduced to 17.3 × 11.1 cm, in the magazine *Paris Illustré*, No. 27.

After unsuccessfully offering it to the art dealer Goupil for 20 francs, Lautrec gave the picture to François Gauzi, who in 1933 bequeathed it to the Musée des Augustins in Toulouse, which was at that time run by Henri Rachou, a friend and fellow student of both Gauzi and Lautrec.

1 See the full-length portrait of François Gauzi (Dortu II, P. 297).
2 Huisman-Dortu 1964, p. 74.
3 Dortu II, P. 298–P. 300; Dortu V, D. 3029.

SOURCES: François Gauzi, Paris.
BIBLIOGRAPHY: Joyant 1926, p. 263; Joyant 1927, p. 12; Mack 1938, p. 293; Jourdain-Adhémar 1952, No. 17 Ill., p. 94, p. 110; Gauzi 1954, pp. 8f., pp. 151f.; Cooper 1955, p. 40; Perruchot 1958, pp. 152f.; Daulte 1960, pp. 52f, Ill.; Huisman-Dortu 1964, p. 46 Ill., p. 74, p. 158; Fermigier 1969, p. 54 Ill.; Dortu II, pp. 134f. P. 298 Ill.; Polasek 1972, with No. 23; Josifovna 1972, Ill. 30; Caproni-Sugana 1977, No. 223c Ill.; Adriani 1978, pp. 55f. Ill. 10; Dortu-Méric 1979, I, p. 74 No. 244 Ill.; Arnold 1982, p. 105.
EXHIBITIONS: Toulouse 1932, No. 18; Paris 1951, No. 17; Albi 1951, No. 124; Nice 1957, No. 11; London 1961, No. 22; Munich 1961, No. 137; Cologne 1961–1962, No. 137; Rennes 1963, No. 41; Albi-Paris 1964, No. 27.

29 Hélène Vary 1888

Dortu II, P. 320
Oil on cardboard, 74.5 × 49 cm
Signed in dark blue paint, lower right: 'T-Lautrec'
Kunsthalle (Cat. No. 188–1914/2), Bremen

Lautrec painted three portraits of a model called Hélène Vary: a small head-and-shoulders portrait in profile facing right (Dortu II, P. 318), a painting on cardboard facing left, seated in front of a table looking at a sheet of paper (Dortu II, P. 319), and lastly, this relatively small vertical picture, which can be seen as summing up the earlier experiments. In front of a carelessly placed pile of canvases, leaning on plain floorboards with their faces to the wall – one can scarcely think of a more inconsequential setting – the artist expressed all his longing for beauty in the majestic figure of the girl. She was seventeen when she sat for Lautrec in his studio in the Rue Caulaincourt and had worked as a model at Cormon's studio when she was still a child. Although it was fully and consistently taken up only once again in 1892–1893, in the poster for the Divan Japonais,[1] Lautrec clearly found this almost apodictically presented motif of a seated figure an ideal picture format, since he asked François Gauzi, his studio neighbour, to photograph Hélène Vary from the same uncomplicated viewpoint (Ill. p. 82). He used the photograph to assist his memory and to keep his model always in view, since it was not possible for her to be available continually during the lengthy work on the painting.[2]

A comparison between the photograph and the resulting painting shows just how subtly differentiated the artist's methods were; he paid attention to every detail and adapted it to his

pictorial imagination. His draughtsmanship makes the pretty, but vacant face in the photograph harder; her chin appears more angular, the line of her forehead, her eyes and mouth are strengthened and her bosom is more emphasized. The effect of her erect posture is on the whole stiffer. The only feature that is unaltered is her pinned-up hair. In the painting Hélène Vary looks older than she actually was, and, if less charming, she appears all the more perfect: the beauty taken from life has been developed, turning the girl into a woman of distinction. The expressive power of the painting derives from various elements of tension, indeed divergences, which are deliberately introduced into what at first sight seems a harmonious composition. For example, Lautrec was not afraid of emphasizing the coarse working hands of the delicately balanced figure, by placing them against the white material on the brown skirt. Also noticeable is his use of the tense relationship between the static motif of the seated figure and a more dynamic spatial recession created by the diagonal of the floorboards and stretchers.

The most important discrepancy, however, results from the way the figure is not related to the surroundings in which she is placed. In order to ensure the most objective view possible, Lautrec chose to paint the portrait in his studio, where the girl had to hold her own in unfamiliar surroundings. The desire to structure the composition, following early Italian Renaissance portraits (cf. No. 25), brought with it the decision to use the comparatively impersonal profile view. The young woman in her working-girl's dress is arranged in a classical pose. All incidental elements have been eliminated; there is nothing to indicate her origins, her work or her tastes. The carefully imposed neutrality of the surroundings and the diffuse lighting, which results in a predominantly grey-green or grey-blue tone, underlines the weight of the self-contained figure, as does the picture's narrow shape, which is determined by her. What in itself is a trivial portrait composition has been transformed into a formula expressive of dignity. Not without reason was this one of the first works which Lautrec exhibited to the Parisian public. It was shown in 1890 at the exhibition in the Rue Volney by the Cercle Artistique et Littéraire, of which he was a member for a short time.

Hélène Vary, the model, photographed by François Gauzi, 1888

1 Adriani 1986, p. 8.
2 Lautrec himself was also photographer; in December 1885 he wrote that he was spending his time photographing animals and people (Goldschmidt-Schimmel 1969, p. 98 [263]).

SOURCES: Alfred Walter Heymel, Munich.
BIBLIOGRAPHY: Esswein 1912, p. 7 Ill.; Coquiot (1923), Ill. 11; K. Scheffler, 'Lautrec-Ausstellung in der Galerie Matthiesen', in: *Kunst und Künstler*, 23, 1925, pp. 141 ff. Ill.; *Katalog der Kunsthalle Bremen*, Bremen 1925, No. 188; Joyant 1926, p. 67 Ill., p. 266; E. Waldmann, *Die Kunst des Realismus und des Impressionismus im 19. Jahrhundert*, Berlin 1927, p. 486 Ill.; Fosca 1928, Ill. 18; Jedlicka 1929, p. 97 Ill.; W. Uhde, *Die Impressionisten*, Vienna 1937, Ill. 113; Lassaigne 1939, Ill. 50; Jedlicka 1943, pp. 144–145 Ill., p. 214; Jourdain-Adhémar 1952, No. 20 Ill.; Gauzi 1954, p. 41, pp. 141–143 Ill.; Gauzi 1954 (*Arts*), p. 14 Ill.; G. Busch-H. Keller, *Handbuch der Kunsthalle Bremen*, Bremen 1954, pp. 78 f. Ill.; G. Busch-H. Keller, *Meisterwerke der Kunsthalle Bremen*, Bremen 1959, Ill. 114; Daulte 1960, pp. 48 f., Ill.; Bouret 1963, p. 52 Ill.; Huisman-Dortu 1964, p. 57 Ill. (Detail); Gassiot-Talabot 1966, Ill. 4; Novotny 1969, p. 12, Ill. 7; Fermigier 1969, p. 52 Ill.; Zenzoku 1970, Ill. 10; Dortu II, pp. 154 f. P. 320 Ill.; Polasek 1972, p. 9, p. 29; Josifovna 1972, Ill. 15; Huisman-Dortu 1973, pp. 24 f. Ill., p. 82; Eto (etc.) 1973, Ill. 21; Muller 1975, Ill. 6; Werner-Helms (1977) Ill.; Caproni-Sugana 1977, Ill. X, No. 220 a Ill.; Adriani 1978, p. 55, Ill. 11; Dortu-Méric 1979, I, p. 73 Ill., p. 80 No. 266 Ill.; Chicago 1979, pp. 20 f. Ill. 5; Arnold 1982, p. 110 Ill.; Günter Busch, *Die Kunsthalle Bremen in vier Jahrzehnten*, Bremen 1984, p. 13, pp. 20 f. Ill., p. 101; New York 1985, p. 75.
EXHIBITIONS: Paris 1890; Berlin 1924, No. 26; Paris 1931, No. 51; London 1951, No. 6; Albi 1951, No. 41; *Impressionistes et Romantiques Français dans les Musées Allemands*, Musée de l'Orangerie, Paris 1951, No. 83; Amsterdam-Otterlo 1953, No. 19; Winterthur 1955, No. 196; Albi-Paris 1964, No. 25; Vienna 1966, No. 8.

30 Circus Scene (Scène de Cirque) *c.* 1888

Dortu III, A. 197
Watercolour and pastel on white paper, in the shape of a fan, 31 × 57 cm
Signed (anagram) in blue and red paint, lower right: 'Treclau'
Private Collection

The painting of fans, which was practised by some of the Impressionists, can be traced primarily to Japanese prototypes. At the fourth Impressionist Exhibition held between 10 April and 11 May 1879 at 28 Avenue de l'Opéra, a special area had been set aside for painted fans; Degas showed five of them and Pissarro, twelve. Before the mid-1880s Degas had painted more than twenty of these semi-circular arc shapes, and more than sixty examples by Pissarro are known. Other artists who were not members of the Impressionists' circle, such as John Lewis Brown, Giuseppe de Nittis, Forain, Ibels, Steinlen and Gauguin, also devoted themselves to fan-painting with varying degrees of success.

The topical form had at least a sporadic attraction for Lautrec (*cf.* No. 114), although none of the seven known designs[1] dating from between 1888 and 1901 can be compared with the boldness of Degas's inventions. Also, Lautrec must have been less interested in the treatment of fashionable accessories than in the unusual arc shape, which in some of his examples is made to coincide with a segment of the circus ring. The view over the wide arena and the colourfully costumed performers is shown in exaggerated perspective, as if from one of the highest galleries. They are shown in extremely abbreviated form so as to fit the shape of the fan.

Henri de Toulouse-Lautrec had been familiar with the world of the circus since his first visits to Paris. Occasionally he would accompany his mentor René Princeteau to the giant domed building of the Cirque Fernando (later known as the Cirque Médrano) at

63 Boulevard Rochechouart, where in 1879 Degas had portrayed the famous female acrobat Miss Lala high up in the dome, and where Renoir too had found motifs for his paintings. The handicapped Lautrec must have been fascinated by the superior skills of the trapeze artists, the dexterity of the equestriennes, jugglers, buffoons and the clowns, who could laugh at themselves. He was enthusiastic about all those who had such control over their muscular bodies.[2] Between 1887 and 1888 this enthusiasm was reflected in a grand manner in the painting AT THE CIRQUE FERNANDO, (Ill. p. 305), where the decentralized compositional structure, spectacular fragmentation of figures, abrupt foreshortening and steep perspective tending to a flatness already found in Degas and in Japanese woodcuts, are treated in a quite original way.

The present fan painting should be seen in connection with this important early work which gave rise to heated debate when it was exhibited at the Salon des XX in Brussels, in February 1888.[3] In both pictures the composition is bisected by the barrier surrounding the ring, and almost the same protagonists are the centre of interest: the equestrienne performing her daredevil act, the ringmaster Loyal in his tailcoat brandishing a whip, and a clown in green make-up standing on a high pedestal – although in the painting only his legs are showing. He is wearing the classic white clown's costume and holds a hoop for the female acrobat to jump through, which appears as a light-coloured disk almost obscuring her centrifugal act. Lastly, on the right another clown can be seen wearing a pair of baggy white trousers, the back of which is decorated with the dark silhouette of an elephant.[4]

Both in the large painting (which was placed in the entrance hall of the Moulin Rouge immediately after its opening on 5 October 1889) and in the fan, the use of exaggerated foreshortenings and sometimes distorted proportions increases enormously the suggestion of movement and the sense of circulating space. But unlike the painting, the viewpoint in the fan, where the audience is shown as just a dark patch of colour, is from above, looking down steeply on the climax of the performance, meticulously painted in glowing watercolours.

It appears that in his circus scenes of around 1888 the artist wanted to explore the whole breadth of his artistic capabilities. Besides this miniature scene on the fan there was also a monumental circus painting, several square metres in area and probably intended as a

Grandville, BIRD'S EYE VIEW OF THE EARTH, published 1844

backcloth, which the artist could execute only with the aid of a high step-ladder.[5] Unfortunately, this enormous wall decoration, which would have made a distinguished ornament for any circus or dance-hall, has not survived. Parts of it are visible in a photograph taken in 1890 showing Lautrec at work on the painting AU MOULIN ROUGE, LA DANSE (Dortu II, P. 361; Ill. pp. 282f.). Visible in the gigantic painting, beside which the painter looks even tinier than usual, are the over-life-size figures of a clown, the ringmaster and a few spectators in the background. But this was not enough. Lautrec adapted the composition on the fan to fill the narrow vertical format of a screen with a daring bravura picture of a circus equestrienne (Dortu II, P. 314). He even decorated a tambourine with a painting of the wild rider (Dortu II, P. 316), using a sophisticated foreshortening of the horse's body to create the illusion that the horse with its rider had just jumped through the hoop formed by the drum of the tambourine.

One of the first to react to Lautrec's circus motifs was Seurat, whose large circus painting of 1890–1891 is very close to the composition on the fan (see Ill. below). The small fan painting is once again signed with the anagram (cf. No. 25). It was possibly hung in the Chat Noir since it originally belonged to Rodolphe Salis, owner of that artists' cabaret.

1 Dortu III, A. 202, A. 261, A. 263; Dortu V, D. 3055 (No. 114), D. 3461; Dortu VI, D. 4625, D. 4702.
2 *Cf.* Dortu IV, D. 1435–D. 1441, D. 1521; Dortu V, D. 2155.
3 *Cf.* other circus scenes also dating from around 1888; No. 31; Dortu II, P. 313–P. 316, P. 321, P. 322; Dortu V, D. 2109 (which was probably painted in 1887–1888 and not 1881), D. 3034, D. 3035, D. 3054, D. 3056–D. 3058; for the circus scenes that were drawn later, particularly in 1899, see No. 110.
4 This emblem was used by Lautrec in a similar form in many of his lithographs, particularly in the years 1894–1896.
5 Joyant 1926, p. 86, mentions several enormous canvases with scenes from the Cirque Fernando in the studio on the Rue Caulaincourt. When at the beginning of May 1897 Lautrec gave up the studio, they were probably left behind or destroyed because there would have been no room for them at his new, smaller home at 15 Avenue Frochot.

SOURCES: Rodolphe Salis, Paris; Marcel Lecomte, Paris; Paul Gosselin und René Legueltel, Paris; Alfred Daber, Paris; M. Kaganovitch, Paris; Marlborough Fine Art Ltd, London; Jan Krugier, Geneva.
BIBLIOGRAPHY: Newton 1953, p. 84; Dortu III, pp. 493f. A. 197 Ill.; Chicago 1979, with No. 32 Ill.
EXHIBITIONS: *Paris in the Nineties*, Wildenstein & Co. Gallery, London 1954, No. 71; *Dix Ans d'Activité*, Galerie Jan Krugier, Geneva 1983, No. 21.

Georges Seurat, THE CIRCUS, 1890–1891, Musée d'Orsay, Paris

31 THE CLOWN
(LE PITRE) *c.* 1888

Dortu II, P. 327
Oil on cardboard, 35 × 32 cm
Signed in pencil, lower right: 'T-Lautrec'
Private Collection (by arrangement with Galerie Schmit, Paris)

This half-length figure of a clown with his garish white-painted face and red nose is placed as a silhouette against the plain brown of the cardboard base (for the circus motif, see No. 30). His arms and hands stretched out behind him, the clown in his turquoise tailcoat turns away from the viewer towards an unseen audience hidden beyond the white and red parapet. The abrupt twist of his body seems to follow the sweep of the circus ring suggested by the segment of the parapet. In the gleaming, unreal light his powdered face becomes a mask. The viewpoint – and the treatment of the isolated figure – can be compared with the view of the ringmaster in the picture AU CIRQUE FERNANDO, L'ECUYÈRE (Ill. p. 305; *cf.* also the sketch Dortu V, D. 3057).

SOURCES: Vente Hôtel Drouot, Paris 23 June 1933, No. 64; M. Peyrent, Paris; Vente Hôtel Drouot, Paris 6 April 1936, No. 105; M. Dernis, Paris.
BIBLIOGRAPHY: Dortu II, pp. 158f. P. 327 Ill; Dortu-Méric 1979, I, p. 82 No. 272 Ill.

32 CARICATURE OF LAUTREC AND LILI GRENIER
(CARICATURE DE LAUTREC ET LILI GRENIER) 1888

Dortu VI, E. 14
Pen and black ink on beige paper, 11.1 × 17.7 cm
Red monogram stamp (Lugt 1338), lower right
Private Collection

Lautrec painted only one self-portrait (No. 1); it was in the field of caricature that he found the most suitable means of depicting himself.[1] Over seventy such caricatures were sketched between 1881 and 1899 (*cf.* Nos. 33, 108). Nature had let him down and his sarcastic self-definitions were an attempt to defy this betrayal: 'Just look at him, how he lacks any elegance, his fat behind, the potato nose; it is not beautiful'; in this way he would turn himself into a fool; or he would joke: 'I'm only a half bottle.' He advised his mother in a letter of January 1885 to wipe away a kiss as dirty as his was, and in 1890 he ends a letter to her by describing himself as 'this horribly abject being, who is the cause of your despair'.[2] This sarcasm of one who had nothing to lose was applied much more strictly in his judgment of himself than of others. He could escape from himself into caricature, which debased his ridiculous figure still further and emphasized with a coarse juvenile bluntness the physical attributes that remained to him.[3]

Since the summer of 1884 Lautrec had lodged with his friend René Grenier and his wife Lili on the second floor of 19a Rue Fontaine, and later he lived close nearby. He obviously

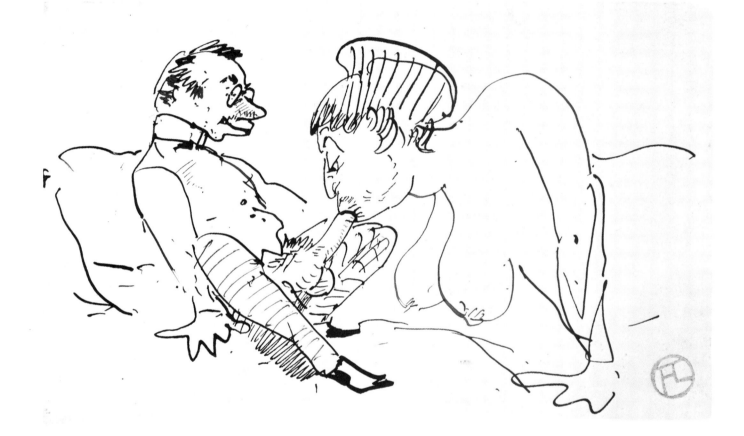

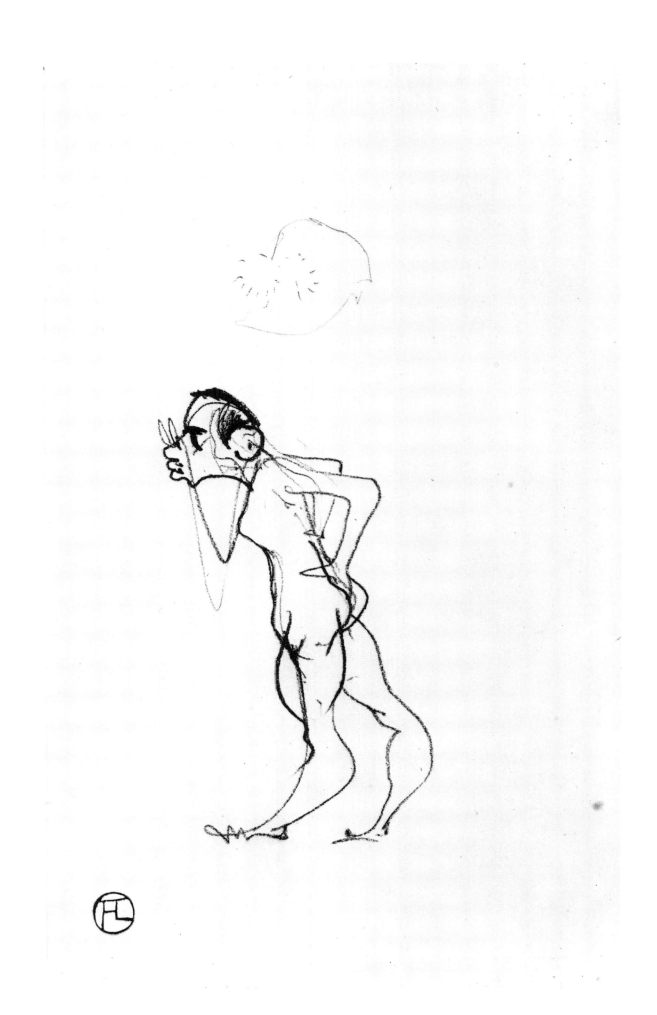

felt at home there, for in October of that year he told his mother: 'I am very much settled down in my kind friend's place, so much so indeed that I could be in danger of becoming an intruder....'[4] Lili was a tall, beautiful blonde of peasant stock from Brie-Comte-Robert, who had worked as a model for the Princesse Mathilde, Degas and others. Lautrec made several portraits of her between 1885 and 1888,[5] and called her ironically Lili-la-Rosse, Lili the rogue, or, rather lewdly, Duchesse, which means not only duchess but also a sort of bed.[6] Between 1886 and 1888 he produced a series of amusing pornographic chalk and ink sketches which were made at the Greniers' or for the couple.[7]

1 Dortu I, pp. 72ff.
2 Perruchot 1960, pp. 53, 66; Goldschmidt-Schimmel 1969, pp. 89, 116 [261, 268].
3 In this respect he liked to compare himself to a coffee pot with a clumsy body and a big spout (Perruchot 1960, p. 53 note 1).
4 Goldschmidt-Schimmel 1969, p. 260; *cf.* also the letters, pp. 83 [260f., 263].
5 Dortu II, P. 253, P. 302, P. 303; Dortu V, D. 2983, D. 2984.
6 In a letter to Lili in 1886 he wrote: 'Duchesse, I want to remind you that tomorrow we are eating together. The waiters at the Ermitage told me that the other day you were there waiting for us, with an old man. Kindly 'lose' him somewhere' (Goldschmidt-Schimmel 1969, p. 103 [265]).
7 Dortu V, D. 3048; Dortu VI, E. 2-E. 7, E. 13-E. 19, E. 22-E. 42.

SOURCES: René und Lili Grenier, Paris; Gustave Pellet, Paris; Maurice Exsteens, Paris; Auction *Moderne Kunst des neunzehnten und zwanzigsten Jahrhunderts*, Galerie Kornfeld, Bern 22–24 June 1983, No. 862.
BIBLIOGRAPHY: Dortu VI, pp. 942f. E. 14 Ill.

33 SELF-CARICATURE (CARICATURE DE LAUTREC) 1888

Dortu, V, D. 3304
Black chalk on white paper, 25.5 × 16 cm
Red monogram stamp (Lugt 1338), lower left
Museum Boymans-van Beuningen (Cat. No. M. B. 1951/T3), Rotterdam

Dortu dated this caricature around 1892, but, like the preceding sketch (No. 32), it must have been drawn earlier. This is suggested by a comparison with the self-caricatures done in 1888.[1] Moreover, after 1888 the artist only ever portrayed himself with a beard.

1 Dortu V, D. 3048; Dortu VI, E. 15.

SOURCES: Musée Toulouse-Lautrec, Albi (?).
BIBLIOGRAPHY: Joyant 1927, p. 247; Jedlicka 1929, p. 91 Ill.; E. Haverkamp Begemann, in: *Bulletin Museum Boymans*, II, April 1951, 2, pp. 33ff. Ill.; L. Goldscheider, 'Rückblick auf die Toulouse-Lautrec-Ausstellung', in: *Die Kunst und das schöne Heim*, 65, I, 1966, p. 14 Ill.; Longstreet 1966, Ill.; Hoetink 1968, p. 149 No. 257 Ill.; Novotny 1969, Ill. 17; Dortu V, pp. 544f. D. 3304 Ill.; Dortu I, p. 74 Ic. 31 Ill.; Lucie-Smith 1983, p. 7, p. 15 Ill.
EXHIBITIONS: Vienna 1966, No. 42.

34 HANGOVER, THE WOMAN DRINKER (GUEULE DE BOIS, LA BUVEUSE) 1889

Dortu V, D. 3092
Pen and brush with black ink, blue and black chalks on paper that has turned brown,
49.3 × 63.2 cm
Signed in black ink, lower right: 'T-Lautrec'
Musée Toulouse-Lautrec, Albi

In contrast to the studio setting in the portrait POUDRE DE RIZ (No. 26) the streetgirl seated here, leaning her elbows on a bar table, is depicted in an appropriate milieu. Degas, Manet and Van Gogh had prepared the way for this with their paintings L'ABSINTHE (Ill. p. 298), LA PRUNE (National Gallery, Washington) and AU CAFÉ DU TAMBOURIN (Ill. p. 73). Lautrec added an element of his own to these important models by reducing their complicated arrangements of figures and space to the simplicity of his well-tried profile view.[1] In this way he concentrated on the head of the girl, placing her exactly on the centre axis of the picture.[2] The upper part of her body leans forward as she perches alone at the round, metal café table which was also one of the artist's studio props (Ill. p. 303). Her chin resting on her hand and the corners of her mouth turned down, she gazes into the distance. The hardness of the draughtsmanship emphasizes the burnt-out features of her drained and disillusioned face. A tension is created by the way surfaces intensified with lines alternate with areas left bare or heightened with colour. In keeping with their thematic importance in the picture, the glass and bottle form a little still-life presented as if on a round pedestal.

The artist has turned his twenty-two-year-old model, Marie-Clémentine Valade (1867–1938), into a symbol of the fatal dangers and degeneration that confronted people in the city. It could be seen as an irony of fate that the real life of the woman here depicted as a drinker, was to be blighted by the alcoholism of her son, the artist Maurice Utrillo. Suzanne Valadon, as she later called herself, was from Bessines-sur-Gartempe in the Limousin. She came to Paris with her mother, who was a laundress, and first sought success in the Cirque Molier as an equestrienne and trapeze artiste until her career was suddenly cut short by a bad fall.

Afterwards her slender figure made her much in demand as a model. She stood for Puvis de Chavannes, Renoir and, after 1887, for Lautrec,[3] after he had rented a studio in the house where she lived in the Rue Caulaincourt. Close contact with her artist friends made Valadon increasingly interested in drawing. Degas in particular supported her in this; he thought very highly of her talent as a draughtsman and wrote many encouraging letters to 'la terrible Maria' between 1894 and 1901.[4]

In 1889 Jules Roques the publisher of the magazine Le Courrier Français commissioned Lautrec, who now had a reputation in Montmartre circles, to make four drawn copies from his paintings for publication. The present drawing appeared as the first of these on 21 April 1889 in No. 16 of Le Courrier Français (Ill. p. 302). It reproduces the painting GUEULE DE BOIS (Dortu II, P. 340) in the graphic medium, with minimal alterations. The complicated method of reproduction by means of a drawn copy was chosen, because it was only by transposing the composition into graphic terms that the image could be reduced to the size required for magazine illustrations (cf. No. 22).[5]

The collaboration with Jules Roques ended, however, immediately after publication of the four drawings in April, May and June 1889. Disagreements must have arisen between the artist and his publisher, for as late as 1901, in an obituary published on 15 September 1901 Roques wrote in harsh, unfounded terms about his former colleague. He described him as 'a sort of Quasimodo whom one could not look at without laughing ..., who did all he could to make the girls of Montmartre ... appear ridiculous, base, slovenly or trivially obscene' About his business methods he wrote that 'like a book-keeper and bailiff rolled into one

he knew very well how to set the whole machinery of the law into action and to let loose a stream of officially stamped papers as soon as he believed that his interests were being harmed, even if it was only a matter of small amounts of money.' Roques summed up his remarks thus: 'Just as there are enthusiastic admirers of bullfights, executions and other distressing spectacles, so there are admirers of Lautrec.'[6]

1 *Cf.* the painting A GRENELLE, BUVEUSE D'ABSINTHE (Dortu II, P. 308).
2 *Cf.* the pastel study Dortu II, P. 339.
3 Dortu II, P. 249, P. 250 (both portraits should be dated on stylistic grounds to 1887 rather than 1885), P. 312, P. 315, P. 322 (Suzanne Valadon was also the model for the equestrienne, presumably as an allusion to her circus past).
4 Marcel Guérin, *Degas Letters*, Oxford, 1947, pp. 189f., 193f., 197, 199, 203f., 206, 213, 218f.
5 Lautrec wrote to his mother about his work for *Le Courrier Français*: 'I am delivering some photographs of my Mirliton panels to Roques. What will become of them is hard to tell; my other drawing was declared bad after being reduced. What a nuisance.' (Goldschmidt-Schimmel 1969, p. 108 [266]). This letter, which was written in early 1889 (not in 1888), probably relates to the two paintings A MONTROUGE (Dortu II, P. 305) and A LA BASTILLE (Dortu II, P. 307), which belonged to Aristide Bruant and were exhibited for a time in his cabaret Le Mirliton. Lautrec made drawn copies of these pictures (Dortu V, D. 3090, D. 3089), which were published on 2 June and 12 May 1889 respectively in *Le Courrier Français*. The fourth drawing (Dortu V, D. 3091) was a copy of the painting AU BAL DU MOULIN DE LA GALETTE (Dortu II, P. 335); it was published on 19 May 1889.
6 Joyant 1927, pp. 126, 128.

SOURCES: Marie Dihau, Paris.
BIBLIOGRAPHY: Joyant 1927, p. 22 Ill., p. 193; Joyant 1930, No. 23 Ill.; Lassaigne 1939, p. 76 Ill.; Julien 1942, p. 37 Ill.; Frankfurter 1951, p. 100 Ill.; Jourdain-Adhémar 1952, p. 117 with No. 26; Lassaigne 1953, p. 26; Cooper 1955, p. 9 Ill.; Dortu-Grillaert-Adhémar 1955, p. 37; Perruchot 1958, p. 163; *Toulouse-Lautrec* 1962, p. 64 Ill.; Bouret 1963, p. 66; Huisman-Dortu 1964, p. 59 Ill.; Zinserling 1964, p. 25, Ill. 41; Keller 1968, p. 31, p. 83 Ill.; Fermigier 1969, p. 45 Ill.; Goldschmidt-Schimmel 1969, p. 16; Dortu V, pp. 506f. D. 3092 Ill.; Dortu II, p. 166 with P. 338–P. 340; Devoisins 1972, p. 9; Polasek 1972, p. 29, No. 24 Ill.; Josifovna 1972, Ill. 18; *Cat. Musée Toulouse-Lautrec* 1973, pp. 122f. No. D. 76, p. 125 Ill.; Muller 1975, Ill. 12; Devoisins 1980, p. 27 Ill.; Morariu 1980, Ill. 12; Henze 1982, p. 29 Ill., p. 36; Arnold 1982, p. 50 Ill.; Cooper 1983, p. 6 Ill.; Lucie-Smith 1983, pp. 9f., Ill. 11; *Cat. Musée Toulouse-Lautrec* (1985), p. 106 with No. 132, p. 194 Ill., p. 197 No. D. 88.
EXHIBITIONS: Paris 1931, No. 204; New York 1937, No. 31; London 1938, No. 35; Paris 1938, No. 7; Basel 1947, No. 103; Amsterdam 1947, No. 73; Brussels 1947, No. 73; New York 1950–1951, No. 33; Paris 1951, No. 92; Albi 1951, No. 147; Philadelphia-Chicago 1955–1956, No. 89; Paris 1958–1959, No. 55; London 1961, No. 77; Munich 1961, No. 104; Cologne 1961–1962, No. 104; Albi-Paris 1964, No. 96; *Suzanne Valadon*, Musée National d'Art Moderne, Paris 1967, No. 184; Stockholm 1967–1968, No. 53; Humlebaek 1968, No. 53; Liège 1978, No. 46

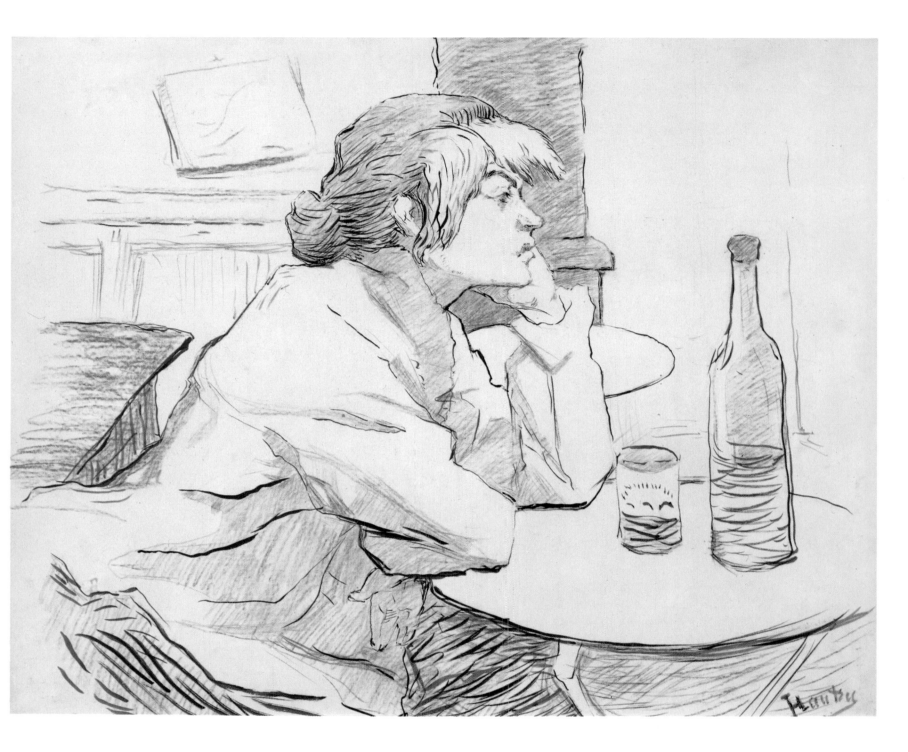

35 In the Promenade, Lust (Au Promenoir, la Convoitise) 1889

Dortu II, P. 337
Oil on cardboard, 50.2 × 38.1 cm
Signed in red chalk, lower left: 'T–Lautrec'
Private Collection

This 'snapshot' captures exactly the play of facial expressions in city society. Everything happens in passing. The lustful eyes of the *bon viveur* are fixed on the object of his desire, a young blonde who is thoroughly aware of her charms. She is wearing a flat hat and therefore does not fall into the same category as the streetgirls, who went around hatless and were thus recognizable as prostitutes. The treatment of the figures is as fleeting as the manner of their meeting, characterized as it is wholly by lustful glances. It was above all in his prints that Lautrec took up the theme of this sort of confrontation of the sexes.[1]

The painting was originally in the collection of the journalist Maurice Donnay for whom Lautrec made three lithograph title pages for songs in 1894.[2]

1 *Cf.* Adriani 1986, 7, 36, 45, 47, 48, 97, 193, 309, 315, 316.
2 *Ibid.*, 91–93.

SOURCES: Maurice Donnay, Paris; Bernard Kramarsky, New York.
BIBLIOGRAPHY: Joyant 1926, p. 267; Jedlicka 1929, p. 125 Ill.; Dortu II, pp. 166f. P. 337 Ill.; Dortu-Méric 1979, I, p. 84 No. 282 Ill.
EXHIBITIONS: Paris 1914 (Galerie Rosenberg), No. 5; New York 1956, No. 37.

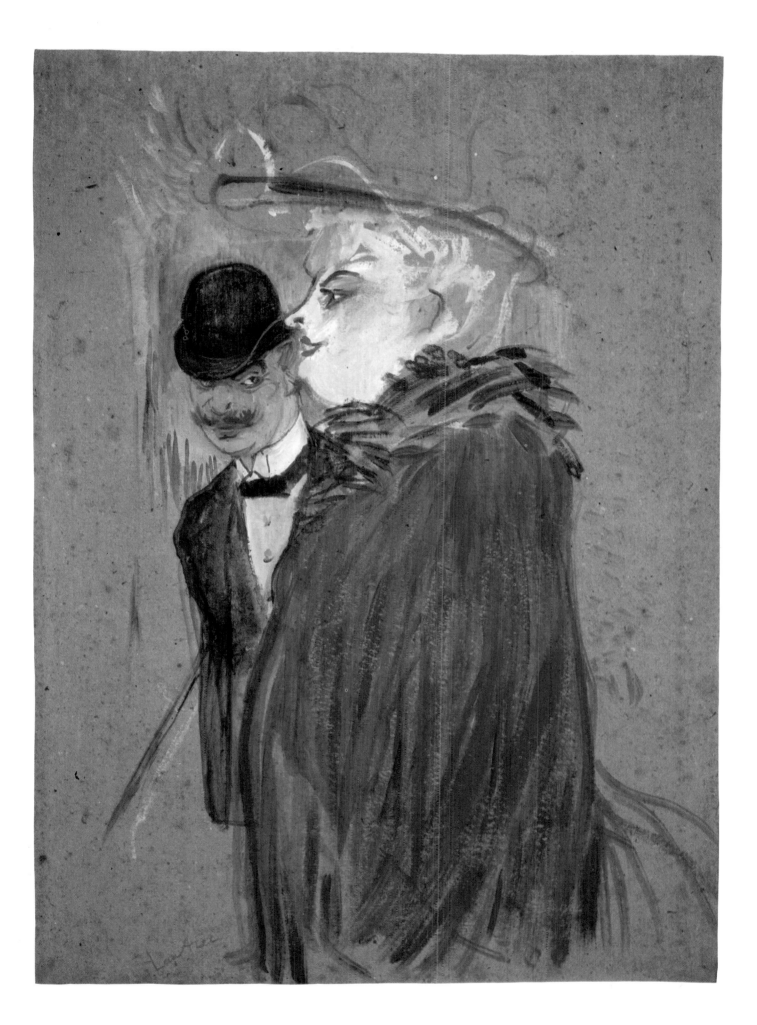

36 MONSIEUR EMILE DAVOUST 1889

Dortu II, P. 332
Oil on cardboard, 38 × 28 cm
Signed in pencil, lower left: 'T-Lautrec'
Private Collection

Lautrec was an enthusiastic swimmer and usually spent the summer months at the seaside. From 1886 onwards his favourite resorts, easily reached from the Château de Malromé, were Arcachon on the Atlantic coast not far from Bordeaux, and the small nearby resort of Taussat-les-Bains. Emile Davoust's yacht *Le Cocorico* was anchored in Arcachon harbour, and during Lautrec's third stay there, in the summer of 1889, he painted the proud boat-owner on board his vessel.

Even when he was outside his accustomed Paris territory, Lautrec was not stimulated to paint by new landscape impressions, but by the people he met. The blue-green surface of the water, the overcast sky, the harbour mole and the boom jutting boldly into the picture merely serve as a setting to familiarize the viewer with the character of this man in his habitual environment. He is posing majestically on the steps that lead down to the inside of the boat, so that the lower part of his legs is cut off by the rim of the hatch. By making him emerge from the hatch in this way, the painter has, as it were, reduced the powerful figure to his own size. There may be a psychological explanation for the fact that Lautrec painted only a few full-length portraits, and these are almost exclusively of male subjects. When he went beyond the quarter-length he usually cut the legs down, or portrayed the subjects seated.

This stands out among the few pictures Lautrec painted in the open air because of its distinctive treatment of light and shade. The sunlight illuminates the figure from the right and throws a grey-blue, sharply outlined shadow onto the deck on the left. This sort of compact shadow, almost independent of its cause, appears only once again as an important element in a picture, in the imposing dance painting AU MOULIN ROUGE (Dortu II, P. 361) of 1890.

As a child Henri had been interested in ships of various kinds, which he would look at during his holidays in Nice. There are many sheets of sketches as well as whole sketchbooks from the second half of the 1870s filled with drawings of boats. He gave particular emphasis to details of the rigging, the supports of the masts, the tangles of the ropes, and the process of hoisting the sails. But thereafter, the only evidence of this interest is found in the present painting, in a picture of a bowsprit and in the late portraits of Maurice Joyant and Paul Viaud.[1]

1 Dortu II, P. 333; Dortu III, P. 701, P. 702, P. 722.

SOURCES: Emile Davoust, Arcachon; L. Bernard, Paris.
BIBLIOGRAPHY: Duret 1920, Ill. XXXVIII; Coquiot 1921, p. 122; Coquiot (1923), p. 33; Astre (1926), p. 82; Joyant 1926, p. 266; Mack 1938, pp. 271 f.; Dortu II, pp. 162f. P. 332 Ill.; Caproni-Sugana 1977, No. 244 Ill.; Dortu-Méric 1979, I, p. 84 No. 277 Ill.; Lucie-Smith 1983, No. 5 Ill.
EXHIBITIONS: Paris 1902, No. 61; Paris 1914, No. 11; Vienna 1966, No. 11.

37 MONSIEUR HENRI FOURCADE 1889

Dortu V, D. 3094
Charcoal on beige paper, 39 × 28 cm
Signed in charcoal, lower left: 'T-Lautrec'
Musèe Toulouse-Lautrec, Albi

In 1889 at the group exhibition of the Cinquième Salon des Indépendants Lautrec exhibited
the portrait of Monsieur Fourcade at the Opéra Ball painted in the same year (see Ill. below).
This rather conventional portrait drawing, showing Lautrec's banker friend in three-quarter
view, was probably made in connection with the painting.

SOURCES: L. C. Hodebert, Paris.
BIBLIOGRAPHY: Joyant 1927, p. 194; Jourdain-Adhémar 1952, p. 94; Focillon 1959, No. 7 Ill.; Dortu V, pp. 506f.
D. 3094 Ill.; Dortu II, p. 162 with P. 331; Polasek 1972, No. 25 Ill.; *Cat. Musée Toulouse-Lautrec* 1973, pp. 123f. No. D. 77;
Cat. Musée Toulouse-Lautrec (1985), p. 198 No. D. 89.
EXHIBITIONS: Munich 1961, No. 105; Cologne 1961–1962, No. 105.

MONSIEUR HENRI FOURCADE AT THE OPÉRA BALL,
1889, Museu de Arte, São Paulo

38 Woman in Evening Dress at the Entrance to a Theatre Box
(Femme en Toilette de Bal à l'Entrée d'une Loge de Théâtre) 1889–1890

Dortu III, P. 523
Oil on canvas, 81 × 51.5 cm (the painting has been heavily cut down on the right from its original size)
Musée Toulouse-Lautrec, Albi

Joyant dated this theatre painting to 1894, and this date has been accepted by all subsequent literature on Lautrec, although it can easily be proved to be wrong. In early 1890 Lautrec was photographed at work in his studio on the almost completed painting Au Moulin Rouge, la Danse (Dortu II, P. 361) which was exhibited in March of that year (Ill. pp. 282 f.). Among the various pieces of studio equipment visible in the photograph, the present canvas is clearly recognizable. The fact that it is placed in such an ostentatious position suggests that it had only recently been painted and was completed in the autumn of 1889 or early in 1890. There are close stylistic analogies with two dated portraits of 1889, one of the actor Samary on the stage of the Comédie Française (Dortu II, P. 330) and the other of Monsieur Fourcade at the Opéra Ball (Ill. p. 101). All three works are characterized by a similar, perspectivally distorted arrangement of space, an exaggeration of the figures that amounts almost to caricature, and a painting technique consisting mainly of long parallel brushstrokes.

This painting, with its sophisticated light effects, is one of Lautrec's most original achievements. Who else would have portrayed someone full-length without showing the face? And yet with so much individuality in the outline of the figure, her attitude, her hair and dress, that it does not seem to matter that the facial features are omitted. The female figure seen from behind stands before a half-open door like some strange, colourfully decked-out bird of paradise with folded wings. She is about to leave a theatre box, though this is made clear only by the reflection in the mirror on her left, behind the pale outline of an armchair.[1] In the mirror can be seen parts of an illuminated stage, and – an important pendant to the female figure – a gentleman in evening dress who is cut off by the edge of the glass. He is turning towards the viewer and yet is faceless. By means of this reflected picture-within-a-picture the man and woman are brought together and yet remain distanced from each other. Their meeting in the *chambre séparée* may have been as fleeting and incongruent in reality as it is in the composition of the picture.

1 A similar spatial arrangement is found in the full-length portrait of Le Docteur Tapié de Céleyran dans un Couloir de Théâtre (Dortu III, P. 521).

SOURCES: Comtesse Adèle Zoë de Toulouse-Lautrec, Toulouse.
BIBLIOGRAPHY: Joyant 1926, p. 281; Dortu-Grillaert-Adhémar 1955, p. 20; Dortu III, pp. 324 f. P. 523 Ill.; *Cat. Musée Toulouse-Lautrec* 1973, p. 64 No. 164; Caproni-Sugana 1977, No. 385 Ill.; Dortu-Méric 1979, II, p. 44 No. 440 Ill.; *Cat. Musée Toulouse-Lautrec* (1985), pp. 130 f. No. 165 Ill.
EXHIBITIONS: Albi 1951, No. 76; Paris 1958–1959, No. 28; Munich 1961, No. 64; Cologne 1961–1962, No. 64; Chicago 1979, No. 65.

39 MADEMOISELLE DIHAU AT THE PIANO (MADEMOISELLE DIHAU AU PIANO) 1890

Dortu II, P. 358
Oil on cardboard, 68 × 48.5 cm
Dated and signed in dark paint, upper right: '90 T-Lautrec'
Musée Toulouse-Lautrec, Albi

In March 1890 Lautrec showed this portrait of MADEMOISELLE DIHAU AT THE PIANO – together with the painting AU MOULIN ROUGE, LA DANSE (Dortu II, P. 361) – at the sixth exhibition of the Salon des Indépendants. He wrote enthusiastically to his mother about the opening of the exhibition: 'I am still reeling from the second *vernissage*. What a day!! But what a success. The Salon [i.e., the official Salon] got a slap in the face from which it will recover perhaps, but which will give many people something to think about.'[1] The art dealer Theo van Gogh also wrote about the event in a letter of 19 March to his brother Vincent in Saint-Rémy, 'Your pictures are very well hung and made a good effect. A lot of people have asked us to send you their compliments. Gauguin said your pictures were the chief attraction of the exhibition. . . . From Lautrec there is a very good portrait of a woman at the piano and a big picture that is very striking.'[2]

This portrait of the pianist was a bold move on Lautrec's part, since it had to stand beside a portrait of Mademoiselle Dihau painted by Degas almost twenty years earlier (Ill. p. 106). Marie Dihau and her brothers Désiré and Henri came from Lille and lived in Paris at 6 Rue Frochot. Marie, a successful pianist and former singer, gave piano and singing lessons, while her brother Désiré was a bassoonist in the orchestra of the Paris Opéra (No. 41). Since the 1860s the Dihaus had been friends of Degas, who made Désiré the central figure in his famous painting of THE ORCHESTRA OF THE OPÉRA (Ill. p. 110).[3] This early group portrait by Degas was one of the pictures that Lautrec most admired. He was distantly related to the Dihaus on his mother's side and used this connection to gain an introduction to Degas, and to study the artist's major works, which were kept in the house in the Rue Frochot.

He could not, and did not want to compete with the orchestra painting, but he was stimulated to emulate Degas's portrait of Marie Dihau at the piano – though he still wondered whether his little effort could bear comparison with its great model.[4] Degas had been primarily interested in the face, which the pianist momentarily turns towards the viewer; the younger artist is fascinated by her concentration on the playing of the instrument, her attentive reading of the music, and not least by her hands, which are shown in the actual process of playing. He includes more of the room in his picture and attaches greater importance to the surroundings: the piano stacked with scores and the picture-covered walls of the Dihaus' dining room. As a homage to Degas he includes a significant picture-within-a-picture: the portrait of Marie Dihau, which is visible in a gold frame in the upper right-hand corner. An element of disruption is created in the otherwise static composition, with its predominance of dark blue-green, by the projection into the picture of the unbroken white surface of a sheet of music on a stand, drastically truncated in the manner of Daumier. The emphasis given to the intrusion of this music sheet suggests that it is intended for a musician outside the picture who is accompanying Marie Dihau.[5]

Van Gogh probably saw the portrait, that Theo had already told him about, between 17 and 19 May 1890 in the Rue Caulaincourt when he met Lautrec during a brief stop in Paris on his way from Saint-Rémy to Auvers-sur-Oise. The similarities with MARGUÉRITE GACHET PLAYING THE PIANO (Ill. p. 106), which Van Gogh painted at the end of June 1890 in Auvers-sur-Oise, are so compelling that they can hardly be explained by the two artists coincidentally thinking along the same lines. In one of his last letters, Van Gogh wrote to his brother: 'I retain many pleasant memories of that journey to Paris [presumably the three days he stayed there in May 1890, not his day visit to Theo in the first half of July]; for

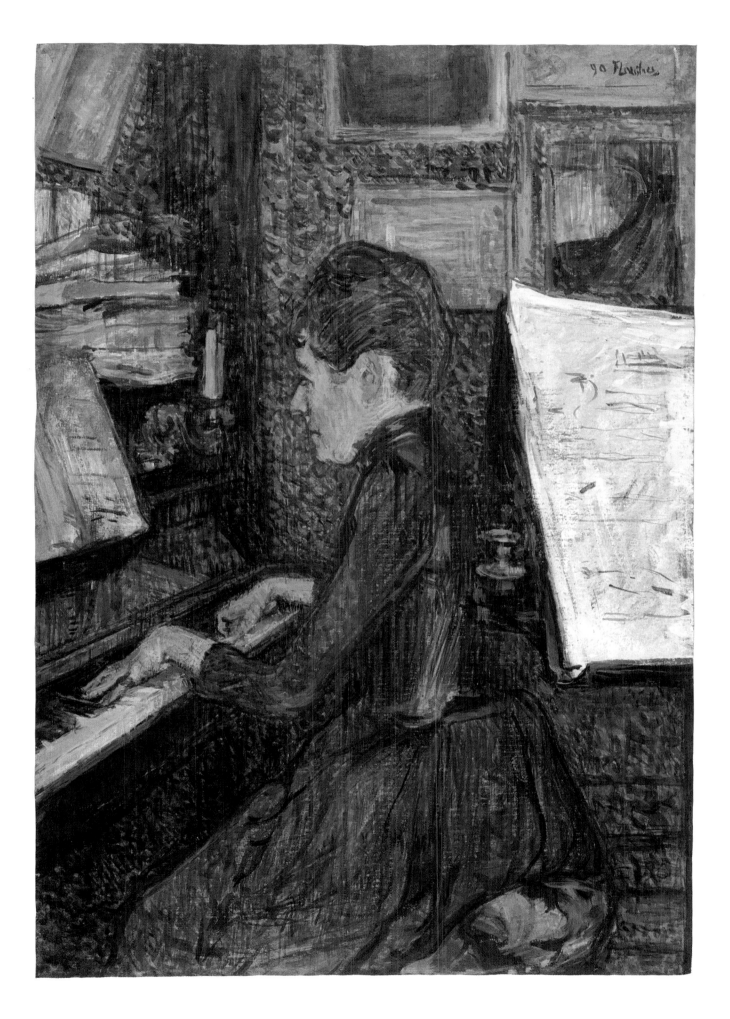

several months I had hardly dared see my friends again. . . . Lautrec's picture, the portrait of a musician, is amazing. I was very moved by it.'[6]

Marie Dihau, who died in 1935, bequeathed her portrait to the Musée Toulouse-Lautrec, Albi, together with the portraits Lautrec had painted of Désiré (No. 41; Dortu II, P. 380) and Henri (Dortu II, P. 381). The Louvre acquired Degas's THE ORCHESTRA OF THE OPÉRA and his portrait of the pianist under the same terms.

1 Goldschmidt-Schimmel 1969, p. 115 [268].
2 Vincent Willem van Gogh, *The Complete Letters of Vincent van Gogh*, London, 1958, III, p. 565.
3 In 1893 Lautrec took up this motif again in the lithograph POUR TOI! (Adriani 1986, 28).
4 Joyant 1926, p. 130.
5 Eight years later Lautrec again painted a more portly Marie Dihau at the piano in the same setting, this time accompanying a singer: LA LEÇON DE CHANT, MADEMOISELLE DIHAU ET MADAME JEANNE FAVEREAU (Dortu III, P. 658); *cf.* also the portraits of women playing the piano Dortu III, P. 579, P. 630, P. 642.
6 Vincent van Gogh, *The Complete Letters of Vincent van Gogh*, London, 1958, III, p. 296.

SOURCES: Marie Dihau, Paris.
BIBLIOGRAPHY: Duret 1920, pp. 59f.; Coquiot 1921, pp. 121f.; Coquiot (1923), pp. 33f.; Astre (1926), p. 82, p. 125; Joyant 1926, pp. 128f. Ill., p. 268; Joyant 1927, p. 254; Joyant 1927 (*L'Art et les Artistes*), p. 149 Ill.; Jedlicka 1929, p. 177; Schaub-Koch 1935, p. 208; *Bulletin des Musées de France*, 9 November 1936, p. 174 Ill.; *Revue du Tarn*, 10, 15 March 1937, p. 40 Ill.; Mack 1938, pp. 261f. Ill., p. 305; Cassou 1938, p. 233 Ill.; Jedlicka 1943, p. 147; *Toulouse-Lautrec* 1951, Ill.; Dortu 1951, p. 1 Ill.; Bellet 1951, p. 23; Jourdain-Adhémar 1952, No. 34 Ill. (Detail), p. 111; Lassaigne 1953, pp. 32f. Ill.; Cooper 1955, pp. 86f. Ill.; Dortu-Grillaert-Adhémar 1955, p. 35; Perruchot 1958, pp. 171f., p. 174, p. 327; Julien (1959), p. 18; Focillon 1959, p. 60; *Toulouse-Lautrec* 1962, p. 119 Ill.; Bouret 1963, p. 101; Zinserling 1964, pp. 21f., Ill. 7; Vienna 1966, with No. 43; Rewald 1967, p. 238, p. 370 Ill.; Cionini-Visani 1968, Ill. 21; Goldschmidt-Schimmel 1969, Ill. 31, p. 308; Fermigier 1969, p. 47 Ill.; Zenzoku 1970, No. 6; Devoisins 1970, p. 55; J. B. de la Faille, *The Works of Vincent van Gogh*, Amsterdam 1970, p. 296; Dortu II, pp. 186f. P. 358 Ill.; Devoisins 1972, p. 10; Polasek 1972, p. 31; Josifovna 1972, Ill. 22, 23; *Cat. Musée Toulouse-Lautrec* 1973, pp. 38ff. No. 131 Ill.; Adriani 1976, pp. 31f. Ill.; Caproni-Sugana 1977, Ill. XIII, No. 263 Ill.; Dortu-Méric 1979, I, p. 87. Ill., p. 92 No. 302 Ill.; Henze 1982, p. 35 Ill., p. 56; *Cat. Musée Toulouse-Lautrec* (1985), pp. 104ff. No. 132 Ill.; Munich 1985, p. 43; New York 1985, pp. 48f. Ill., p. 60, p. 67.
EXHIBITIONS: Paris 1890 (Indépendants), No. 791; Paris 1914, No. 10; San Francisco 1916; Paris 1931, No. 64; *La Vie Parisienne*, Musée Municipal, Paris 1937; New York 1937, No. 5; London 1938, No. 1; Paris 1938, No. 8; *La Peinture Française au XIX. Siècle*, Prinz Paul Museum, Belgrade 1939, No. 108; Basel 1947, No. 162; Amsterdam 1947, No. 17; Brussels 1947, No. 17; Venice 1948, No. 75; New York (etc.) 1950–1951, No. 6; Paris 1951, No. 25; Albi 1951, No. 46; Amsterdam-Otterlo 1953, No. 22; Marseilles 1954, No. 6; Philadelphia-Chicago 1955–1956, No. 22; Paris 1958–1959, No. 11; London 1961, No. 24; Munich 1961, No. 41; Cologne 1961–1962, No. 41; Albi-Paris 1964, No. 34; Kyoto-Tokyo 1968–1969, No. 12; Paris 1975–1976, No. 15; Liège 1978, No. 14; Chicago 1979, No. 42, with Nos. 43, 44; Tokyo (etc.) 1982–1983, No. 23.

Edgar Degas, MARIE DIHAU PLAYING THE PIANO, 1869–1872, Musée d'Orsay, Paris

Vincent van Gogh, MARGUÉRITE GACHET PLAYING THE PIANO, 1890, Kunstmuseum, Basel

40 Gabrielle the Dancer (Gabrielle la Danseuse) 1890

Dortu II, P. 359
Black chalk and oil on cardboard, 53.3 × 40.2 cm
Signed in dark purple paint, lower right: 'T-Lautrec'
Musée Toulouse-Lautrec, Albi

Joyant mentions that the portrait of the dancer Gabrielle was painted in the garden of Monsieur Forest. Not far from Lautrec's studio, at the junction of the Rue Caulaincourt and the Boulevard de Clichy, on the edge of Montmartre cemetery, was the garden of Forest the photographer, who is commemorated today by the street which bears his name. Henri Rachou wrote of his artist friend's work in this garden: 'With me he studied diligently in the mornings at the Atelier Cormon, and spent the afternoons painting one of our regular models – Père Cot, Carmen [Gaudin], Gabrielle, etc. – either in a little garden in the Rue Ganneron, where I lived for seventeen years, or in Monsieur Forest's garden in the Rue Forest.'[1] There is also a description by Coquiot: 'The garden was completely overgrown and one could believe that one was stuck out in the bush, far away from Paris. Lautrec soon became a regular visitor to this garden. As soon as the fine weather began he would go down the Rue Caulaincourt and install himself at his friend Père Forest's. Quite at his ease, in his shirt-sleeves and with his hat pulled down over his forehead, from early morning onwards, he would receive his models, mostly women from the Boulevard de Clichy, the Place Blanche and the brothels which he frequently visited. It was in this auspicious garden, in the open air, that he painted many of his pictures: the woman with the parasol, the woman with the dog, the woman in the black hat, the woman in the garden, the street-walker, Gabrielle the Dancer, etc.'[2]

With the permission of Père Forest, who was fond of the budding artist, Lautrec worked in this garden as a *plein-air* painter, probably from the mid-1880s until the beginning of the 1890s, and painted many portraits there (see Nos. 41, 42). Despite the variety in their compositions, these 'punishment works', as the artist disparagingly called them, have one thing in common: none of them can be described as *plein-air* painting in the sense of the comparable garden portraits of Monet or Renoir. They almost deliberately reject the Impressionists' interest in a precise rendering of surface reflections, in a varied play of light and shade, unifying the figures and the background. In Lautrec's painting the dabbed-on foliage is no more than an abstract foil, whose main purpose is to act as a decorative pattern and to demonstrate how the figure is distanced from nature. His figures are no longer integrated into any natural space. The blond Gabrielle in her high-necked white dress and feather hat is all dressed up for strolling along the boulevards; she seems to have wandered by accident into this rural Elysium, which is more like a fragment of garden space than a garden landscape.[3]

1 Huisman-Dortu 1964, p. 44.
2 Coquiot 1921, pp. 128f.
3 In 1891 Lautrec painted Gabrielle from a similar viewpoint in front of a stage-scenery tree (Dortu II, P. 393). She appears again in 1895 as a stout old woman in *petit-bourgeois* dress among the figures in Au Moulin Rouge, la Clownesse Cha-u-Kao (Dortu III, P. 593). See also the portraits Dortu II, P. 504; Dortu III, P. 600.

SOURCES: Comtesse Adèle Zoë de Toulouse-Lautrec, Toulouse.
BIBLIOGRAPHY: Coquiot 1921, p. 129; Astre (1926), p. 78; Joyant 1926, p. 268; Lapparent 1927, p. 21; Jourdain-Achémar 1952, p. 111; *Toulouse-Lautrec* 1962, p. 151 Ill.; Dortu II, pp. 186f. P. 359 Ill.; *Cat. Musée Toulouse-Lautrec* 1973, pp. 36f. No. 129 Ill.; Caproni-Sugana 1977, No. 253 Ill.; Dortu-Méric 1979, I, p. 89 Ill., p. 92 No. 303 Ill.; Lucie-Smith 1983, with No. 6; *Cat. Musée Toulouse-Lautrec* (1985), pp. 104f. No. 130 Ill.
EXHIBITIONS: Paris 1914, No. 58; San Francisco 1916; Paris 1931, No. 412; Venice 1948, No. 74; Albi 1951, No. 44; Nice 1957, No. 13; Paris 1958–1959, No. 9; London 1961, No. 23; Munich 1961, No. 39; Cologne 1961–1962, No. 39; Paris 1975–1976, No. 14; Tokyo (etc.) 1982–1983, No. 24.

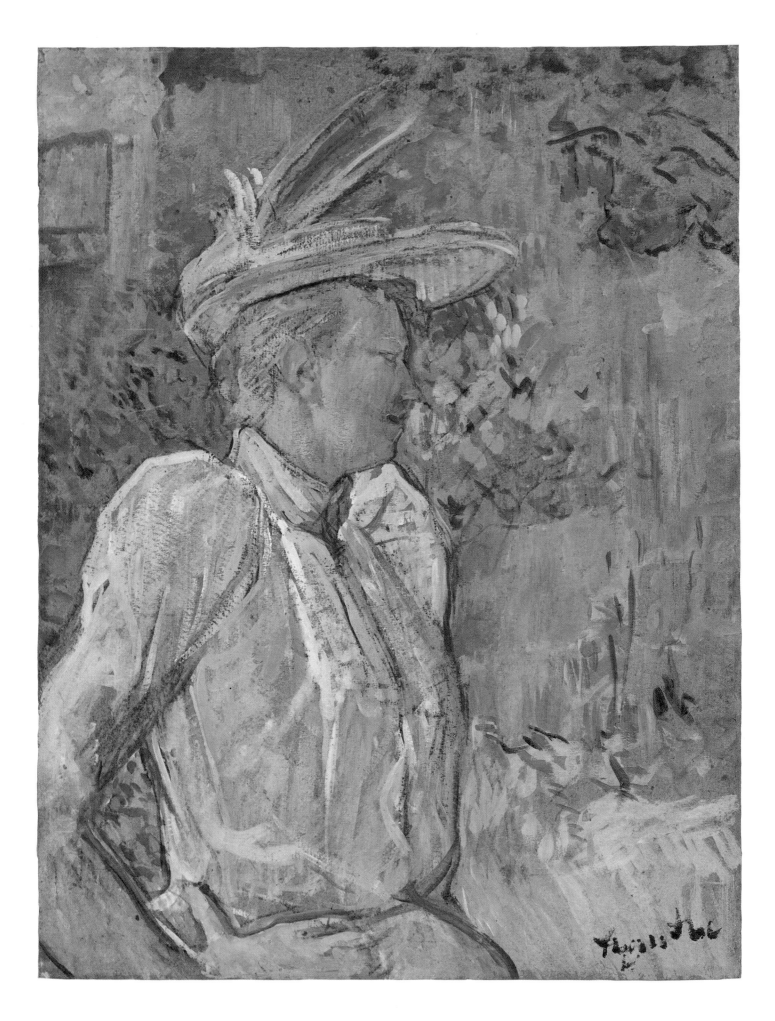

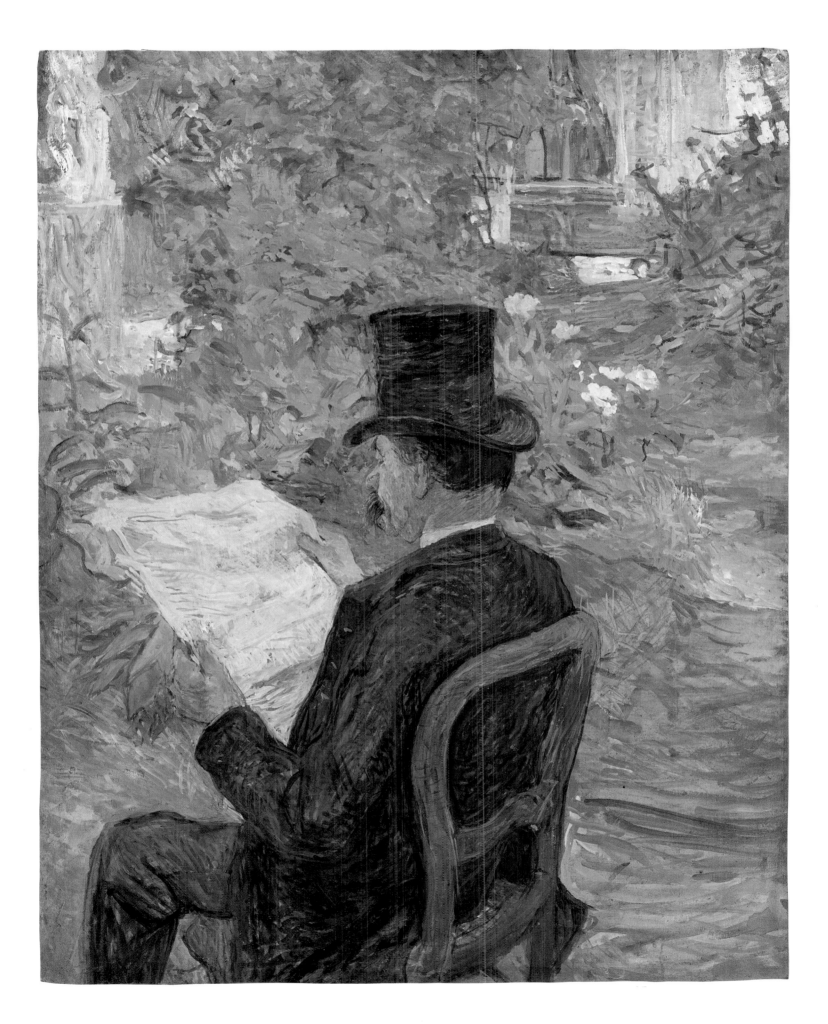

41 Monsieur Désiré Dihau, Bassoonist at the Opéra (M. Désiré Dihau, Basson de l'Opéra) 1890

Dortu II, P. 379
Oil on cardboard, 56.2 × 45 cm
Musée Toulouse-Lautrec, Albi

Désiré Dihau (1835–1909) played the bassoon in the orchestra of the Paris Opéra. He was the brother of Marie Dihau (No. 39) and appears in the central position in Degas's group portrait L'ORCHESTRE DE L'OPÉRA (see Ill. below). Lautrec's portrait of him, however, gives no clues as to his professional activities.[1] It was painted over twenty years after Degas's masterpiece. Dihau is now shown as a pensioner who has withdrawn to the quiet seclusion of Forest's garden to read the newspaper (*cf.* Nos. 40, 42). He is portrayed not as an ambitious musician, but as a Parisian *petit bourgeois* who is just having a quick look at the paper before going out for his walk.

Dihau had a versatile talent: besides his work in the orchestra, he also composed cabaret songs for the Chat Noir and melodies for texts by Jean Richepin and Achille Melandri. Lautrec was later to make 26 lithographs as title pages for him. Seated beside a garden path in these overgrown surroundings, he is an alien element, like most of the models placed there by Lautrec – GABRIELLE THE DANCER (No. 40), JUSTINE DIEUHL and HONORINE PLATZER (Dortu II, P. 394, p. 398) were painted in the same spot. The figure is not related in terms of subject, form or colour to the landscape background, sketched in green and purple. From the way he is dressed, the musician would seem much more at home in a street café than in this enchanted garden idyll, and his chair, too, is not exactly what one would call a piece of garden furniture. But these very inconsistencies may have interested the painter. Presumably Lautrec wanted his view of Dihau's character to be as far removed as possible from that of Degas, and yet the motif of the seated figure facing away from the viewer is similar to Gouffé, the double bass player on the right of Degas's orchestra painting.

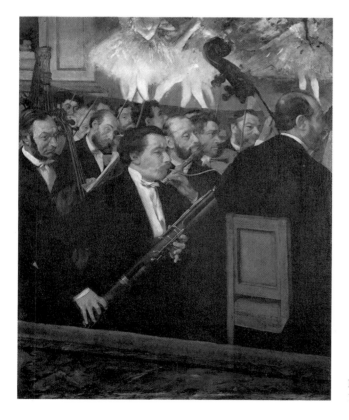

Edgar Degas, THE ORCHESTRA OF THE OPÉRA, 1868–1869, Musée d'Orsay, Paris

According to Joyant, the portrait of Dihau was painted in 1891 in the garden of Forest the photographer. However, it was exhibited in February of that year at the Cercle Artistique et Littéraire in the Rue Volney and from March to April at the seventh Salon des Indépendants.[2] If one assumes that the garden portraits of this period were all painted on the spot – and all the sources indicate this (see No. 40) – then Dihau, a distant cousin of the painter must have sat for him earlier, in 1890, when the trees and bushes were still in leaf.

1 Only in the lithograph Pour Toi! (Adriani 1986, 28) is he shown as a bassoonist, in a paraphrase of Degas's painting.
2 The critic Octave Mirbeau wrote in the *Echo de Paris* of 30 March 1891 about the portraits which Lautrec was showing at the Indépendants: 'And despite the blackness with which he very unbecomingly besmirches his figures, M. de Toulouse-Lautrec displays a true, spiritual and tragic power in the handling of physiognomies and in the fathoming of character.' Gustave Geoffroy, who was later to be one of Lautrec's admirers, still gave a very critical analysis of his works shown at the Indépendants. In *La Vie Artistique* he wrote that the artist was intending to be sarcastic when he represented dubious milieux in dirty colours, where loathsome wretches, figures of vice and misery appeared. But Roger-Marx in *Le Rapide* of 30 May 1891 was much more positive: 'The Portrait of a Gentleman by M. de Toulouse-Lautrec stands out, and the memory remains of an acute analyst, but also of a painter who is master of his craft and is to the highest degree in possession of a personal means of expression' (Joyant 1927, pp. 16, 18f.).

SOURCES: Marie Dihau, Paris.
BIBLIOGRAPHY: Duret 1920, p. 59; Coquiot 1921, p. 122; Conquiot (1923), p. 33; Astre (1926), p. 78; Joyant 1926, p. 128 Ill., p. 270; Jedlicka 1929, p. 176; Schaub-Koch 1935, p. 208; *Bulletin des Musées de France*, 9 November 1936, p. 174 Ill.; *Revue du Tarn*, 10, 15 March 1937, p. 40 Ill.; Mack 1938, p. 263; Lassaigne 1939, Ill. 65; Jedlicka 1943, p. 147; Vinding 1947, p. 165; Kern 1948, p. 9; Bellet 1951, p. 27; Natanson 1951, pp. 112–113 Ill.; Jourdain-Adhémar 1952, No. 33 Ill.; Lassaigne 1953, p. 38; Julien 1953, p. 13 Ill.; Dortu-Grillaert-Adhémar 1955, p. 30, p. 36; Perruchot 1958, pp. 171f.; Julien (1959), p. 18, p. 86; Cabanne 1959, p. 23 Ill.; *Toulouse-Lautrec* 1962, p. 61 Ill.; Zinserling 1964, p. 22, Ill. 9; Vienna 1966, with No. 43; Novotny 1969, p. 49, Ill. 20; Goldschmidt-Schimmel 1969, p. 122; Fermigier 1969, p. 68 Ill.; Dortu II, pp. 210f. P. 379 Ill.; *Cat. Musée Toulouse-Lautrec* 1973, p. 39 Ill., p. 42 No. 135; Caproni-Sugana 1977, No. 282 Ill.; Dortu-Méric 1979, II, p. 12 No. 323 Ill.; *Cat. Musée Toulouse-Lautrec* (1985), pp. 107ff. No. 136 Ill.
EXHIBITIONS: Paris 1891, No. 187: Paris 1891 (Indépendants); Paris 1902, No. 85; Paris 1914, No. 19; Paris 1931, No. 71; New York 1937, No. 6; London 1938, No. 2; Paris 1938, No. 9; Basel 1947, No. 163; Amsterdam 1947, No. 21; Brussels 1947, No. 21; Venice 1948, No. 75a; New York (etc.) 1950–1951, No. 7; Paris 1951, No. 27; Albi 1951, No. 48; Philadelphia-Chicago 1955–1956, No. 35; Nice 1957, No. 14; Paris 1958–1959, No. 12; London 1961, No. 26; Munich 1961, No. 42; Cologne 1961–1962, No. 42; Albi-Paris 1964, No. 35; Paris 1975–1976, No. 16; Liège 1978, No. 15; Chicago 1979, p. 24, No. 44, with Nos. 43, 45, 48, 49, 53; Tokyo (etc.) 1982–1983, No. 25.

Monsieur Forest's garden

42 UNDER THE LEAVES (SOUS LA VERDURE) 1890–1891

Dortu II, P. 409
Oil on wood panel, 55 × 46 cm
Signed in dark paint, lower left: 'T–Lautrec'
Private Collection, Zurich

The colouring of this painting goes against Lautrec's usual practice of clearly distinguishing the figures from their landscape background. Here, the combination of luminous green and light purple which predominates in some of his garden portraits is reflected also in the figure itself, where light and shade are contrasted in exactly the same resplendent green and red tones. In spite of the artificiality of the colours and the foliage, which almost resembles stage scenery, set against a purple background, this figure of a young woman in Père Forest's garden, with her profile turned to the right, is full of expressive power (*cf.* Nos. 40, 41). The picture is tightly composed, and the head is bathed in a cold, abstract light, resting on the massive body as if on a pedestal. In places the fluid turpentine-thinned paint allows the ground and the network of lines sketched in pale blue to show through. The matt quality of the paint, applied in quick strokes, is reminiscent of Degas's pastel portraits of around 1890.

SOURCES: Arsène Alexandre, Paris; Vente *Collection Alexandre*, Galerie Georges Petit, Paris 18–19 May 1903, No. 63; Ambroise Vollard, Paris; Durand-Ruel, Paris; Hugo Moser, Berlin.
BIBLIOGRAPHY: Joyant 1927, p. 258; Paret 1969, Ill.; Dortu II, pp. 238f. P. 409 Ill.; Huisman-Dortu 1973, p. 82 Ill.; Dortu-Méric 1979, II, p. 18 No. 352 Ill.
EXHIBITIONS: Paris 1902, No. 51; Kyoto-Tokyo 1968–1969, No. 14; *Portraits et Figures*, Galerie Beyeler, Basel 1982, No. 102.

Lautrec at work in Monsieur Forest's garden, 1890

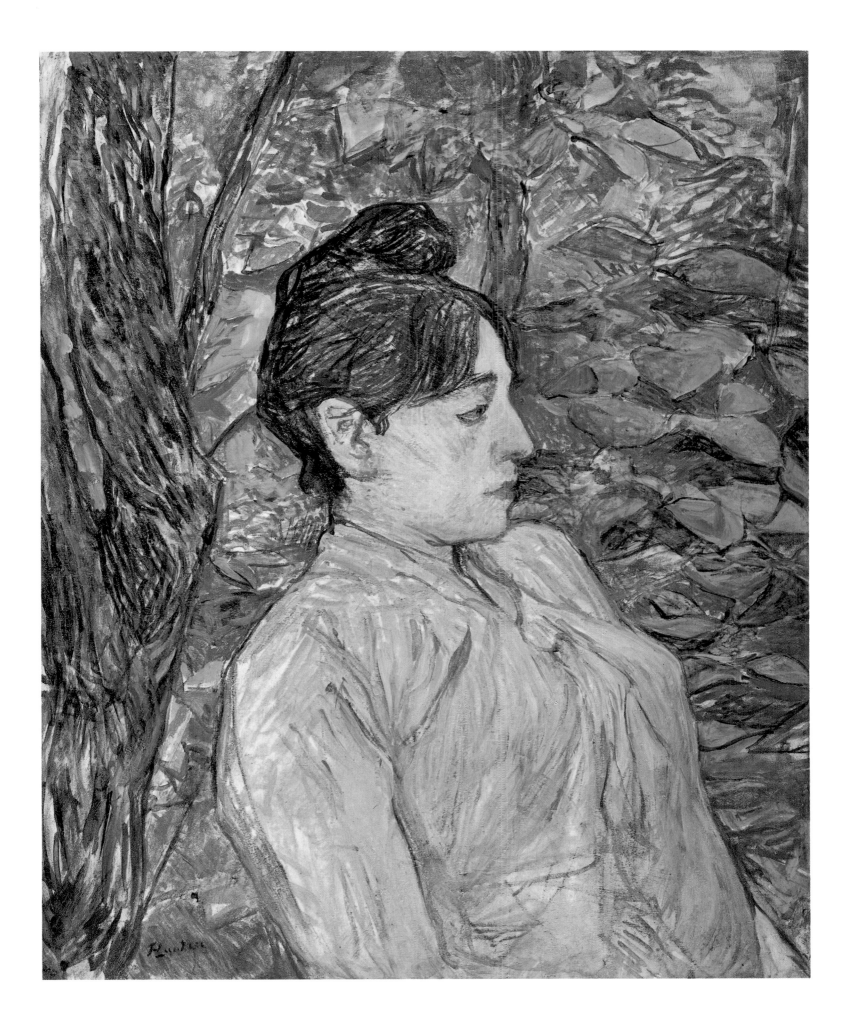

43 Dancer Adjusting her Tights, the First Pair of Tights (Danseuse Ajustant son Maillot, le Premier Maillot) 1890

Dortu II, P. 371
Black chalk and oil on cardboard, 59 × 46 cm
Signed in blue-grey paint, lower left: 'T-Lautrec'
Private Collection, Switzerland

It was mainly between 1885 and 1890 that Lautrec dealt with the theme of dancers in the manner that had been pioneered by Degas.[1] These were the years of his most intensive exploration of Degas's radical aims. Among the results of this exploration are two sketches, complete in every respect, of a young dancer in pink tights, painted on sheets of cardboard of almost identical dimensions. In one of them she is shown with her tutu turned up sitting on a sofa (Dortu II, P. 370), while in the other she is standing holding her raised tutu under her chin and revealing a pair of excessively long, pink legs resting on big feet.

Less than half the card is covered with the thinned oil paint, yet the swiftly sketched composition gives an impression of rich colouring. The exquisite delicacy of the draughtmanship is matched by a sophisticated use of colour, which is as impressive as anything the artist later achieved. His mastery is apparent in the way the formal relationships result from a sparing deployment of line and pigment; from the way plasticity is created by means of a few brushstrokes, and a quite unobtrusive spatial effect achieved by using the greyish brown of the cardboard. The sureness of touch is striking. The sharpness in the handling of the forms and the disciplined balance of colour prevent the picture from slipping into the popular anecdotal genre, current among Degas's imitators. The figure of the ballerina, who is still little more than a child, is also depicted with remarkable psychological empathy. Her long gangly limbs are not yet in proper proportion to her torso, and she is very like the wax statuette of the Petite Danseuse de Quatorze Ans (Paul Mellon, Upperville), created by Degas almost ten years earlier in order to revolutionize received ideas about sculpture.

1 *Cf.* Dortu II, P. 240, P. 241, P. 248, P. 257, P. 262, P. 263, P. 290, P. 309, P. 310, P. 326, P. 370; Dortu V, D. 3093. Not listed in Dortu is a standing dancer in pink tights (signed and dated 1890, lower left), illustrated in Huisman-Dortu 1973, p. 35.

SOURCES: Michael Manzi, Paris; Vente *Collection Manzi*, Galerie Manzi Joyant & Cie., Paris 13–14 March 1919, No. 95; Pierre Decourcelle, Paris; Vente *Collection Pierre Decourcelle*, Hôtel Drouot, Paris 16 June 1926, No. 76; Reynaldo Hahn, Paris; Paul Rosenberg, Paris; Jacob Goldschmidt, Berlin.
BIBLIOGRAPHY: Joyant 1926, p. 93 Ill., p. 269; Joyant 1927, p. 256, p. 261, p. 264; Jedlicka 1929, pp. 186f., p. 391 Ill.; Schaub-Koch 1935, p. 73, p. 178; Lassaigne 1939, Ill. 58; Jedlicka 1943, pp. 150–151 Ill., pp. 153f., p. 318; Jourdain 1948, Ill. 10; Kern 1948, Ill. 10; Jourdain-Adhémar 1952, No. 31 Ill., p. 90, p. 111; Keller 1968, p. 32; Dortu II, pp. 200f. P. 371 Ill.; Dortu V, p. 506 with D. 3093; *Auge und Vision. Die Sammlung Jacques Koerfer*, Bolligen 1972, No. 11 Ill.; Josifovna 1972, Ill. 31; Caproni-Sugana 1977, No. 268 Ill.; Dortu-Méric 1979, I, p. 94 No. 315 Ill.
EXHIBITIONS: Paris 1902, No. 40; Paris 1914, No. 42; Paris 1914 (Galerie Rosenberg), No. 18; *La Danse et la Musique*, Hôtel Charpentier, Paris 1923, No. 41; *Cinquante Ans de Peinture Française*, Musée des Arts Décoratifs, Paris 1925; Bern 1953, No. 128; Vevey 1954, No. 111; Winterthur 1955, No. 197.

114

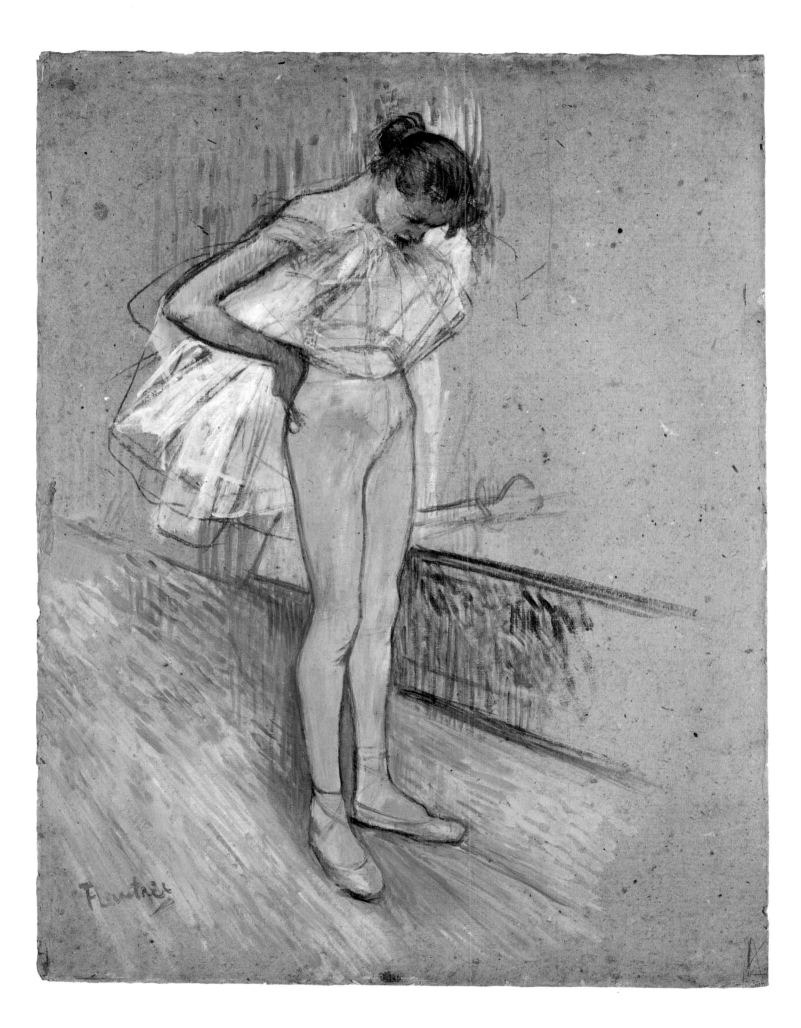

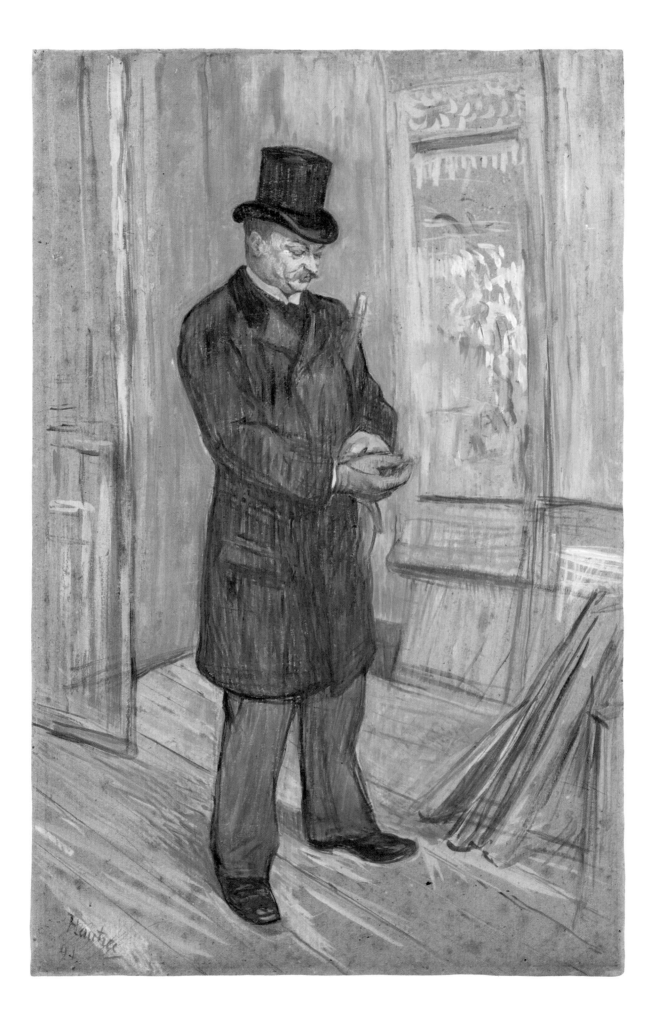

44 MONSIEUR LE DOCTEUR BOURGES 1891

Dortu II, P. 376
Oil on cardboard, 79 × 50.5 cm
Signed and dated in purple paint, lower left: 'T-Lautrec / 91'
Museum of Art, Carnegie Institute (acquired through the generosity of the Sarah
Mellon Scaife family 1966), Pittsburgh

In 1888 Lautrec had painted a full-length portrait of François Gauzi (Dortu II, P. 297) in
which he showed his friend wearing a coat and top hat with his hands in his pockets (cf. Ill.
p. 79), standing at the open double doors that led to the studio in the Rue Caulaincourt.
Three years later the artist took up the idea of this first, relatively large-scale portrait form of
an isolated standing male figure in a studio setting, and produced a total of six pictures of
friends and relations (cf. No. 45).[1] In these he was mainly concerned with capturing a
momentary situation; all the portraits deliberately give the impression that the painter's
companions, still in their hats and coats, have just that instant dropped in to the studio to
keep him from his work.

The same corner of the studio and almost the same viewpoint were chosen for the portraits
of Henri Bourges, Paul Sescau the photographer (Dortu II, P. 383) and the painter's cousin
Louis Pascal (Dortu II, P. 466). The figures are placed on steeply sloping floorboards near the
entrance to the studio beside piles of canvases and portfolios leaning against the wall. On the
right in the background can be seen a Japanese kakemono, a picture scroll with a landscape
motif,[2] which fits particularly well into the narrow, vertical format of the painting. The
spatial setting is suggested only casually by means of an ingenious framework of vertical and
diagonal axes, while the full-length figures are painted with precision, as dark silhouettes
moving against a lighter background.

As a medical student and subsequently, as a physician, Dr Henri Bourges was for many
years a friend of the artist. In 1897 – not without a sideways glance at Lautrec on whom he
constantly urged moderation – he published a much-respected treatise on *L'Hygiène du
Syphilitique*. Lautrec shared an apartment with him in the Rue Fontaine from March 1887 to
the middle of January 1894 when Bourges got married. Shortly after January 1891, when the
two of them moved from No. 19 to No. 21 Rue Fontaine, Lautrec wrote to his mother that
he was working on three portraits of Gaston (Dortu II, P. 410), Louis (No. 45 or Dortu II,
P. 466) and Bourges for the exhibition at the Salon des Indépendants.[3] This portrait of the
imposing Henri Bourges buttoning his gloves was completed in time for the seventh
exhibition at the Salon des Indépendants, held between 20 March and 27 April 1891, and was
exhibited there with other works (see No. 41).

1 Dortu II, P. 376, P. 377, P. 383, P. 410, P. 466, P. 467 (No. 45).
2 A book of accounts kept jointly by Lautrec and Bourges (Goldschmidt-Schimmel 1969, Ill. 34) records the purchase of
 such a kakemono for 37.50 francs in January 1893.
3 *Ibid.*, p. 271.

SOURCES: Henri Bourges, Paris; Knoedler, New York.
BIBLIOGRAPHY: Coquiot 1913, p. 188; Alexandre 1914, p. 4 Ill.; Duret 1920, p. 54; Coquiot 1921, p. 121; Coquiot
(1923), p. 33; Astre (1926), p. 77; Joyant 1926, p. 131, p. 135 Ill., p. 270; Joyant 1927, p. 20, p. 58, p. 63; Joyant 1927 (*L'Art et
les Artistes*), p. 159 Ill.; Jedlicka 1929, p. 149 Ill.; Schaub-Koch 1935, p. 208; Mack 1938, p. 232, p. 258, p. 305; Jedlicka 1943,
pp. 144–145 Ill.; Kern 1948, p. 15, p. 27, Ill. 14; Jourdain 1948, Ill. 14; Jourdain-Adhémar 1952, p. 111; Gauzi 1954, p. 58;
Gustav von Groschwitz, 'Portrait of Dr. Henri Bourges by Toulouse-Lautrec', in: *Carnegie Magazine*, Pittsburgh 1966,
pp. 191 f.; Goldschmidt-Schimmel 1969, p. 17, Ill. 33, p. 124, p. 271; Dortu II, pp. 206 f. P. 376 Ill.; Caproni-Sugana 1977,
No. 272 Ill.; Dortu-Méric 1979, II, p. 12 No. 320 Ill.
EXHIBITIONS: Paris 1891 (Indépendants); Paris 1902, No. 59; Paris 1914, No. 61; Chicago 1979, No. 46, with Nos. 33,
36, 47, 81, 85, 95, 105.

45 MONSIEUR LOUIS PASCAL 1891

Dortu II, P. 467
Oil on cardboard, 81 × 54 cm
Signed in dark blue paint, lower left: 'T-Lautrec'
Musée Toulouse-Lautrec, Albi

In the letter of February 1891 mentioned above, Lautrec wrote that he was busy with the portraits of Gaston (Dortu II, P. 410), Louis and Bourges (No. 44) for an exhibition (i.e., the seventh exhibition of the Salon des Indépendants from 20 March to 27 April).[1] Among the works to be seen there were the portraits of his friends Henri Bourges and Gaston Bonnefoy. The passage in the letter indicates that the portrait of his cousin Louis Pascal must also have been painted early in 1891. In another letter, also written at the beginning of 1891, Lautrec says that he is seeing Louis Pascal daily in order to work on his portrait.[2]

Lautrec painted his cousin twice. The first sketchy version is a full-length back view (Dortu II, P. 466), while the present portrait must represent the final version. Both Joyant and Dortu date the two Pascal portraits to 1893, but a date early in 1891 is indicated by the two letters, as well as on stylistic grounds. In both portraits Louis Pascal posed in front of a light blue painted wall in the same corner of the studio as Henri Bourges (No. 44) and, also in 1891, Paul Sescau the photographer (Dortu II, P. 383). It is unlikely that the artist, whose concern with a specific person, motif, object or setting lasted only short time, should have given a portrait of 1893 an almost identical background to one of 1891.

From the autumn of 1872 Louis Pascal had been a fellow pupil with Lautrec at the Lycée Fontanes in Paris, and at the age of twelve Henri was already describing his cousin as a big, strong, handsome fellow with a beautiful moustache.[3] Later, however, in a letter written to his grandmother on 24 December 1883, he was more critical in his assessment: 'I'm told you enjoyed my handsome friend [bel ami!] Louis's charming ways and patent leather shoes. You ought to find him an heiress and throw her into his arms. He's not much good, I'd say, for anything else.' Shortly after this he wrote, 'Louis Pascal is going to work in the Comptoir [National] d'Escompte [a bank in Paris]. A good place for a likeable old fool to end up in.'[4] Early in 1891, thanks to the recommendation of the Archbishop of Paris, Louis Pascal was able to work for a short time as an insurance agent,[5] until in the summer of 1892 the Pascal family ran into financial difficulties and both Lautrec and his mother felt compelled to come to the aid of their relations.[6]

In this portrait the painter combined all the features that so distinguished his good-looking cousin – and which were so lacking in himself. Pascal the *boulevardier* is shown as a *bon viveur par excellence*, as elegance personified. In his coat and top hat, a cigar in the corner of his mouth and a gold-knobbed stick under his arm, he is standing at the studio door ready to be on his way. It is almost as if the two friends Henri Bourges (No. 44) and Louis Pascal had met in the studio to go out together.

1 Goldschmidt-Schimmel 1969, p. 124 [271].
2 *Ibid.*, p. 124 [270].
3 *Ibid.*, p. 40 [249].
4 *Ibid.*, pp. 76 f. [258].
5 *Ibid.*, pp. 124 f. [271].
6 *Ibid.*, pp. 151 ff. [277 ff.].

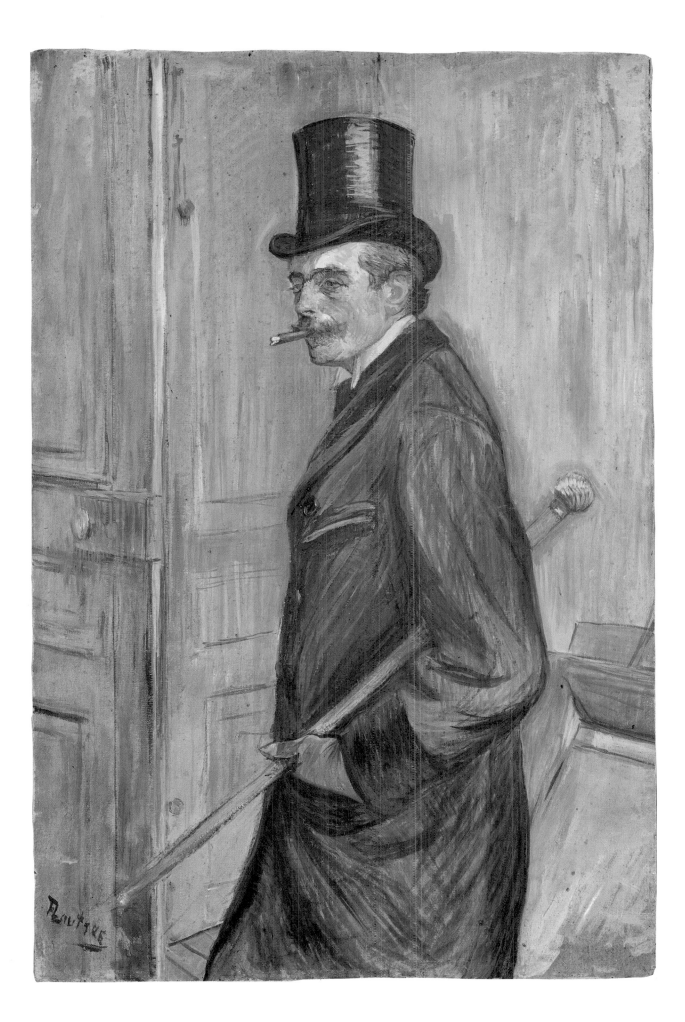

SOURCES: Comtesse Adèle Zoë de Toulouse-Lautrec, Toulouse.
BIBLIOGRAPHY: Astre (1926), p. 76; Joyant 1926, p. 148, p. 177 Ill., p. 277; Joyant 1927, p. 20, p. 58; Lapparent 1927, p. 21, p. 34, p. 37 Ill. 10; Jedlicka 1929, pp. 190ff., p. 386 Ill.; Huyghe 1931, Ill.18; Schaub-Koch 1935, p. 141, p. 209; Mack 1938, p. 260; Mac Orlan 1941, p. 119; Jedlicka 1943, pp. 154–155 Ill., pp. 157ff., p. 283; Vinding 1947, p. 39; Jourdain 1948, Ill. 24; Kern 1948, p. 15, Ill. 24; *Revue du Tarn*, 13, 15 March 1949, p. 8 Ill.; *Toulouse-Lautrec* 1951, Ill.; Bellet 1951, p. 18; London 1951, with No. 19; Natanson 1951, pp. 192–193 Ill.; Jourdain-Adhémar 1952, No. 74 Ill., p. 102, p. 111; Lassaigne 1953, p. 52; Gauzi 1954, p. 25, p. 157; Dortu-Grillaert-Adhémar 1955, p. 36; Perruchot 1958, p. 228; *Toulouse-Lautrec* 1962, p. 70 Ill.; Bouret 1963, p. 141; Zinserling 1964, p. 36, Ill. 13; Cogniat (1966), p. 27 Ill.; Fermigier 1969, p. 62 Ill.; Zenzoku 1970, Ill. 35; Dortu II, pp. 284f. P. 467 Ill.; Devoisins 1972, p. 41; Josifovna 1972, Ill. 102; *Cat. Musée Toulouse-Lautrec* 1973, pp. 51ff. No. 150 Ill.; Caproni-Sugana 1977, Ill. XXXI, No. 331 Ill.; Dortu-Méric 1979, II, p. 26 No. 387 Ill., p. 39 Ill.; Arnold 1982, p. 92 Ill.; *Cat. Musée Toulouse-Lautrec* (1985), pp. 118ff. No. 151 Ill.
EXHIBITIONS: Paris 1914, No. 43; Paris 1931, No. 101; New York 1937, No. 12; London 1938, No. 4; Paris 1938, No. 15; Basel 1947, No. 202; Amsterdam 1947, No. 25; Brussels 1947, No. 25; New York (etc.) 1950–1951, No. 12; Paris 1951, No. 44, with No. 34; Albi 1951, No. 62; Marseilles 1954, No. 9; Philadelphia-Chicago 1955–1956, No. 47; Nice 1957, No. 17; Dallas 1957; Paris 1958–1959, No. 20; London 1961, No. 36; Munich 1961, No. 53; Cologne 1961–1962, No. 53; Kyoto-Tokyo 1968–1969, No. 19; Paris 1975–1976, No. 24; Liège 1978, No. 20; Chicago 1979, No. 47, with Nos. 46, 85; Tokyo (etc.) 1982–1983, No. 29.

46 Woman Combing her Hair (Celle qui se Peigne) 1891

Dortu II, P. 389
Oil on cardboard, 58 × 46 cm
Signed and dated in dark blue paint, lower left: 'T-Lautrec / 91'
Lent by the Visitors of The Ashmolean Museum, Oxford

The motif of a woman combing her hair, which Degas had treated with so many variations in the 1880s and 1890s, suddenly appears in Lautrec's work in 1891, in five figure compositions.[1] It is certainly true that he was inspired by Degas's pictures, such as La Toilette (Ill. p. 298), a pastel drawn in 1883 showing a woman in the same attitude in front of a mirror, which belonged to Joyant's friend and later business partner Michel Manzi at this time. Possibly it was this series of pictures of women combing their hair that the aloof Degas had in mind when he encouraged the young painter in his work, although in fact he did not think very highly of Lautrec's art. Lautrec was very concerned to gain the approval of the artist, whom he admired and took as his model. In September 1891 he wrote to his mother, 'Degas has encouraged me by saying my work this summer wasn't too bad. I'd like to believe it.'[2]

1 Dortu II, P. 374, P. 375, P. 389–P. 391.
2 Goldschmidt-Schimmel 1969, p. 133 [273].

SOURCES: Bernheim-Jeune, Paris; Matthiesen, London; F. Hindley Smith, Oxford.
BIBLIOGRAPHY: Alexandre 1902, p. 18 Ill.; Maurice Hamel, 'Toulouse-Lautrec' in: *Les Arts*, 35, 1904, p. 34 Ill.; Duret 1920, Ill. XVIII; Brook 1923, p. 132 Ill.; Joyant 1926, p. 271; Lassaigne 1939, Ill. 54; Jourdain-Adhémar 1952, No. 56 Ill., p. 111; Dortu II, pp. 222f. P. 389 Ill.; Caproni-Sugana 1977, No. 289 Ill.; Dortu-Méric 1979, II, pp. 13f. Ill.; Chicago 1979, with No. 49.
EXHIBITIONS: Paris 1904; Paris 1908, No. 5; Paris 1914 (Galerie Rosenberg), No. 10; *Französische Kunst des XIX. und XX. Jahrhunderts*, Zurich 1917, No. 245; *Selection of Paintings of different Collections*, The Ashmolean Museum, Oxford 1962, No. 25; New York 1985, No. 138.

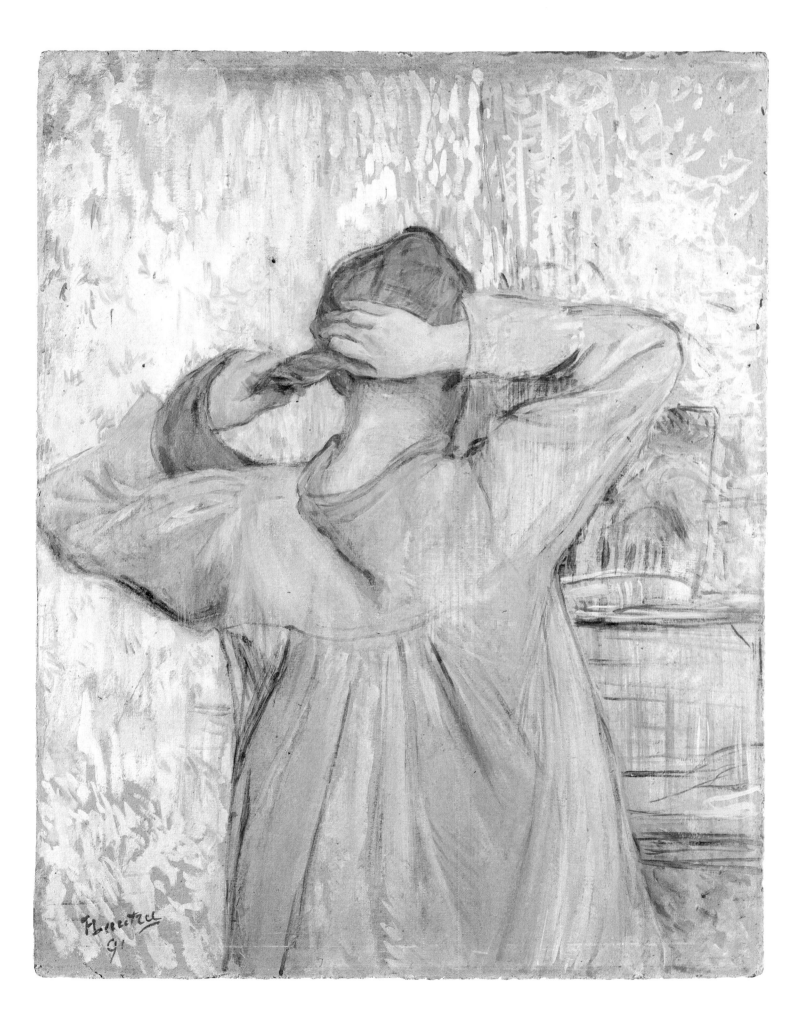

47 La Goulue [the Glutton] and Valentin le Désossé [the Double-jointed] (La Goulue et Valentin le Désossé) 1891

Dortu II, P. 402
Charcoal and oil on canvas, 154 × 118 cm
Inscribed in charcoal, above: 'LA GOULUE TOUS / LES SOIRS'
Musée Toulouse-Lautrec, Albi

This monumental charcoal drawing of a dance scene with La Goulue and Valentin le Désossé was the outcome of a prestigious commission from Charles Zidler, the impresario responsible for the shows at the Moulin Rouge, to design a poster for the beginning of the autumn season 1891 (Ill. p. 310). The risk Zidler was taking, in giving this commission to an artist with no experience in this field, only becomes apparent when one considers that by this date Jules Chéret had already been an important specialist in poster design for several decades.

Lautrec, as the young challenger, must certainly have been aware that he could only compete with the undisputed master in this field – who had recently given of his best in the poster for the opening of the Moulin Rouge in 1889 (Ill. p. 310) – by making full use of Chéret's discoveries in printing techniques, while at the same time adapting them to a completely new stylistic concept, making no concessions to public taste. Lautrec liked the idea of being Chéret's rival in an area which had for long been closed to him for lack of commissions, but which, if he were successful, could bring him far more public recognition and widespread influence than even his occasional magazine illustrations had done.

His astonishing and immediate mastery in the field of printed graphics can be attributed to the fact that Lautrec only turned to this medium at a stage when his artistic skills were fully mature, and his assured draughtsmanship allowed him to experiment on the lithographic stone as he wished. The spontaneous effect of the Moulin Rouge poster, which caused such amazement among critics and passers-by when it was posted on hoardings and walls, as well as indoors, was the result of painstaking preparatory work and detail studies.[1] These culminated in the present charcoal sketch which established the final form and dimensions of the poster in all details. It is characteristic of the artist's methods that he always disciplined his intuitive grasp of the moment by means of a rigorous working process – nothing should be left to chance. In this imposing drawing, with its unmistakeable feeling for the form best suited to its purpose and subject matter, he distilled the essential elements from the various dance scenes with Valentin that he had produced since 1887 (cf. No. 23).[2]

The poster itself eclipsed all that had gone before it. It hammers its short textual message into the viewer by repeating it three times in bright red letters – a technique that has only recently been recognized once again to be particularly effective for advertising purposes. The drawing, however, is largely restricted to the depiction of the figures. Against the dark silhouette of the spectators, reminiscent of East Asian shadow plays, La Goulue, a black moiré ribbon round her neck and her bird-of-prey-like profile picked out in colour, is waving her skirts revealingly at the audience. The provincial girl from Alsace, with her combination of impudence and shamelessness, was described by the magazine *Fin de Siècle* of 26 August 1891 as 'delineating the St Andrew's cross of pleasure' in a wan light that turned night into a false day. The artist sought to exploit this indecency in a striking manner. The floor boards seem to bend under the staccato pounding of the dance, and act as rays, leading the eye steeply upwards to the central figure – the *monstre adorée* whose uncouth charms both delighted and scandalized the Parisians. Pushed right into the foreground is the half-length silhouette of Valentin le Désossé seen in profile against back lighting and cut off by the picture frame. The life-size portrait imposes itself on the viewer with the black elegance of a

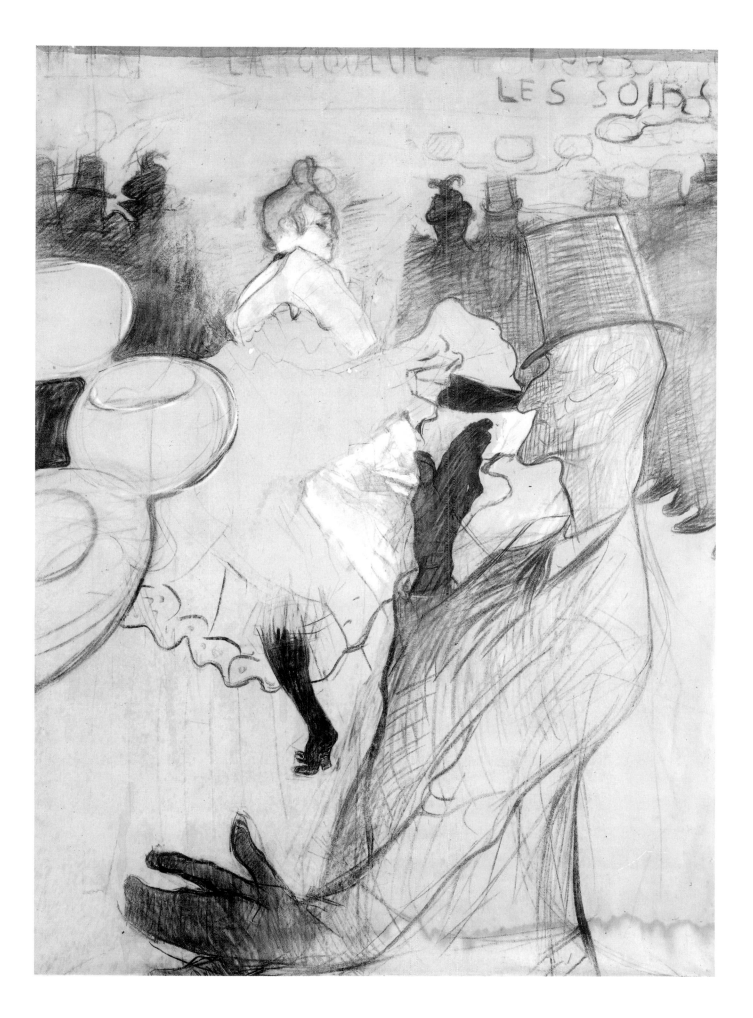

figure from a medieval dance of death. The difference in size between his two enormous hands, gliding past like dark wing-tips, suggests the way in which he is sucked into the picture space.

The infectious enthusiasm of the pair had taken the public by storm. The previously unknown phenomenon of a star representing the reputation of an institution appeared here for the first time and in its most striking form. Whereas Chéret's stereotyped figurines – pert, attractive Pierrots, Columbines and Harlequins – were anonymous enough to be called simply 'Chérettes', Lautrec's poster suddenly confronted the viewer with boldly outlined personalities who existed in their own right and were known to all. This is true in spite of a high degree of abstraction which has the effect of flattening spatial relationships and giving the figures an almost ornamental function, but one which is never allowed to become an end in itself. For Lautrec the simplest, clearest form became the highest virtue, but he remained an interpreter of individuals with their own particular characteristics, which only he could exploit in such a striking manner. With a minimum of artistic means he expresses the characters of the two protagonists, their monomaniac concentration on their performance, extending to their very fingertips and the soles of their shoes. This emphasis on individuality – which precisely because of the stylization never detracts from the formal structure – is the outstanding innovation of all the artist's poster designs.

Lautrec achieved an impression of immediacy and movement by means of an off-centre composition, which gives the effect of a random view. The scene is cut off by the edge of the picture without regard for the composition as a whole or for meaningful connections between the figures, so that some of the truncated elements at the margin of the picture loom larger than the centre of the image. To increase as much as possible the suggestiveness of the image, Lautrec made use of techniques of foreshortening, such as had been pioneered by Daumier and Grandville. Degas in particular, inspired by the Japanese woodcuts that had aroused such enthusiasm in the Paris art world since the 1860s, had tied the space in his compositions closely to the picture surface and bisected groups of interrelated figures apparently at random. His decentralizing methods of composition, with bold foreshortenings, and his organization of space around steep diagonals, were taken up by Lautrec, who developed them further and, particularly in the field of graphics, brought them to their highest perfection.

1 Dortu II, P. 400, P. 401; Dortu V, D. 3202, D. 3219.
2 Dortu II, P. 281, P. 311, P. 361.

SOURCES: Comtesse Adèle Zoë de Toulouse-Lautrec, Toulouse.
BIBLIOGRAPHY: Joyant 1926, p. 273; Joyant 1927, p. 109 Ill.; Lassaigne 1939, pp. 15 f. Ill.; Julien 1942, p. 39 Ill.; Dortu 1952, p. 6 Ill. 21; Jourdain-Adhémar 1952, No. 48 Ill., p. 106; Lassaigne 1953, pp. 42 f. Ill.; Asmodi 1956, Ill.12; Perruchot 1958, p. 188; Focillon 1959, No. 31 Ill.; *Toulouse-Lautrec* 1962, p. 104 Ill.; Zinserling 1964, p. 27, p. 34, Ill. 46; Chastel 1966, Ill. 6; Vienna 1966, with No. 196; Edouard Julien, *Die Plakate von Toulouse-Lautrec*, Monte Carlo 1967, p. 6 Ill.; Keller 1968, p. 37, p. 74, p. 88 Ill.; Fermigier 1969, p. 104 Ill.; Novotny 1969, p. 39 Ill. 22; Lassaigne 1970, Ill. 27; Devoisins 1970, p. 50; Zenzoku 1970, No. 7; Dortu II, pp. 234 f. P. 402 Ill.; Devoisins 1972, p. 37; Polasek 1972, p. 34, No. V Ill.; *Cat. Musée Toulouse-Lautrec* 1973, p. 41 Ill., pp. 43 f. No. 137; Muller 1975, Ill. 19; Adriani 1976, p. 36 Ill., p. 254 with 1; Caproni-Sugana 1977, No. 287 a Ill.; Adriani 1978, p. 80; Dortu-Méric 1979, II, p. 16 No. 345 Ill.; Devoisins 1980, p. 55 Ill.; Morariu 1980, Ill. 17; Henze 1982, p. 49, p. 52 Ill., p. 58; *Cat. Musée Toulouse-Lautrec* (1985), pp. 110 f. No. 138 Ill.; Adriani 1986, with 1.
EXHIBITIONS: Paris 1931, No. 75; New York (etc.) 1950–1951, No. 8; Paris 1951, No. 33, with Nos. 15, 32, 60; Albi 1951, No. 50; Philadelphia-Chicago 1955–1956, No. 34; Paris 1958–1959, No. 13; London 1961, No. 27; Munich 1961, No. 43; Cologne 1961–1962, No. 43; Albi-Paris 1964, No. 38; Paris 1975–1976, No. 17.

48 A Tonsil Operation, Dr Jules Emile Péan (Une Opération aux Amygdales) 1891

Dortu II, P. 384
Oil on cardboard, 73.9 × 49.9 cm
Red monogram stamp (Lugt 1338), lower left
Sterling and Francine Clark Art Institute (Cat. No. 567 [R.S.C. 1938]), Williamstown

Gabriel Tapié de Céleyran, Lautrec's cousin, had come to Paris in the autumn of 1891 to continue his medical studies by attending the lectures given by the surgeon Dr Jules Emile Péan (1830–1898) at the Hôpital Saint-Louis (see No. 130). In his time, Péan was regarded as the leading surgeon in Paris. Léon Daudet who began his career as a doctor, described him as 'a virtuoso of the knife, who amputates three legs and two arms one after the other, . . . dismantles a couple of shoulders, trepans five crania, takes out half a dozen wombs and cuts off a few testicles. He works like this for about two hours. He is dripping with blood and sweat. From his hands the blood runs down in streams. His feet stand in pools of blood. The patients are moved swiftly and hurriedly away under his arms. Forceps and other instruments are still sticking out of their open bodies. The sight is so gruesome that when they are admitted to such operations for the first time students throw up . . . Heaps of stumps and lumps of flesh lie around – and in the midst of them Péan continues calmly with his operations.[1]

When scenes of hospitals and operations became increasingly popular from the mid-1870s onwards, Henri Gervex, a leading figure at the Salon and a specialist in female nudes, turned his attention to the subject. The vast canvas he painted in 1887 – its dimensions would have honoured any history painting – showed Péan in the attitude of a Roman orator lecturing to an attentive audience at the sick-bed of a beautiful young woman (see Ill. below). Its iconography is in the tradition of the type of anatomy lecture picture established in the Renaissance. It is scarcely credible that only a few years lie between this overgrown image of success, which received much attention at the Salon, and Lautrec's representation of the excellent surgeon who apparently had no objection to being shown in action.

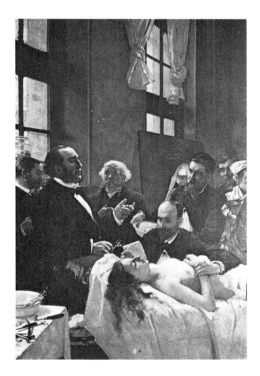

Henri Gervex, Dr Péan at the Hôpital Saint Louis, 1887,
formerly Musée du Luxembourg, Paris

Gervex's conventional figure painting is more concerned with the lovingly modelled charms of the attractive patient than with the actual conditions in the operating theatre. The fact that the emotively gesticulating Péan is the most important participant in the picture is given particular emphasis by the haemostatic Péan clamp that he holds as an attribute in his right hand. The conception of Lautrec's picture is quite different; it is concentrated exclusively on the surgeon as he performs his professional duties.[2] The patient is indicated in only a few lines; his face, stiffened into a pale, wax-like mask and dominated by a tortured, wide-open mouth and a bony lower jaw, is merely the object on which the doctor practises his craft. The surgeon is clearly not much bothered with sterile conditions: he is working in his jacket and his only protection – more for the sake of his clothes than for the good of the patient – is a white napkin tied round his neck. Only on closer inspection does it become apparent that the dark shape projecting into the picture on the right is the strangely abstracted silhouette of the back of a head and a shoulder, which clarifies the subtle spatial interaction of the figures. Only Daumier could have presented such a subject so suggestively, with the patient's mouth offered up in this helpless way to the skills of the doctor.

Lautrec liked the atmosphere of hospitals and the doctors who worked in them. He had been made familiar with this world through Henri Bourges and Gabriel Tapié de Céleyran and was a regular spectator of Péan at both the Hôpital Saint-Louis and, after 1892, at his newly founded Hôpital International in the Rue de la Santé. One of Péan's assistant doctors reported a remark by Lautrec: 'If I were not a painter I should like to be a doctor and a surgeon.'[3] The artist regarded Péan as the master of his art. In the operating theatre he was always armed with a small note-pad, and would keep as close as possible to the surgeon and his assistants in order to give as full an account as possible of events – almost like a news photographer. There are no less than 45 sketches in ink and pencil showing the tense features of Péan with his fashionable side-whiskers, his vigorous, stocky figure, his posture as he operated, his movements and gestures in his lectures, etc.[4] Only three drawings, however, are related directly to this painting of an operation.[5] The series of small sketches – which survive thanks to the prudence of Gabriel Tapié – reveal the long, painstaking method by which the artist, obsessed with detail, felt his way towards an understanding of a person, of his idiosyncrasies and the style of his appearance, before distilling these into an apparently spontaneous picture.

1 Jedlicka 1943, p. 91.
2 *Cf.* the operation scene Dortu II, P. 385.
3 N.L. Baragnon, 'Toulouse-Lautrec chez Péan', *Chronique Médicale*, 15 February 1902.
4 Dortu V, D. 3154–D. 3175, D. 3177–D. 3185, D. 3187–D. 3191, D. 3195a, D. 3195b, D. 3197, D. 3198; Dortu VI, S.D. 17–S.D. 19.
5 Dortu V, D. 3165b, D. 3181, D. 3182.

SOURCES: Gabriel Tapié de Céleyran, Albi; M. G. Dortu, Paris; Knoedler, Paris; R. S. Clark, Williamstown.
BIBLIOGRAPHY: Pigasse 1907, p. 33; Alexandre 1914, p. 15; Duret 1920, p. 52; Coquiot 1921, p. 124; Astre (1926), p. 82; Joyant 1926, p. 133 Ill., p. 271; Joyant 1927 (*L'Art et les Artistes*), p. 156 Ill.; Lapparent 1927, p. 63 Ill. 6; Jedlicka 1929, pp. 118f. Ill.; Schaub-Koch 1935, p. 194; Mack 1938, p. 235 Ill., p. 258; Lassaigne 1939, p. 21, Ill. 80, p. 166; Jedlicka 1943, pp. 90–91 Ill., pp. 95f., p. 316; Jourdain-Adhémar 1952, p. 52, No. 41 Ill., p. 102, p. 111; Lassaigne 1953, p. 54; Cooper 1955, p. 28 Ill.; Dortu-Grillaert-Adhémar 1955, p. 33, Ill. 8; Perruchot 1958, p. 194, pp. 224–225 Ill.; 'The Berkshire Trove of Toulouse-Lautrec', in: *Art News*, March 1960, pp. 32f. Ill.; *Toulouse-Lautrec* 1962, p. 62 Ill.; Keller 1968, p. 32, p. 34, p. 48, p. 86 Ill.; Dortu II, pp. 214f. P. 384 Ill.; Polasek 1972, p. 33; Hans Schadewaldt (et al), *Kunst und Medizin*, Cologne 1974, p. 241, Ill. 225; Caproni-Sugana 1977, No. 283 Ill.; Axel Hinrich Murken – Christa Murken, ' "Wenn ich nicht Maler wäre, möchte ich Arzt sein . . .", Operationsszenen in der Malerei von 1875–1975', in: *Die Waage*, 3, 16, 1977, p. 115 Ill., p. 117; Axel Hinrich Murken, 'Die Einführung anti- und aseptischer Operationsverfahren in Spiegel der bildenden Kunst von 1875 bis 1912', in *Medizinische Monatsschrift*, 31, 5 May 1977, p. 221, p. 223; Arnoldo Cherubini, *Il Medici scrittori dal XV. al XX. Secolo*, Rome 1977, p. 295 Ill.; Adriani 1978, pp. 102f. Ill. 19; Chicago 1979, pp. 26f. Ill., with No. 109; Dortu-Méric 1979, II, pp. 12ff. No. 328 Ill.; Sakai 1979, Ill. 30; Bernard S. Moskow, *Art and the Dentist*, Tokyo 1982, pp. 258f. Ill.; New York 1985, p. 38.
EXHIBITIONS: Brussels 1902, No. 276; Paris 1902, No. 19; Paris 1914, No. 71; Paris 1938, No. 11; *French Paintings of the 19th Century*, Sterling and Francine Clark Art Institute, Williamstown 1956, No. 131; Williamstown 1960, No. 4; *Treasures from the Clark Art Institute*, Galerie Wildenstein, New York 1967, No. 51.

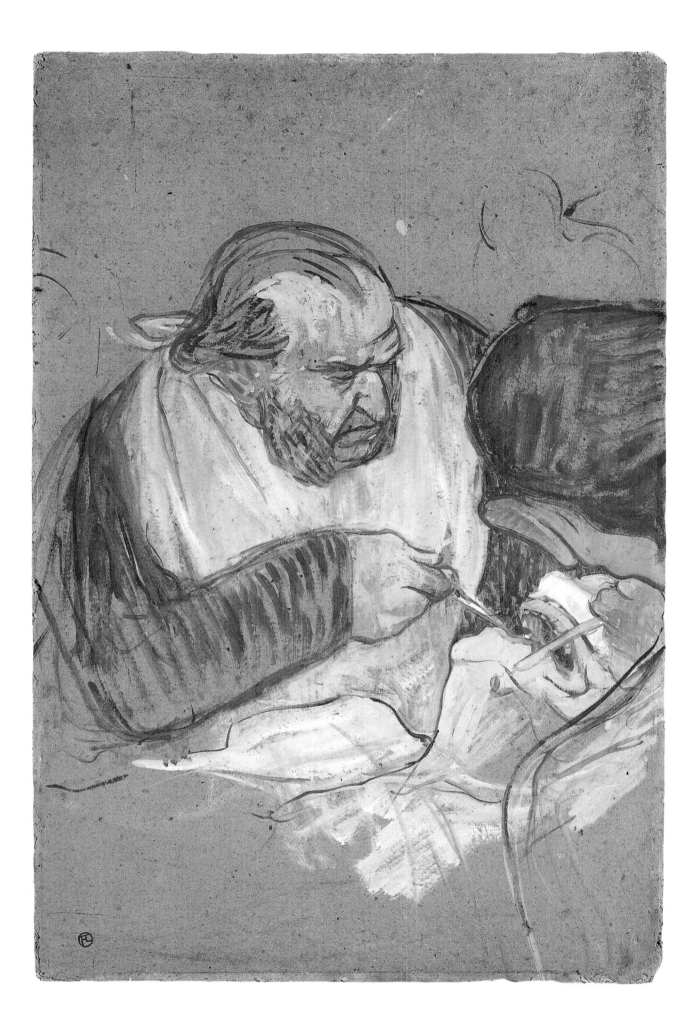

49 Mr Warrener at the Moulin Rouge (Au Moulin Rouge, M. Warrener) 1892

Dortu II, P. 426
Oil on cardboard, 57.3 × 45.3 cm
Red monogram stamp (Lugt 1338), lower right
Musée Toulouse-Lautrec, Albi

After the success of Lautrec's huge Moulin Rouge poster on the walls of Paris (see No. 47), the winter season 1891–1892 was dominated, for him, by the dance-hall and its habitués. Most of his famous paintings showing the dancers La Goulue and Jane Avril, with the friends and hangers-on of this remarkable Montmartre rendez-vous, date from this brief period.[1] Among the regular guests at the Moulin Rouge was the painter William Tom Warrener (1861–1934) from Lincoln. The technique of this portrait, showing his face in three-quarter view, is closer to drawing than painting, and the underpainting shows through as a dense network of brown lines. Together with a small ink sketch (Dortu V, D. 3229), it was a study for the painting L'Anglais au Moulin Rouge (Dortu II, P. 425), in which the Englishman is shown in conversation with two young female visitors. The painting was in turn used as the basis for one of Lautrec's first two printed graphics, which were put on sale in a limited edition of one hundred signed copies in October 1892.[2] Whether this portrait sketch of early 1892 and the painting that followed it were originally conceived with their translation into the smaller size of a coloured lithograph already in mind, remains an open question. In view of the particular topicality of Moulin Rouge subjects at that time, it could be that Maurice Joyant, Theo van Gogh's successor as a partner of the art dealers Boussod and Valadon at 18 Boulevard Montmartre, who commissioned the lithograph from his old friend, encouraged the artist to make his pictures more widely known by issuing them as prints. The intense colour and verve of the portrait study are transformed into a highly decorative effect in the lithograph; the outlines are sharp and the colouring reduced to a few boldly arranged areas of tone.

It can be shown that the number of drawings and paintings rose dramatically in connection with the graphic work which began in 1891–1892. The amount of give and take between drawing, painting and printed graphics is an indication of the extent to which the artist was able to transfer a motif from one medium to another obeying different rules, without any loss of substance. His sure sense of the individual character of each technique meant that he could leave the painterly draughtsman-like brushwork for the more restricted opportunities offered by printed graphics, and adapt the spontaneously drawn contour to the requirements of the graphic line.

1 Dortu II, P. 399, P. 414, P. 417, P. 421–P. 428.
2 Adriani 1986, 7.

SOURCES: Comtesse Adèle Zoë de Toulouse-Lautrec, Toulouse.
BIBLIOGRAPHY: Joyant 1926, p. 139 Ill., p. 275; Joyant 1927 (*L'Art et les Artistes*), p. 154 Ill.; Schaub-Koch 1935, p. 208; Mac Orlan 1941, p. 120; Jourdain (1951), Ill. 3; Natanson 1951, pp. 136–137 Ill.; Lassaigne 1953, p. 50 Ill.; Landolt 1954, with No. 4; Julien (1959), p. 33; Huisman-Dortu 1964, p. 91 Ill. (Detail); Cogniat (1966), p. 13 Ill. (Detail); Vienna 1966, with No. 68; Keller 1968, p. 15 Ill., p. 38; Cionini-Visani 1968, Ill. 29; Fermigier 1969, p. 83 Ill.; Novotny 1969, p. 18, Ill. 37; Devoisins 1970, p. 49; Dortu II, pp. 256f. P. 426 Ill.; *Cat. Musée Toulouse-Lautrec* 1973, p. 45 Ill., p. 48 No. 143; Huisman-Dortu 1973, p. 79 Ill.; Adriani 1976, p. 254 with 4; Caproni-Sugana 1977, No. 301b Ill.; Keller 1980, Ill. 62; Henze 1982, p. 69 Ill.; Lucie-Smith 1983, No. 14 Ill., with No. 15; *Cat. Musée Toulouse-Lautrec* (1985), p. 113 Ill., p. 115 No. 144; Adriani 1986, with 7.
EXHIBITIONS: Venice 1948, No. 75b; New York (etc.) 1950–1951, No. 10; Paris 1951, No. 40; Albi 1951, No. 56; Marseilles 1954, No. 10; Philadelphia-Chicago 1955–1956, No. 37; Dallas 1957; Paris 1958–1959, No. 17; London 1961, No. 33; Munich 1961, No. 47, with No. 121; Cologne 1961–1962, No. 47, with No. 121; Kyoto-Tokyo 1968–1969, No. 17; Paris 1975–1976, No. 19; Liège 1978, No. 18; Tokyo (etc.) 1982–1983, No. 27.

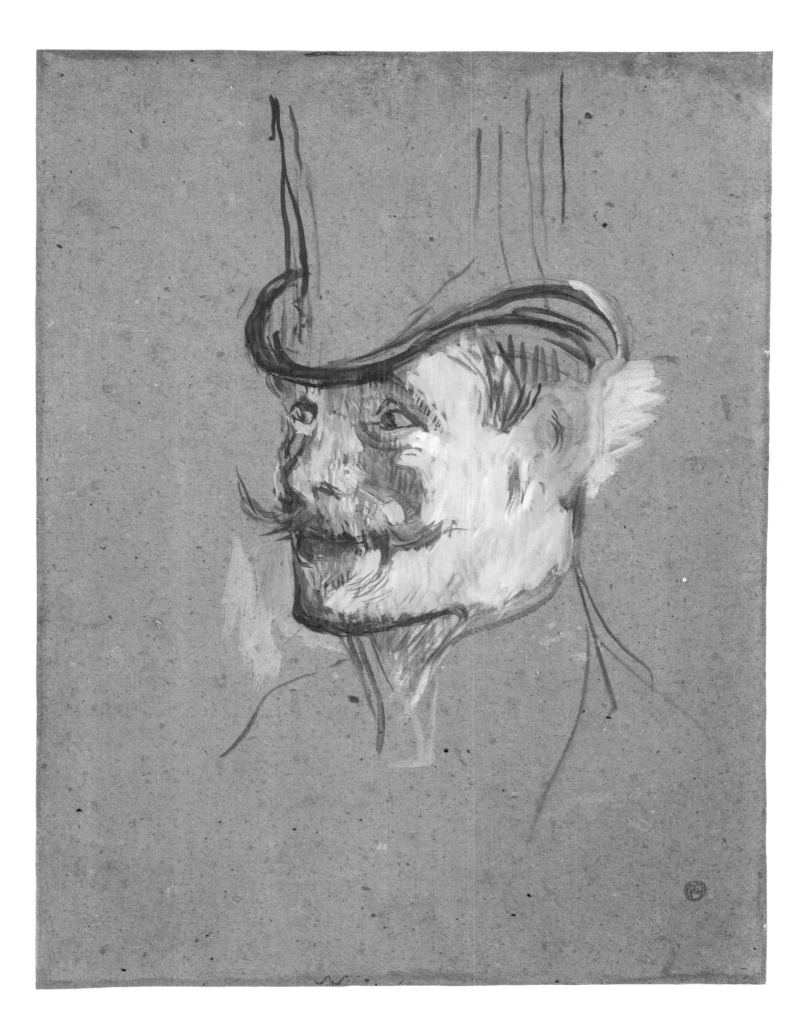

50 JANE AVRIL, THE EXPLOSIVE (JANE AVRIL, LA MÉLINITE) 1892

Dortu II, P. 415
Oil on cardboard, 86.5 × 65 cm
Musée Toulouse-Lautrec, Albi

This exaggerated dancing figure emerges from a tangle of radiant blue lines and brushstrokes, with touches of yellow. She stands out against the plain cardboard ground with the addition of a little grey. There are just a few red-brown marks to act as guidelines for the network of swift combinations of strokes. The faceless, yet by no means anonymous figure is all movement. Jane Avril (1868–1943) is shown as an isolated figure, unimpeded by any indications of spatial setting.[1]

Of all his models, the one Lautrec portrayed most often from 1890 onwards was the witty Jane Avril (cf. No. 51), the ever melancholy *fin de siècle* heroine whose beauty Arthur Symons, the English poet and a regular guest at the Moulin Rouge, described as having 'an air of depraved virginity'.[2] It was wise of her to make use of her friend's creative ability, and she stood by him to the end – even in 1899, his most difficult time, she gave him a commission for a poster (see No. 121). The offspring of a liaison between La Belle Elise, one of the *grandes horizontales* of the Second Empire, and the Marchese Luigi de Font, she had her greatest triumphs under the name of La Mélinite with her wild dances, following the example set by Kate Vaughan, at the Jardin de Paris, the Casino de Paris, the Moulin Rouge and the Folies Bergère. She put her heart and soul into her dancing; her legs were inspired, moving 'like orchids in a frenzy', according to the newspapers. Her interest in literature, her refined tastes and the restraint of her manner set her agreeably apart from the lewdness of her rivals at the Moulin Rouge.

1 She appears in a similar attitude in the background of the painting LA PROMENADE AU MOULIN ROUGE (Dortu II, P. 399), and as the main figure in the narrow vertical painting JANE AVRIL DANSANT (Dortu II, P. 416).
2 Perruchot 1960, p. 155.

SOURCES: Comtesse Adèle Zoë de Toulouse-Lautrec, Toulouse.
BIBLIOGRAPHY: Joyant 1926, p. 274; Huisman-Dortu 1964, p. 100 Ill.; Fermigier 1969, p. 136 Ill.; Dortu II, pp. 244f. P. 415 Ill.; Polasek 1972, p. 39, No. VII Ill.; *Cat. Musée Toulouse-Lautrec* 1973, pp. 49f. No. 147 Ill.; Muller 1975, Ill. 29; Caproni-Sugana 1977, No. 319 Ill.; Morariu 1980, Ill. 21; *Cat. Musée Toulouse-Lautrec* (1985), pp. 116f. No. 148 Ill.
EXHIBITIONS: Munich 1961, No. 48; Cologne 1961–1962. No. 48.

51 JANE AVRIL 1892

Dortu II, P. 484
Oil on cardboard, 66.8 × 52.2 cm
Red monogram stamp (Lugt 1338), lower left
Musée Toulouse-Lautrec, Albi

One of the secrets of Lautrec's portraiture is the way in which he – like Degas – leaves many of his faces invisible, trusting to the elegance of the posture, details in the outlines of the figure or the distinctive design of a hat, to ensure that the person is sufficiently identifiable (*cf.* Nos. 38, 55).[1] Joyant's 1393 date for this back view of Jane Avril, wearing a large bonnet and holding a glass in her right hand, should be revised. Early in 1892 Lautrec developed this motif of a seated figure – though in reverse – in a poster design for Aristide Bruant's appearance at the Ambassadeurs (Ill. p. 313). This first design (which was finally rejected, probably because it was too closely related to Steinlen's illustration for the title page of a Bruant chanson published in 1888)[2] showed Jane Avril at Bruant's feet in almost identical pose and dress. Such a long interval of time separating two such closely matched figures would be completely out of key with the artist's usual working methods.

1 *Cf.* the pictures of Jane Avril Dortu II. P. 428, P. 478, P. 479, P. 485; Dortu V, D. 3338, among others.
2 Adriani 1976, Ill. p. 42.

SOURCES: Comtesse Adèle Zcë de Toulouse-Lautrec, Toulouse.
BIBLIOGRAPHY: Joyant 1926, p. 279; Lapparent 1927, p. 35; Schaub-Koch 1935, p. 208; *Toulouse-Lautrec* 1951, Ill.; Jourdain (1951), Ill. (Jacket); Jourdain-Adhémar 1952, p. 52, No. 59 Ill., p. 86; Dortu-Grillaert-Adhémar 1955, p. 36; Dortu II, pp. 296f. P. 484 Ill.; Josifovna 1972, Ill. 53; *Cat. Musée Toulouse-Lautrec* 1973, p. 50 with No. 147, p. 55 No. 154, p. 57 Ill.; Muller 1975, Ill. 31; Caproni-Sugana 1977, No. 329a Ill.; Dortu-Méric 1979, II, p. 32 No. 401 Ill.; *Cat. Musée Toulouse-Lautrec* (1985), pp. 122f. No. 156 Ill.
EXHIBITIONS: Paris 1914, No. 190; New York 1937, No. 13; London 1938, No. 5; Paris 1938, No. 16; Basel 1947, No. 139; Amsterdam 1947, No. 30; Brussels 1947, No. 30; New York (etc.) 1950–1951, No. 14; Paris 1951, No. 46; Albi 1951, No. 66; Philadelphia-Chicago 1955–1956, No. 46; Munich 1961, No. 56; Cologne 1961–1962, No. 56; Paris 1975–1976, No. 21; Tokyo (etc.) 1982–1983, No. 30.

52 QUEEN OF JOY (REINE DE JOIE) 1892

Dortu V, D. 3225
Blue and red chalk on white paper, 20 × 10.8 cm
Red monogram stamp (Lugt 1338), lower left
Private Collection, Basel

See No. 53

SOURCES: Musée Toulouse-Lautrec, Albi (?).
BIBLIOGRAPHY: Joyant 1927, p. 198; Dortu V, pp. 532f. D. 3225 Ill.; Adriani 1976, p. 254 with 7; Adriani 1986, with 5.

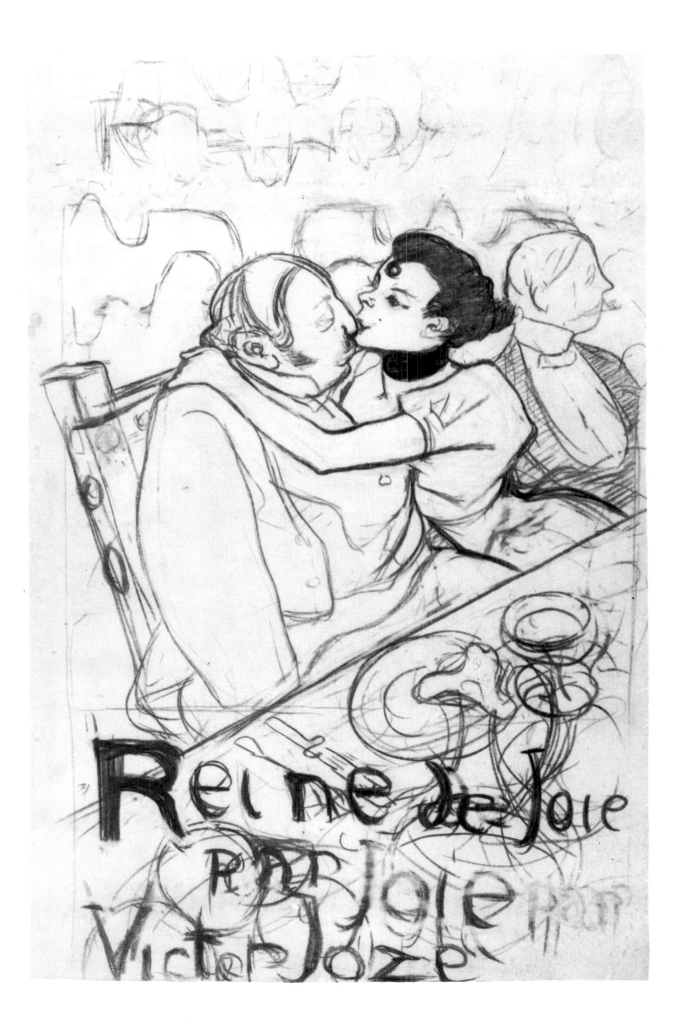

53 QUEEN OF JOY (REINE DE JOIE) 1892

Dortu V, D. 3224
Charcoal on canvas, 152 × 105 cm
Inscribed in charcoal, below: 'Reine de Joie / par / Victor Joze'
Musée Toulouse-Lautrec, Albi

The Polish writer Victor Joze, otherwise known as Victor Dobrsky, asked his friend Lautrec – who was no longer unknown as a poster designer – for a large colour poster to advertise his book *Reine de Joie, Mœurs du Demi-Monde*, published by Henry Julien.[1] On 4 June 1892 the *Fin de Siècle* magazine, edited by Joze, reported the appearance of this very idiosyncratic composition which was also reproduced as the title page of the issue. As with the Moulin Rouge poster (see No. 52), a full-size charcoal drawing based on a small coloured chalk sketch (No. 52) was prepared. It gave the printer an exact idea of the desired effect of the end result and could be easily transferred to the two lithographic stones required for printing.

The appearance of the poster and the anti-Semitic book in the series *La Ménagerie Sociale* created a scandal. The episode illustrated shows the ironic motif of a dissimilar pair of lovers current since the Renaissance. The heroine, Hélène Roland, is shown kissing the lecherous Olizac during a sumptuous meal (in fact Lautrec portrayed Georges Lasserre and Luzarche d'Azay). Baron Rothschild, however, believing the main character in the novel to be an unflattering portrait of himself, intervened and the edition was confiscated. This could not stop the editors of the *Fin de Siècle* issuing what remained of the edition, and did not prevent the magazine *En Dehors* from mentioning the poster on 10 July 1892.

1 Adriani 1986, 5

SOURCES: Comtesse Adèle Zoë de Toulouse-Lautrec, Toulouse.
BIBLIOGRAPHY: Joyant 1927, p. 198; Jedlicka 1929, p. 291; Jedlicka 1943, p. 323; Focillon 1959, No. 32 Ill.; Zinserling 1964, p. 31 Ill. 45; Vienna 1966, with No. 198; Keller 1968, p. 69 Ill.; Dortu V, pp. 530f. P. 3224 Ill.; Polasek 1972, No. 28 Ill.; *Cat. Musée Toulouse-Lautrec* 1973, p. 125 Ill., p. 127 No. D. 85; Adriani 1976, p. 46 Ill., p. 254 with 7; Lucie-Smith 1983, Ill. 13; *Cat. Musée Toulouse-Lautrec* (1985), p. 194 Ill., pp. 200f. No. D. 98; Adriani 1986, with 5.
EXHIBITIONS: Paris 1931, No. 206; Nice 1957, No. 38; Paris 1958–1959, No. 62; London 1961, No. 78; Munich 1961, No. 106; Cologne 1961–1962, No. 106; Stockholm 1967–1968, No. 55 A; Humlebaek 1968, No. 56; Paris 1975–1976, No. 54.

54 BRUANT ON A BICYCLE (BRUANT À BICYCLETTE) 1892

Dortu II, P. 411
Oil on cardboard, 74.5 × 65 cm
Red monogram stamp (Lugt 1338), lower right
Musée Toulouse-Lautrec, Albi

A brilliant deep blue came to be used increasingly for figure studies in 1892. It was applied in long, fluid brushstrokes, mainly to give a sure outline to figures and objects, while

particularly important parts of the picture were accentuated in other colours. Lautrec used this technique up until his late period to capture a spontaneous idea and get it quickly down on paper; then, he would work on it until only a few outlines and shadows of the underlying blue structure of the figures remained visible.

These rapid brushstrokes are ideal for conveying an impression of the momentum of Aristide Bruant seated majestically on his bicycle (*cf.* Nos. 22, 59). Bruant chose to be depicted as a sporting cyclist rather than in his role as a popular chansonnier already well known throughout Paris. This may be because cycling had become a fashionable sport after J. B. Dunlop's invention of the pneumatic rubber tyre in 1889. The velodromes were meeting places for elegant society, *cyclomanes* thronged the streets and even society ladies peddled through the Bois wearing baggy trousers. Perhaps Lautrec was thinking of turning this unusual motif into a poster. The posters he designed in 1892–1893 were mostly for Bruant; no less than four posters for his appearances at the Ambassadeurs, the Eldorado etc. date from this time.[1] It could be that this subject did not correspond to the ideas of his friend and patron, who preferred to see himself placed in a scene with impressive monumentality (Ill. pp. 147, 313).

1 Adriani 1986, 3, 4, 12, 57.

SOURCES: Comtesse Adèle Zoë de Toulouse-Lautrec, Toulouse.
BIBLIOGRAPHY: Joyant 1926, p. 273; Jedlicka 1929, p. 159 Ill.; Lassaigne 1939, p. 13 Ill.; *Toulouse-Lautrec* 1951, Ill. (Jacket); Dortu 1952, p. 6 Ill. 24; Jourdain-Adhémar 1952, p. 111; Natanson 1951, pp. 160–161 Ill.; *Toulouse-Lautrec* 1962, p. 14 Ill.; Bouret 1963, p. 67; Huisman-Dortu 1964, pp. 180–181 Ill.; Fermigier 1969, p. 120 Ill.; Dortu II, pp. 240f. P. 411 Ill.; Polasek 1972, p. 39, No. VI, Ill.; *Cat. Musée Toulouse-Lautrec* 1973, p. 45 Ill., p. 47 No. 141; Muller 1975, Ill. 48; Caproni-Sugana 1977, No. 295 Ill.; Dortu-Méric 1979, II, p. 18 No. 354 Ill.; *Cat. Musée Toulouse-Lautrec* (1985), pp. 113f. Ill. No. 142.
EXHIBITIONS: Paris 1914, No. 114; Paris 1931, No. 96; Paris 1951, No. 35; Albi 1951, No. 54.

55 RED-HAIRED WOMAN, BACK VIEW (FEMME ROUSSE VUE DE DOS) 1892–1893

Dortu II, P. 404
Oil on cardboard, 78 × 59.7 cm
Red monogram stamp (Lugt 1338), lower left
Musée Toulouse-Lautrec, Albi

Since the early 1870s Degas had perfected a form of picture related to views of ballet performances seen from theatre boxes, in which the viewer looks past the backs of large figures towards a fragmented view of the dancing in the bright background beyond.[1] Almost twenty years later Lautrec made use of this element of tension between the monumental truncated figure in the foreground and the abrupt recession into space, which further confirms the viewer's function as eye witness. In the same way he juxtaposed the near spectators and the distant performers in the large-scale painting on cardboard AU NOUVEAU CIRQUE, LA CLOWNESSE AUX CINQ PLASTRONS (Ill. p. 312).[2] This unusual image was inspired by the ballet *Papa Chrysanthème* which was performed at the Nouveau Cirque from November 1892, with great success. The circus ring was specially transformed into a lake

with artificial water-plants floating on it. In the middle of this lake the leading actress danced a solo in the manner of Loïe Fuller (see No. 56). The ballet gave rise to several sketches.[3] The present painting of a woman's back can be related directly to the woman spectator with the lorgnon in the almost cloisonné-like final version. To the right of her head the outline of a dancer leaning back in a broad arc is shown, as in the final painting, and the dabs of blue suggest the surface of the water.

Joyant and Dortu dated the two paintings of the woman spectator to 1891 (though it was not until the autumn of 1892 that the first performance took place), but dated the ballet scenes to 1892 and 1893. Since Lautrec was usually one of the first to attend such extravagant productions, the figure study – judging by the winter clothing – must have been painted in the autumn of 1892 or early in 1893.

1 P. A. Lemoisne, *Degas et son Œuvre*, Paris, 1946, II–III, 295, 476, 577, 737, 828, 829.
2 Similar compositional principles are found in the drawing Dortu VI, D. 4180, and – in the field of printed graphics – in the poster for Jane Avril, DIVAN JAPONAIS, and the two lithographs UNE SPECTATRICE and BRANDÈS DANS SA LOGE (Adriani 1986, 8, 25, 66).
3 Dortu II, P. 430, P. 431, P. 515.

SOURCES: Comtesse Adèle Zoë de Toulouse-Lautrec, Toulouse.
BIBLIOGRAPHY: Joyant 1926, p. 273; *Toulouse-Lautrec* 1951, Ill.; Landolt 1954, with No. 24; *Toulouse-Lautrec* 1962, p. 52 Ill.; Bouret 1963, p. 63; Fermigier 1969, p. 75 Ill.; Dortu II, pp. 234f. P. 404 Ill.; *Cat. Musée Toulouse-Lautrec* 1973, p. 41 Ill., p. 44 No. 139, p. 46; Caproni-Sugana 1977, No. 292 Ill.; Dortu-Méric 1979, II, p. 18 No. 347 Ill.; *Cat. Musée Toulouse-Lautrec* (1985), p. 110 Ill.; p. 112 No. 140.
EXHIBITIONS: Paris 1914, No. 2; New York (etc.) 1950–1951, No. 11; Paris 1951, No. 31; Albi 1951, No. 52; Philadelphia-Chicago 1955–1956, No. 30; Nice 1957, No. 15; Paris 1958–1959, No. 15; London 1961, No. 28; Munich 1961, No. 45; Cologne 1961–1962, No. 45; Kyoto-Tokyo 1968–1969, No. 15; Liège 1978, No. 16; Chicago 1979, No. 53, with No. 49.

56 LOÏE FULLER AT THE FOLIES BERGÈRE (LA LOÏE FULLER AUX FOLIES BERGÈRE) 1892–1893

Dortu II, P. 468
Black chalk and oil on cardboard, 63.2 × 45.3 cm
Signed in pencil (barely visible), lower left: 'T-Lautrec'
Musée Toulouse-Lautrec, Albi

In February 1893 the colour lithograph of MISS LOÏE FULLER appeared in an edition of 50 copies.[1] The present study in oils, presumably derived from a pencil sketch made on the spot, was a preparatory study for the print of the Chicago-born dancer, which was a great technical achievement.[2]

After an American tour and performances in London Loïe Fuller appeared at the Folies Bergère from November 1892. The *spectacle optique*, which she devised herself and later patented, provoked genuine storms of enthusiasm. She created extraordinary light effects in the multicoloured electric spotlights which were installed specially for her act, by appearing in long swinging voile skirts and brandishing through the air tulle veils on the end of long sticks. Lautrec endeavoured to translate the arabesques of her dance and the special stage lighting effects into graphic terms. La Serpentine, as she was called, looks small, seen from

above as she performs her world-famous *Danse du feu*. The painter praised the American dancer for her 'Samothracic' quality,[3] by which he may have meant the way the viewer's attention was concentrated on the fullness of the drapery. Certainly this sketch is exceptional, in that linear stylization predominates over the depiction of individuality. Behind the undulating lines which suggest contour, volume and space all at once, the figure and physiognomy become unrecognizable. Lautrec has here developed a formula for movement which is strikingly similar to the work of the contemporary Art Nouveau artists whom he disparaged.

1 Adriani 1986, 10.
2 Dortu V, D. 3420; *cf.* also Dortu II, P. 434.
3 Perruchot 1960, p. 165.

SOURCES: Comtesse Adèle Zoë de Toulouse-Lautrec, Toulouse.
BIBLIOGRAPHY: Astre (1926), p. 102; Joyant 1926, p. 277; Huyghe 1931, Ill. 45; Schaub-Koch 1935, p. 210; Jedlicka 1943, pp. 176–177 Ill.; Jourdain-Adhémar 1952, No. 71 Ill., p. 99; Lassaigne 1953, pp. 64f. Ill.; Landolt 1954, p. 16, p. 24, No. 6 Ill.; Cooper 1955, p. 28 Ill.; Perruchot 1958, p. 214; Bouret 1963, p. 132; Cionini-Visani 1968, Ill. 37; Dortu II, pp. 284f. P. 468 Ill.; Dortu V, p. 564 with D. 3420; *Cat. Musée Toulouse-Lautrec* 1973, pp. 52ff. No. 151 Ill.; Muller 1975, Ill. 53; Adriani 1976, p. 50 Ill., p. 53, p. 254 with 8; Caproni-Sugana 1977, Ill. XXXV, No. 335 Ill.; Dortu-Méric 1979, II, p. 26 No. 388 Ill., p. 40; Morariu 1980, Ill. 25; *Cat. Musée Toulouse-Lautrec* (1985), pp. 119ff. No. 152 Ill.; Adriani 1986, with 10.
EXHIBITIONS: New York (etc.) 1950–1951, No. 13; Paris 1951, No. 45; Albi 1951, No. 63; Marseilles 1954, No. 12; Philadelphia-Chicago 1955–1956, No. 44; Dallas 1957; London 1961, No. 44; Munich 1961, No. 54; Cologne 1961–1962, No. 54; Albi-Paris 1964, No. 46; *Jean Cocteau et son Temps*, Musée Jacquemart-André, Paris 1965, No. 62; Kyoto-Tokyo 1968–1969, No. 20; Paris 1975–1976, No. 22; Liège 1978, No. 21; Tokyo (etc.) 1982–1983, No. 31.

57 CAUDIEUX 1893

Dortu II, P. 474
Charcoal and oil on brown faded paper, 114 × 88 cm
Inscribed in blue-grey paint, upper left: 'Caudieux'
Musée Toulouse-Lautrec, Albi

The infectious *élan* of this massive bundle of energy, seen on stage at the Petit Casino, is depicted in a vigorous manner. The arms and legs of the comedian Caudieux and the tails of his coat seem to turn like the sails of a windmill around his corpulent body. He is seen from below – the only definitive viewpoint for Lautrec – and imposes himself on the viewer directly as a physical presence. Several closely interconnected diagonals, a favourite device since 1892, create a picture structure full of force and vitality.

This coloured study, almost the same size as the poster that was made from it,[1] represents the last stage before its realization on the lithographic stone. The project began with a small sheet of sketches giving only a rough indication of the composition with the most important outlines (Dortu V, D. 3369). The horizontal format of these first pencil sketches was transformed to a vertical format as the idea was developed in a second sheet of the same size (Dortu V, D. 3453). In this, the figure of Caudieux, outlined in ink and cut off on three sides, fills almost the whole of the sheet. Both drawings may have been made as quick sketches of ideas during the performances of the popular comedian, who appeared at both the Ambassadeurs and Eldorado.[2] As he moved towards the final execution of the colour poster

the artist changed to a large format. A charcoal drawing was prepared for the printer, complete with all the details down to the positioning of the text (Dortu V, D. 3324). And finally, in the present painting, the black of the tail coat, the garish red accent of the lips and the highlights on the brightly made-up face were added as the important colour contrasts. The colouring is thus restricted to the classic triad of black, white and red, revealing a feeling for the most striking effects.

1 Adriani 1986, 15.
2 *Cf.* also the portrait studies Dortu II, P. 472, P. 473; Dortu V, D. 3619 and the lithograph Adriani 1986, 23.

SOURCES: Comtesse Adèle Zoë de Toulouse-Lautrec, Toulouse.
BIBLIOGRAPHY: Joyant 1926, p. 140 Ill., p. 278; Mack 1938, p. 192; Lassaigne 1953, pp. 62f. Ill.; Fermigier 1969, p. 111; Dortu II, pp. 288f. P. 474 Ill.; Dortu V, p. 548 with D. 3324; *Cat. Musée Toulouse-Lautrec* 1973, p. 49 Ill., p. 51 No. 149, p. 129 with No. D. 95; Adriani 1976, p. 62 Ill., p. 255 with 12; Caproni-Sugana 1977, No. 328 Ill.; Dortu-Méric 1979, II, p. 30 No. 393 Ill., p. 43 Ill.; *Cat. Musée Toulouse-Lautrec* (1985), pp. 118f. No. 150 Ill., p. 203 with No. D. 113; Adriani 1986, with 15.
EXHIBITIONS: Paris 1931, No. 103; Albi 1951, No. 61; Paris 1958–1959, No. 19; London 1961, No. 35; Munich 1961, No. 52; Cologne 1961–1962, No. 52; Albi-Paris 1964, No. 45; Liège 1978, No. 22; Chicago 1979, No. 58.

58 Pierre Ducarre 1893

Dortu VI, D. 3738
Pencil with pen and ink on white paper, 21 × 13 cm
Red monogram stamp (Lugt 1338), lower right
Private Collection

Pierre Ducarre was, among other things, the manager of the Ambassadeurs, a *café-concert* at 3 Avenue Gabriel. His sure instinct for a bold *coup* led him to engage the *chansonnier* Aristide Bruant for his grand establishment in the immediate vicinity of the Champs Elysées, after Bruant had caused such a furore by insulting his audiences on Montmartre (see No. 59). However, he showed less foresight when he tried to prevent the publication of the colour poster which Bruant had commissioned from Lautrec for his appearance at the Ambassadeurs (Ill. p. 313), in order to give the commission to Alphonse Lévy. Only Bruant's threat to cancel his première planned for 3 June, unless Lautrec's poster was stuck up on the stage and in the streets, could make Ducarre change his mind.

Dortu dated this profile study to *c.* 1894, despite the fact this it is a preparatory work for the lithograph Ducarre aux Ambassadeurs, which appeared as the ninth print in the series Le Café-Concert in 1893.[1]

1 Adriani 1986, 24.

SOURCES: Arthur Hahnloser, Wintherthur.
BIBLIOGRAPHY: Dortu VI, pp. 628f., D. 3738 Ill.; Adriani 1976, p. 256 with 25; Adriani 1986, with 24.

59 ARISTIDE BRUANT 1893

Dortu V, D. 3447
Black chalk on white paper, 35 × 22 cm
Private Collection

More than 250 of the almost 1900 paintings and drawings made between 1892 and 1900 were
preparatory studies for lithographs (see Nos. 47, 49, 52, 53, 56–58, 74, 75, 84, 87, 92, 102, 118,
121). Like the preceding portrait sketch this drawing was made in connection with a
lithograph which appeared in 1893 as the seventh print in the series LE CAFÉ-CONCERT.[1]
Basing himself on the poster he had designed for Bruant's appearance at the Ambassadeurs
(Ill. p. 313), Lautrec combined the two figures shown there to produce the single image of his
friend with his right arm raised. Aristide Bruant had a good grasp of his money-earning
potential and had therefore transferred his activities from Montmartre to the more
sophisticated establishments in the centre of town. In spite of – or perhaps because of – his
argot, he became a celebrated performer at the Ambassadeurs, a *café-concert* in the diplomatic
quarter of the Avenue Gabriel (see No. 58) and at the Eldorado in the Boulevard de
Strasbourg. He was a phenomenal inventor of crude abuse directed at the audience. Even
here, at the centre of high society, he did not tone it down in the presence of 'people born
with silver spoons in their mouths' and continued to sing the praises of pariahs and rebuke
the 'dandies with their *de luxe* tarts' with great fervour.

'Tas d'inach'vés, tas d'avortus
Fabriqués avec des viandes veules
Vos mèr's avaient donc pas d'tétons
Qu'a's ont pas pu vous fair' des gueules?
Vous êt's tous des fils de michés
Qu'on envoy' téter en nourrice.
C'est pour ça qu'vous êt's mal torchés . . .
Allez donc dir' qu'on vous finisse!'[2]

With his hard-hitting style Bruant, the former office boy from the Paris slums who used
his natural poetic talent to revenge himself on a society that masochistically submitted itself
to his insults, had much in common with Lautrec, the aristocrat who proudly bore the name
of the Bourbon pretender to the throne. They displayed the same lack of restraint in their
treatment of the *grand-* and *demi-monde*. Unlike Bruant's songs, however, Lautrec's pictures
do not have a moral. This is not to say that they are amoral, but that they do not impose
value judgments; they do not point a moralizing finger or express those prejudiced
bourgeois misinterpretations which often nullify the message of socially committed art.

1 Adriani 1986, 22.
2 Perruchot 1960, p. 101.

SOURCES: Vente Hôtel Drouot, Paris 6 May 1953, No. 186; Stavros Niarchos, Paris.
BIBLIOGRAPHY: Keller 1968, pp. 41 f., p. 90 Ill.; Dortu V. pp. 568 f. D. 3447 Ill.; Polasek 1972, No. 29 Ill., with No. 30;
Adriani 1976, p. 256 with 23; Adriani 1986, with 22.
EXHIBITIONS: *Célébrités Françaises*, Galerie Charpentier, Paris 1954, No. 169.

60 The Ladies in the Refectory (Ces Dames au Réfectoire) 1893

Dortu II, P. 499
Oil on cardboard, 60.3 × 80.3 cm
Signed in red chalk, lower left: 'T-Lautrec'
Szépmüvészeti Múzeum, Budapest

Between 1892 and 1895 Lautrec frequented the brothels in the Rue des Moulins, the Rue d'Amboise and the Rue Joubert. He often lodged there for weeks at a time, and his main reason for doing so was to find out about the everyday life of the women 'who take off their decency along with their shirts' (Emile Zola). As he cynically used to remark, they were *les bourgeoises* who suited him. He was pleased by how receptive they were to his courtesy. In order to depict them just as they were, he shared in their fears and problems, their emotional outpourings and dreams of bourgeois respectability. He came to know their sorrows, their naïve morality, their intimacies, their pitiful slyness, and the stupid indifference that characterized the dreary hopelessness of their work. As their confidant, he appreciated the discreet attitude of these desecrated mothers towards his deformity. The dress regulations stipulated that they had to go around naked, but in front of Lautrec, who belonged, as it were, to the house, they did not have to bother with these hypocritical means of self-advertisement. The tired faces and worn-out bodies of women such as Rolande (see No. 71), Gabrielle or Marcelle (see No. 70) were ideal models, always available for *Monsieur Henri le peintre*. They alone were depicted; their customers, in the rare instances where they are shown, are merely interchangeable accessories relegated to a marginal position (see No. 87). The sophisticated decoration of the brothels' interiors, designed to appeal to even the most extravagant taste, found no favour in his eyes, though it expressed with a final – though banal – splendour the nineteenth century's obsession with history and universality. It included a stylistically correct torture chamber complete with crucifix and stocks, Gothic state rooms, Rococo boudoirs, classical halls and Oriental cabinets (Ill. pp. 314–315).

The artist developed a profound understanding of the human condition and of the circumstances of this existence. In the present painting he depicted a group of women, with their mirror reflection, gathered at a dining table.[1] Outside their working hours the prostitutes wore high-necked dresses; only the garish pink, turquoise and yellow colours give an indication of their barrack-like existence as prostitutes. No smiles lighten the lowering expressions of these joyless *filles de joie*, available on call, and their beauty and youth have long since fallen victim to the relentless demands of their employment (*cf*. Ill. p. 314). Paris would scarcely have felt itself challenged to pass judgment on these women.

1 *Cf.* the figure study Dortu VI, D. 3728, which Dortu dates to *c.* 1894.

SOURCES: Arsène Alexandre, Paris; Vente *Collection Alexandre*, Galerie Georges Petit, Paris 18–19 May 1903, No. 62; Eugène Blot, Paris; Alfred Walter Heymel, Munich; Vente *Collection Heymel*, Hôtel Drouot, Paris 30 April 1913, No. 1; M. Lévêque, Paris.
BIBLIOGRAPHY: Coquiot 1921, p. 112; Joyant 1926, p. 157, p. 283; Joyant 1927, p. 258, p. 260; Mack 1938, p. 254; Jourdain-Adhémar 1952, p. 41, No. 87 Ill.; Dortu-Grillaert-Adhémar 1955, p. 33; Julien (1959), p. 34; István Genthon, 'Un Tableau de Toulouse-Lautrec au Musée des Beaux-Arts de Budapest', in: *Bulletin du Musée Hongrois des Beaux-Arts*, 26, 1965, pp. 47ff.; István Genthon, *Du Romantisme au Postimpressionisme*, Budapest 1965, No. 37; Novotny 1969, p. 41, Ill. 76; Dortu II, pp. 306f. P. 499 Ill.; Josifovna 1972, Ill. 96; Caproni-Sugana 1977, No. 411 Ill.; Jullian 1977, p. 145 Ill.; Werner-Helms (1977), Ill.; Dortu-Méric 1979, II, p. 36 No. 415 Ill.; Chicago 1979, with No. 94; Lucie-Smith 1983, No. 36 Ill.
EXHIBITIONS: Brussels 1902, No. 286; Paris 1902, No. 49; Bremen 1909, No. 324; Berlin 1924, No. 28; Vienna 1966, No. 21.

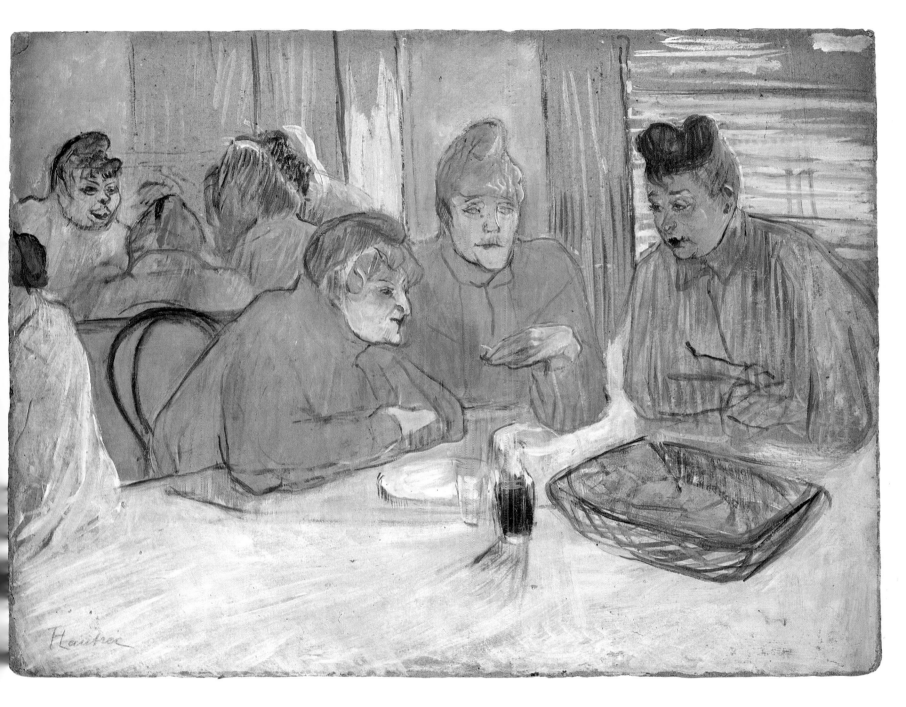

61 WOMAN AT HER WINDOW (FEMME À SA FENÊTRE) 1893

Dortu II, P. 507
Oil on cardboard, 58.5 × 46.6 cm
Signed in blue paint, lower right: 'T-Lautrec'
Musée Toulouse-Lautrec, Albi

The subdued mood of the figure in this portrait of a young woman seated at her window is in striking contrast to the richly diversified colours and forms of the interior. Dressed in a white negligé, she sits quite close to the window which has its net curtains drawn. Here, at the point where the space opens onto the exterior, the paintwork is also most porous. Although much of the profile is hidden by her blond hair, there is no doubt that the woman's gaze is directed towards an outside world very different from her own miserable existence – the lost profile is a symbol for this lost soul.

The portrait, arranged like a still life, is probably one of those snapshot views giving an insight into the daily routine of the women available in the Paris brothels. The banal objectivity of the few utensils (which are specific to the woman's profession) is integrated into the radiantly bright colour harmonies of red, blue and yellow.

SOURCES: Comtesse Adèle Zoë de Toulouse-Lautrec, Toulouse.
BIBLIOGRAPHY: Astre (1926), p. 90; Joyant 1926, p. 238 Ill., p. 284; Bellet 1951, p. 29; Julien 1953, p. 23 Ill.; Bouret 1963, p. 99; Zinserling 1964, p. 35, Ill. 20; Cionini-Visani 1968, Ill. 39; Zenzoku 1970, Ill. 38; Dortu II, pp. 310f. P. 507 Ill.; *Cat. Musée Toulouse-Lautrec* 1973, pp. 58f. No. 159 Ill.; Caproni-Sugana 1977, No. 357 Ill.; Dortu-Méric 1979, II, p. 38 No. 423 Ill.; *Cat. Musée Toulouse-Lautrec* (1985), p. 124 Ill., p. 126 No. 160.
EXHIBITIONS: Paris 1914, Ill.; San Francisco 1916; Paris 1931, No. 105; New York (etc.) 1950–1951, No. 15; Paris 1951, No. 47; Albi 1951, No. 71; Marseilles 1954, No. 11; Philadelphia-Chicago 1955–1956, No. 45; Dallas 1957; Paris 1958–1959, No. 25; London 1961, No. 41; Munich 1961, No. 59; Cologne 1961–1962, No. 59; Albi-Paris 1964, No. 50; Paris 1975–1976, No. 25; Liège 1978, No. 25; Chicago 1979, No. 62; Tokyo (etc.) 1982–1983, No. 34.

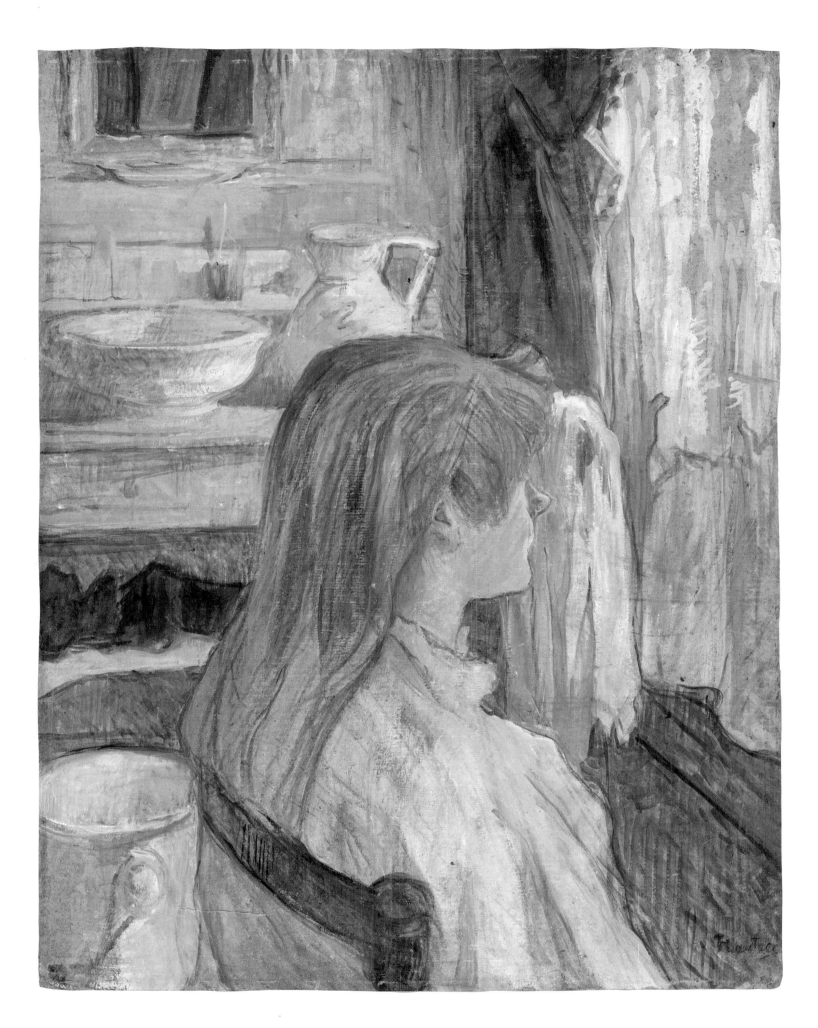

62 MONSIEUR, MADAME AND THE DOG (MONSIEUR, MADAME ET LE CHIEN) 1893

Dortu II, P. 494
Black chalk and oil on canvas, 48 × 60 cm
Red monogram stamp (Lugt 1338), lower left
Musée Toulouse-Lautrec, Albi

Fully aware of the responsibility of their position as proprietors of one of the Parisian brothels, Monsieur and Madame sit enthroned on a red upholstered sofa. To add further weight to the *gravitas* of these Daumier-like heads, they are reflected in the mirror behind them. The comparison may seem far-fetched, but this *petit-bourgeois* couple, the guardians of discipline and order in a world where much value was set on these qualities, could be regarded as an ironic pendant to a masterpiece which Lautrec regarded particularly highly: Jan van Eyck's wedding portrait of the Lucca merchant Giovanni Arnolfini and his young bride Giovanna Cenami in the National Gallery, London (see Ill. below).

In both pictures the couples pose in front of a background mirror; the colouring in both is based on red and green; and, not least, there is the lap-dog which has an important symbolic function – though in Lautrec's painting the symbol of love has turned into a yapping pinscher. While Van Eyck's couple are supposed to be shown at the beginning of their life together, Lautrec observes with ironic detachment the outcome of such a venture into married life. Instead of turning towards each other the figures now turn away; instead of

Jan van Eyck, THE WEDDING OF GIOVANNI ARNOLFINI AND GIOVANNA CENAMI, 1434, National Gallery, London

152

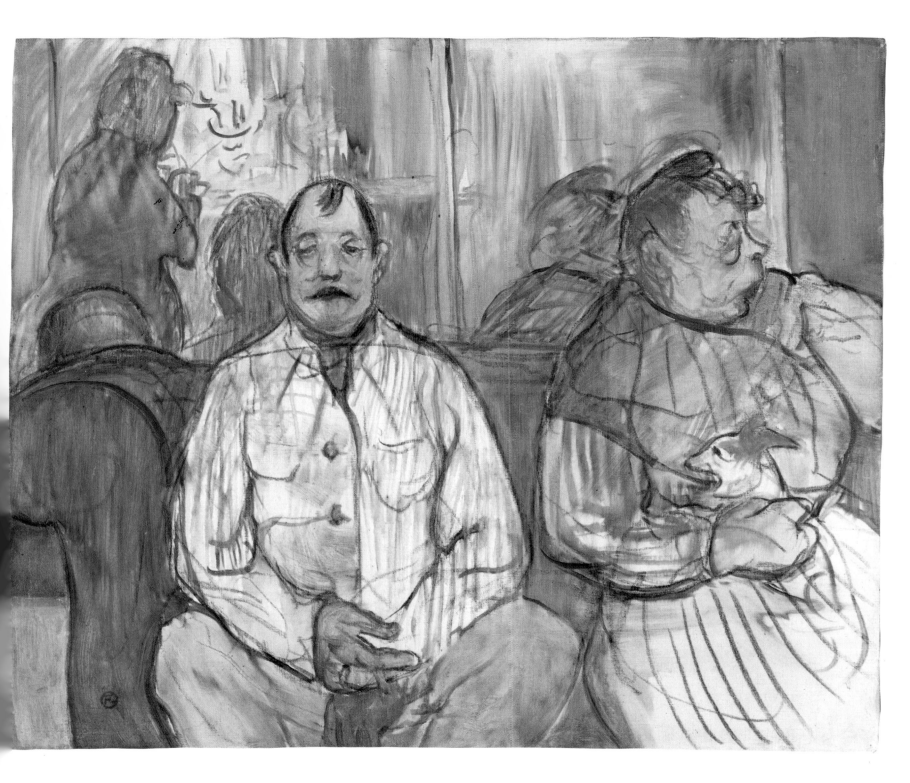

standing in a dignified manner they perch on the seat and their bodies are cut off abruptly; instead of the nobility of youth, they offer almost a caricature of decrepit old age. Lautrec's couple is transferred from the private sphere into a quasi-public setting. The man with his Napoleonic hairstyle is seen frontally as he self-consciously returns the viewer's gaze, while his female counterpart inspects her surroundings with a stern expression.

These two pictures are of course worlds apart – chronologically, socially and stylistically – but it would be typical of Lautrec, an admirer of the Flemish wedding picture in London, to suggest such a malicious confrontation between the beginning and end of a relationship.

SOURCES: Comtesse Adèle Zoë de Toulouse-Lautrec, Toulouse.
BIBLIOGRAPHY: Astre (1926), p. 95; Joyant 1926, p. 158, p. 171 Ill., p. 283; Joyant 1927, p. 256; Lapparent 1927, p. 37, p. 47, p. 54, p. 57, Ill. 13; Schaub-Koch 1935, p. 209; Cassou 1938, p. 234 Ill.; Mack 1938, p. 255; Frankfurter 1951, p. 107 Ill.; Jourdain (1951), Ill. 6; Dortu-Grillaert-Adhémar 1955, p. 32, p. 36, Ill. 15; Perruchot 1958, p. 244; Cabanne 1959, p. 19 Ill.; Julien (1959), p. 45 Ill.; Bouret 1963, p. 133; Huisman-Dortu 1964, p. 139 Ill.; Zinserling 1964, p. 34, Ill. 15; Chastel 1966, p. 13; Keller 1968, p. 51, p. 98 Ill.; Cionini-Visani 1968, Ill. 38; Fermigier 1969, p. 159 Ill.; Zenzoku 1970, Ill. 4; Devoisins 1970, p. 54; Dortu II, p. 302 P. 494 Ill.; Devoisins 1972, p. 10; *Cat. Musée Toulouse-Lautrec* 1973, pp. 56ff. No. 157 Ill.; Caproni-Sugana 1977, Ill. XXXIV, No. 355 Ill.; Adriani 1978, p. 127 Ill.; Dortu-Méric 1979, II, p. 34 No. 410 Ill.; Morariu 1980, Ill. 30; Arnold 1982, pp. 90f. Ill.; *Cat. Musée Toulouse-Lautrec* (1985), pp. 124f. No. 158 Ill.
EXHIBITIONS: Brussels 1902, No. 288; Paris 1909; Paris 1931, No. 99; New York 1937, No. 16; Paris 1938, No. 17; London 1938, No. 6; Basel 1947, No. 205; Amsterdam 1947, No. 26; Brussels 1947, No. 26; Albi 1951, No. 69; Paris 1958–1959, No. 24; London 1961, No. 40; Munich 1961, No. 58; Cologne 1961–1962, No. 58; Albi-Paris 1964, No. 49; Stockholm 1967–1968, No. 17; Humlebaek 1968, No. 16; Kyoto-Tokyo 1968–1969, No. 23; Paris 1975–1976, No. 26; Liège 1978, No. 24; Chicago 1979, No. 61, with No. 68; Tokyo (etc.) 1982–1983, No. 33.

63 THE GAME OF CARDS (LA PARTIE DE CARTES) 1893

Dortu II, P. 505
Black chalk and oil on cardboard, 57.5 × 46 cm
Signed in black chalk, lower right: 'T-Lautrec'
Private Collection, Switzerland

The Munich publisher and collector Alfred Walter Heymel, on the advice of Julius Meier-Graefe, took an early interest in Toulouse-Lautrec's work, and by the beginning of the century he already possessed nearly all his prints. He was also the owner of this scene showing two women playing cards in the big salon of the brothel in the Rue des Moulins. Heymel himself described it – in terms typical of the Wilhelminian period – as a depiction of one of those 'places that are accessible, but not alway congenial to the respectable citizen'.[1] It is particularly fortunate that five works from his collection (see Nos. 29, 60, 100, 102) can now be shown again for the first time in seventy-five years. Besides the graphic work which was acquired complete by Heinrich Stinnes in 1911, Heymel owned twenty-two paintings, drawings and gouaches by Lautrec. With two exceptions these were auctioned in Paris in 1913.

Together with HÉLÈNE VARY (No. 29) and CES DAMES AUX RÉFECTOIRE (No. 60) this picture of the cardplayers was among the most important works in the collection. Wrapped in light-coloured dressing gowns, they have settled down on a fiery red sofa, while in the background a ruthlessly truncated figure can be seen lying curled up on another sofa. A cushion is being used as a card table. The powdered faces match the dry, tempera-like

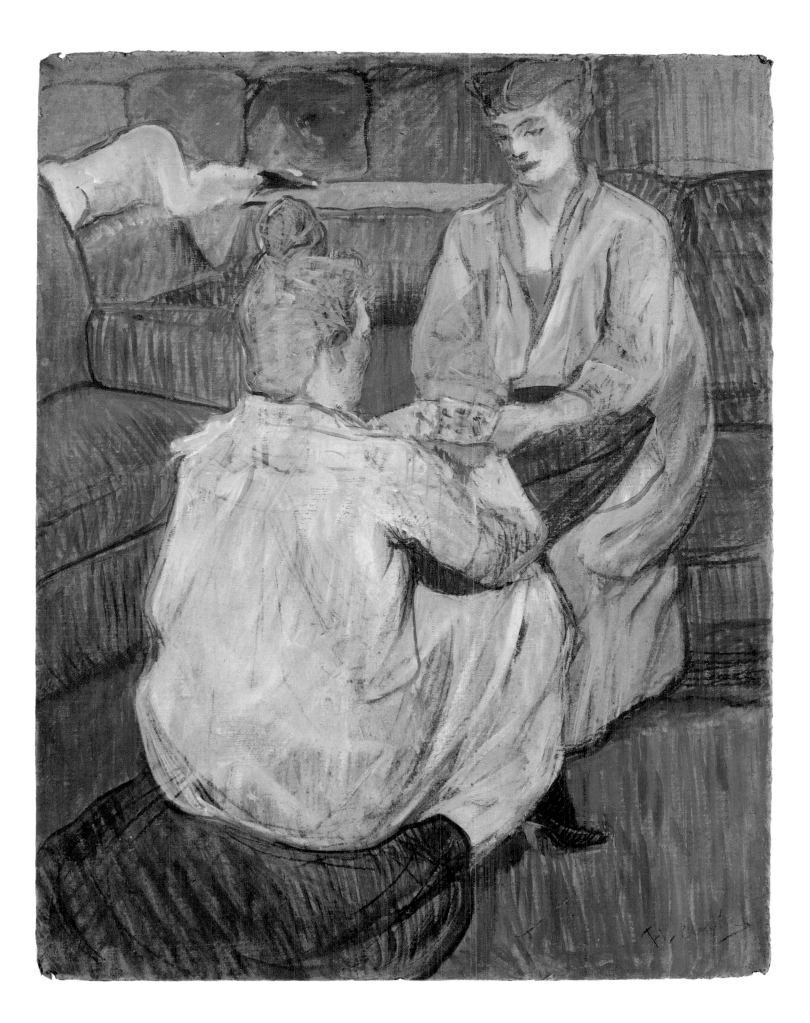

application of paint, and the fleeting nature of their meeting is reflected in the swift action of the brushstrokes.

It cannot be fortuitous that Lautrec, who had so little beauty himself, painted his most beautiful images of people against this particular background. There are no daring effects in these exalted, unapproachable figures, but there is a magnificent sublimation of the beauty immanent even in misery, to be found as a spiritualized form in that intermediate area between reality and illusion.

1 Esswein 1912, p. 50.

SOURCES: Alfred Walter Heymel, Munich; Vente *Collection Heymel*, Hôtel Drouot, Paris 30 April 1913, No. 6; Paul Rosenberg, Paris; Hans R. Hahnloser, Bern.
BIBLIOGRAPHY: Coquiot (1923), Ill. 1; Joyant 1926, p. 284; Joyant 1927, p. 260; Fosca 1928, p. 2 Ill.; Jourdain-Adhémar 1952, p. 41, No. 88 Ill.; Novotny 1969, Ill. 59; Dortu II, pp. 310f. P. 505 Ill.; Josifovna 1972, Ill. 92; Caproni-Sugana 1977, No. 349 Ill.; Werner-Helms (1977), Ill.; Dortu-Méric 1979, II, p. 38 No. 421 Ill.; Lucie-Smith 1983, p. 10, No. 25 Ill.
EXHIBITIONS: Bremen 1909, No. 323; Berlin 1924, No. 32; *Sammlung Hahnloser*, Kunstmuseum, Lucerne 1941, No. 124; Bern 1953, No. 127; Munich 1961, No. 144; Cologne 1961–1962, No. 144; Schaffhausen 1963, No. 131; Vienna 1966, No. 16.

64 THE TWO FRIENDS (LES DEUX AMIES) 1894

Dortu III, P. 549
Oil on cardboard, 48 × 34 cm
Monogram in pencil, lower left
The Trustees of the Tate Gallery (Cat. No. 5142), London

Two versions exist of this distinctive image of friendship showing two women on the red sofas in the salon of the Rue des Moulins brothel (*cf*. No. 65). The prostitutes bear the mark of their meaningless work. They are not depicted in the poses of desirable temptresses; by showing their everyday life Lautrec returned their humanity to these Olympias and Nanas: the *grandes cocottes* are shown humiliated and abandoned as their value as merchandise decreases, and they seek a companionship which excludes men. Their naturalness appealed to Lautrec: 'Models always look as if they were stuffed; these women are alive. I wouldn't dare pay them to pose for me, yet God knows they're worth it. They stretch themselves out on the divans like animals . . . they're so lacking in pretension, you know!'[1]

Lautrec did not become their confidant to provoke them in their challenging passivity and their aversion to any emotional involvement, but because of his desire for security among people whose nostalgia for bourgeois respectability and moralistic attitudes often produced very strange results. When he was living with them in the brothels, their daily routine and moments of trusting intimacy were continually before his eyes. He observed them meticulously in their leisure time (No. 63), at their toilette (No. 103), at breakfast (No. 60), waiting for customers (No. 67), or during the doctor's visit (No. 68), and he felt at home in the strictly regulated atmosphere of these peripheral places permitted by a hypocritical society for the 'public' practice of prostitution.

1 Perruchot 1960, p. 157.

SOURCES: M. Laugier, Paris; M. Paleseau, Paris; Clovis Sagot, Paris; Paul Cassirer, Berlin; Reid & Lefevre, London; Georges Bernheim, Paris; Reid & Lefevre, London; Montague Shearman, London.
BIBLIOGRAPHY: Coquiot 1913, p. 88; Coquiot 1921, p. 111; Joyant 1926, p. 285; Mack 1938, p. 251; Newton 1953, p. 83 Ill.; John Rothenstein, *The Tate Gallery*, London 1958, p. 129 Ill.; Dortu III, pp. 336f. P. 549 Ill.; Caproni-Sugana 1977, No. 374 Ill.; Chicago 1979, with No. 73; Dortu-Méric 1979, II, p. 48, with No. 464; Alley 1981, pp. 727f. Ill.; Lucie-Smith 1983, pp. 10f., No. 26 Ill.
EXHIBITIONS: Paris 1914, No. 104; *Ein Jahrhundert französischer Zeichnung*, Galerie Paul Cassirer, Berlin 1929–1930, No. 78; *La Peinture Française aux XIXème et XXème Siècles*, Galerie van Wisselingh, Amsterdam 1931, No. 55; *French Paintings of the Nineteenth Century* National Gallery of Canada, Ottawa – Art Gallery, Toronto – Art Association, Montreal 1934, No. 113; *French Paintings by the Impressionists and Modern Artists*, W. Scott & Sons Gallery, Montreal 1934, No. 18; *Nineteenth and Twentieth Century French Paintings*, Boyer Gallery, Philadelphia 1936, No. 2; *Corot to Cézanne*, Lefevre Gallery, London 1936, No. 26; *Milestones in French Painting*. Lefevre Gallery, London 1939, No. 17; *The Montague Shearman Collection*, Redfern Gallery, London 1940, No. 12; *The Tate Gallery's Wartime Acquisitions*, National Gallery, London 1942, No. 137; *Acquisitions of the CAS*, The Tate Gallery, London 1946, No. 35a; London 1961, No. 53.

65 THE TWO FRIENDS (LES DEUX AMIES) 1894

Dortu III, P. 550
Oil on cardboard, 43 × 34.5 cm
Monogram in pencil, lower left
Musée Toulouse-Lautrec, Albi

See No. 64.

SOURCES: Comtesse Adèle Zoë de Toulouse-Lautrec, Toulouse.
BIBLIOGRAPHY: Joyant 1926, p. 285; Schaub-Koch 1935, p. 192; Dortu 1952, p. 7 Ill. 32; Perruchot 1958, pp. 208–209 Ill.; *Toulouse-Lautrec* 1962, p. 199 Ill.; Bouret 1963, p. 205; Keller 1968, p. 57, p. 99 Ill.; Novotny 1969, Ill. 68; Dortu III, pp. 336f. P. 550 Ill., with P. 549; *Cat. Musée Toulouse-Lautrec* 1973, p. 67 Ill., p. 69 No. 174; Caproni-Sugana 1977, No. 375 Ill.; Jullian 1977, p. 92 Ill.; Dortu-Méric 1979, II, p. 48 No. 454 Ill.; Alley 1981, p. 728; *Cat. Musée Toulouse-Lautrec* (1985), pp. 136f. No. 176 Ill.
EXHIBITIONS: New York (etc.) 1950–1951, No. 20; Paris 1951, No. 54; Albi 1951, No. 87; Marseilles 1954, No. 15; Philadelphia–Chicago 1955–1956, No. 53; Paris 1958–1959, No. 33; London 1961, No. 54; Munich 1961, No. 71; Cologne 1961–1962. No. 71; Chicago 1979. No. 73, with No. 74; Tokyo (etc.) 1982–1983. No. 42.

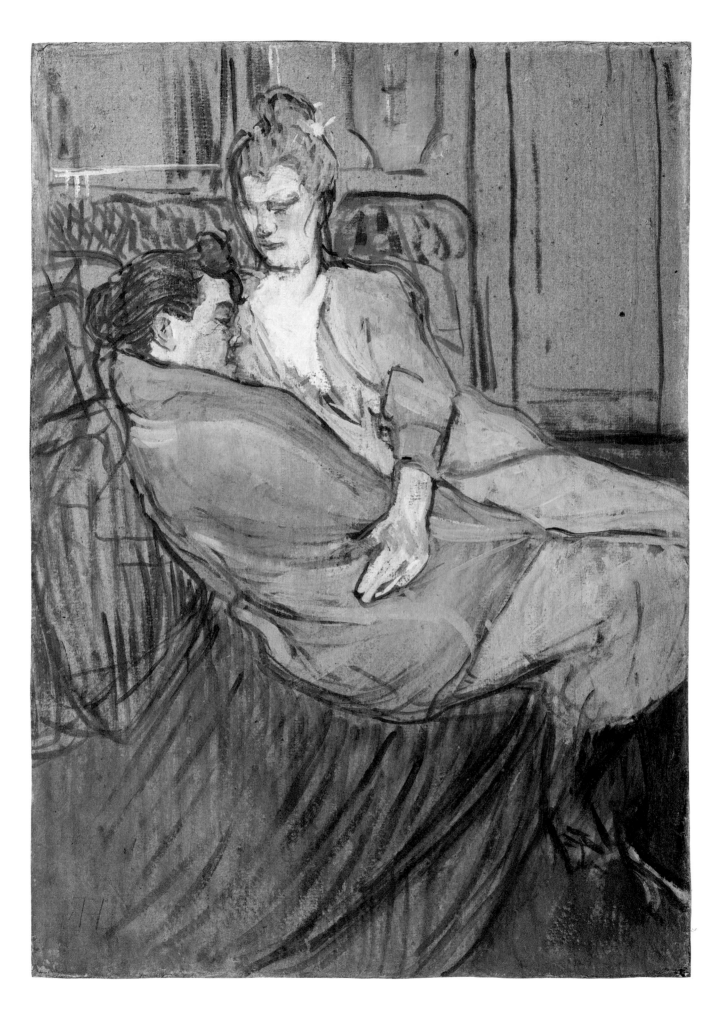

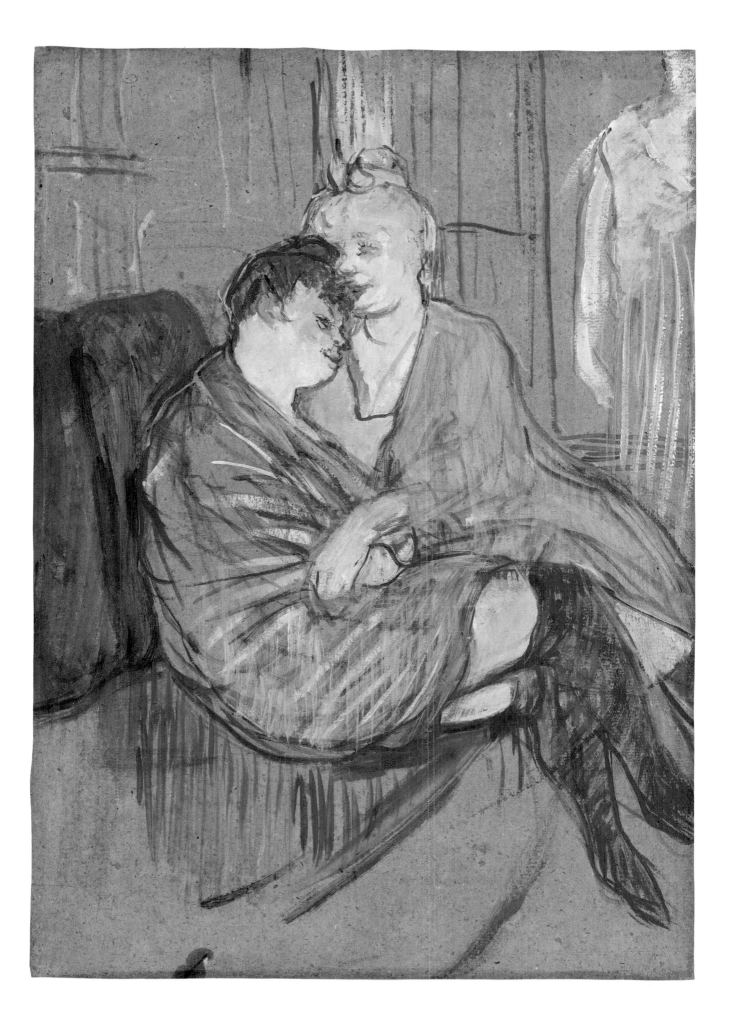

66 PUSSY
(MINETTE) *c.*1894

Not in Dortu
Oil on cardboard, 60.3 × 46.5 cm
Signed in dark blue paint, lower left: 'T-Lautrec'; inscribed in yellow paint, lower right: 'MINETTE'
Private Collection, Switzerland

Apart from one early representation (Dortu II, P. 156), this is the only portrait of a cat among Lautrec's many animal pictures. The artist took a great deal of trouble over it, giving it a full signature and title. The animal is placed on the red upholstery familiar from the brothel salons, and set against a turquoise background decorated with gold fleurs-de-lis. Baudelaire had identified the animal with the destructive power of woman in his poem *Le Chat* and Zola had given the cat a demonic character in his novel *Thérèse Raquin* of 1867; since then – if not earlier – the animal had become a symbol of sexual aggression. Whether Lautrec intended this sort of interpretation is not known, but in a letter written in 1895 to his friend Maxime Dethomas he was worrying about the natural requirements of such an animal; he informed Dethomas that Miss Belfort – the English *chansonnette* singer – was looking for a tom-cat for her female and inquired whether Dethomas's own Siamese cat might not be suitable for the task.[1]

1 Goldschmidt-Schimmel 1969, p. 184 [285].

EXHIBITIONS: Tokyo (etc.) 1982–1983, No. 45.

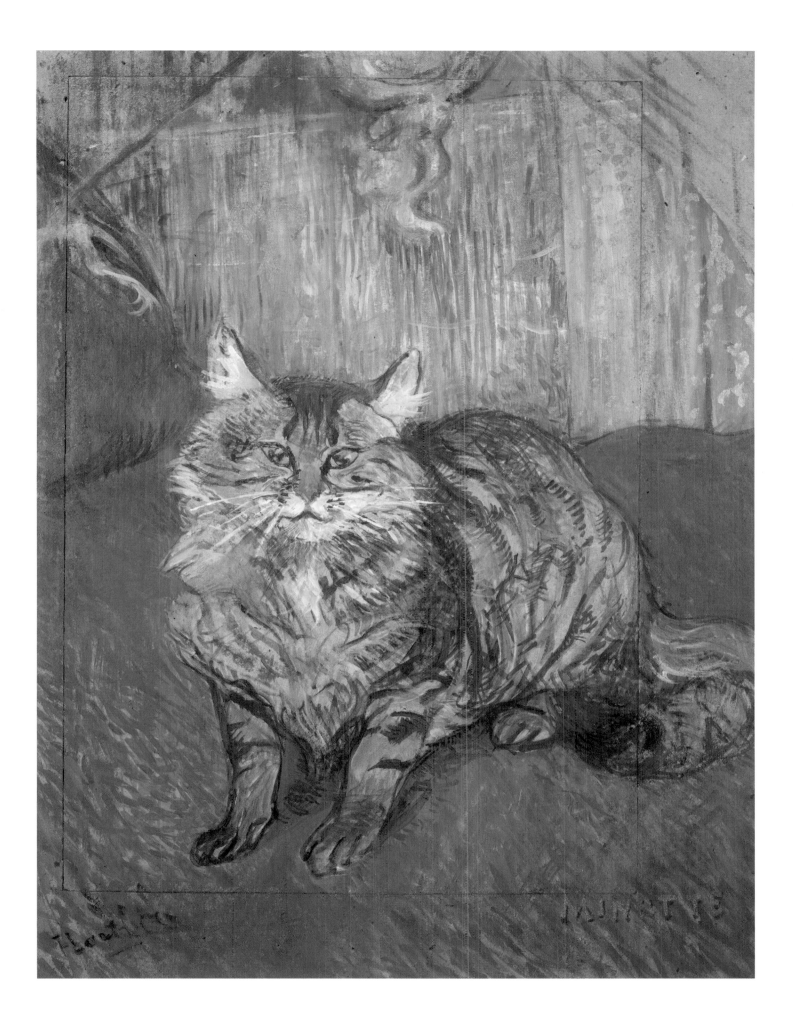

67 THE SALON OF THE RUE DES MOULINS (AU SALON DE LA RUE DES MOULINS) 1894

Dortu III, P. 559
Black chalk and oil on canvas, 111.5 × 132.5 cm
Monogram in black paint, lower left
Musée Toulouse-Lautrec, Albi

It is known from contemporary sources that the salon in the brothel at 24 (now 6) Rue des Moulins was decorated in the Moorish style, but this is not apparent in the artist's painting, which was executed in the studio from numerous sketches and meticulous preparatory studies.[1] There is only a vague impression of a grandiose interior with panelling, mirrors and a chandelier whose light brings out the pallor of the inmates' complexions. What stays most in the memory are the broad divans with their subdued reddish-purple upholstery. Grouped around the green of a fluted column, they create an effect of detachment from the viewer. Lautrec directed his attention wholly toward the sense of exposure characteristic of the figures installed in their cloistered surroundings, as they put themselves and the unassuming luxury of their underwear on display. Only 'Madame', who with her modestly high-necked dress has the faded charm of a middle-aged governess, is prepared to make eye contact with the viewer – a very rare occurrence in Lautrec's work. She sizes him up without embarrassment; her strict régime guarantees the quality of the merchandise she displays; her companions, none of whose gazes meet, are ready and waiting. The tragic effect of the ensemble is underlined by our knowledge of the utilitarian agreement by which society has assigned these women their place, and by which nature is abused through their having constantly to be sexually available.[2]

Lautrec's unusual painting – which today is the showpiece of the former archiepiscopal palace at Albi – can be compared only with Goya's portraits. The two southerners had much in common: at the beginning and end of the nineteenth century respectively, they transformed group portraits into extraordinary symbols of existential experience. It would be wrong, however, to attribute any allegorical intent to Lautrec. He was not one of the myth-makers who doubted the reality of perception, like Gauguin or Munch, 'the esoteric painter of love, jealousy, sorrow and death' (August Strindberg). Lautrec's *allégorie réelle*, the outcome of a specific view of humanity, arose from his acquaintance with places where

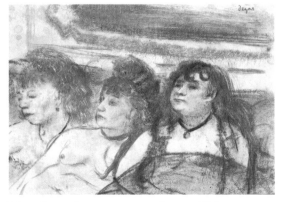

Edgar Degas, PROSTITUTES ON A SOFA, *c.* 1879,
Rijksmuseum, Amsterdam

Vittore Carpaccio, COURTESANS, 1495–1550, Museo
Correr, Venice

absolute availability was almost legitimized by being correctly run as a business. He was amused by the smooth organization of these *hauts lieux d'amour* because it reminded him of the sterile conventions of his social equals. When 'Madame' called her girls to order – 'But ladies, where do you think you are!'[3] – he became fully aware of the significance of his new Cité du Retiro as a place of refuge, where social relations were at their most concentrated.

Others had prepared the way for the painting's unique atmosphere: Constantin Guys and Jean Louis Forain had taken up the long-rejected theme of prostitution in illustrations for Huysmans's novel *Marthe, Histoire d'une Fille* published in 1876, as had Manet and Degas – the latter inspired by Edmond de Goncourt's novel *La Fille Elisa* (Ill. pp. 162, 202). Their work was supplemented by Lautrec's astonishing ability to understand the conditions of the socially ostracized milieu without obscuring them by the addition of anecdotal, genre-like elements and details intended to elucidate the context. Degas and Manet, who according to Huysmans was the first to successfully paint prostitutes, had endeavoured to examine the representatives of this *race maudite* with detachment, avoiding the iconography of the Impressionists and adopting a rather furtive, voyeuristic standpoint. Lautrec had a photograph of Vittore Carpaccio's painting of two courtesans (Ill. p. 162) and it was with this in mind that he brought his almost clinical vision of alienated humanity to bear on the falseness of feeling in many Symbolist interpretations, and the risqué raciness with which some academic painters endowed similar scenes. His detached aristocratic position enabled him to look behind the façade of a crumbling bourgeois civilization. In 1907 Picasso paraphrased with radical consistency Lautrec's magnificent group portrait in his DEMOISELLES D'AVIGNON (Museum of Modern Art, New York).

1 The studies for this group portrait range from quick sketches of details and figures to an elaborate full-size pastel: Dortu II, P. 558, P. 560, Dortu V, D. 3010 (?), D. 3478, D. 3483, D. 3556–D. 3559, D. 3628, D. 3675.
2 The picture was given an amusingly frivolous character when the artist had himself photographed with one of his Muses in front of the completed work (see endpapers). This was a parody of the old painter-and-model motif, and possibly also of Courbet's painting of his ATELIER, the epoch-making *allégorie réelle* of 1855.
3 Joyant 1926, p. 158.

SOURCES: Comtesse Adèle Zoé de Toulouse-Lautrec, Toulouse.
BIBLIOGRAPHY: Astre (1926), p. 92; Joyant 1926, pp. 15+f. Ill., p. 287; Lapparent 1927, p. 18; Jedlicka 1929, pp. 268ff.; Huyghe 1931, Ill. 53; Schaub-Koch 1935. p. 191; Tourette 1938, Ill.; Mack 1938, pp. 254–255 Ill.; Cassou 1938, p. 229 Ill.; Lassaigne 1939, Ill. 125; Mac Orlan 1941, p. 48 Ill., p. 108; Jedlicka 1943, pp. 214–215 Ill., pp. 217ff., p. 221, p. 283; Vinding 1947, p. 169; Venturi 1947, p. 11 Ill.; Jourdain 1948, Ill. 28; Kern 1948, p. 15, Ill. 28; Delaroche 1948, pp. 10f.; Jourdain (1951), Ill. 11; Frankfurter 1951, p. 102 Ill.; Jourdain-Adhémar 1952, p. 41. No. 85 Ill., p. 112; Dortu 1952, p. 7, Ill. X; Jean Cassou, 'Les Impressionnistes et leur Epoque', in: *L'Amour de l'Art*, 1953, p. 77 Ill.; Lassaigne 1953, Ill. (Detail, Frontispiece), pp. 70ff. Ill., p. 76; Colombier 1953, p. 6 Ill. 24; Hunter 1953, Ill. 24; Julien 1953, p. 16, p. 33 Ill.; Gauzi 1954 (*Arts*), p. 14 Ill.; Gauzi 1954, pp. 138–139 Ill., p. 141; Landolt 1954, p. 16; Dortu-Grillaert-Adhémar 1955, p. 22, p. 36; Focillon 1957, p. 162; Perruchot 1958, p. 245, p. 266; Cabanne 1959, p. 30 Ill.; Focillon 1959, p. 24, p. 60; Julien (1959), p. 34, p. 36, p. 58 Ill.; *Toulouse-Lautrec* 1962, pp. 134f. Ill.; Bouret 1963, p. 148; Huisman-Dortu 1964, p. 135, p. 137, pp. 140f. Ill.; Zinserling 1964, p. 35, Ill. 14; Chastel 1966, Ill. 16; Vienna 1966, with No. 21; Keller 1968, p. 33 Ill., pp. 51f.; Cionini-Visani 1968, Ill. 43; Fermigier 1969, p. 157 Ill.; Paret 1969, p. 33, Devoisins 1970, p. 52; Dortu III, p. 340 with P. 558, pp. 342f. P. 559 Ill., with P. 560; Dortu V, p. 588 with D. 3529. D. 3532, p. 592 with D. 3556–D. 3559, p. 602 with D. 3628; Polasek 1972, p. 39; Josifovna 1972, Ill. 95; *Cat. Musée Toulouse-Lautrec* 1973, pp. 71 ff. No. 178 Ill.; Huisman-Dortu 1973, Ill. (Jacket, Detail); Muller 1975, Ill. 68; Caproni-Sugana 1977, pp. 7f., Ill. XL–XLI, No. 372a Ill.; Jullian 1977, p. 144 Ill.; Adriani 1978, p. 89 Ill. 8, p. 128, pp. 130f., p. 133; Dortu-Méric 1979, II, p. 50 No. 470 Ill., pp. 58f. Ill.; Devoisins 1980, p. 18, p. 20, p. 64; Daniel Robbins – Eugenia Robbins, *Henri de Toulouse-Lautrec, A Selection of Works from The Art Institue of Chicago*, Chicago 1980, p. 15; Morariu 1980, Ill. 33; Henze 1982, pp. 52ff. Ill.; Arnold 1982, p. 53 Ill.; Cooper 1983, p. 44; New York 1985, p. 48, p. 51, p. 68; *Cat. Musée Toulouse-Lautrec* (1985), pp. 139f. No. 180 Ill.
EXHIBITIONS: Paris 1914, No. 39; Paris 1931, No. 125; New York 1937, No. 17; London 1938, No. 7; Paris 1938, No. 19; Basel 1947, No. 191; Amsterdam 1947, No. 37; Brussels 1947, No. 37; New York 1950–1951, No. 22; Paris 1951, No. 57; Albi 1951, No. 91; Marseilles 1954, No. 13; Philadelphia-Chicago 1955–1956, No. 50; Dallas 1957; Paris 1958–1959, No. 37; London 1961 No. 51; Munich 1961, No. 75; Cologne 1961–1962, No. 75; Albi-Paris 1964, No. 57; Paris 1975–1976, No. 30; Chicago 1979, p. 24, p. 75, with Nos. 61, 72–74; Tokyo (etc.) 1982–1983, No. 43.

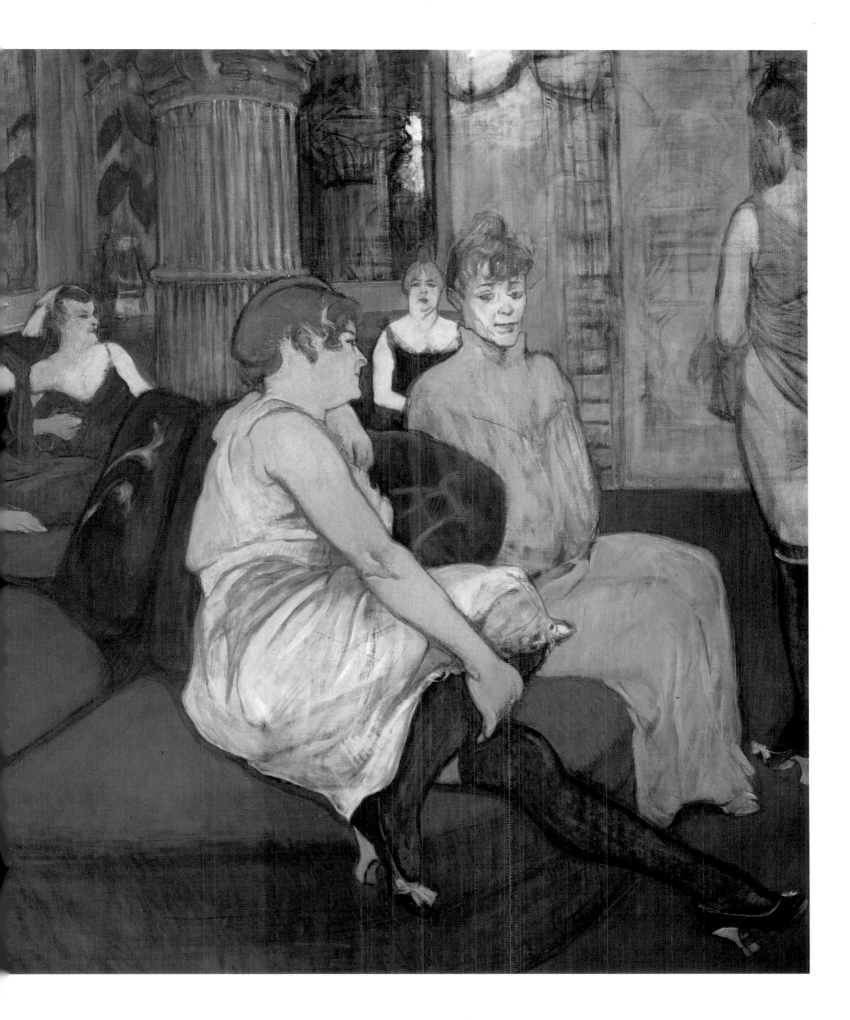

68 Two Half-Nude Women seen from Behind in the Rue des Moulins Brothel (Deux Femmes Demi-Nues de Dos, Maison de la Rue des Moulins) 1894

Dortu III, P. 556
Oil on cardboard, 54 × 39 cm
Monogram in dark blue paint, lower left
Musée Toulouse-Lautrec, Albi

Here again the prostitutes are depicted not as significant temptresses, but as people threatened by a total loss of identity 'in the humble pose of personal hygiene' (Joris Karl Huysmans). The extreme discretion of the painting, however, is the exact antithesis of the exciting piquancy that was expected by a public used to Salon *galanteries*. Artists from Courbet to Renoir had turned their subjects into a mythical embodiment of the feminine, and the Symbolists had indulged in an ornate mixture of erotic desire, yearning and resignation. But Lautrec stays in the world of the present and depicts a worn-out physicality, which has an unpicturesque dignity sharing a particular kinship with mortality. The academic code of well-proportioned trivialities which answered the voyeur's demand for the indiscreet, is here superseded by the humiliated physical bodies of tired old women. In Lautrec's pictorial idiom, concerned as it is only with humanity, the repulsiveness of the woman is mitigated by sympathy. Instead of being provocatively exposed, they are in a natural state of undress.

Four paintings deal with the medical inspection at the Rue des Moulins brothel.[1] In what is probably the final version (Dortu III, P. 557) the original back view of the two figures has been changed to a profile view.

1 Dortu III, P. 554–P. 557.

SOURCES: Comtesse Adèle Zoë de Toulouse-Lautrec, Toulouse.
BIBLIOGRAPHY: Joyant 1926, p. 286; Schaub-Koch 1935, p. 191; Jourdain (1951), Ill. 7; Chastel 1966, Ill. 18; Dortu III, pp. 340f. P. 556 Ill., with P. 557; *Cat. Musée Toulouse-Lautrec* 1973, pp. 71f. No. 177 Ill.; Caproni-Sugana 1977, No. 369b Ill.; Dortu-Méric 1979, II, p. 50 No. 467 Ill.; Richard Thomson. 'Toulouse-Lautrec and Sculpture', in: *Gazette des Beaux-Arts*, February 1984, p. 83; *Cat. Musée Toulouse-Lautrec* (1985), pp. 138f. No. 179 Ill.
EXHIBITIONS: Paris 1931, No. 121; Albi 1951, No. 90; Paris 1958–1959, No. 36; Paris 1960–1961, No. 706; Munich 1961, No. 74; Cologne 1961–1962, No. 74; Chicago 1979, p. 24, No. 72, with Nos. 75, 108; Tokyo (etc.) 1982–1983, No. 44.

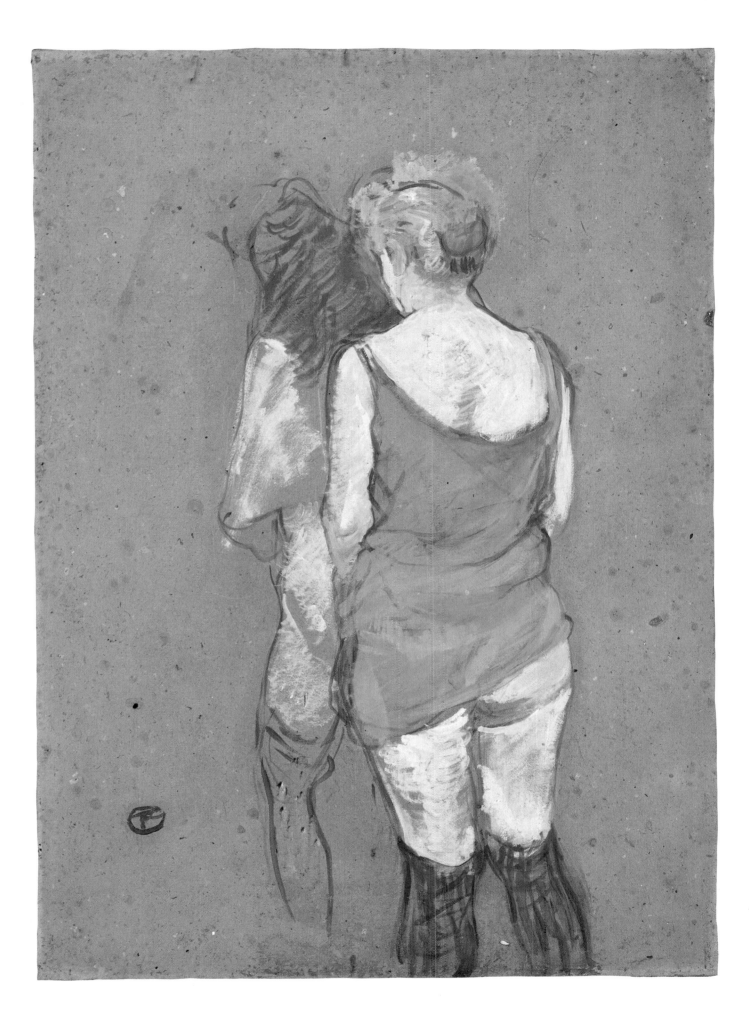

69 WOMAN PULLING UP A STOCKING (FEMME QUI TIRE SON BAS) 1894

Dortu III, P. 553
Oil on cardboard, 61.5 × 44.5 cm
Signed in red chalk (hardly visible), lower left: 'T-Lautrec'
Musée Toulouse-Lautrec, Albi

A final version of this motif (Dortu III, P. 552), fully painted in dark colours, includes an additional female figure on the left.

SOURCES: Comtesse Adèle Zoë de Toulouse-Lautrec, Toulouse.
BIBLIOGRAPHY: Joyant 1926, p. 127 Ill., p. 286; Jedlicka 1929, p. 181 Ill.; Lassaigne 1939, Ill. 123; Frankfurter 1951, p. 108 Ill.; *Toulouse-Lautrec* 1951, Ill.; Dortu 1952, Ill. (Jacket); Lassaigne 1953, pp. 74f. Ill.; Colombier 1953, Ill. 21; Hunter 1953, Ill. 21; *Toulouse-Lautrec* 1962, p. 137 Ill.; Bouret 1963, p. 136; Huisman-Dortu 1964, pp. 134–135 Ill.; Zinserling 1964, p. 35, Ill. 19; Chastel 1966, Ill. 14; Keller 1968, p. 43 Ill., pp. 57f.; Cionini-Visani 1968, Ill. 47; Fermigier 1969, p. 161 Ill.; Paret 1969, p. 36; Dortu III, pp. 338f. P. 553 Ill.; Devoisins 1972, p. 15; Polasek 1972, p. 39, No. IX Ill.; Josifovna 1972, Ill. 94; *Cat. Musée Toulouse-Lautrec* 1973, pp. 70f. No. 175 Ill., pp. 74–75 Ill.; Muller 1975, Ill. 67; Caproni-Sugana 1977, Ill. XLIII, No. 371b Ill.; Dortu-Méric 1979, II, p. 50 No. 466 Ill., p. 55 Ill.; Chicago 1979, with No. 61; Morariu 1980, Ill. 31; *Cat. Musée Toulouse-Lautrec* (1985), pp. 137ff. No. 177 Ill.
EXHIBITIONS: Paris 1914, No. 129; Paris 1931, No. 123; New York (etc.) 1950–1951, No. 21; Paris 1951, No. 56; Albi 1951, No. 88; Philadelphia-Chicago 1955–1956, No. 56; Paris 1958–1959, No. 34; London 1961, No. 49; Munich 1961, No. 72; Cologne 1961–1962, No. 72; Albi-Paris 1964, No. 55; Stockholm 1967–1968, No. 20; Humlebaek 1968, No. 19; Kyoto-Tokyo 1968–1969, No. 31; Liège 1978, No. 29; Tokyo (etc.) 1982–1983, No. 37.

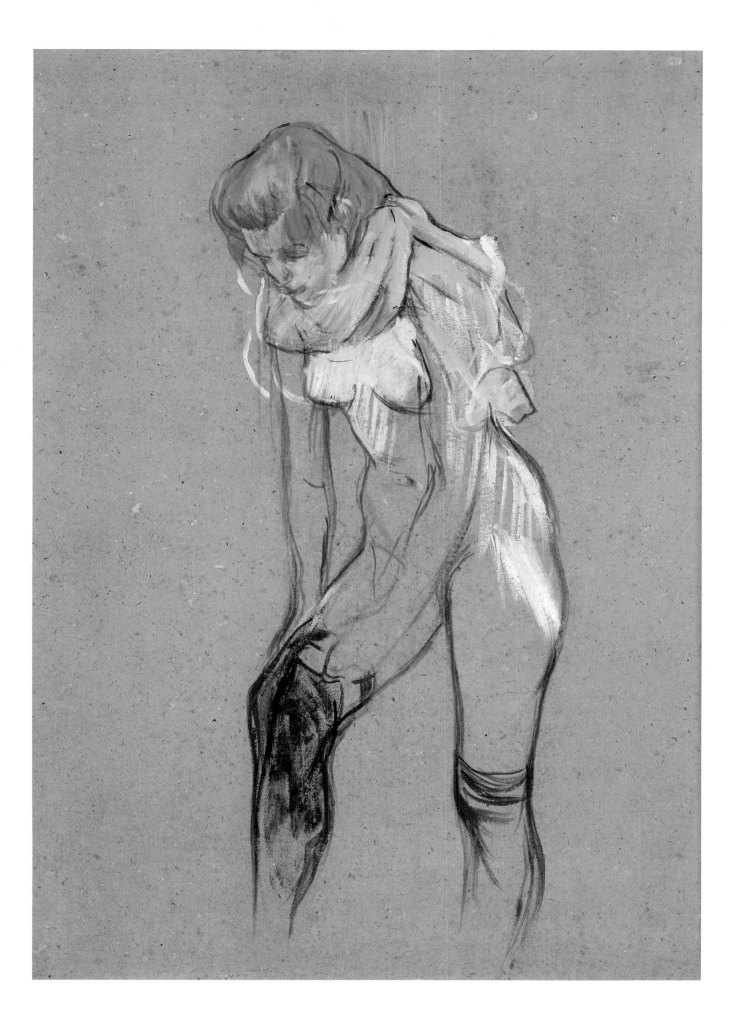

70 MARCELLE 1894

Dortu III, P. 542
Oil on cardboard, 46.5 × 29.5 cm
Signed in blue chalk, lower right: 'T-Lautrec'; inscribed in dark blue paint, upper left:
'Marcelle'
Musée Toulouse-Lautrec, Albi

What is immediately noticeable about this profile portrait of a prostitute called Marcelle is the very subtle differentiation of colours. Everything is calculated to give due value to the pale, painted face in sharp contrast to the dark hair. The almost unbroken pale colouring of the complexion is relatively finely textured, and the shadows and outlines are carefully considered, whereas the brushwork in the dark areas of the hair and the white of the shirt is much freer. Here the paint is applied fluidly in several layers of parallel and cross-hatching. The dark blue-grey of the bedspread – which functions as a professional attribute – stands out in the background against the natural brown of the cardboard.

The figure herself is motionless – fatigued by having to sit still, the woman gazes wearily into the distance.[1] The picture's liveliness derives from the variety of painting techniques used. The contrast between precise execution and sketchy suggestion, between fully painted areas and bare cardboard ground is characteristic of the open style which Lautrec had developed since 1886–1888 and was to use for over a decade.

1 *Cf.* the portrait drawing Dortu V, D. 3479.

SOURCES: Comtesse Adèle Zoë de Toulouse-Lautrec, Toulouse.
BIBLIOGRAPHY: Alexandre 1914, p. 13 Ill.; Astre (1926), p. 81; Joyant 1926, p. 150 Ill., p. 158, p. 285; Jedlicka 1929, pp. 266f. Ill.; Joyant 1930, p. 12 Ill.; Schaub-Koch 1935, p. 191; Mac Orlan 1941, p. 113; Jedlicka 1943, pp. 214–215f. Ill., p. 283; Lassaigne 1953, p. 72; Landolt 1954, p. 22, with No. 9, No. 10 Ill.; Dortu-Grillaert-Adhémar 1955, p. 33; Perruchot 1958, p. 244; Bouret 1963, p. 144; Zinserling 1964, p. 35, Ill. 16; Cogniat (1966), p. 20 Ill.; Keller 1968, p. 39 Ill., p. 57; Fermigier 1969, p. 164 Ill.; Dortu III, pp. 332f. P. 542 Ill.; Josifovna 1972, Ill. 93; Muller 1975, Ill. 62; Caproni-Sugana 1977, No. 390 Ill.; Dortu-Méric 1979, II, p. 48 No. 457 Ill.; Chicago 1979, with No. 69; *Cat. Musée Toulouse-Lautrec* (1985), pp. 133f. No. 171 Ill.
EXHIBITIONS: Brussels 1902, No. 284; Paris 1902, No. 13; Paris 1914, No. 85; Paris 1931, No. 117; Albi 1951, No. 82; Paris 1958–1959, No. 31; London 1961, No. 48; Munich 1961, No. 68; Cologne 1961–1962, No. 68; Albi-Paris 1964, No. 54; Stockholm 1967–1968, No. 21; Kyoto-Tokyo 1968–1969, No. 37; Tokyo (etc.) 1982–1983, No. 40.

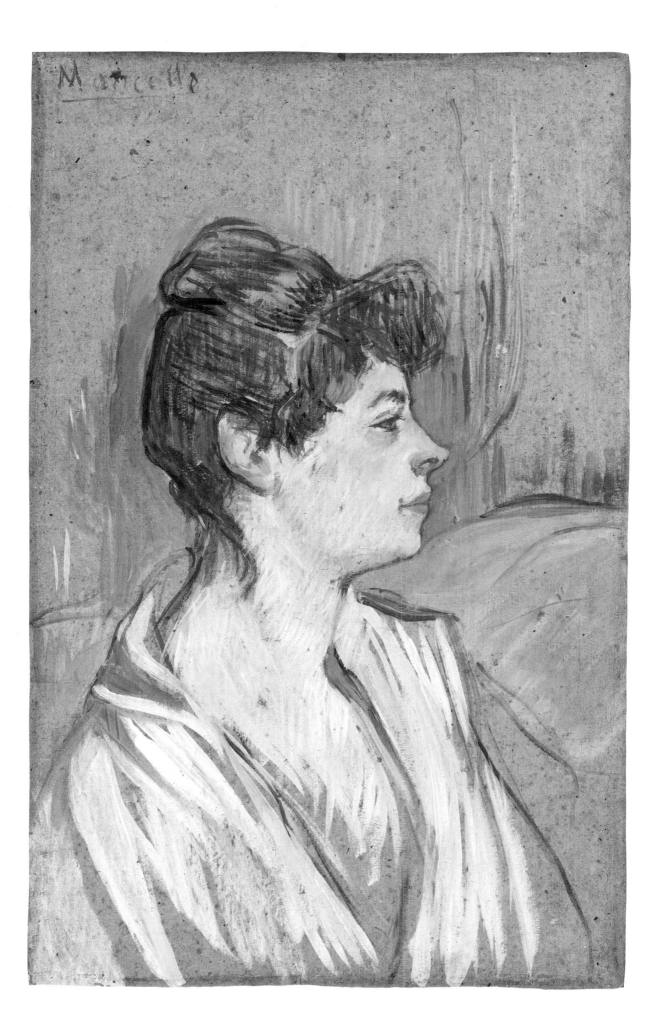

71 THE DIVAN, ROLANDE (LE DIVAN, ROLANDE) 1894

Dortu III, P. 546
Oil on cardboard, 51.7 × 66.9 cm
Red monogram stamp (Lugt 1338), lower left
Musée Toulouse-Lautrec, Albi

The particular emphasis in Lautrec's work on the varied roles of woman – as maternal companion, lover, prostitute and actress – may perhaps be explained by the helplessness of his longings. The fact that these models often have the faces of real people gives them a contemporary reality unchallenged by the nineteenth century's extravagant interpretations of woman, ranging from innocence to wantonness; the artist extracted from his models the very essence of their authentic reality. His interpretations may sometimes seem sarcastic, but they never slip into the indiscreet or wounding – even in those cases where the work could have encouraged a certain obtrusiveness in the figures.

One of the inmates of the Rue des Moulins brothel was Rolande, known as 'Le petit Mac'. Her characteristic snub-nosed profile crops up several times (*cf.* No. 72).[1] Like most of his favourite models she had reddish-blond hair. She is shown here with one of her fellow inmates, seated on the edge of the bed and illuminated by the bedside lamp in a way that Georges de la Tour or Daumier could not have achieved more effectively.

1 Dortu III, P. 545, P. 548; Dortu V, D. 3477; Dortu VI, E. 65.

SOURCES: Comtesse Adèle Zoë de Toulouse-Lautrec, Toulouse.
BIBLIOGRAPHY: Joyant 1926, p. 158, p. 285; Joyant 1927, p. 256; Dortu III, pp. 334f. P. 546 Ill.; *Cat. Toulouse-Lautrec* 1973, pp. 67ff. No. 172 Ill.; Caproni-Sugana 1977, No. 392 Ill.; Dortu-Méric 1979, II, p. 48 No. 461 Ill.; Chicago 1979, with Nos. 70, 71; *Cat. Musée Toulouse-Lautrec* (1985), pp. 135f. No. 174 Ill.
EXHIBITIONS: Paris 1909; Paris 1914, No. 127; Albi 1951, No. 85; Kyoto-Tokyo 1968–1969, No. 33.

72 In Bed
(Au Lit) 1894

Dortu III, P. 547
Oil on cardboard, 52 × 67.3 cm
Red monogram stamp (Lugt 1338), lower right
Musée Toulouse-Lautrec, Albi

The high nostrils in this very bold view from below suggest that the figure buried in this mountain of pillows may also be the prostitute Rolande performing her professional duties (*cf.* No. 71).[1] Less abstract bedroom scenes had been part of Lautrec's repertoire of themes since 1892.[2]

1 There is a preparatory sketch for the composition, probably drawn on the spot (Dortu VI, D. 3741).
2 Dortu II, P. 436–P. 439; Dortu VI, D. 3748.

SOURCES: Comtesse Adèle Zoë de Toulouse-Lautrec, Toulouse.
BIBLIOGRAPHY: Joyant 1926, p. 285; Lapparent 1927, p. 37. p. 47; Jedlicka 1929, p. 311; Schaub-Koch 1935, p. 192; Jedlicka 1943, p. 246; Landolt 1954, p. 16, p. 25, No. 11 Ill.; Devoisins 1970, p. 54; Dortu III, pp. 336 f. P. 547 Ill.; *Cat. Musée Toulouse-Lautrec* 1973, p. 67 Ill., p. 69 No. 173; Caproni-Sugana 1977, No. 393 Ill.; Dortu-Méric 1979, II, p. 48 No. 462 Ill.; *Cat. Musée Toulouse-Lautrec* (1985), pp. 135 ff. No. 175 Ill.
EXHIBITIONS: Paris 1914, No. 131; New York (etc.) 1950–1951, No. 19; Paris 1951, No. 53; Albi 1951, No. 86; Marseilles 1954, No. 14; Philadelphia-Chicago 1955–1956, No. 54; Munich 1961, No. 70; Cologne 1961–1962, No. 70; Kyoto-Tokyo 1968–1969, No. 32; Paris 1975–1976, No. 29; Liège 1978, No. 27; Chicago 1979, No. 71, with No. 80; Tokyo (etc.) 1982–1983, No. 41.

73 The Laundryman at the Brothel (Le Blanchisseur de la Maison) 1894

Dortu III, P. 544
Oil on cardboard, 57.8 × 46.2 cm
Signed in dark blue chalk, upper right: 'T–Lautrec'
Musée Toulouse-Lautrec, Albi

This everyday event in one of the Paris brothels is open to many possible interpretations. These range from regarding it as a straightforward genre scene, showing the man collecting the laundry standing in front of his customer, to unambiguously sexual readings of the motif. The crucial point in the composition is the grotesque mask-like face of the man.[1] While the fat *sous-maîtresse* of the establishment checks the bill, the delivery-man's gaze is lecherously fixed on her body. Unmoved by the lustful stare of this satyr in workman's garb, she is concerned only with the business aspects of the encounter.

1 There are two small preparatory sketches for the figure (Dortu V, D. 3687, D. 3688).

SOURCES: Comtesse Adèle Zoë de Toulouse-Lautrec, Toulouse.
BIBLIOGRAPHY: Alexandre 1914, p. 13 Ill.; Astre (1926), p. 99; Joyant 1926, p. 158 Ill., p. 285; Joyant 1927, p. 256; Lapparent 1927, p. 37, p. 47, Ill. 12; Schaub-Koeh 1935, p. 191; Mack 1938, p. 255; Mac Orlan 1941, p. 99 Ill., p. 113; Jourdain-Adhémar 1952, p. 41; Lassaigne 1953, pp. 76 f Ill.; Cooper 1955, p. 116; Dortu-Grillaert-Adhémar 1955, p. 33 Ill. 17; Julien (1959), p. 48 Ill.; *Toulouse-Lautrec* 1962, p. 257 Ill.; Bouret 1963, p. 165; Huisman-Dortu 1964, p. 138 Ill.; Zinserling 1964, p. 24 Ill. 17; Cionini-Visani 1968, Ill. 46; Novotny 1969, Ill. 71; Dortu III, pp. 334 f. P. 544 Ill.; Dortu V, p. 614 with D. 3687, D. 3688; Josifovna 1972, Ill. 91; *Cat. Musée Toulouse-Lautrec* 1973, pp. 67 f. No. 171 Ill.; Huisman-Dortu 1973, p. 79 Ill.; Caproni-Sugana 1977, Ill. XXXVIII, No. 391 Ill.; Dortu-Méric 1979, II, p. 48 No. 459 Ill., p. 53 Ill.; Morariu 1980, Ill. 32; Arnold 1982, p. 54 Ill.; Lucie-Smith 1983, Ill. 29; *Cat. Musée Toulouse-Lautrec* (1985), pp. 135 f. No. 173 Ill.
EXHIBITIONS: Brussels 1902, No. 287; Paris 1902, No. 229; Paris 1909; Paris 1931, No. 120; Albi 1951, No. 84; Paris 1958–1959, No. 32; Munich 1961, No. 69; Cologne 1961–1962, No. 69; Kyoto-Tokyo 1968–1969, No. 35; Brussels 1973, No. 12; Paris 1975–1976, No. 27; Chicago 1979, No. 68, with No. 61; Tokyo (etc.) 1982–1983, No. 39.

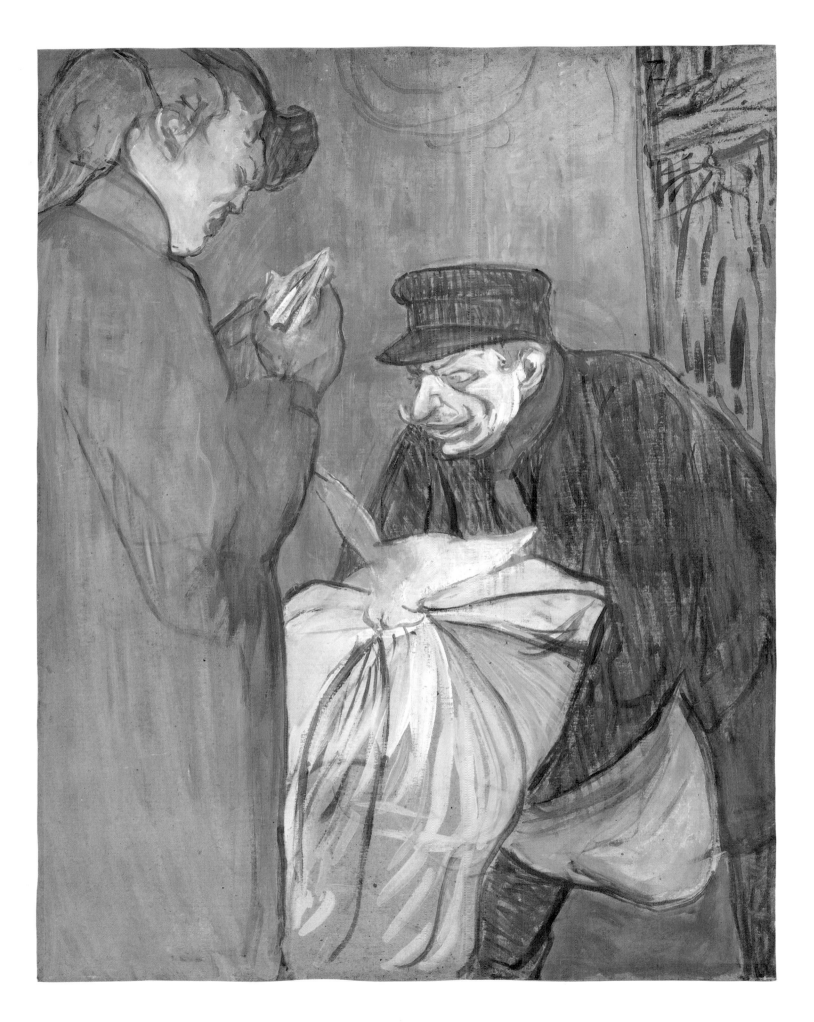

74 Yvette Guilbert Taking a Bow (Yvette Guilbert Saluant le Public) 1894

Dortu III, P. 520
Oils painted over a reproduction on photographic paper, 48 × 28 cm
Monogram in red chalk, lower right
Musée Toulouse-Lautrec, Albi

Lautrec got to know the cabaret performer, *diseuse* and singer Yvette Guilbert (1865–1944) at the beginning of 1893 through her songwriter Maurice Donnay. After a brief period on the theatrical stage she had, since 1889, devoted herself to the *cafés-concert* and had great success as a *divette fin-de-siècle* at the Eldorado, the Divan Japonais, the Scala and the Ambassadeurs. Lautrec was delighted by Yvette's robust, superficial wit as she intoned salacious stories to melancholy tunes in a biting and yet reluctantly dragging manner.

His Yvette Guilbert Album, which appeared in the summer of 1894, contained sixteen lighographic marginal illustrations devoted entirely to the *diseuse* (*cf.* No. 75),[1] and the text of the album, written by the critic Gustave Geffroy, described the milieu of the Paris *cafés-concert*. It was printed in an edition of one hundred copies solely to promote the *artiste's* reputation. Reaction was mixed; in *L'Echo de Paris* of 15 October 1894 Jean Lorrain accused Lautrec of having carried the cult of ugliness too far. Yvette herself was worried at first, but allowed herself to be convinced by Geffroy of the quality of the pictures; she signed the edition after Georges Clemenceau in *La Justice* of 15 September had written appreciatively, 'this ghost has the deeply moving effect of an apocalyptic vision'. Gaston Davenay in *Le Figaro* was also positive in his comments.

A chalk drawing heightened with watercolour (Dortu III, A. 214) served as a preparatory study for the sixteenth and last of the illustrations in the album.[2] The present sheet is a reproduction of this drawing overpainted with thinned oil-colour instead of watercolour. The narrow view, cut off on one side by the wings, is carefully chosen. Bathed in pale stage lighting, the cabaret *artiste's* harshly painted face, reddish-blond hair, attitude and costume have an almost grotesque effect.

1 Adriani 1986, 74–89.
2 *Cf.* also the sheets of sketches Dortu V, D. 3373, D. 3646, D. 3647.

SOURCES: Comtesse Adèle Zoë de Toulouse-Lautrec, Toulouse.
BIBLIOGRAPHY: Joyant 1926, p. 280; Lapparent 1927, p. 36; Mack 1938, p. 197 Ill.; Jourdain 1948, Ill. 27; Kern 1948, Ill. 27; Lassaigne 1953, p. 66 Ill.; Cooper 1955, pp. 114f Ill.; Dortu-Grillaert-Adhémar 1955, p. 36; Bouret 1963, p. 129; Chastel 1966, Ill. 17; Vienna 1966, with No. 47; Keller 1968, p. 41, p. 60, p. 95 Ill.; Cionini-Visani 1968, Ill. 41; Fermigier 1969, p. 153 Ill.; Lassaigne 1970, Ill. 42; Dortu III, pp. 320f. P. 520 Ill., p. 506 with A. 214; *Cat. Musée Toulouse-Lautrec* 1973, pp. 61 ff. No. 162 Ill.; Muller 1975, Ill. 36; Adriani 1976, p. 262 with 93; Caproni-Sugana 1977, Ill. XLII, No. 382 Ill.; Dortu-Méric 1979, II, p. 44 No. 437 Ill., p. 49 Ill.; Morariu 1980, Ill. 38; Arnold 1982, p. 40 Ill.; Cooper 1983, pp. 40f. Ill.; *Cat. Musée Toulouse-Lautrec* (1985), pp. 127 ff. No. 163 Ill.; Adriani 1986, with 89.
EXHIBITIONS: Paris 1914, No. 180; New York 1937, No. 33; London 1938, No. 36; Paris 1938, No. 21; Amsterdam 1947, No. 33; Brussels 1947, No. 33; New York (etc.) 1950–1951, No. 17; Paris 1951, No. 49; Albi 1951, No. 74; Philadelphia-Chicago 1955–1956, No. 60; Nice 1957, No. 20; Dallas 1957; London 1961, No. 52; Paris 1975–1976, No. 28; Liège 1978, No. 28; Tokyo (etc.) 1982–1983, No. 38.

75 Yvette Guilbert's Black Gloves (Gants Noirs d'Yvette Guilbert) 1894

Dortu III, P. 518
Black chalk and oil on cardboard, 62.8 × 37 cm
Inscribed in dark grey paint, upper right: 'Yvette'
Musée Toulouse-Lautrec, Albi

Yvette Guilbert's long, black gloves were her trademark (*cf.* No. 74). They gave emphasis in a curious way to the theatrically expansive gestures of their wearer. So it is not surprising that Lautrec chose this pair of gloves, draped over a dressing table next to a powder-puff, for the jacket illustration of his first Yvette Guilbert Album published in the summer of 1894.[1] The rectangular area for reproduction has been marked on the vertical format of the cardboard with horizontal chalk lines, and the typography for the jacket is concisely indicated.

1 Adriani 1986, 73.

SOURCES: Henri Bourges, Paris
BIBLIOGRAPHY: Joyant 1926, p. 280; Lapparent 1927, p. 36; Bouret 1963, p. 139; Keller 1968, p. 60, p. 94 Ill.; Novotny 1969, p. 36, p. 48, Ill. 53; Dortu III, pp. 320f. P. 518 Ill.; *Cat. Musée Toulouse-Lautrec* 1973, pp. 59f. No. 160 Ill.; Adriani 1976, p. 261 with 77; Caproni-Sugana 1977, No. 381; Jullian 1977, p. 200 Ill. (turned sideways); Dortu-Méric 1979, II, p. 42 No. 435 Ill.; *Cat. Musée Toulouse-Lautrec* (1985), pp. 126f. No. 161 Ill.; Adriani 1986, with 73.
EXHIBITIONS: Albi 1951, No. 72; Munich 1961, No. 60; Cologne 1961–1962, No. 60; Kyoto-Tokyo 1968–1969, No. 30; Chicago 1979, No. 63, with Nos. 64, 78, 79.

76 Three Chorus Girls at the Folies Bergère (Aux Folies Bergère, Trois Figurantes) 1894

Dortu III, P. 524
Oil on cardboard, 69 × 59 cm
Red monogram stamp (Lugt 1338), lower left
Musée Toulouse-Lautrec, Albi

A group of dancers at the Folies Bergère is sketched here in rapid strokes as they appeared either in the pantomime *Fleur de Lotus* by Armand Silvestre or in the review *Bal des Quatr'z-Arts* by G. Courteline and C. Marsolleau.

SOURCES: Comtesse Adèle Zoë de Toulouse-Lautrec, Toulouse.
BIBLIOGRAPHY: Joyant 1926, p. 281; Jourdain (1951), Ill. 9; Dortu III, pp. 324f. P. 524 Ill.; *Cat. Musée Toulouse-Lautrec* 1973, p. 64 No. 165; Caproni-Sugana 1977, No. 386 Ill.; Dortu-Méric 1979, II, p. 44 No. 441 Ill.; *Cat. Musée Toulouse-Lautrec* (1985), pp. 130f. No. 166 Ill.
EXHIBITIONS: Paris 1914, No. 122.

77 Footit as a Ballerina (Footit en Danseuse) 1894–1895

Dortu VI, D. 3776
Black and blue chalk, with white wash on white paper, 36 × 23.2 cm
Monogram in black chalk, lower left
Private Collection

The English clown George Footit (1864–1921), seen here in a ballerina's tutu, used to appear mainly at the Noveau Cirque, 251 Rue Saint-Honoré (*cf.* Nos. 110, 114). This drawing was reproduced as the last of five illustrations for Romain Coolus's article 'Théorie de Footit sur le Rapt' in the magazine *Le Rire*, No. 12, on 26 January 1895.[1]

1 Dortu VI, D. 3772–D. 3775; *cf.* also the pictures of Footit Dortu VI, D. 3921, D. 3924, D. 3925.

SOURCES: Otto Gerstenberg, Berlin.
BIBLIOGRAPHY: Astre (1926), p. 102; Joyant 1927, p. 211; Dortu VI, pp. 640f. D. 3776 Ill.
EXHIBITIONS: Ingelheim 1968, No. 33.

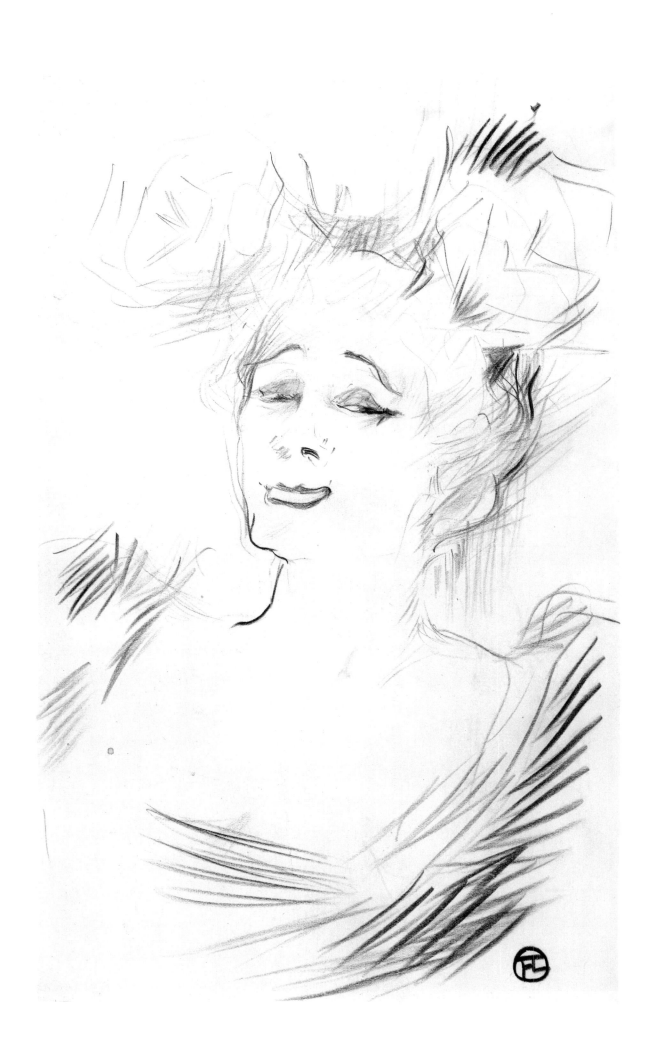

78 MADEMOISELLE MARCELLE LENDER 1895

Dortu VI, D. 3765
Black and blue chalk on white paper, 30.2 × 19 cm
Monogram in black chalk, lower right
Mr and Mrs Eugene Victor Thaw, New York

From 18 February 1895 Florimond Ronger Hervé's operetta-review *Chilpéric* was revived at the Théâtre des Variétés. Its main attraction was the bolero danced by Anne Marie Bastien, known as Marcelle Lender (1862–1926), in the role of Galaswintha. It was not so much the subject matter of this Merovingian foolery, as the actress, dressed in a fantastic Spanish costume, that made Lautrec attend nearly twenty performances of the operetta. He would always watch from the same viewpoint, lurking with his drawing pad. In the end his friend Romain Coolus refused to accompany Lautrec, after attending a number of performances, and asked the reason for this extraordinary persistence; Lautrec replied that he was particularly struck by Lender's admirable back: 'Look at it carefully, you won't find a more magnificent one.'[1]

Among the many paintings, drawings and lithographs inspired by Lender's performances in *Chilpéric*,[2] none can be related directly to the present portrait drawing. The staccato lines subject the head to an endurance test of caricature that is not to be found in any of the other Lender portraits. Quite unconcerned with such distortions, Lautrec vividly reveals the sensuous appearance of the actress through this nervous linear structure.

1 Coolus 1931, p. 139.
2 Dortu III, P. 626, P. 627; Dortu VI, D. 3810, D. 3814, D. 3815, D. 3897, D. 3898, D. 4141, D. 4242; Adriani 1986, 111–115.

SOURCES: S. Sévadjian, Paris; Vente *Collection Sévadjian*, Hôtel Drouot, Paris 22 March 1920, No. 28; M. Kroller, Paris; T. Edward Hanley, Bradford; Tullah Hanley, Bradford; Elisabeth Molnar, Bradford.
BIBLIOGRAPHY: Joyant 1927, p. 208, p. 262; Dortu VI, pp. 634f. D. 3765 Ill.
EXHIBITIONS: *The T. Edward Hanley Collection*, Albright Art Gallery, Buffalo 1946, No. 34; *T. Edward Hanley Collection*, Museum of Art, Philadelphia 1957; *Paintings and Drawings from the Hanley Collection*, Wildenstein & Co. Gallery, New York 1961, No. 115; New York 1964, No. 73; *Drawings from the Collection of Mr. & Mrs. Eugene V. Thaw*, The Pierpont Morgan Library, New York – The Cleveland Museum of Art – The Art Institute of Chicago – The National Gallery of Canada, Ottawa 1976, No. 105.

79 MADEMOISELLE POLAIRE 1895

Dortu III, P. 594
Oil on cardboard, 56 × 41 cm
Signed in red chalk, lower right: 'T-Lautrec'
Musée Toulouse-Lautrec, Albi

The Algerian-born *diseuse* Emilie Marie Bouchaud, known as Polaire (born in 1879) appeared at the Ambassadeurs, the Folies Bergère, the Eldorado and the Scala. She was said by *La Vie Parisienne* to sing with her legs, speak with her arms and to use the rest of herself

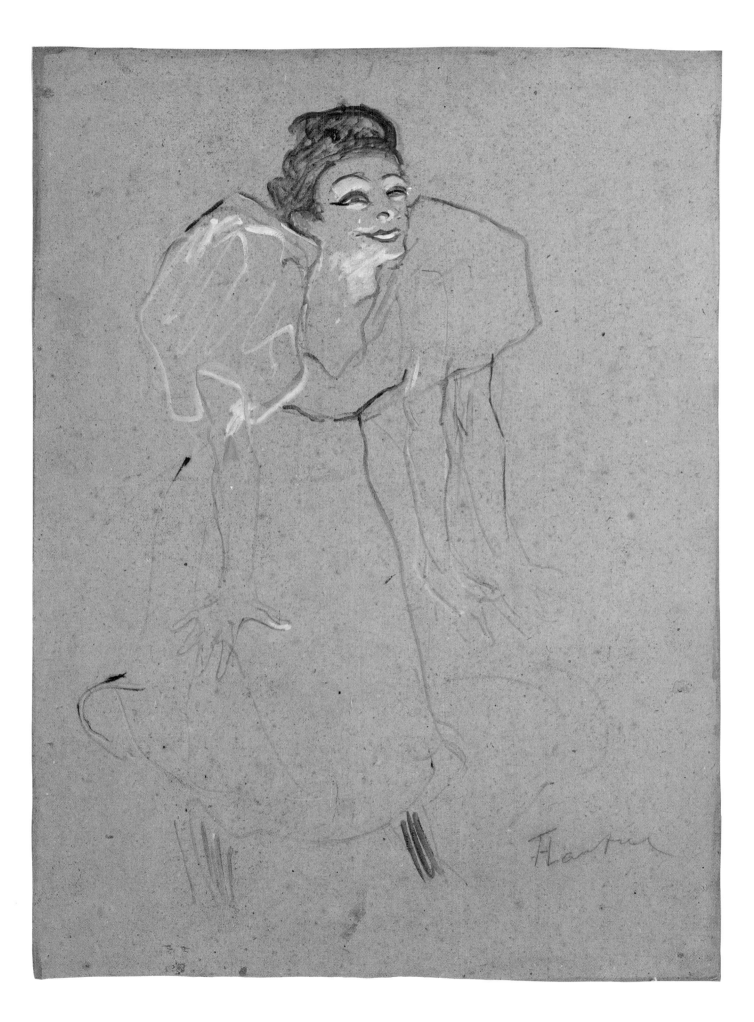

for emphasis. This oil sketch was a study for an identical drawing (Dortu VI, D. 3768) which was reproduced in colour on 23 February, in the magazine *Le Rire*, No. 16.

Such celebrities of the day provided Lautrec with a welcome opportunity to penetrate into a world where an evanescent splendour, founded on the illusions created by distance and stage make-up, could also represent more general truths. However, in Lautrec's work the individual performance, placed as if on a pedestal, on the stage with its harsh, inescapable lighting, was not supported — as it was with Degas — by a stage filled with supernumeraries; instead, it developed increasingly into an exposure of the individual — a sort of secular *Ecce Homo*.

SOURCES: Comtesse Adèle Zoë de Toulouse-Lautrec, Toulouse.
BIBLIOGRAPHY: Joyant 1926, p. 291; Jedlicka 1929, p. 329 Ill.; Perruchot 1958, p. 268; *Toulouse-Lautrec* 1962, p. 110 Ill.; Fermigier 1969, p. 132 Ill.; Dortu III, pp. 366f. P. 594 Ill.; *Cat. Musée Toulouse-Lautrec* 1973, pp. 76ff. No. 184 Ill.; Muller 1975, Ill. 42; Caproni-Sugana 1977, No. 406 Ill.; Dortu-Méric 1979, II, pp. 57f. No. 503 Ill.; *Cat. Musée Toulouse-Lautrec* (1985), pp. 144f. No. 186 Ill.
EXHIBITIONS: Paris 1902, No. 132; Munich 1961, No. 78; Cologne 1961–1962, No. 78; Albi-Paris 1964, No. 61; Brussels 1973, No. 14.

80 ABANDON, THE TWO FRIENDS (L'ABANDON, LES DEUX AMIES) 1895

Dortu III, P. 598
Oil on cardboard, with strip added on the left, 45.5 × 67.5 cm
Signed in dark green paint, lower left: 'T-Lautrec'
Private Collection

This painting of two women is one of the most beautiful representations of human affection. On a broad, yellow-patterned couch, surrounded by high cushions, the two friends dressed in their underclothes recline and turn devotedly to one another. Lautrec had first dealt with the theme of a lesbian relationship in four paintings of 1892 (see Nos. 64, 65).[1]

Some decades earlier Courbet had used all the rhetoric of drapery and the body to transpose this theme into the sphere of erotic sensuality in his depiction of a female couple in two large and scandalous paintings (Ills. p. 190). Lautrec's vision was more restrained. While Courbet's dreaming figures lie open to the viewer, the models in Lautrec's picture shut themselves off from the outsider. His theme is not the fullness of life; he portrays, rather, two life-worn people escaping into a protective togetherness and relying on one another with confidence. Indiscriminate availability gives way to devotion to a beloved partner.

If the relationship of the two faces, one of which is shown in lost profile, and the position of the figure seen from the back, are compared with Velázquez's VENUS AT HER MIRROR (Ill. p. 190), the juxtaposition is even more telling than the comparison with Courbet's paintings. The reflected confrontation in the Velázquez is cited by Lautrec in its unbeautified reality. The divine, illusory reflection in the mirror, whose frame motif is incorporated into Lautrec's painting by the position of the arms, is reduced to a face in which disillusion has become second nature.

1 Dortu II, P. 436–P. 439; *cf.* also the later variants Dortu III, P. 597, P. 601, P. 602.

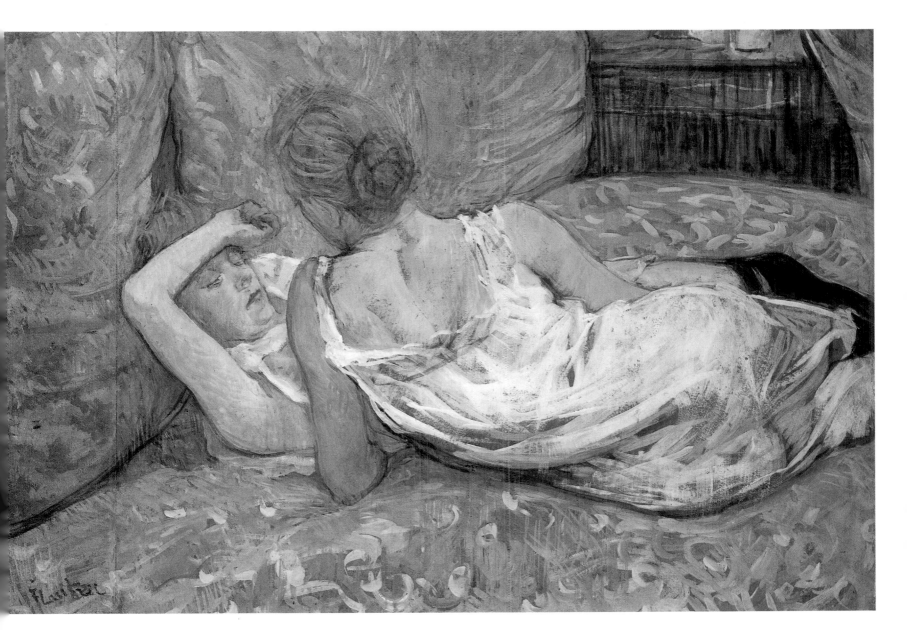

SOURCES: P. Gallimard, Paris; Paul Cassirer, Amsterdam; Hans R. Schinz, Zurich.
BIBLIOGRAPHY: Coquiot 1913, p. 109 Ill.; Coquiot (1923), Ill. 3; Joyant 1926, p. 291; Jedlicka 1929, p. 303 Ill.; Lassaigne 1939, Ill. 128; Mac Orlan 1941, p. 177 Ill.; Jedlicka 1943, pp. 248–249f. Ill.; Jourdain 1948, Ill. 32; Kern 1948, Ill. 32; Jourdain-Adhémar 1952, p. 52, No. 54 Ill., p. 112; Dortu 1952, p. 8 Ill. 47; Cooper 1955, p. 102, pp. 120f. Ill.; *Sammlung Emil G. Bührle*, Kunsthaus, Zurich 1958, with No. 205; Paret 1969, Ill.; Fermigier 1969, p. 173 Ill.; Dortu III. pp. 368f. P. 598 Ill.; Caproni-Sugana 1977, No. 409 Ill.; Dortu-Méric 1979, II, pp. 57f. No. 507 Ill.; Cooper 1983, pp. 46f. Ill.
EXHIBITIONS: Paris 1931, No. 129; Zurich 1933, No. 95; Rotterdam 1933–1934, No. 82; Paris 1938 (Galerie des Beaux-Arts), No. 117; *Honderd Jaar Fransche Kunst*, Stedelijk Museum, Amsterdam 1938, No. 239; Zurich 1943, No. 693; Basel 1947, No. 174; Paris 1951, No. 65; Winterthur 1955, No. 198; Schaffhausen 1963, No. 132; Chicago 1979, p. 24, No. 79, with No. 80.

Gustave Courbet, GIRLS ON THE BANKS OF THE SEINE, 1856–1857, Musée du Petit Palais, Paris

Gustave Courbet, SLEEP, 1866, Musée du Petit Palais, Paris

Diego Velázquez, VENUS AT HER MIRROR (THE ROKEBY VENUS), *c.* 1644–1648, National Gallery, London

81 PRESENTATION OF A HORSE (PRÉSENTATION D'UN CHEVAL) 1895

Dortu VI, D. 4031
Pen and black ink on white paper, 20.2 × 31 cm
Red monogram stamp (Lugt 1338), lower left
Museum Boymans-van Beuningen (Cat. No. F. II 157), Rotterdam

This racecourse scene should be seen in connection with some sketches drawn in 1895 as preparatory studies for four illustrations to Romain Coolus's story *Le Bon Jockey* (see No. 82).[1]

1 Dortu VI, D. 3930–D. 3933, D. 4028–D. 4030, S.D. 24–S.D. 26.

SOURCES: Franz Koenigs, Haarlem.
BIBLIOGRAPHY: Dortu-Grillaert-Adhémar 1955, p. 38; Longstreet 1966, Ill.; Hoetink 1968, p. 147 No. 250, Ill.; Dortu VI, pp. 688f. D. 4031 Ill.
EXHIBITIONS: Amsterdam 1946, No. 181; Amsterdam 1947, No. 109; Brussels 1947, No. 109; Vienna 1966, No. 61; Stockholm 1967–1968, No. 129; Brussels 1973, No. 36.

82 STUDIES OF RIDERS (ETUDES DE CAVALIERS) *c.* 1880/1895

Dortu III, P. 566
Pencil and oil on canvas, 65 × 40 cm
Musée Toulouse-Lautrec, Albi

This canvas with a study of a horseman set against a dark background was left unfinished around 1880. The sketch of the rider in brown heightened with white in the lower half of the canvas, was probably related to four illustrations for Romain Coolus's story *Le Bon Jockey*, which were reproduced in July 1895 in *Le Figaro Illustré*, No. 64[1] (*cf.* No. 81). A similar figure of a rider is also found on the sheet of sketches Dortu VI, D. 3928.

1 Dortu III, A. 217–A. 220.

SOURCES: Comtesse Adèle Zoë de Toulouse-Lautrec, Toulouse.
BIBLIOGRAPHY: Joyant 1926, p. 287; Bouret 1963, p. 160; Dortu III, pp. 344f. P. 566 Ill.; *Cat. Musée Toulouse-Lautrec* 1973, p. 79 No. 186; Caproni-Sugana 1977, No. 407 Ill.; Dortu-Méric 1979, II, p. 52 No. 476 Ill.; *Cat. Musée Toulouse-Lautrec* (1985), p. 144 Ill., p. 146 No. 188.
EXHIBITIONS: Tokyo (etc.) 1982–1983, No. 46.

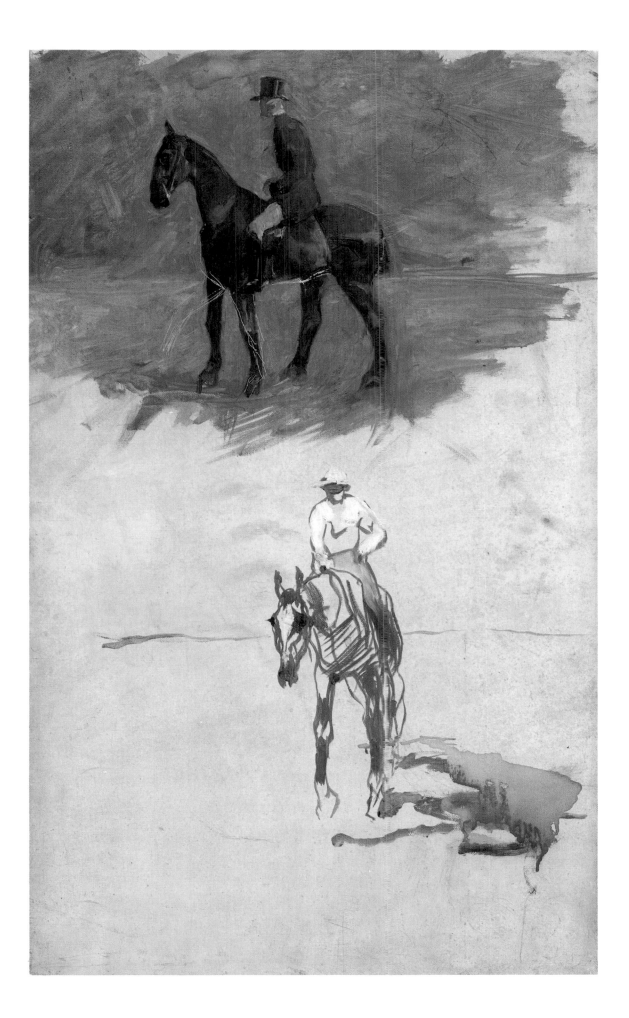

83 HEAD OF A RACING STABLE LAD (TÊTE DE LAD D'ECURIE DE COURSES) 1895

Dortu III, P. 578
Oil on cardboard, 68 × 53 cm
Signed in red chalk, lower right; 'T-Lautrec'
Musée Toulouse-Lautrec, Albi

It is constantly fascinating to observe how economically the artist deployed his means. He liked to contrast the pale, chalky complexions of his models with the dark blue of a fluid outline, or to set their profiles against a strong turquoise-green. The denser brushwork is limited to the young man's head. He alone is worked out in plastic terms, and lent a firmly three-dimensional reality by the white form of his fashionable high collar. Beyond the delicate head and shoulders, the brown cardboard is left entirely in its original state – and yet nothing needs to be added to this, one of Lautrec's consummate and original portraits.

SOURCES: Comtesse Adèle Zoë de Toulouse-Lautrec, Toulouse.
BIBLIOGRAPHY: Joyant 1926, p. 288; Jedlicka 1929, p. 299 Ill.; Mack 1938, pp. 228–229 Ill.; *Toulouse-Lautrec* 1951, Ill.; Dortu-Grillaert-Adhémar 1955, p. 36; Zinserling 1964, Ill. 27; Fermigier 1969, p. 199 Ill.; Dortu III, pp. 352 f. P. 578 Ill.; *Cat. Musée Toulouse-Lautrec* 1973, pp. 74 ff. No. 182 Ill.; Caproni-Sugana 1977, No. 404 Ill.; Dortu-Méric 1979, II, p. 54 No. 487 Ill.; *Cat. Musée Toulouse-Lautrec* (1985), p. 141 Ill., p. 143 No. 184.
EXHIBITIONS: Paris 1914, No. 106; Paris 1931, No. 127; Basel 1947, No. 141; Amsterdam 1947, No. 42; Brussels 1947, No. 42; New York (etc.) 1950–1951, No. 23; Paris 1951, No. 61; Albi 1951, No. 95; Philadelphia-Chicago 1955–1956, No. 66; Paris 1958–1959, No. 38; London 1961, No. 55; Munich 1961, No. 77; Cologne 1961–1962, No. 77; Kyoto-Tokyo 1968–1969, No. 42.

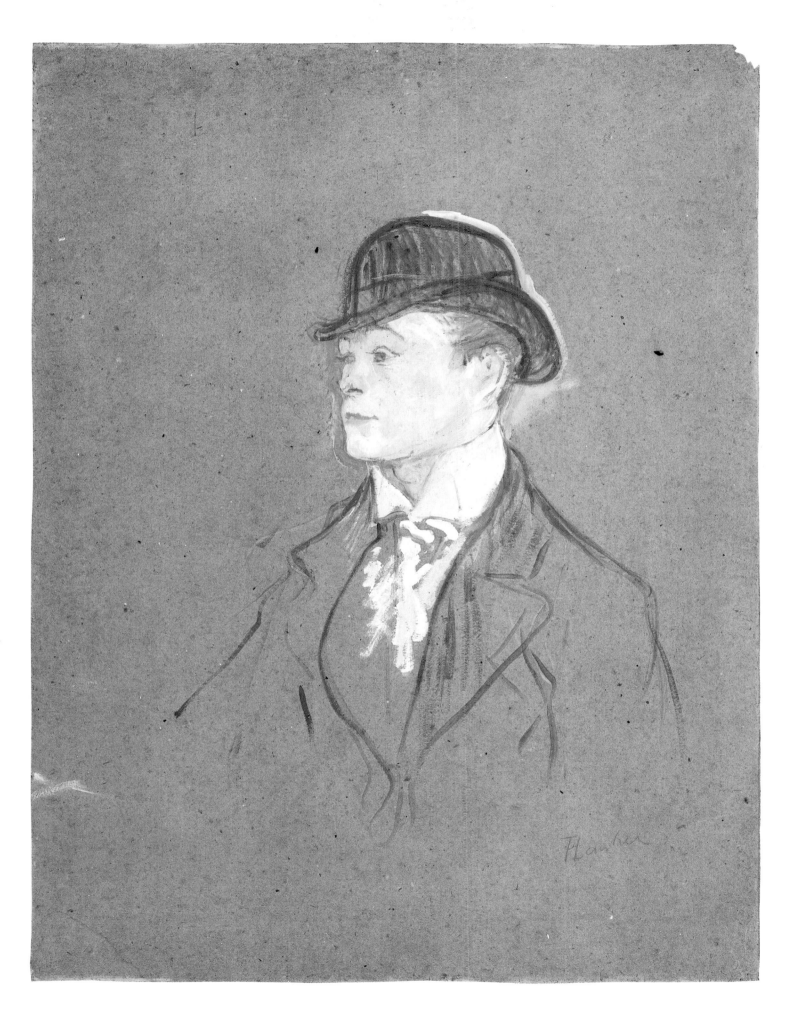

84 MISS MAY MILTON 1895

Dortu VI, D. 3887
Blue and black chalk on pale brown paper, 74 × 58.9 cm
Inscribed in blue and black chalk, above: 'May Milton'
Yale University Art Gallery (Cat. No. 1954.43.6, gift of Walter Bareiss, BS 1940),
New Haven

This large-scale chalk drawing is a sketch design for a poster with the simple curved
inscription 'May Milton' which was one of Lautrec's boldest solutions in this field.[1] It was
intended for an American tour by the dancer and was not posted in Paris, but it became
known there in a slightly altered version which appeared in the magazine *Le Rire* on
3 August 1895.

Even in the sketch it is clear that the artist was endeavouring to use an almost ornamental
contour as a means of creating spatial relationships and surface effects, very much in the
manner of Japanese woodcuts. Despite extreme reduction of form he did not lose sight of the
lively character of the English 'Miss'. At the time, she was appearing at the Moulin Rouge
attired in white débutante's dress.[2] In order to capture an impression of the dance steps as
accurately as possible, a preliminary framework of the body's outlines was drawn beneath
the broad sweep of the dress.

1 Adriani 1986, 134. In his early years Picasso was intensely concerned with Lautrec's work and owned a MAY MILTON
 poster, which hung in a place of honour above the bed in his studio in the Boulevard de Clichy; see his INTERIOR WITH
 BATHING FIGURE, 1901 (Phillips Memorial Gallery, Washington).
2 *Cf.* the portrait study Dortu III, P. 570.

SOURCES: Otto Gerstenberg, Berlin; Fritz Nathan, Zurich; Marianne Feilchenfeldt, Zurich; Richard Zinser, New York;
Walter Bareiss, New York.
BIBLIOGRAPHY: Novotny 1969, p. 18, p. 20 Ill.; E. Haverkamp-Begemann – A. Logan, *European Drawings and
Watercolors in the Yale University Art Gallery, 1500–1900*, New Haven – London 1970, No. 170, Ill. 92; Dortu VI, pp. 660f.
D. 3887 Ill.; Adriani 1976, p. 128 Ill., p. 266 with 138; Adriani 1986, with 134.
EXHIBITIONS: Vienna 1966, No. 49, with No. 210; New York 1985, No. 274.

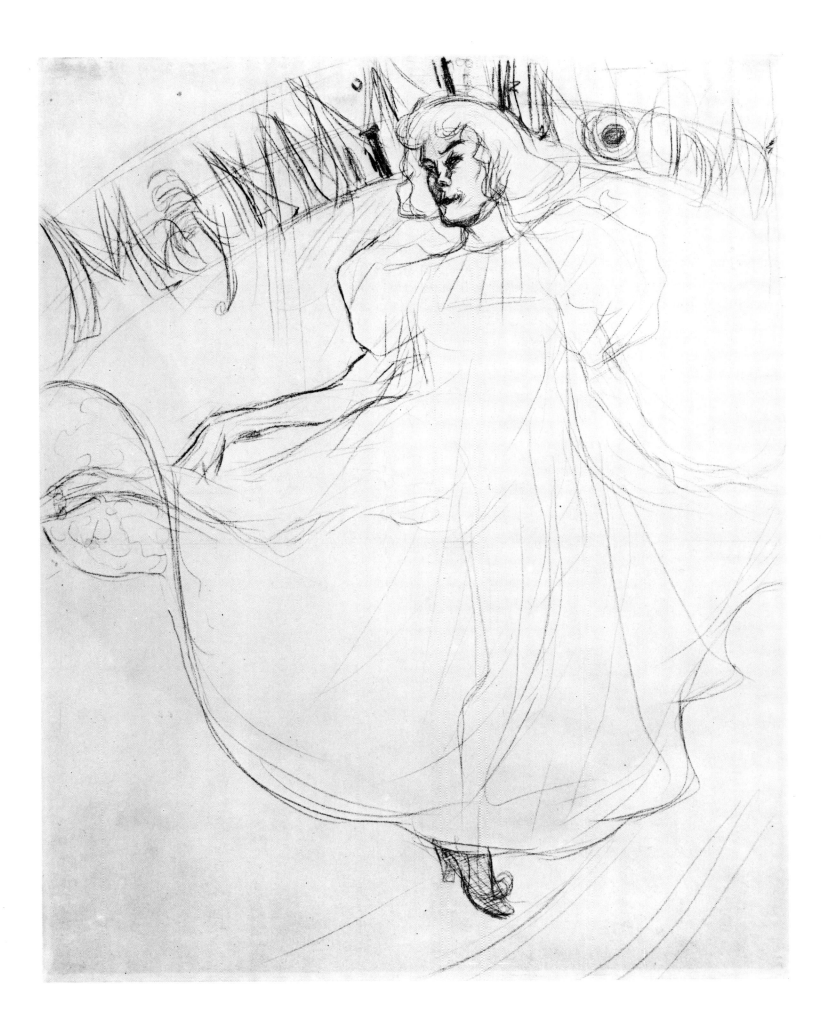

85 Beauty and the Beast, The Rajah's Retinue (La Belle et la Bête, Le Cortège du Rajah) 1895

Dortu III, A. 224
Black and blue chalk with wash on yellow card, 50 × 35 cm
Monogram in pencil, upper left
Private Collection (by arrangement with Thomas Ammann Fine Art, Zurich)

This exotic scene, which originated from a chalk sketch (Dortu VI, D. 3888), was used for one of the four illustrations to Romain Coolus's story *La Belle et la Bête*.[1] The text and colour reproductions were published in September 1895 in the magazine *Le Figaro Illustré*, No. 66. The restrictions imposed by the subject matter of the text may have led Lautrec to adopt the rather sweeping narrative style of this image, which is not typical of his work.

1 Dortu III, P. 564, A. 222, A. 226.

SOURCES: Georges Viau, Paris; 2. Vente *Collection Viau*, Galerie Durand-Ruel, Paris 21–22 March 1907, No. 179; Bernheim-Jeune, Paris; Lucien Henraux, Paris; Mme. Valdo Barbey; Wildenstein & Co., New York; Albert D. Lasker, New York; André Meyer, New York; Auction *Impressionist and Modern Paintings and Sculpture*, I, Sotheby's, New York 14 May 1985, No. 34.
BIBLIOGRAPHY: Coquiot 1921, p. 164, p. 183; Coquiot (1923), p. 44; Astre (1926), p. 100; Joyant 1927, pp. 210f., p. 259; Huisman-Dortu 1964, p. 260 Ill.; Dortu III, pp. 510f. A. 224 Ill.; Dortu VI, p. 660 with D. 3888; Caproni-Sugana 1977, No. 401 c Ill.
EXHIBITIONS: Paris 1902, No. 116; Paris 1904, No. 18; Paris 1931, No. 218; *Chefs d'Œuvre Récupérés d'Allemagne*, Musée de l'Orangerie, Paris 1946, No. 156; *Six Masters of Post-Impressionism*, Wildenstein & Co. Gallery, New York 1948, No. 36; *Drawings through four Centuries*, Wildenstein & Co. Gallery, New York 1949, No. 86; *Carnival and the Circus*, Ringling Museum of Art, Sarasota 1949, No. 45; Philadelphia-Chicago 1955–1956, No. 105; New York 1956, No. 64; New York 1964, No. 75.

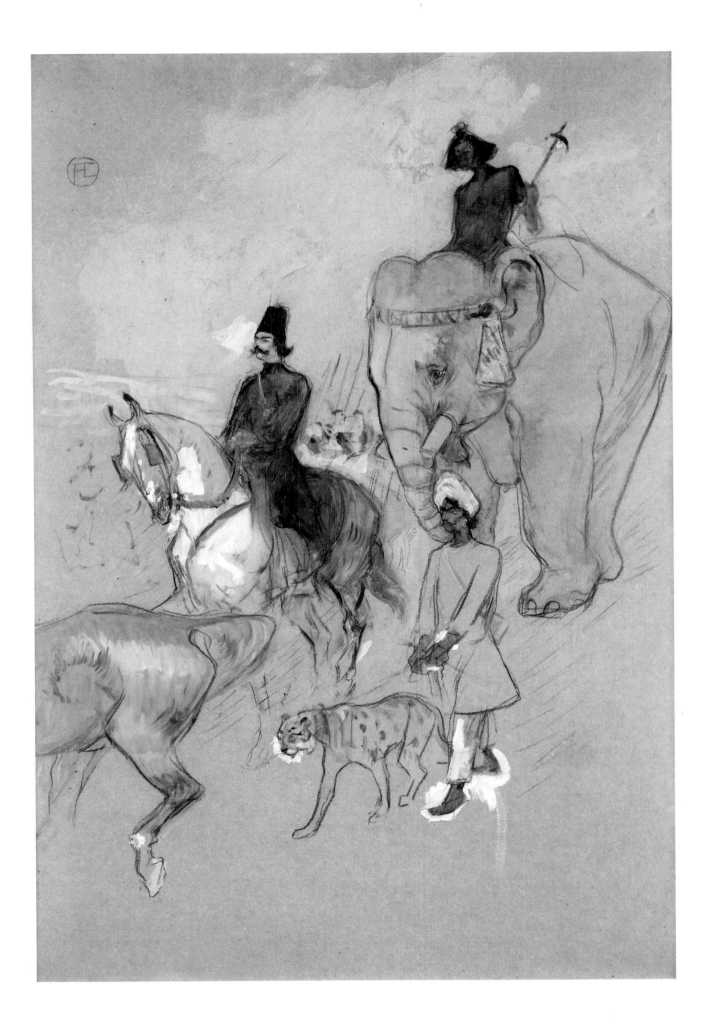

86 CHOCOLAT DANCING IN THE IRISH AMERICAN BAR (CHOCOLAT DANSANT DANS UN BAR, THE IRISH AMERICAN BAR) 1896

Dortu VI, D. 4117
Black ink with brush, black and blue chalk, and white wash on very browned paper, 65 × 50 cm
Monogram in black ink, below; inscribed in blue chalk in reversed lettering, upper right: 'BAR / BRANDY' (?)
Musée Toulouse-Lautrec, Albi

From 1895 to 1896 Lautrec was a regular customer in the bars around the Madeleine: the Weber, 25 Rue Royale, the meeting place for the literary circle centred round Jean de Tinan and Léon Daudet, and the less exclusive Cosmopolitan American Bar at 4 Rue Scribe, or the mahogany-lined Irish American Bar, 33 Rue Royale, where 'Monsieur le Vicomte Marquis' would be served by Achille. There was also Ralph, a Chinese-Indian half-caste, who carried out his duties as barman with a stoical composure, keeping the British jockeys and trainers, as well as the coachmen of the district happy. Among these coachmen Lautrec's particular favourite was Tom, a servant to the Rothschilds, because of his magnificent manners.

Lautrec's regular table in the Irish American Bar was reached by climbing a few steps to an adjoining room, from where he could look down over what went on in the main bar. This is the viewpoint used in this drawing, in which the main character is Chocolat, a black clown from Bilbao, who liked to dance in the bar for his own amusement after his performances at the Nouveau Cirque. The tension of the composition is created by the confrontation of the static secondary figures and the sweeping movement of the dancer, whose effervescent *élan* extends from the soles of his shoes through the twist of his body to the dark fingers of his raised right hand. This delicately articulated extremity emphasized by its white outline is the focal point of the whole picture and the most meticulously executed part. Chocolat and the musician accompanying him on the lyre are concentrating wholly on their combined effort, while the spectators, including Ralph the barman, who is cut off by the edge of the picture, and the white-painted face of Tom the Rothschilds' coachman, are passive, subsidiary figures following the performance on the make-shift stage without much interest.

The drawing has been overpainted in only a few places and demonstrates once again how effortlessly Lautrec was now able to transpose his imaginative powers into the graphic medium. It was intended for reproduction in a magazine and appeared in *Le Rire*, No. 73, on 28 March 1896.

SOURCES: Comtesse Adèle Zoë de Toulouse-Lautrec, Toulouse.
BIBLIOGRAPHY: Duret 1920, p. 71; Coquiot 1921, p. 182; Coquiot (1923), p. 42; Astre (1926), p. 105; Joyant 1926, p. 203; Joyant 1927, p. 72, pp. 74–77 Ill., p. 219; Lapparent 1927, Ill. 20; Joyant 1930, No. 44 Ill.; Mack 1938, pp. 186–187 Ill.; Lassaigne 1939, Ill. 35; Mac Orlan 1941, p. 156; Julien 1942, Ill. 46; Frankfurter 1951, p. 107 Ill.; Jourdain-Adhémar 1952, p. 36, No. 108 Ill., p. 93; Lassaigne 1953, p. 80, pp. 94f. Ill.; Cooper 1955, p. 136; Dortu-Grillaert-Adhémar 1955, p. 38; Perruchot 1958, pp. 112–113 Ill.; Julien (1959), p. 70 Ill.; Focillon 1959, No. 40 Ill.; Th. Charpentier, 'Deux Aquarelles inédites de H. de Toulouse-Lautrec', in: *La Revue des Arts*, 1960, p. 89 Ill.; Bouret 1963, p. 184; Huisman-Dortu 1964, p. 191 Ill.; Zinserling 1964, p. 34, Ill. 53; Vienna 1966, with No. 226; Cionini-Visani 1968, Ill. 60; Keller 1968, p. 66, p. 100 Ill.; Fermigier 1969, p. 209 Ill.; Novotny 1969, p. 53, Ill. 89; Dortu VI, pp. 712f. D. 4117 Ill.; Polasek 1972, p. 41 No. XVII Ill.; Josifovna 1972, Ill. 86; Cat. *Musée Toulouse-Lautrec* 1973, p. 135 Ill., pp. 138f. No. D. 116; Huisman-Dortu 1973, p. 62 Ill.; Muller 1975, Ill. 81; Caproni-Sugana 1977, Ill. L, No. 427 Ill.; Jullian 1977, p. 155 Ill.; Adriani 1978, p. 142, Ill. 44; Devoisins 1980, p. 19 Ill.; Morariu 1980, Ill. 43; Arnold 1982, pp. 48f. Ill.; Cat. *Musée Toulouse-Lautrec* (1985), pp. 214ff. No. D. 138 Ill.
EXHIBITIONS: Paris 1902; Paris 1914, No. 154; Paris 1931, No. 228; New York 1937, No. 36; London 1938, No. 39; Paris 1938, No. 30; Basel 1947, No. 107; Amsterdam 1947, No. 116; Brussels 1947, No. 116; Brussels 1949, No. 213; New York (etc.) 1950–1951, No. 35; Paris 1951 No. 104; Philadelphia-Chicago 1955–1956, No. 108; Paris 1958–1959, No. 58; London 1961, No. 81; Munich 1961, No. 109; Cologne 1961–1962, No. 109; Albi-Paris 1964, No. 114; Stockholm 1967–1968, No. 225; Kyoto-Tokyo 1968–1969, No. 72; Paris 1976; Liège 1978, No. 39.

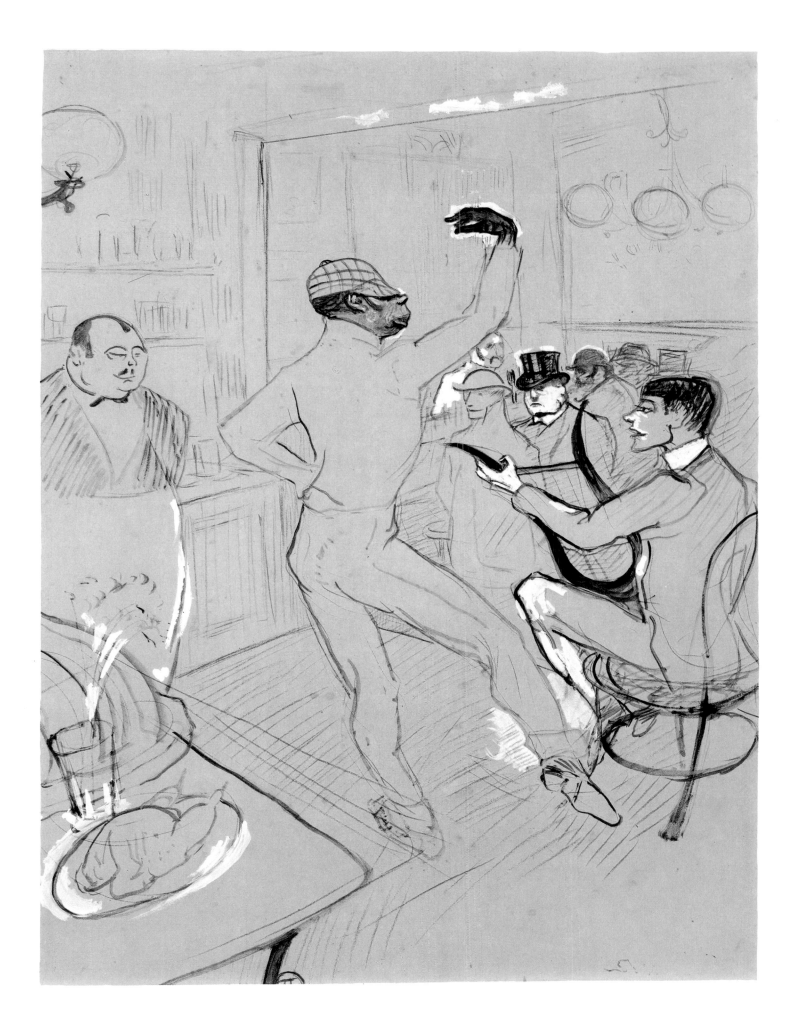

87 WOMAN PUTTING ON HER CORSET, PASSING CONQUEST (FEMME METTANT SON CORSET, CONQUÊTE DE PASSAGE) 1896

Dortu III, P. 617
Black chalk and oil on silk, 104 × 66 cm
Signed in dark brown paint, lower left: 'T-Lautrec'
Musée des Augustins, Toulouse

Lautrec's series ELLES, consisting of ten lithographs with title page and jacket, was one of the highpoints of nineteenth-century printed graphics.[1] It comprised a pictorial epilogue to all that the artist had experienced in the *maisons closes*, the brothels that had been established since the statutes of Colbert in the Rue des Moulins, the Rue d'Amboise and the Rue Joubert, where erotic sentimentality had been transformed into the indifference of collective submission, where lust had become a smooth-running habitual routine, and desire had been reduced to the tedium of hackneyed frivolities.

The ninth plate of the ELLES series, which was first exhibited at the end of April 1896 (Ill. p. 318), is a translation of the present painting into graphic form, with a few alterations to the spatial setting and some of the details.[2] The pictures in the series all present the image of the prostitute with remarkable discretion. Even where allusions to the milieu are unmistakable – such as the gentleman in tails who can be identified as a customer by the fact that he keeps his top hat on – any lewd suggestiveness is eclipsed by the aptness of the composition. Almost twenty years earlier Manet had dealt in a similar way with this theme of the confrontation of the sexes as customer and article for sale (see Ill. below). Lautrec was an admirer of Manet and it is likely that he knew Manet's picture of NANA, especially since it

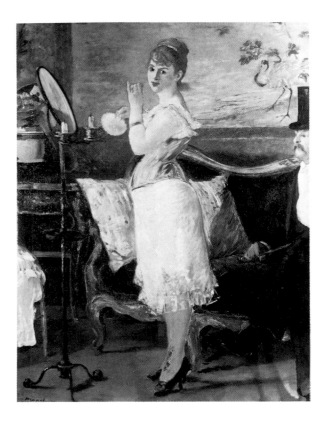

Edouard Manet, NANA, 1877, Hamburger Kunsthalle

could have been seen at the Durand-Ruel Gallery in Paris in 1896. Certainly he vulgarized the motif and turned Manet's youthful, elegant *grande horizontale* flirting with the viewer, into a slut who has difficulty in fitting her large body into her corset. And the voyeuristic customer may have been given the features not of Count Muffat, the character in Zola's novel *Nana*, but of Lautrec's English painter friend Charles Edward Conder (1868–1909) (*cf.* No. 106).[3] Manet's composition, with its intense colours and detailed depiction of the setting, is reduced to a succinctly outlined pair of figures, with only a very restricted range of colours.[4]

1 Adriani 1986, 171–181.
2 *Cf.* the figure studies Dortu III, P. 618; Dortu VI, D. 4274–D. 4276.
3 The parallel motif in LA CLOWNESSE (Dortu III, P. 580) is based on a similar juxtaposition of female object and male viewer.
4 The large-scale study for this picture can be seen on the easel in the background of the portrait of the writer Paul Leclercq (Dortu III, P. 645), painted in the summer of 1897.

SOURCES: Comtesse Adèle Zoë de Toulouse-Lautrec, Toulouse.
BIBLIOGRAPHY: Pigasse 1907, p. 33; Astre (1926), p. 103 Ill.; Joyant 1926, p. 293; Lapparent 1927, Ill. 15; Jedlicka 1929, p. 284; Lassaigne 1939, Ill. 122; Mac Orlan 1941, p. 129 Ill.; Jedlicka 1943, p. 322; Borgese 1945, Ill. 21; Venturi 1947, p. 10 Ill.; *Toulouse-Lautrec* 1951, Ill.; Jourdain-Adhémar 1952, No. 102 Ill., p. 112; Dortu 1952, p. 9 Ill. 50; Landolt 1954, with No. 21; Cooper 1955, p. 140; Dortu-Grillaert-Adhémar 1955, p. 36; Bouret 1963, p. 208 Ill.; Huisman-Dortu 1964, p. 143 Ill.; Vienna 1966, with No. 161; Fermigier 1969, p. 183 Ill.; Dortu III, pp. 378ff. P. 617 Ill., with P. 618; Dortu VI, p. 752 with D. 4275, p. 754 with D. 4276; Josifovna 1972, Ill. 97; *Cat. Musée Toulouse-Lautrec* 1973, p. 79 with No. 188; Adriani 1976, p. 157 Ill., p. 270 with 186; Caproni-Sugana 1977, No. 468a Ill.; Chicago 1979, with Nos. 80, 86; Dortu-Méric 1979, II, p. 62 No. 525 Ill.; *Cat. Musée Toulouse-Lautrec* (1985), p. 148 with No. 190; Adriani 1986, with 180.
EXHIBITIONS: Paris 1902, No. 2; Paris 1931, No. 110; *Quelques Œuvres importantes...*, Galerie Durand-Ruel, Paris 1932, No. 2; Toulouse 1932, No. 21; Basel 1947, No. 175; Amsterdam 1947, No. 44; Brussels 1947, No. 44; Paris 1951, No. 67; Albi 1951, No. 134; Marseilles 1954, No. 16; London 1961, No. 60, with No. 59; Albi-Paris 1964, No. 68.

88 MADEMOISELLE LUCIE BELLANGER 1896

Dortu III, P. 621
Oil on cardboard, 80.7 × 60 cm
Monogram in dark blue paint, lower right
Musée Toulouse-Lautrec, Albi

This concise portrait of Lucie Bellanger in profile view may have been conceived as a preparatory study for the ELLES series (see No. 87), but it was not turned into a lithograph.

SOURCES: Comtesse Adèle Zoë de Toulouse-Lautrec, Toulouse.
BIBLIOGRAPHY: Astre (1926), p. 81; Joyant 1926, p. 158, p. 293; Joyant 1930, Ill. 13; Venturi 1947, p. 8 Ill.; *Toulouse-Lautrec* 1951, Ill.; Jourdain (1951), Ill. 16; Jourdain-Adhémar 1952, p. 113; Lassaigne 1953, p. 72; Dortu-Grillaert-Adhémar 1955, p. 33, p. 36, Ill. 23; *Toulouse-Lautrec* 1962, p. 112 Ill.; Bouret 1963, p. 232; Zinserling 1964, p. 33, p. 35, Ill. 22; Keller 1968, p. 58, p. 104 Ill.; Fermigier 1969, p. 162 Ill.; Dortu III, pp. 380f. P. 621 Ill.; Devoisins 1972, p. 14; *Cat. Musée Toulouse-Lautrec* 1973, pp. 81 f. No. 192 Ill.; Caproni-Sugana 1977, No. 485 Ill.; Dortu-Méric 1979, II, p. 64 No. 529 Ill.; Devoisins 1980, p. 31 Ill.; *Cat. Musée Toulouse-Lautrec* (1985), pp. 149ff. No. 194 Ill.
EXHIBITIONS: Brussels 1902, No. 285; Paris 1931, No. 157; New York 1937, No. 32; London 1938, No. 9; Paris 1938, No. 29; Basel 1947, No. 140; Amsterdam 1947, No. 45; Brussels 1947, No. 45; New York (etc.) 1950–1951, No. 25; Paris 1951, No. 68; Albi 1951, No. 103; Marseilles 1954, No. 17; Philadelphia-Chicago 1955–1956, No 70; Paris 1958–1959, No. 42; London 1961, No. 61; Munich 1961, No. 81; Cologne 1961–1962, No. 81; Kyoto-Tokyo 1968–1969, No. 43; Paris 1975–1976, No. 33; Liège 1978, No. 33; Tokyo (etc.) 1982–1983, No. 47.

89 In the Wings at the Folies Bergère, Mrs Lona Barrison with her Manager (Dans les Coulisses des Folies Bergère, Mrs Lona Barrison avec son Manager) 1896

Dortu VI, D. 4114
Black ink with brush, blue chalk on white paper, 65 × 50 cm
Monogram in black ink, upper left
Musée Toulouse-Lautrec, Albi

A reproduction of this large-scale ink drawing, showing the two artists and their horse, in space-compressing perspective, as they make their way to the stage, appeared on 13 June 1896 in the magazine *Le Rire*, No. 84.

SOURCES: Comtesse Adèle Zoé de Toulouse-Lautrec, Toulouse.
BIBLIOGRAPHY: Coquiot 1921, p. 184; Coquiot (1923). p. 42; Astre (1926), p. 102; Joyant 1926, p. 203; Joyant 1927, p. 110 Ill., p. 219; Julien 1942, p. 44 Ill.; Jourdain-Adhémar 1952, p. 73, p. 93; Focillon 1959, No. 42 Ill.; Julien (1959), p. 72 Ill.; Bouret 1963, p. 194; Huisman-Dortu 1964, p. 204 Ill.; Longstreet 1966, Ill.; Vienna 1966, with No. 227; Keller 1968, p. 13 Ill.; Cionini-Visani 1968, Ill 61; Dortu VI, pp. 708f. D. 4114 Ill.; Polasek 1972, p. 41, No. 39 Ill.; Josifovna 1972, Ill. 85; *Cat. Musée Toulouse-Lautrec* 1973, p. 139 No. D. 117, p. 141 Ill.; *Cat. Musée Toulouse-Lautrec* (1985), pp. 215f. No. D. 139 Ill.
EXHIBITIONS: Marseilles 1954, No. 27; Paris 1958–1959. No. 56; London 1961, No. 79; Munich 1961, No. 107; Cologne 1961–1962, No. 107; Paris 1976; Liège 1978, No. 48.

90 At the Moulin Rouge, in the Dance hall (Au Moulin Rouge, dans la Salle du Bal) 1896

Dortu VI, D. 4099
Black chalk and wash on very browned paper, 56.4 × 42 cm
Monogram in dark grey paint, lower right
Szépmüvészeti Múzeum (Cat. No. 1935-2729), Budapest

The heyday of the Moulin Rouge ended in 1893 when the performers of Montmartre began to turn increasingly to the establishments in the city centre. Now that the *élan* of the leading stars had been reduced to a merely skilful routine and only the vulgar parts of their acts were well received, Lautrec was bored by everything that he had once desired to immortalize in his work. This may explain why, on the occasions when he depicted motifs from the Moulin Rouge in his later years, it was not so much the stars, as anonymous people in the audience whom he transformed into succinctly exaggerated figures.

SOURCES: Paul Majovszky, Budapest.
BIBLIOGRAPHY: Coquiot 1913, p. 51 Ill.; Brook 1923, p. 124 Ill.; Joyant 1927, p. 67 Ill., p. 217; Dortu 1952, p. 9 Ill. 51; Perruchot 1958, pp. 208–209 Ill.; Marianne Haraszti-Takács, 'Etudes sur Toulouse-Lautrec', in: *Bulletin du Musée Hongrois des Beaux-Arts*, 26, 1965, pp. 54f. Ill. 31; Longstreet 1966, Ill.; D. Pataky, *Von Delacroix bis Picasso*, Budapest 1967, No. 59; Dortu VI, pp. 702f. D. 4099 Ill.; Caproni-Sugana 1977, No. 304 Ill.; Keller 1980, Ill. 61.
EXHIBITIONS: *Henri de Toulouse-Lautrec. Grafikái*, Szépmüvészeti Múzeum, Budapest 1964, No. 6; Vienna 1966, No. 41.

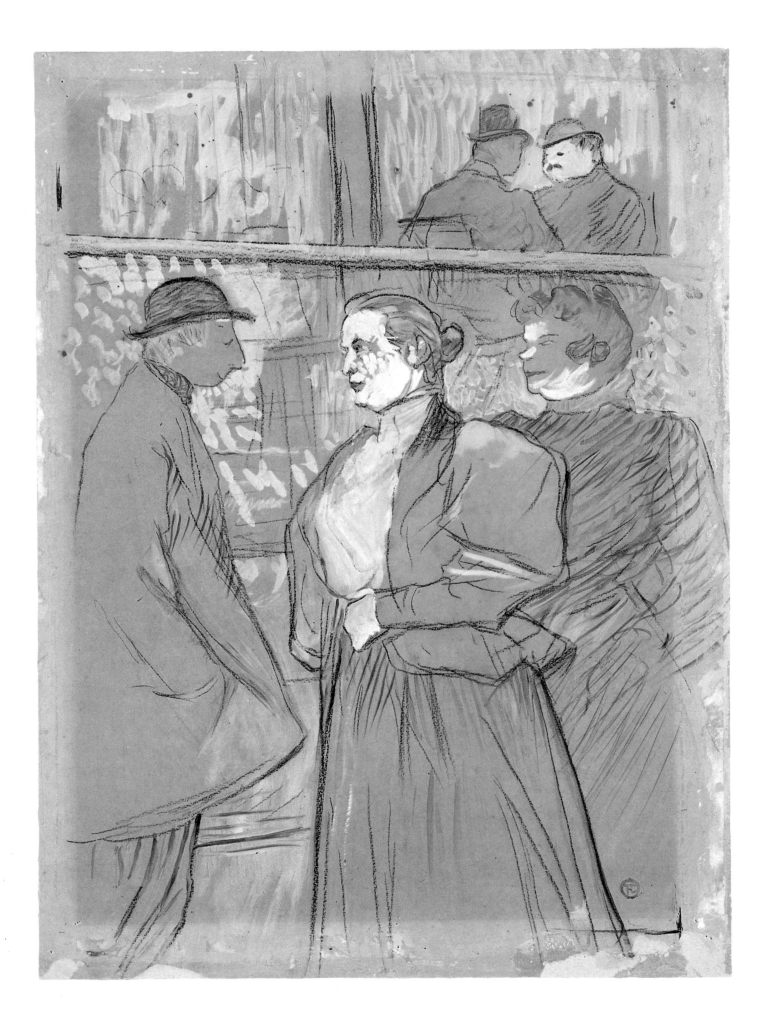

91 SHEET OF SKETCHES WITH FIGURE AND PORTRAIT STUDIES (FEUILLE D'ETUDES, FIGURES ET PORTRAITS) 1896

Not in Dortu
Pen and dark brown ink on white paper, 11.3 × 16.8 cm
Private Collection

This sheet from the same sketchbook as No. 92, shows a recumbent couple embracing and some portrait studies. The face on the left may represent Ville the wrestler.[1]

1 *Cf.* the 1898 etching LE LUTTEUR VILLE (Adriani 1986, 247).

SOURCES: Emmanuel Tapié de Céleyran, Paris; Hector Brame, Paris; Knoedler, Paris; Ludwig Charell, New York; Auction *Catalogue of a Collection of Fine Lithographs and Drawings by Henri de Toulouse-Lautrec*, Sotheby & Co., London 6 October 1966, with No. 75; Auction *Moderne Kunst des neunzehnten und zwanzigsten Jahrhunderts*, Kornfeld and Klipstein, Bern 11–13 June 1975, with No. 973.
BIBLIOGRAPHY: Adriani 1976, pp. 190f. Ill. (Detail), p. 275 with 251.

92 DEBAUCHERY (DÉBAUCHE) 1896

Dortu VI, D. 4245
Pen and dark brown ink on white paper, 16.8 × 11.3 cm
Private Collection

This forceful pen drawing was made in connection with the colour lithograph DÉBAUCHE published in June 1896.[1] The striking scene – probably showing the painter-engraver Maxime Dethomas (1868–1928), a friend of the artist – comes from the same sketchbook as the preceding sheet (No. 91).

1 Adriani 1986, 186; *cf.* also 187 and the figure drawings Dortu VI, D. 4152, D. 4153, D. 4246, D. 4247.

SOURCES: Emmanuel Tapié de Céleyran, Paris; Hector Brame, Paris; Knoedler, Paris; Ludwig Charell, New York; Auction *Catalogue of a Collection of Fine Lithographs and Drawings by Henri de Toulouse-Lautrec*, Sotheby & Co., London 6 October 1966, No. 75; Auction *Moderne Kunst des neunzehnten und zwanzigsten Jahrhunderts*, Kornfeld and Klipstein, Bern 11–13 June 1975, No. 973.
BIBLIOGRAPHY: Dortu VI, pp. 740f. D. 4245 Ill.; Adriani 1976, p. 162 Ill., p. 270 with 190; Adriani 1978, pp. 132f. Ill.; Adriani 1986, with 186.
EXHIBITIONS: *XXVI. Biennale Internazionale d'Arte*, Venice 1952; New York 1956.

93 Woman's Head
(Tête de Femme) 1896

Dortu III, P. 634
Black chalk and oil on cardboard, 42 × 36 cm
Red monogram stamp (Lugt 1338), lower left
Private Collection

The portrait is a concisely suggested sketch executed wholly in the inspiration of the moment. In the worn-out face which hides its disappointment behind a façade of impudence, only the red of the slightly open lips stands out. The hair in various shades of brown and blue separates the face, where the short brushstrokes create a sense of movement, from the grey of the background, which surrounds the head like a halo. On the bare cardboard the painted lines peter out as they move away from the centre of the picture. Despite its shorthand technique, the woman's head, caught in passing as she looks over her shoulder, makes a powerful impression on the viewer.

SOURCES: M. Pierrefort, Paris; J. Cailac, Paris; Hans R. Schinz, Zurich.
BIBLIOGRAPHY: Joyant 1927, p. 253; Jedlicka 1943, pp. 272–273 Ill.; Dortu III, pp. 388f. P. 634 Ill.; Dortu-Méric 1979, II, p. 66 No. 541 Ill.
EXHIBITIONS: Paris 1931, No. 156; Paris 1938 (Galerie des Beaux-Arts), No. 118.

94 'Now then, are you a good girl?'
(Alors, vous êtes sage?') 1896

Dortu III, S.P. 4
Oil on cardboard, 55.8 × 41.3 cm
Signed in red chalk, lower right: 'T-Lautrec'
Verso: Originally the portrait Femme de Maison (Dortu III, S.P. 5) was on the back.
The cardboard has since been split.
Private Collection

See No. 95

SOURCES: M. Duché, Paris; Feilchenfeldt, Zurich.
BIBLIOGRAPHY: Dortu III, pp. 454f. S.P. 4 Ill.; Dortu-Méric 1979, II, pp. 71f. No. 563 Ill.
EXHIBITIONS: Paris 1931, No. 111a.

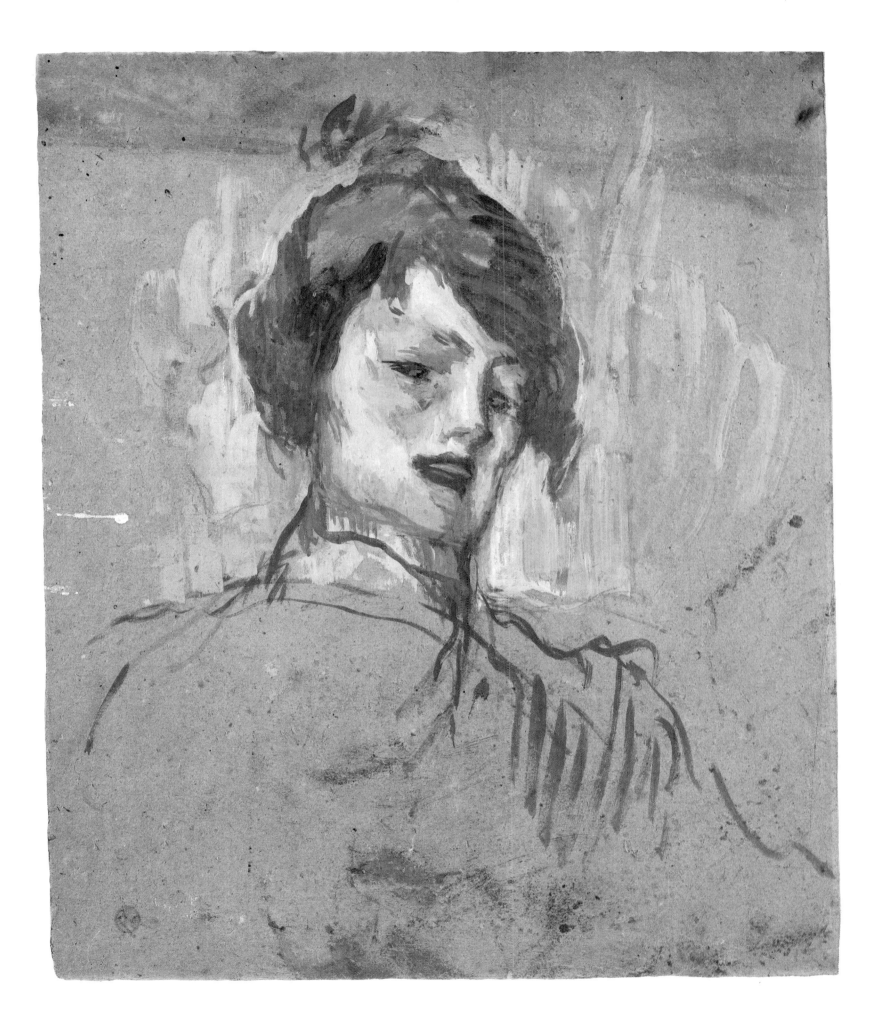

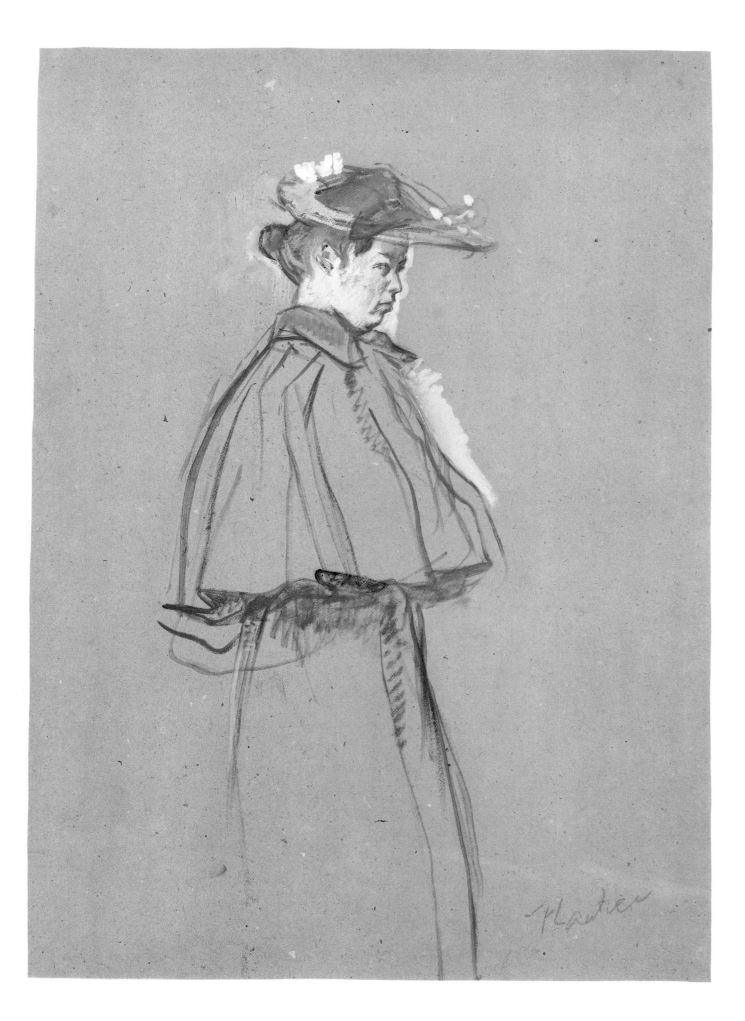

95 'Now then, are you a good girl?' – 'Yes Madame, but I have been out with someone' ('Alors, vous êtes sage?' – 'Oui Madame, mais j'ai fréquenté quelqu' un') 1896

Dortu VI, D. 4327
Back ink with brush, blue chalk, white and red wash on beige paper, 71.5 × 59.2 cm
Monogram in black ink, lower left
Musée Toulouse-Lautrec, Albi

This scene of a 'beginner' being interviewed in one of the *maisons closes* was reproduced in the magazine *Le Rire*, No. 114, on 9 January 1897. Besides the preceding colour study (No. 94), there is also a further figure sketch (Dortu VI, D. 4371) connected with this theme.

SOURCES: Comtesse Adèle Zoë de Toulouse-Lautrec, Toulouse.
BIBLIOGRAPHY: Astre (1926), p. 105; Joyant 1927, p. 226; Julien 1942, p. 47 Ill.; Focillon 1959, No. 19 Ill.; Longstreet 1966, Ill.; Dortu III, p. 454 with S.P. 4; Dortu VI, pp. 766f. D. 4327 Ill., p. 778 with D. 4371; Polasek 1972, No. 27 Ill.; *Cat. Musée Toulouse-Lautrec* 1973, pp. 141ff. No. D. 127 Ill.; *Cat. Musée Toulouse-Lautrec* (1985), p. 219 No. D. 151.
EXHIBITIONS: Paris 1958–1959, No. 60; London 1961, No. 84; Munich 1961, No. 112; Cologne 1961–1962, No. 112; Albi-Paris 1964, No. 120; Liège 1978, No. 50.

96 Seated Woman (Femme Assise) 1897

Dortu III, P. 652
Oil on cardboard, 63 × 48 cm
Monogram in blue-green paint, upper left
Bayerische Staatsgemäldesammlungen, Neue Pinakothek (Cat. No. 8666), Munich

As in many of Lautrec's portraits of the 1890s the neutral matt brown of the cardboard acts as an intermediary between extremes of colour. In this case the warm reddish-blond hair of the model seated in an armchair contrasts with the cool palette which varies between turquoise-green and white with pale and dark blue. These very forced colour harmonies are bound up with a facial expression, full of resignation, which is executed in an extremely subtle manner. Lautrec's extraordinary psychological sensibility manifests itself in the contrast between the radiant colour values and the rather tired, withdrawn mood concentrated in the woman's eyes, which are set in a delicate face almost overwhelmed by the grand hairstyle.

SOURCES: Eduard Arnhold and Robert von Mendelssohn, Berlin.
BIBLIOGRAPHY: Joyant 1926, p. 239 Ill., p. 296; Jedlicka 1929, p. 269 Ill.; Schaub-Koch 1935, p. 192; Kurt Martin, *Die Tschudi Spende*, Munich 1962, p. 27; Zinserling 1964, p. 40, Ill. 29; catalogue of the *Neue Pinakothek, Neue Staatsgalerie. Ausgestellte Werke*, I, Munich 1966, pp. 93f., Ill.; Fermigier 1969, p. 225 Ill.; Dortu III, pp. 398f. P. 652 Ill.; Muller 1975, Ill. 78; Caproni-Sugana 1977, No. 458; Dortu-Méric 1979, II, pp. 70f. No. 559 Ill.; catalogue of the *Neue Pinakothek*, Munich 1982, pp. 340f. Ill.
EXHIBITIONS: *Moderne Französische Malerei*, Haus der Kunst, Munich 1947, No. 149a; Munich 1961, No. 151; *Französische Malerei des 19. Jahrhunderts*, Haus der Kunst, Munich 1965, No. 243; Munich 1985, No. 15.

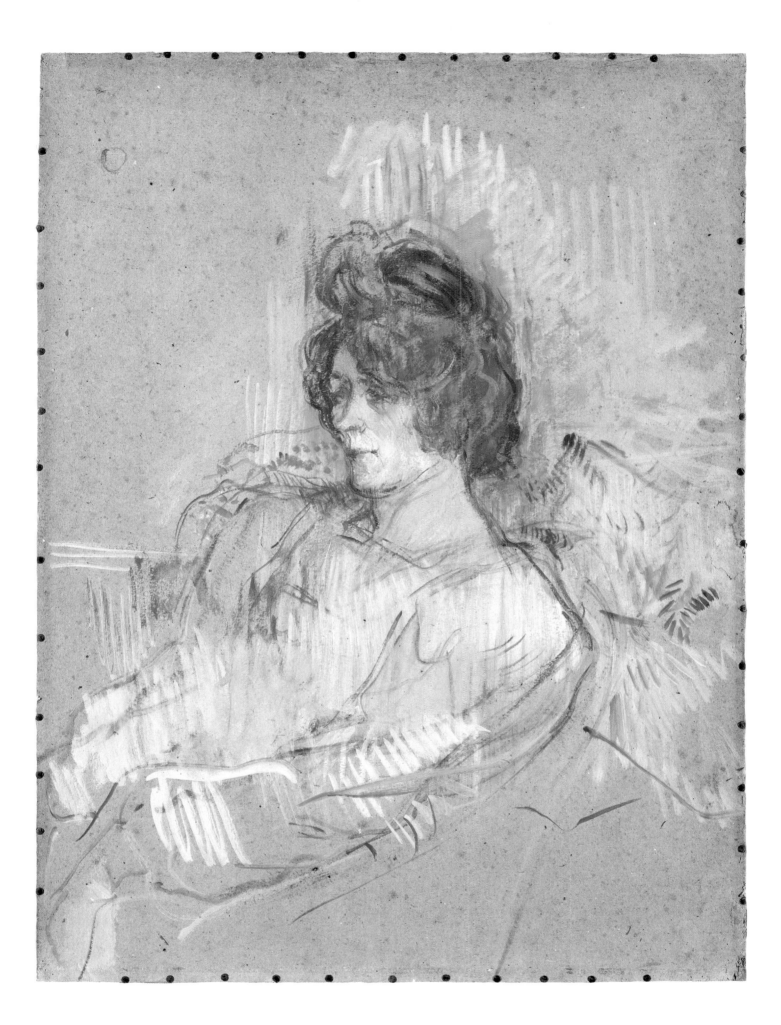

97 Red-Haired Woman Seated on a Divan
(Femme Rousse Assise sur un Divan) 1897

Dortu III P. 650
Oil on cardboard, 58.5 × 48 cm
Signed in red chalk, lower left: 'T-Lautrec'
Private Collection, Switzerland

This composition of 1897 is probably based on two variants showing a female model posing in a somewhat unconvincing attitude on a blue-and-white patterned divan cover.[1]
A comparison of this painting with the similarly constructed Nude Study (No. 15) painted fifteen years earlier is particularly informative, revealing the assured handling of the figure within space and the masterly painting technique that had developed with Lautrec's evolution as an artist. The timid tonality he had employed as a beginner can be contrasted with the glowing palette of this mature work; the earlier, carefully blended painting method has become an intense staccato of brushstrokes which determine the forms. In the early work he has only just freed himself, hesitantly, from the limitations of genre painting, while in the present painting there is a naturalness derived wholly from artistic experience. The very fact that the model is no longer depicted parallel to the picture surface but set slightly at an angle in space creates a high degree of tension. The extremes of the artist's creative career – even though it lasted only a few years – cannot be more impressively demonstrated than by the comparison of these two similar motifs.

1 Dortu III, P. 648, P. 649; the divan cover was one of the studio props (see Ill. pp. 282f.).

SOURCES: Arthur Hahnloser, Winterthur.
BIBLIOGRAPHY: Duret 1920, Ill. XVI; Joyant 1926, pp. 176–177 Ill., p. 296; Jedlicka 1929, pp. 322ff.; Mac Orlan 1941, p. 139 Ill.; Jedlicka 1943, pp. 256ff.; Keller 1968, p. 70 Ill., p. 74, p. 76; Dortu III, pp. 398f. P. 650 Ill.; Caproni-Sugana 1977, No. 460 Ill.; Dortu-Méric 1979, II, p. 70 No. 557 Ill.; Chicago 1979, with Nos. 13, 91.
EXHIBITIONS: Paris 1914 (Galerie Rosenberg), No. 4; Winterthur 1924, No. 250; Basel 1947, No. 176; Wolfsburg 1961, No. 160; Munich 1961, No. 150; Cologne 1961–1962, No. 150; Schaffhausen 1963, No. 135.

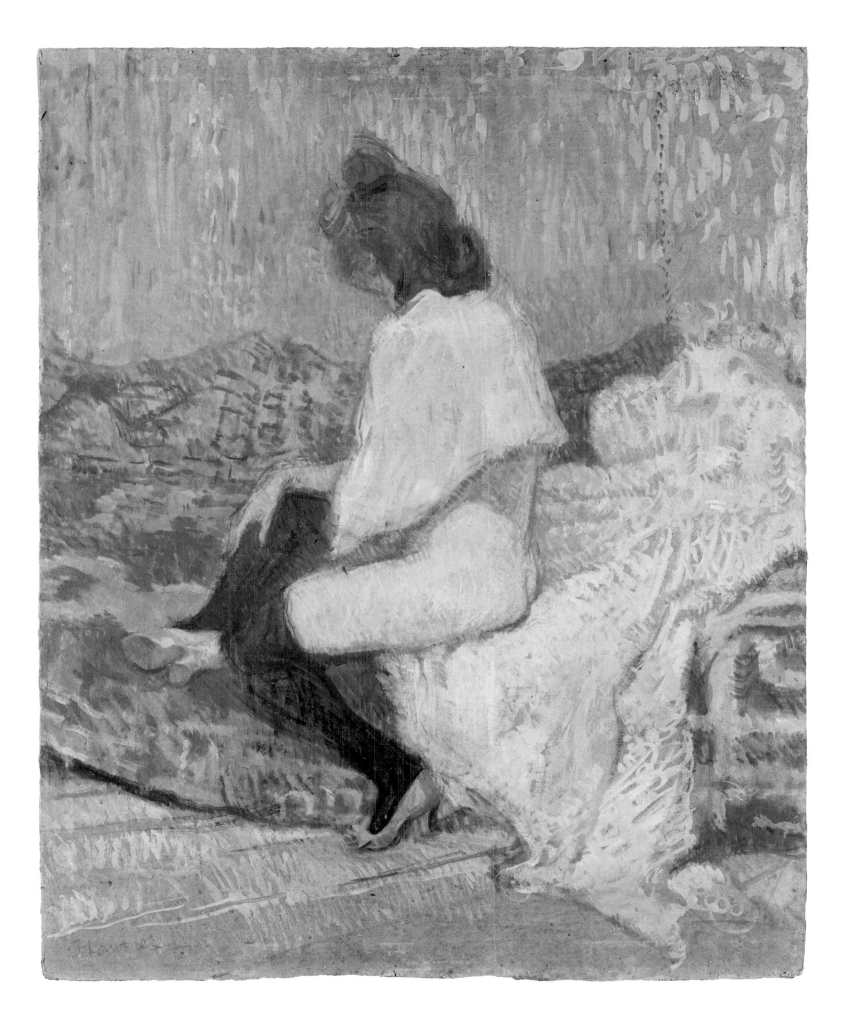

98 Woman's Head in Profile (Tête de Femme de Profil) *c.* 1897

Dortu VI, D. 4378
Pencil on beige paper, 20 × 12.5 cm
Red monogram stamp (Lugt 1338), lower left
Musée Toulouse-Lautrec, Albi

Although this portrait was no more than a casual work, it was nevertheless precisely structured, and the details of the physiognomy are carefully worked out.[1]

1 The same model is shown in frontal view in the sheet of sketches Dortu V, D. 3548.

SOURCES: Comtesse Adèle Zoë de Toulouse-Lautrec, Toulouse.
BIBLIOGRAPHY: Focillon 1959, No. 18 Ill.; Keller 1968, p. 66 Ill.; Dortu VI, pp. 782f. D. 4378 Ill.; Polasek 1972, No. 12 Ill.; *Cat. Musée Toulouse-Lautrec* 1973, pp. 141f. No. D. 126 Ill.; Devoisins 1980, p. 65 Ill.; *Cat. Musée Toulouse-Lautrec* (1985), p. 215 Ill., p. 219 No. D. 150.

99 At the Souris, Madame Palmyre and her Dog (A la Souris, Madame Palmyre et son Chien) 1897

Dortu VI, D. 4333
Pencil on blue-grey paper, 55 × 36 cm
Signed in pencil, lower right: 'T-Lautrec'
Musée Toulouse-Lautrec, Albi

It was mainly in 1897 that Lautrec visited the bars frequented by lesbians: Le Hanneton at 75 Rue Pigalle and La Souris at 29 Rue Monnier, where Madame Palmyre and her bulldog Bouboule kept strict control over the ladies. 'There he sat, enthroned in the harsh light of the electric lamps, surrounded by half a dozen flabby-skinned women with dyed hair and wearing slovenly clothes in garish colours or severe men's jackets and stiff collars. Lautrec was amused by the apparent dignity with which Palmyre busied herself with everything. She was a stout woman with a grumpiness like a bulldog's; although her heart was in the right place, she seemed to want to devour everything. Lautrec – he was almost always known by the name of "Monsieur Henri" – was the darling of the house where Palmyre and her customers, who usually dined there, lived *en famille*.'[1] In the present picture and in an almost identical drawing in coloured pencils (Dortu VI, D. 4373) Madame Palmyre is occupied with her little dog.

1 Leclerq 1958, p. 49.

SOURCES: Comtesse Adèle Zoë de Toulouse-Lautrec, Toulouse.
BIBLIOGRAPHY: Astre (1926), p. 106; Joyant 1927, p. 227; Julien 1942, p. 50 Ill.; Dortu VI, pp. 768f. D. 4333 Ill., p. 778 with D. 4373; *Cat. Musée Toulouse-Lautrec* 1973, p. 141, p. 143 No. D. 128; *Cat. Musée Toulouse-Lautrec* (1985), pp. 219f. No. D. 152, p. 222 Ill.
EXHIBITIONS: Paris 1914, No. 184; Albi 1951, No. 155; Marseilles 1954, No. 28; Nice 1957, No. 41.

100 MADAME BERTHE BADY 1897

Dortu VI, D. 4328
Red chalk on grey-blue paper, 53.5 × 36.5 cm
Red monogram stamp (Lugt 1338), lower left
Private Collection (by arrangement with the Galerie Schmit, Paris)

A red chalk study for the following portrait of the actress Berthe Bady (No. 101).

SOURCES: Alfred Walter Heymel, Munich; Vente *Collection Heymel*, Hôtel Drouot, Paris 30 April 1913, No. 21;
S. Mayer, Paris; Marcel Guérin, Paris; Louis Ritter, New York.
BIBLIOGRAPHY: Joyant 1927, p. 77, p. 226, p. 260; Jedlicka 1929, p. 148 Ill.; Lassaigne 1939, p. 24 Ill.; Delaroche 1948,
Ill. 6; Dortu-Grillaert-Adhémar 1955, Ill. 29; Cooper 1955. p. 138; Dortu III, p. 396 with p. 647; Dortu VI, pp. 766f.
D. 4328 Ill., *Cat. Musée Toulouse-Lautrec* 1973, p. 84 with No. 195; Werner-Helms (1977), Ill.; *Cat. Musée Toulouse-Lautrec*
(1985), p. 152 with No. 197.
EXHIBITIONS: Bremen 1909, No. 322: Paris 1931, No. 233; Philadelphia-Chicago 1955–1956, No. 103; New York 1956,
No. 72; New York 1964, No. 83.

101 MADAME BERTHE BADY 1897

Dortu III, P. 647
Oil on cardboard, 70.3 × 60 cm
Musée Toulouse-Lautrec, Albi

The Belgian actress Berthe Bady had made a name for herself in the 1890s both at Lugné-
Poë's avant-garde Théâtre de L'Œuvre and as the mistress of the writer Henry Bataille. In
1894 and 1896 Lautrec made several lithograph portraits of her in action.[1] In 1897 he
followed these somewhat exaggerated images of her on stage with this more typical portrait,
based on blue-green and crimson-purple, showing her seated in an armchair. In the
preliminary red chalk study (No. 100) her pensive gaze by-passes the viewer, while in the
painted version direct eye contact is established – indeed one has the impression that the sitter
is flirting with an imaginary partner. Fully aware of her charms, she presents herself in a
deliberately casual pose, her chin resting on her hand and her legs crossed. The combination
of boldly drawn outlines, painted hatching and short oblique brushstrokes is used to create a
high degree of psychological empathy. The pale painted complexion stands out effectively
against the crimson background and the dark blue-green of the dress. Everything in this
portrait aims at an almost theatrical effect: the majestic crimson background, the projecting
armchair, the playful facial expression, and not least the compelling *mise-en-scène* of the seated
figure.

1 Adriani 1986, 63–65, 185.

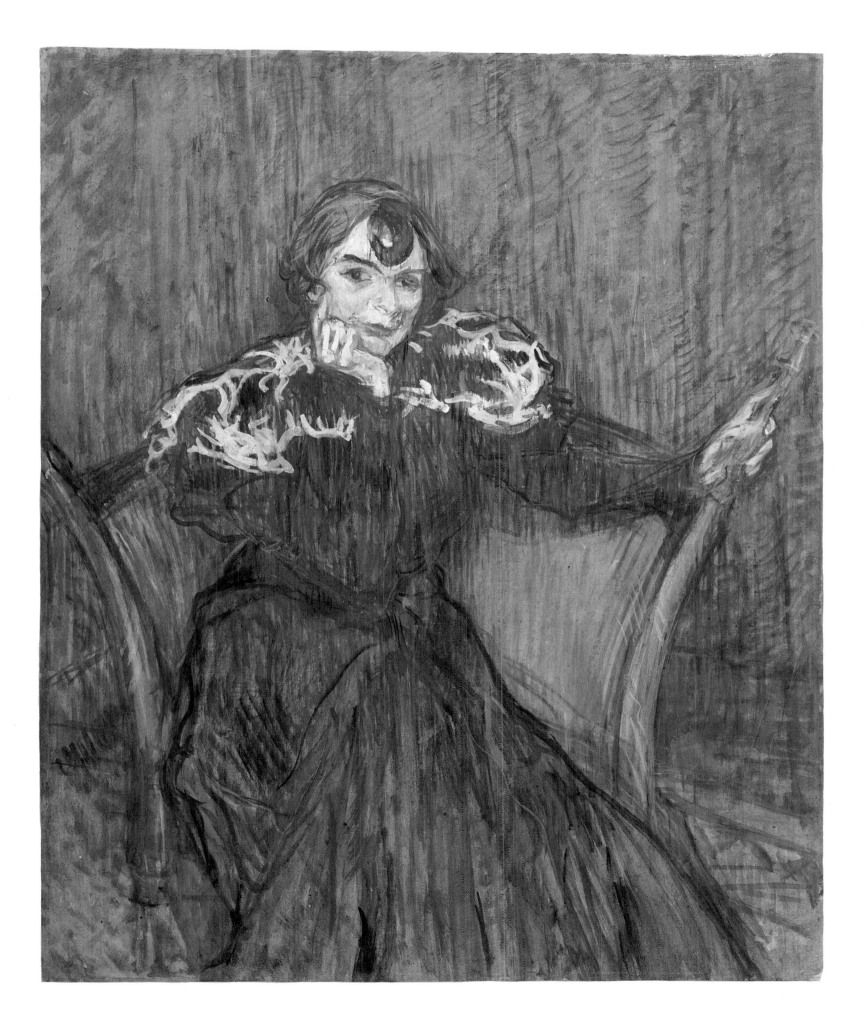

SOURCES: Comtesse Adèle Zoë de Toulouse-Lautrec, Toulouse.
BIBLIOGRAPHY: Astre (1926), p. 143 Ill.; Joyant 1926, pp. 64–65 Ill.; p. 200, p. 295; Joyant 1927, p. 226; Joyant 1927 (*L'Art et les Artistes*), p. 153 Ill.; Jedlicka 1929, p. 148; Schaub-Koch 1935, p. 202, p. 207; Lassaigne 1939, Ill. 113; Mac Orlan 1941, p. 143 Ill.; Schmidt 1948, p. 15, Ill. 9; Jourdain-Adhémar 1952, No. 116 Ill., p. 86, p. 113; Dortu 1952, p. 9 Ill. 55; Lassaigne 1953, p. 93 Ill.; Colombier 1953, Ill. 26; Hunter 1953, Ill. 26; Dortu-Grillaert-Adhémar 1955, p. 19, p. 21, p. 36 Ill. 30; Cooper 1955, pp. 38f. Ill.; Julien (1959), p. 78 Ill.; *Toulouse-Lautrec* 1962; p. 172 Ill.; Bouret 1963, p. 229; Chastel 1966, Ill. 26; Cionini-Visani 1968, Ill. 69; Fermigier 1969, p. 214 Ill.; Devoisins 1970, p. 55; Zenzoku 1970, Ill. 53; Dortu III, pp. 396f. P. 647 Ill.; Dortu VI, p. 766 with D. 4328; Polasek 1972, p. 42; Josifovna 1972, Ill. 107; *Cat. Musée Toulouse-Lautrec* 1973, pp. 83ff. No. 195 Ill.; Caproni-Sugana 1977, No. 470 Ill.; Dortu-Méric 1979, II, p. 70 No. 554 Ill.; Devoisins 1980, p. 20; Arnold 1982, p. 114 Ill.; *Cat. Musée Toulouse-Lautrec* (1985), pp. 152f. No. 197 Ill.
EXHIBITIONS: Paris 1931, No. 163; New York 1937, No. 23; London 1938, No. 10; Paris 1938, No. 35; Basel 1947, No. 197; Amsterdam 1947, No. 51; Brussels 1947, No. 51; New York (etc.) 1950–1951, No. 27; Paris 1951, No. 72; Albi 1951, No. 106; Marseilles 1954, No. 18; Philadelphia-Chicago 1955–1956, No. 63; Paris 1958–1959, No. 44; London 1961, No. 62; Munich 1961, No. 85; Cologne 1961–1962, No. 85; Albi-Paris 1964, No. 72; Stockholm 1967–1968, No. 29; Humlebaek 1968, No. 28; Kyoto-Tokyo 1968–1969, No. 46; Liège 1978, No. 31; Chicago 1979, No. 90; Tokyo (etc.) 1982–1983, No. 48.

102 Two-Wheeled Carriage with Horses in Tandem (Attelage en Tandem) 1897

Dortu VI, D. 4372
Pen and dark brown ink on white paper, 11.5 × 17.3 cm
Private Collection

This impulsive drawing was a sketch for a lithograph (in black) with the same name, only a few copies of which were printed (Adriani 1986, 229).

SOURCES: Alfred Walter Heymel, Munich; Otto Gerstenberg, Berlin.
BIBLIOGRAPHY: Dortu VI, pp. 778f. D. 4372 Ill.; Adriani 1976, p. 272 with 215; Werner-Helms (1977), Ill.; Adriani 1986, with 229.
EXHIBITIONS: Ingelheim 1968, No. 143.

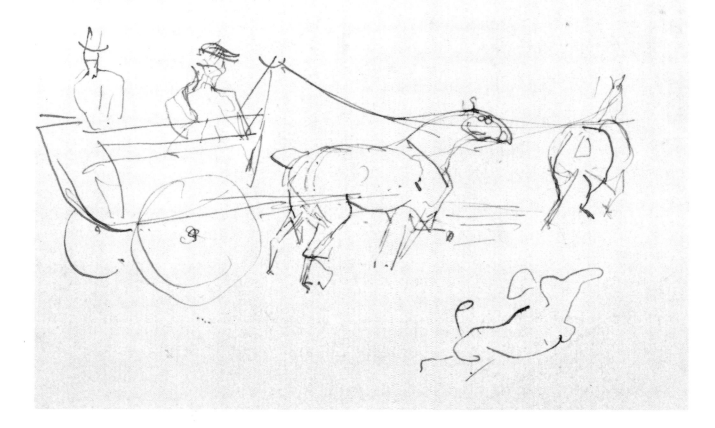

103 AT HER TOILETTE, MADAME POUPOULE
(A LA TOILETTE, MADAME POUPOULE) 1898

Dortu III, P. 668
Oil on wood panel, 60.8 × 49.6 cm
Musée Toulouse-Lautrec, Albi

Alone with her reflection, the prostitute sits in her dressing gown at a white-covered dressing table. The motif of the morning toilette, treated so frequently and so variously in French art of the eighteenth and nineteenth centuries, occupied Lautrec for more than ten years.[1] He could turn the banal subject of a young woman in front of her mirror into a symbol of melancholy introspection which gave a credible, contemporary quality to the traditional *vanitas* image. Even the pigments and brushwork create the impression of heaviness and sorrow. The bottles with their beautifying ingredients and the familiar powder jar (*cf.* No. 26) appear to have had their day as indispensible utensils. Under the luxuriant red-brown mane only a narrow section of face is visible, in which the almost childishly chubby cheeks are combined with the features of an embittered person left alone with herself and forced into a disillusioning partnership with her reflection.

1 Dortu II, P. 347, P. 392; Dortu III, P. 710.

SOURCES: Comtesse Adèle Zoë de Toulouse-Lautrec, Toulouse.
BIBLIOGRAPHY: Alexandre 1914, p. 13; Astre (1926), p. 90; Joyant 1926, pp. 208–209 Ill., p. 297; Lapparent 1927, p. 20, pp. 49f.; Joyant 1927 (*L'Art et les Artistes*), p. 153 Ill.; Schaub-Koch 1935, p. 192; Lassaigne 1939, Ill. 138; Mac Orlan 1941, p. 151 Ill.; Julien 1942, p. 16; Borgese 1945, Ill. 31; Bellet 1951, p. 24; Jourdain-Adhémar 1952, No. 119 Ill., p. 113; Lassaigne 1953, p. 71, pp. 98f. Ill.; Cooper 1955, pp. 148f. Ill.; Dortu-Grillaert-Adhémar 1955, p. 19, p. 37; *Toulouse-Lautrec* 1962, p. 251 Ill.; Bouret 1963, p. 240; Huisman-Dortu 1964, p. 61; Zinserling 1964, p. 23, Ill. 30; Chastel 1966, Ill. 27; Keller 1968, p. 64 Ill., p. 74, p. 76; Fermigier 1969, p. 235 Ill.; Zenzoku 1970, Ill. 60; Dortu III, pp. 408f. P. 668 Ill.; Josifovna 1972, Ill. 136; *Cat. Musée Toulouse-Lautrec* 1973, pp. 85ff. No. 198 Ill.; Huisman-Dortu 1973, pp. 61f. Ill.; Caproni-Sugana 1977, Ill. LVIII, No. 506a Ill.; Dortu-Méric 1979, II, p. 74 No. 576 Ill., p. 82 Ill.; Morariu 1980, Ill. 62: *Cat. Musée Toulouse-Lautrec* (1985), pp. 153ff. No. 200 Ill.
EXHIBITIONS: Paris 1902, No. 18; Paris 1931, No. 171; New York 1937, No. 24; London 1938, No. 11; Paris 1938, No. 37; Basel 1947, No. 190; Amsterdam 1947, No. 53; Brussels 1947, No. 53; New York (etc.) 1950–1951, No. 28; Paris 1951, No. 76; Albi 1951, No. 109; Philadelphia-Chicago 1955–1956, No. 74; Paris 1958–1959, No. 46; London 1961, No. 64; Munich 1961, No. 88; Cologne 1961–1962, No. 88; Albi-Paris 1964, No. 74; Paris 1975–1976, No. 35; Liège 1978, No. 34; Chicago 1979, p. 28, No. 96.

104 STANDING FEMALE NUDE, FRONTAL VIEW (FEMME NUE DEBOUT, DE FACE) 1898

Dortu III, P. 667
Oil on cardboard, 80 × 53 cm
Monogram in purple-grey paint, lower left
Musée Toulouse-Lautrec, Albi

The artist may have been inspired to paint this study by his interest in the plastic qualities of the female body. The *mise-en-page* of the chalky white-painted figure set in the emptiness of the picture space, and the choice of a very simple standing posture with particular emphasis on a firm base provided by the over-large feet, clearly has more to do with the problems of sculpture than with any intention of integrating the nude into a painting.[1]

1 *Cf.* the charcoal study Dortu VI, D. 4408.

SOURCES: Comtesse Adèle Zoë de Toulouse-Lautrec, Toulouse.
BIBLIOGRAPHY: Joyant 1926, p. 297; Huisman-Dortu 1964, p. 127 Ill.; Zinserling 1964, Ill. 31: Dortu III, pp. 408f. P. 667 Ill.; Dortu VI, p. 788 with D. 4408; *Cat. Musée Toulouse-Lautrec* 1973, pp. 85f. No. 197 Ill.; Caproni-Sugana 1977, Ill. LVII, No. 484 Ill.; Dortu-Méric 1979, II, p. 74 No. 575 Ill., p. 81 Ill.; *Cat. Musée Toulouse-Lautrec* (1985), pp. 153f. No. 199 Ill.
EXHIBITIONS: Paris 1914, No. 134; Paris 1931, No. 170; Albi 1951, No. 108; Paris 1958–1959, No. 45; Munich 1961, No. 87; Cologne 1961–1962, No. 87; Kyoto-Tokyo 1968–1969. No. 50.

105 LA SPHYNGE, PROSTITUTE
(LA SPHYNGE, FEMME DE MAISON) 1898

Dortu III, P. 665
Oil on cardboard, 86 × 65 cm
Signed and dated in blue chalk, lower left: 'T-Lautrec / 1898'
Private Collection

The nineteenth century wanted to place woman within a frame of reference which extended to the fanciful image of the sphinx, elevating her to an idol of sensual power, an icon of fertility, giving her the leading role in the confrontation of the sexes. None of these concepts of feminine nature had any validity for Lautrec; instead, he related his models simply and clearly to their contemporary reality and created true images of them as they really were.

In the present portrait all that remains to remind us of such images is the nickname Sphinx, given to a full-bosomed, blond prostitute who sat for him in a negligé dappled with green and white, before a deep red background. She has her back to the principal light source, so the important parts of her face are in shade. Instead of the light, fluid consistency of the thinned paint used earlier, in his later years the artist preferred a thick application of pigment, modelling the forms in broad brushstrokes. His technique became more ponderous, the colour more subdued, and he found it more difficult to guide the brush. Pictures like this mark the beginning of an almost elegaic swansong to youth and to the fullness of life embodied in feminine beauty.

SOURCES: Louis Bouglé, Paris; Eugène Blot, Paris; Vente *Collection Blot*, Hôtel Drouot, Paris 2 June 1933, No. 64; Mme Gillou, Paris; Mme Fenwick, Paris; Marianne Feilchenfeldt, Zurich.
BIBLIOGRAPHY: Joyant 1926, pp. 104–105 Ill.; p. 158, p. 297; Schaub-Koch 1935, p. 191; Lassaigne 1939, p. 135 Ill.; Mac Orlan 1941, pp. 16–17 Ill.; Borgese 1945, Ill. 32; Jourdain-Adhémar 1952, p. 113; Lassaigne 1953, p. 98; *Toulouse-Lautrec* 1962, p. 217 Ill.; Novotny 1969, Ill. 117; Dortu III, pp. 406f. P. 665 Ill.; *25 Jahre Feilchenfeldt in Zürich 1948–1973*, Zurich 1973, Ill.; Caproni-Sugana 1977, No. 476 Ill.; Dortu-Méric 1979, II, p. 74 No. 573 Ill.; Lucie-Smith 1983, No. 43 Ill., with No. 45.
EXHIBITIONS: Paris 1902, No. 81; Paris 1914 (Galerie Rosenberg), No. 6; Paris 1931, No. 172; Vienna 1966, No. 28.

106 JOB, ENGLISH SOLDIER SEATED, SMOKING HIS PIPE (JOB, SOLDAT ANGLAIS ASSIS ET FUMANT SA PIPE) 1898

Dortu VI, D. 4384
Charcoal on white paper, 144 × 110 cm
Inscribed in charcoal, above: 'JOB'
Musée Toulouse-Lautrec, Albi

This large-scale charcoal drawing was the design for a poster for a cigarette-paper company called Job, but it was never used.[1] The figure next to the uniformed smoker at the bar is probably the English painter and illustrator Charles Edward Conder (*cf.* No. 87),[2] who was a friend of Oscar Wilde and had made the acquaintance of Lautrec at the Moulin Rouge, where he was a regular visitor. From 1894 onwards he worked in London on the magazine *The Yellow Book* which was devoted largely to Beardsley's work.

1 *Cf.* the figure study and sketch Dortu III, P. 666, P. 673.
2 Lautrec had portrayed Conder several times as a marginal figure: Dortu II, P. 428, P. 462, P. 471, P. 477; Dortu V, D. 3441, D. 3442; Adriani 1986, 69, 192, 208.

SOURCES: Comtesse Adèle Zoë de Toulouse-Lautrec, Toulouse.
BIBLIOGRAPHY: Joyant 1927, p. 108, p. 228; Focillon 1959, No. 27 Ill.; Bouret 1963, p. 256; Edouard Julien, *Die Plakate von Toulouse-Lautrec*, Monte Carlo 1967, p. 13; Dortu III, p. 406 with P. 666; p. 412 with P. 673; Dortu VI, pp. 748f. D. 4384 Ill.; Polasek 1972, No. 51 Ill.; *Cat. Musée Toulouse-Lautrec* 1973, p. 86 with No. 196, p. 144 No. D. 132; *Cat. Musée Toulouse-Lautrec* (1985), p. 154 with No. 198, pp. 221f. No. D. 156 Ill.
EXHIBITIONS: Paris 1975–1976, No. 62.

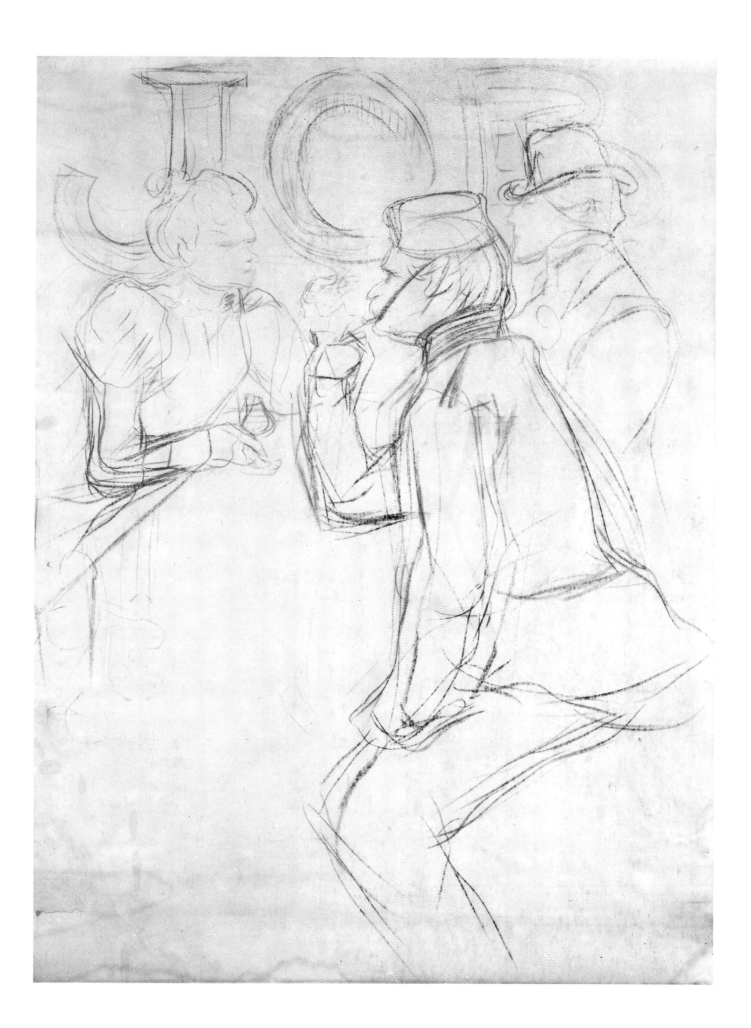

107 At the Café, the Customer and the Anaemic Cashier (Au Café, le Consommateur et la Caissière Chlorotique) 1898

Dortu III, P. 657
Oil on cardboard, 81.5 × 60 cm
Signed in dark paint, lower right: 'T-Lautrec'
Kunsthaus (Cat. No. 2297), Zurich

The lack of communication between the sexes is penetratingly portrayed in this painting. Three of Lautrec's other major works are concerned with this same subject.[1] Of these, the picture of MONSIEUR AND MADAME WITH DOG (No. 62) painted five years earlier presents the closest comparison, as regards composition, with the present painting. In both pictures the viewer is confronted with an ageing couple, alienated from one another seated in front of a mirror. The fat face of a *petit-bourgeois* man offers the possibility of eye contact, while his female partner turns away to the right. Important foundations for the café scene had of course been laid by Degas's epoch-making painting L'ABSINTHE (Ill. p. 298), which had been further developed by Manet and which was to be taken up again several times by the young Picasso. Like Lautrec, Degas too barricaded his couple behind tables where they sit listlessly beside each other in front a wall mirror, with glass and bottle close at hand.

1 Dortu II, P. 386, P. 494 (No. 62); Dortu III, P. 677.

SOURCES: Henri Bourges, Paris: Paul Cassirer, Berlin; Estella Katzenellenbogen, Berlin; Paul Cassirer, Amsterdam.
BIBLIOGRAPHY: Joyant 1926, p. 215 Ill., p 296; Jedlicka 1929, p. 341 Ill.; Schaub-Koch 1935, p. 185, p. 204; Lassaigne 1939, Ill. 142; Venturi 1947, p. 6 Ill.; Jourdain-Adhémar 1952, No. 114 Ill., p. 113; Lassaigne 1953, p. 96 Ill.; Jean Cassou, *Die Impressionisten und ihre Zeit*, Lucerne 1953, Ill. 73; Landolt 1954, with No. 28; Dortu-Grillaert-Adhémar 1955, p. 36; Julien (1959), Ill. (Jacket, Detail); Zinserling 1964, Ill. 28; Negri 1964, Ill. 13; Keller 1968, pp. 74ff. Ill.; Novotny 1969, Ill. 115; Lassaigne 1970, Ill. 45; Zenzoku 1970, No. 57 Ill.; Dortu III, pp. 402f. P. 657 Ill.; Josifovna 1972, Ill. 31; Huisman-Dortu 1973, p. 63 Ill.; Sakon Sou 1975, No. 24 Ill.; Shone 1977, Ill. 35; Caproni-Sugana 1977, No. 480 Ill.; Dortu-Méric 1979, II, pp. 71 f. No. 565 Ill.; Lucie-Smith 1983, No. 42 Ill., with No. 46.
EXHIBITIONS: Paris 1902, No. 60; Paris 1914, No. 55; *La Peinture Française du XIXème Siècle en Suisse*, Zurich 1917, No. 103; Paris 1938 (Galerie des Beaux-Arts), No. 121; Zurich 1943, No. 697; Basel 1947, No. 199; Amsterdam 1947, No. 52; Brussels 1947, No. 52; Venice 1948, No. 78; *Die Maler der Revue Blanche*, Kunsthalle, Bern 1951, No. 254; *Werke der französischen Malerei und Grafik des 19. Jahrhunderts*, Villa Hügel, Essen 1954, No. 104; Wolfsburg 1961, No. 159; Munich 1961, No. 153; Cologne 1961–1962, No. 152; Albi-Paris 1964, No. 73; *Autour de la Revue Blanche 1891–1903*, Galerie Maeght, Paris 1966; Vienna 1966, No. 30; Chicago 1979, p. 24. No. 95, with Nos. 26, 100; *Meisterwerke aus der Graphischen Sammlung*, Kunsthaus, Zurich 1984, No. 128.

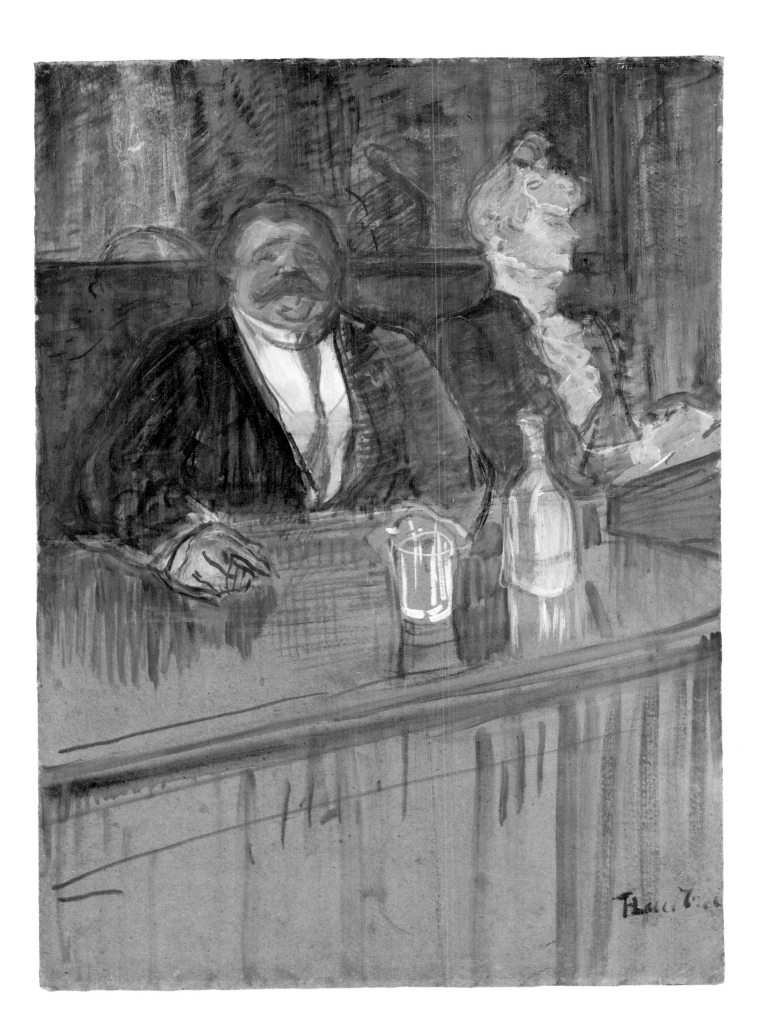

108 SELF-CARICATURE
(CARICATURE DE LAUTREC) 1899

Dortu VI, D. 4605
Blue and red chalk on grey-lined, white paper, 26.5 × 20 cm
Monogram in blue and red chalk, lower right
Private Collection

In 1899 Lautrec was merciless in his self-criticism, and this is the most relentless of the caricatures of himself (*cf.* Nos. 32, 33). It is a precise record of his condition; by this time he was showing symptoms that made his friends increasingly concerned. Deep depressions and hallucinations alternated in ever more rapid succession in 1898–1899. His alcoholism was disastrously combined with symptoms he had been neglecting for years, which were the result of his youthful recklessness. Any attempt to withstand temptation was frustrated by his drinking companions and prostitutes. His work progressed slowly and with enormous effort as physical and psychological exhaustion took their toll. He reached a stage where, in a state of insomniac hyper-sensitivity, he felt constantly threatened, and he developed anxiety neuroses. The self-irony of many of Lautrec's caricatures gave way to a despairing cynicism and his red drunkard's nose became the trademark of this.

SOURCES: Otto Gerstenberg, Berlin.
BIBLIOGRAPHY: Joyant 1930, Ill. 3; Perruchot 1958, pp. 16–17 Ill.; Zinserling 1964, p. 40 Ill.; Dortu I, p. 79 Ic. 64 Ill.; Dortu VI, pp. 890f. D. 4605 Ill.
EXHIBITIONS: Ingelheim 1968, No. 37.

109 Scene in the Brothel (Scène au Bordel) *c.* 1899

Not in Dortu
Pencil on white paper, 23.2 × 31.5 cm
E. W. Kornfeld, Bern

Nearly all Lautrec's erotic drawings – 73 of these are listed by Dortu[1] – are caricature sketches, which gives them an ironic detachment from their subject.[2]

1 Dortu VI, E. 1–E. 73.
2 *Cf.* the drawings Dortu VI, D. 4625, E. 45, E. 53, E. 57, and the lithograph Dans le Monde (Adriani 1986, 294).

SOURCES: Gustave Pellet, Paris; Maurice Exteens, Paris.

110 At the Circus, the Clown as Animal Trainer (Au Cirque, Clown Dresseur) 1899

Dortu VI, D. 4523
Coloured chalks on beige paper, 25.9 × 43.3 cm
Dated, signed and inscribed with dedication in pencil, lower left: 'Madrid Paques 1899 / a Arsène Alexandre / souvenir de ma captivité T-Lautrec'; monogram in black chalk, upper left
Den kongelige Kobberstiksamling, Statens Museum for Kunst (Cat. No. 18474), Copenhagen

The dedication in the lower left of the pastel ('Madrid Pâques 1899 / à Arsène Alexandre / souvenir de ma captivité T-Lautrec') refers to a serious turn of events in the spring of 1899. Lautrec had suffered an acute attack of delirium tremens at his lodgings at the Rue des Moulins brothel. In the opinion of his friend Dr Bourges, who had published his investigations into the hygiene of the syphilitic in 1897, only a radical withdrawal cure and complete rest could bring about the hoped-for recovery. On his insistence it was decided regretfully that the artist should be temporarily confined in Dr Sémelaigne's psychiatric clinic at 16 Avenue de Madrid, Neuilly, which was reserved for an exclusive circle of clients. The treatment was drastic but it seemed to give hope of success. As early as 17 March the patient was asking Joyant for 'litho crayons and good quality Indian ink and paper'.[1] And on 30 March the critic Arsène Alexandre could give a very positive report of his progress in *Le Figaro*: 'I saw a madman who is full of wisdom, an alcoholic who no longer drinks, one regarded as lost who looks in the best of health. ... This supposedly doomed man, who is regarded by some as a monster, has such vitality in him, such power of life radiates from him, that even those who saw him heading for the abyss of ruin are amazed to see him looking so well again.'[2]

In a desperate situation, similar to that experienced by his friend Van Gogh and later, occasionally, by Edvard Munch, Lautrec realized that his artistic work was his only means of self-assertion and that he needed it to survive. In this dangerous situation he had to prove to himself and to others that he retained an undiminished mastery of his art. He could remember only vaguely his recent experiences, but his memory had firmer outlines when it came to motifs which had been rooted in his imagination since childhood – since his visits to the Cirque Fernando with Princeteau (cf. Nos. 30, 31). So he turned again to circus subjects in a series of 39 drawings in pastel, pencil and coloured pencils.[3]

It is clear from the rather stiff mastery of the visual imagery – which was probably a deliberate attempt to overcome his crumbling grasp of reality – how difficult he found it to overcome his hallucinatory tensions. In many cases the compositions are fragmented; his powers of abstraction, which had usually predominated, are sometimes outshone by the authority of the details. The exquisite use of line conflicts with the vivid colouring in parts. The figures – including, in the present drawing, George Footit the clow (cf. Nos. 77, 114), 'whose hairstyle hovered between Sarah Bernhardt and Queen Alexandra' (Jean Cocteau), in an animal training act;[4] Cha-u-Kao the clownesse from the Moulin Rouge, trying like Europa on the bull to stay on the back of a bucking horse (No. 111); and Loyal the ringmaster watching an imposing horse, drawn with exaggerated foreshortening, and with an equestrienne on its back (No. 112, cf. No. 30) – are all the products more of deliberate thought than of direct experience. They are conjured up into a scurrilously distorted existence where they perform without an audience in front of eerily empty rows of seats. They move uncertainly through enormous spaces which shrink in the foreground or suddenly converge, so that they only touch the rectangle of the picture in passing. While it is true that these works would be a credit to any artist – and their expressiveness may seem particularly fascinating to an eye trained in modern art – in Lautrec's case it becomes strangely apparent that they were means to an end, virtuoso pieces produced, sometimes laboriously, as evidence of his skill.

'I have bought my freedom with my drawings',[5] he declared with some satisfaction to Joyant, when the doctors decided on 17 May that he had shown no recent signs of insanity and that there remained hardly any symptoms of alcoholic poisoning.

1 Joyant 1926, p. 216.
2 Joyant 1927, p. 125.
3 Dortu VI, D. 4522–D. 4560.
4 Cf. the lithographs Adriani 1986, 104, 318, 319.
5 Joyant 1926, p. 222.

SOURCES: Arsène Alexandre, Paris; M. Keller, Paris; Vente Collection Keller, Hôtel Drouot, Paris 13 January 1929, No. 13; Maurice Exsteens, Paris; Heinrich Stahl, Berlin; Otto Gerstenberg, Berlin; Margarete Scharf, Berlin; Leo Swane, Copenhagen.
BIBLIOGRAPHY: Alexandre 1905, No. 2 Ill.; Coquiot 1921, p. 82, pp. 138 ff.; Astre (1926), p. 129; Joyant 1926, pp. 225 f.; Joyant 1927, p. 234; Joyant 1930, No. 63 Ill.; Mack 1938, p. 219, p. 333; Julien 1942, p. 12; Kern 1948, p. 16; Delaroche 1948, p. 9; Julien 1951, p. 11; Erik Fischer-Jorgen Sthyr, Seks Arhundreders europaeisk Tegnekunst, Copenhagen 1953, p. 95 Ill.; Huisman-Dortu 1964, p. 208 Ill.; Zinserling 1964, p. 42, Ill. 57; Dortu VI, pp. 814 f. D. 4523 Ill.; Adriani 1978. pp. 153 f. Ill. 51; Kompositionen im Halbrund, Fächerblätter aus vier Jahrhunderten, Staatsgalerie Graphische Sammlung, Stuttgart 1984, with No. 93; Adriani 1986, with 318.
EXHIBITIONS: Paris 1931 No. 243; Munich 1961, No. 154; Cologne 1961–1962, No. 153; Copenhagen 1967, p. 67 Ill., p. 72; Stockholm 1967–1968, No. 230.

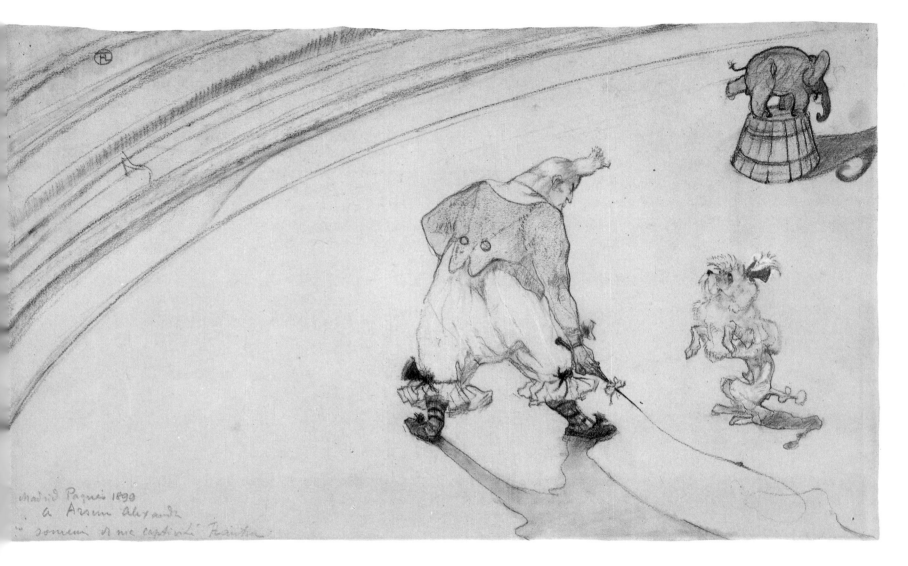

Madrid Paques 1893
a Arsène Alexandre
"sommium et non captioli" Feinsin

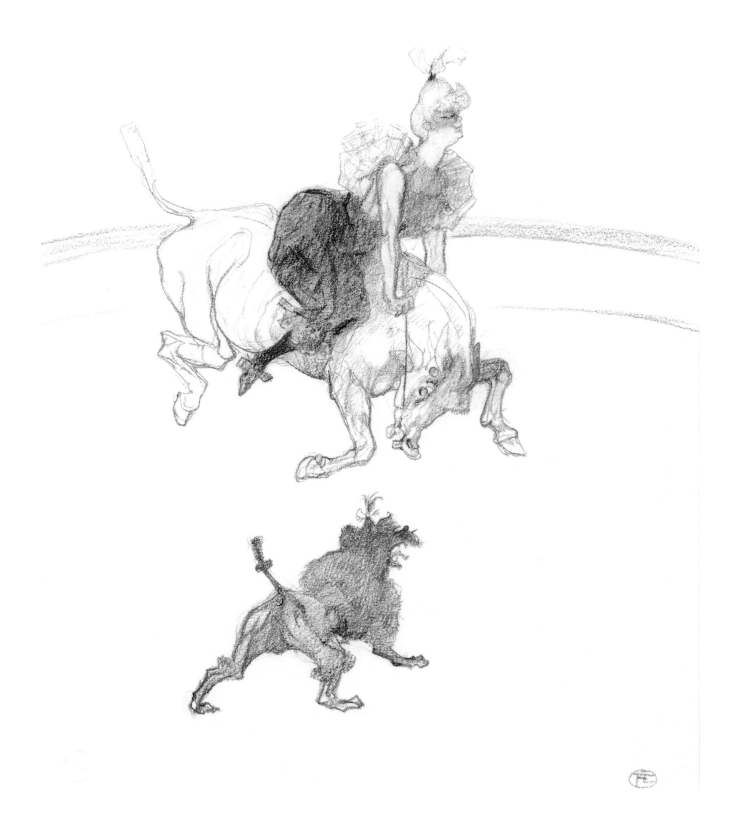

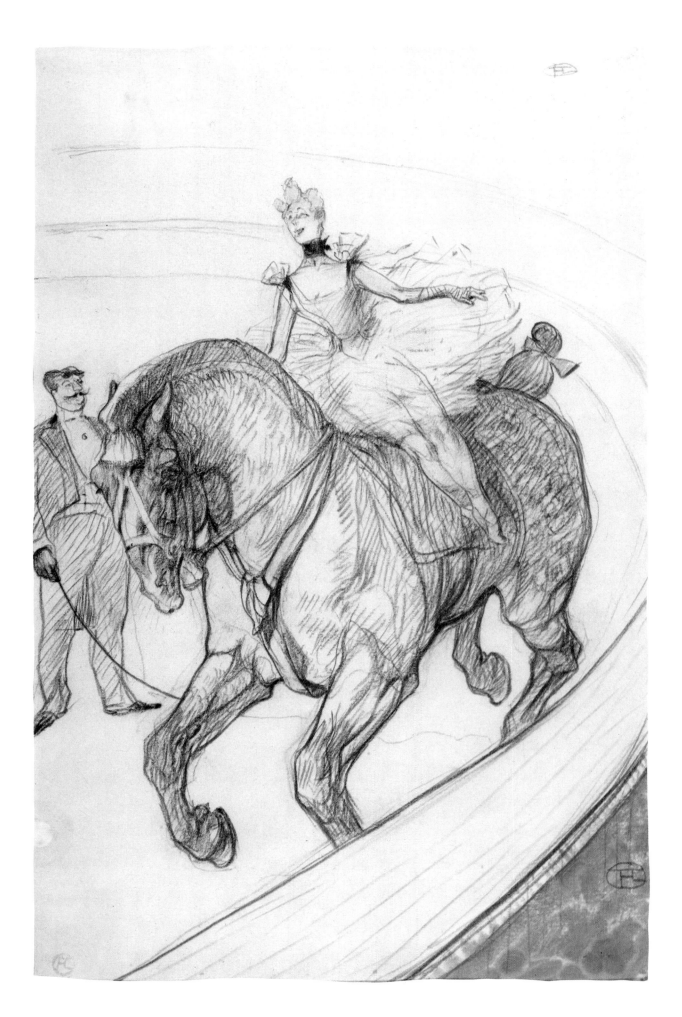

111 At the Circus, the Female Clown
(Au Cirque, Clownesse) 1899

Dortu VI, D. 4528
Coloured chalks on white paper, 35.6 × 25.4 cm
Monogram in blue chalk, lower right; red monogram stamp (Lugt 1338), lower left
Harvard University Art Museums, Fogg Art Museum (Cat. No. 1979.56, bequest of
Frances L. Hofer), Cambridge (Mass.)

See No. 110.

SOURCES: Maurice Joyant, Paris; M. G. Dortu, Paris; Otto Gerstenberg, Berlin; Knoedler & Co., New York; Philip
Hofer, Cambridge (Mass.).
BIBLIOGRAPHY: Alexandre 1902, p. 9 Ill.; Alexandre 1905, No. 7 Ill.; Coquiot 1921, p. 82, pp. 138 ff.; Astre (1926),
p. 129; Joyant 1927, p. 235; Mack 1938, p. 219, p. 333; Lassaigne 1939, p. 148 Ill.; Julien 1942, p. 12; Kern 1948, p. 16;
Delaroche 1948, p. 9; Julien 1951, p. 11; Lassaigne 1953, pp. 102 f. Ill.; *Toulouse-Lautrec* 1962, p. 208 Ill.; Huisman-Dortu
1964, p. 207 Ill.; Fermigier 1969, p. 226 Ill.; Dortu VI, pp. 824 f. D. 4528 Ill.; Robert Wallace, *Van Gogh und seine Zeit
1853–1890*, 1971, p. 60 Ill.; Josifovna 1972, Ill. 133; Huisman-Dortu 1973, p. 66 Ill.; Morariu 1980, Ill. 60; Adriani 1986,
with 318.
EXHIBITIONS: Paris 1931, No. 248; New York 1931, No. 6; *Art in New England*, Museum of Fine Arts, Boston 1939,
No. 210; New York 1946, No. 47; *French Paintings*, Carnegie Institute, Pittsburgh 1951, No. 171; Philadelphia-Chicago
1955–1956, No. 114; New York 1956, No. 75; Albi-Paris 1964, No. 123; *Master Drawings and Watercolors: The Hofer
Collection*, Fogg Art Museum, Harvard University Art Museums, Cambridge (Mass.) 1984, No. 35.

112 At the Circus, Bareback Riding
(Au Cirque, Travail sans Selle) 1899

Dortu VI, D. 4541
Coloured chalks and wash on white paper, 49.5 × 32.5 cm
Monogram in black chalk, upper right and lower right; red monogram stamp (Lugt
1338), lower left
Museum of Art, Rhode Island School of Design (Cat. No. 34.003, gift of Mrs
Murray S. Danforth), Providence

See No. 110; the sketch Dortu V, D. 3220 may be a preparatory drawing for the
equestrienne.

SOURCES: Maurice Joyant, Paris; M. G. Dortu, Paris; Knoedler & Co., New York; Mrs Murray S. Danforth,
Providence.
BIBLIOGRAPHY: Alexandre 1905, No. 20 Ill.; Coquiot 1913, p. 206; Coquiot 1921, p. 82, pp. 138 ff.; Astre (1926), p. 129;
Joyant 1927, p. 236; Mack 1938, p. 219, p. 333; Lassaigne 1939, p. 149 Ill.; Julien 1942, p. 12, p. 54 Ill.; Jedlicka 1943,
pp. 288–289 Ill.; Kern 1948, p. 16; Delaroche 1948, p. 9; Julien 1951, p. 11; Dortu VI, pp. 850 f. D. 4541 Ill.; Adriani 1986,
with 318.
EXHIBITIONS: Paris 1931, No. 261; New York 1931, No. 19; New York 1937, No. 52; *The Horse*, Fogg Art Museum,
Cambridge (Mass.) 1938, No. 20; New York 1946, No. 48; Philadelphia-Chicago 1955–1956, No. 120; New York 1956,
No. 76; New York 1964, No. 85.

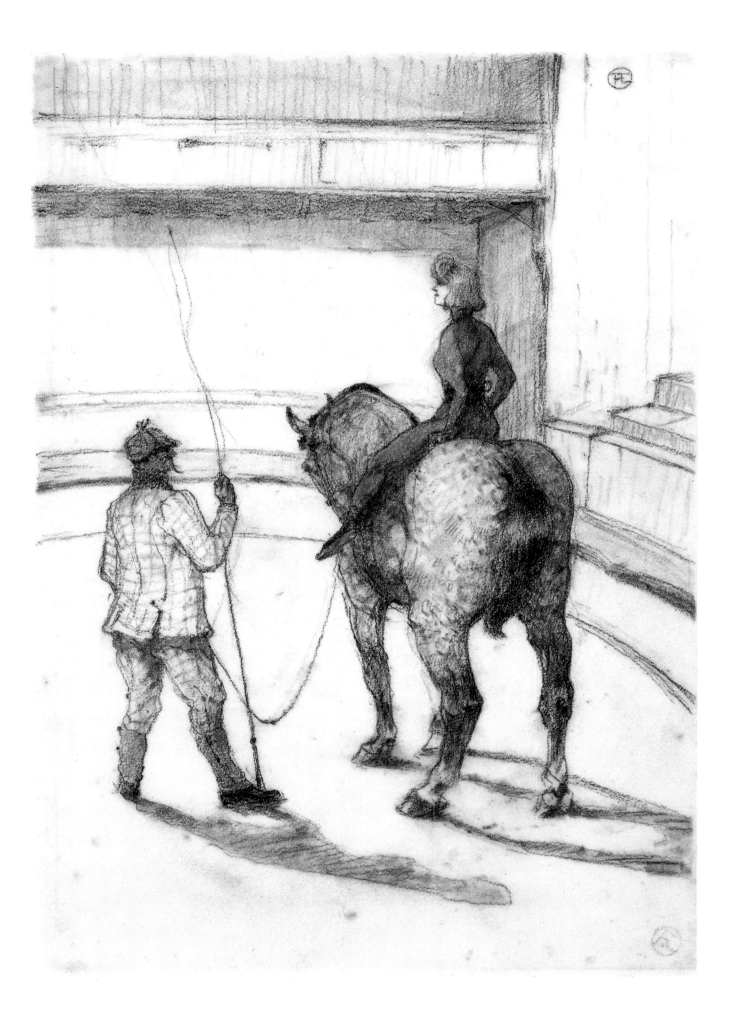

113 AT THE CIRCUS, REHEARSAL (AU CIRQUE, TRAVAIL DE RÉPÉTITION DU PANNEAU) 1899

Dortu VI, D. 4555
Coloured chalks on white paper, 35.5 × 25.5 cm
Monogram in black chalk, upper right; red monogram stamp (Lugt 1338),
lower right
Private Collection, New York

See No. 110.

SOURCES: Maurice Joyant, Paris: M. G. Dortu, Paris; Knoedler & Co., New York; Mrs C. Suydam Cutting, New York.
BIBLIOGRAPHY: Coquiot 1921, p. 82; Joyant 1927, p. 238; Jacomet (1932), No. 12 Ill.; Mack 1938, p. 219, p. 333; Julien 1942, p. 12; Kern 1948, p. 16; Delaroche 1948, p. 9, Ill. 36; Julien 1951, p. 11; *Toulouse-Lautrec, The Circus – Thirty-Nine Crayon Drawings in Color*, New York 1952, No. 34 Ill.; Dortu VI, pp. 874f. D. 4555 Ill.; Huisman-Dortu 1973, p. 66 Ill.; Adriani 1986, with 318.
EXHIBITIONS: Paris 1931, No. 274; *Nineteenth Century Master Drawings*, The Newark Museum, Newark 1961, No. 50.

114 AT THE CIRQUE FERNANDO (AU CIRQUE FERNANDO) 1899

Dortu V, D. 3055
Black and red ink with brush on white fan-shaped paper, 21 × 66 cm
Monogram in pencil, lower left
E. W. Kornfeld, Bern

This fan (*cf.* No. 30), formerly mounted for use, shows the clown George Footit in an animal training act with an elephant balancing on a pedestal. In all probability it was painted not in 1888, as Dortu thought, but in 1899. This is suggested by stylistic comparison with a circus drawing above (No. 110), with a monotype (No. 115) also made in spring of 1899 and with the late lithograph DÎNER DES TARNAIS (Adriani 1986, 319). The very abbreviated form of composition and the fluid ductus of the brush are examples of the artist's original and successful use of Japanese methods of representation.

SOURCES: Gustave Pellet, Paris; Maurice Exsteens, Paris.
BIBLIOGRAPHY: Dortu V, pp. 496f. D. 3055 Ill.; Adriani 1976, p. 279 with 324; Frank Whitford, *Japanese Prints and Western Painters*, London 1977, p. 209 Ill.; Monika Kopplin, *Das Fächerblatt von Manet bis Kokoschka*, Saulgau 1981, pp. 180ff.; Adriani 1986, with 319.
EXHIBITIONS: *Choix d'une Collection privée, Sammlungen G.P. und M.E., Impressionisten, Neoimpressionisten, Spätimpressionisten*, Galerie Klipstein and Kornfeld, Bern 1960, No. 74; *Der Japanismus in der Malerei und Graphik des 19. Jahrhunderts*, Haus am Waldsee, Berlin 1965, No. 28; Ingelheim 1968, No. 18; *Weltkulturen und moderne Kunst*, Haus der Kunst, Munich 1972, No. 821; *Kompositionen im Halbrund, Fächerblätter aus vier Jahrhunderten*, Staatsgalerie Graphische Sammlung, Stuttgart 1984, No. 93.

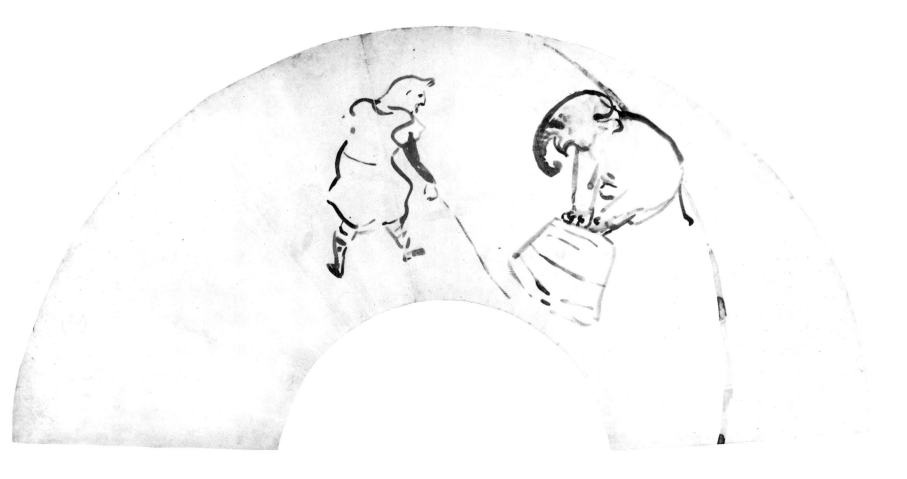

115 THE CLOWN
(LE CLOWN) 1899

Dortu III, M. 1
Monotype in oils on white paper (second of three impressions), 49.5 × 35.5 cm
Monogram in dark paint, lower left
Private Collection

In connection with the 39 drawings made during his stay at the clinic from mid-March to mid-May 1899 (see Nos. 110–113), Lautrec also produced four coloured monotypes (*cf.* No. 116).[1] The monotype was an old technique, which involved printing an image drawn in ink or turpentine-thinned oil paints on copper, zinc or glass plates. It had been rediscovered in the 1870s by Degas, who loved experimentation and created many works in this medium.

1 Dortu III, M. 1, M. 3, M. 4, M. 6 (No. 116); the monotypes M. 3 and M. 6 are known only in a single impression, but there are three known impressions of M. 1 (the first of these is reproduced in sales catalogue 190, *Moderne Kunst des neunzehnten und zwanzigsten Jahrhunderts*, Galerie Kornfeld, Bern, 23–25 June 1982, No. 912; the third in Dortu III, pp. 532f. M. 2 Ill.), and two impressions of M. 4, in each of which the drawing is fainter.

SOURCES: Eugène Mutiaux, Paris; Otto Gerstenberg, Berlin.
BIBLIOGRAPHY: Dortu III, pp. 532f. M. 1 Ill.; Wolfgang Wittrock, *Toulouse-Lautrec, the Complete Prints*, II, London 1985, No. 338 Ill. (wrongly claimed to be first printing).
EXHIBITIONS: Ingelheim 1968, No. 42; Kyoto-Tokyo 1968–1969, No. 80.

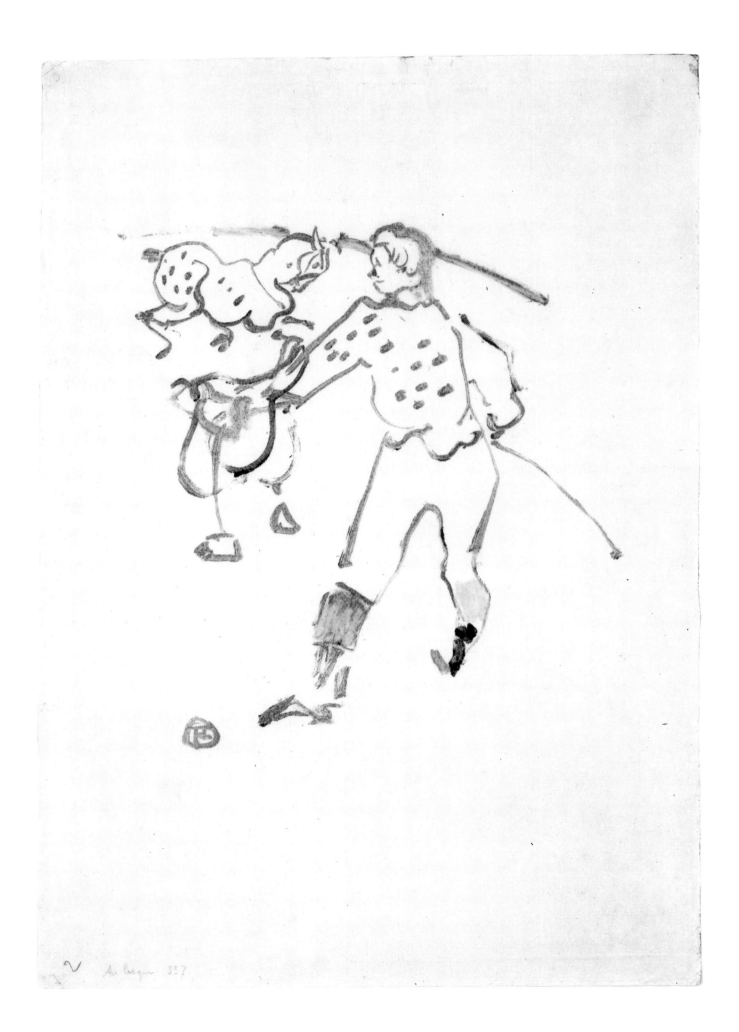

116 CONVERSATION 1899

Dortu III, M. 6
Monotype in oils on white paper (only this impression known), 49.5 × 35.5 cm
Private Collection

See No. 115.

SOURCES: Otto Gerstenberg, Berlin.
BIBLIOGRAPHY: Dortu III, pp. 532f. M. 6 Ill.; Wolfgang Wittrock, *Toulouse-Lautrec, the Complete Prints*, II, London 1985, No. 337 Ill.
EXHIBITIONS: Ingelheim 1968, No. 45; Kyoto-Tokyo 1968–1969, No. 79.

117 Old Man's Head, a Patient at the Madrid Hospital in Neuilly
(Tête de Vieil Homme, un Pensionnaire de la Maison de Santé de Madrid à Neuilly) 1899

Dortu VI, D. 4474
Coloured chalks on blue-grey paper, 35 × 30.4 cm
Musée Toulouse-Lautrec, Albi

In this coloured chalk drawing Lautrec sympathetically depicted the disturbed expression of a white-haired fellow patient at Dr Sémelaigne's psychiatric clinic. On a second sheet the old gentleman is shown full length (Dortu VI, D. 4614).

SOURCES: Comtesse Adèle Zoë de Toulouse-Lautrec, Toulouse.
BIBLIOGRAPHY: Joyant 1926, p. 217, p. 223; Joyant 1927, p. 233; Julien 1942, p. 52 Ill.; Landolt 1954, p. 26, No. 30 Ill.; Perruchot 1958, pp. 349f.; Dortu VI, pp. 804f. D. 4474 Ill.; Polasek 1972, with No. 54; *Cat. Musée Toulouse-Lautrec* 1973, pp. 148f. No. D. 144 Ill.; Devoisins 1980, p. 51 Ill.; *Cat. Musée Toulouse-Lautrec* (1985), p. 225 No. D. 167.
EXHIBITIONS: Paris 1976.

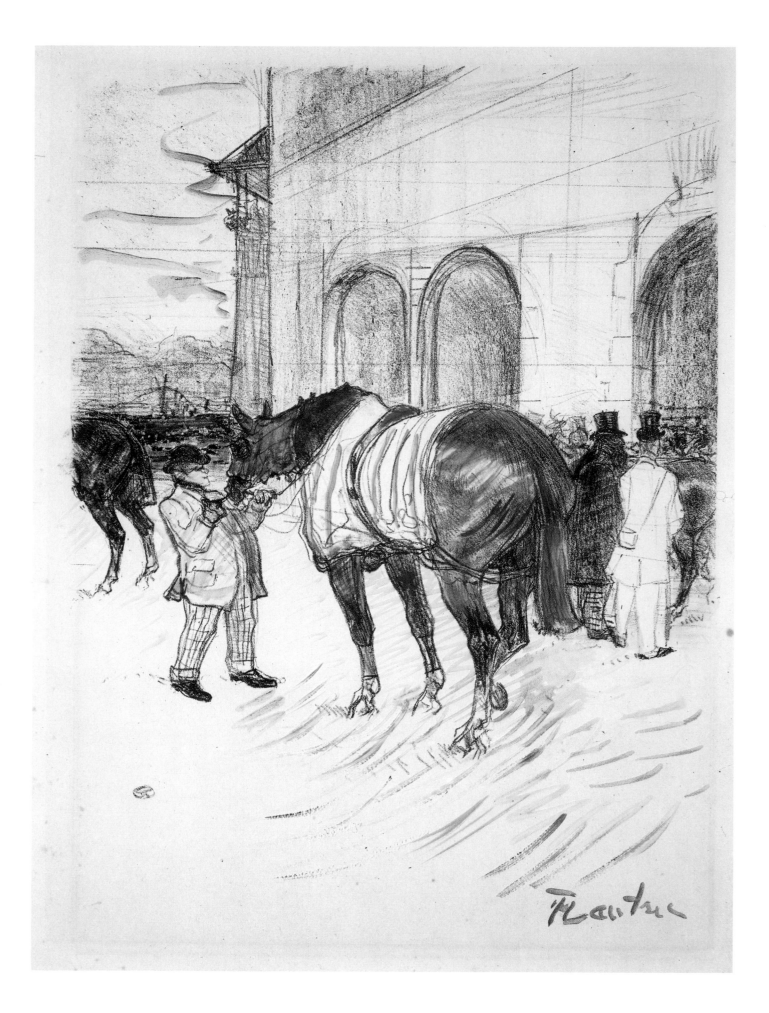

118 THE PADDOCK
(LE PADDOCK) 1899

Dortu III, A. 258
Lithograph in black, painted over with watercolour and wash, 44 × 33 cm
Signed in blue-grey paint, lower right: 'T-Lautrec'; monogram on the lithographic
stone, lower left
Den kongelige Kobberstiksamling. Statens Museum for Kunst (Cat. No. 18092),
Copenhagen

During his stay at Dr Sémelaigne's psychiatric clinic at Neuilly in the spring of 1899, the
artist rediscovered his earlier interest in dogs and horses as the embodiment of natural beauty,
strength and speed. At the suggestion of the publisher Pierrefort, who visited Lautrec at the
clinic with Henri Stern, Lautrec's lithographer, on 17 May 1899, he planned to publish a
series of racecourse lightographs with the title LES COURSES. Four prints in all were made on
this theme,[1] but Pierrefort only published the one coloured lithograph JOCKEY, while the
other motifs were printed only as trial proofs. Lautrec may perhaps have considered having
LE PADDOCK printed in a coloured edition too, and it is possible that, in order to try out
possible colour effects, he overpainted one of the few proof copies and gave it his signature.[2]

1 Adriani 1986, 345–348.
2 Another impression also overpainted in colour is in the Bibliothèque Nationale, Paris.

SOURCES: Otto Gerstenberg, Berlin; Margarete Scharf, Berlin; Leo Swane, Copenhagen.
BIBLIOGRAPHY: Coquiot 1913, p. 159 Ill.; Coquiot (1923), Ill. 45; Joyant 1927, p. 61 Ill., p. 230; Jedlicka 1929, p. 379 Ill.;
Jorgen Sthyr, 'Kobberstiksamlingens nyerhvervelser', in: *Kunstmuseets Aarsskrift,* XXXVII, Copenhagen 1950, p. 49,
pp. 143f. Ill.; Copenhagen 1967, p. 74; Dortu III, pp. 522f. A. 258 Ill.; Adriani 1976, p. 281 with 357; Adriani 1986, with
346.
EXHIBITIONS: Paris 1931, No. 357; Vienna 1966, No. 193.

119 The English Girl at the Star in Le Havre (L'Anglaise du Star du Havre) 1899

Dortu VI, D. 4445
Red and white chalk on blue-grey paper, 62 × 47 cm
Signed in red chalk, lower left: 'T-Lautrec'
Musée Toulouse-Lautrec, Albi

The blond Miss Dolly was a barmaid and singer at an English sailors' bar in the Rue Général Faidherbe, Le Havre. This meticulously executed portrait drawing was done as a study for a head-and-shoulders portrait of the English girl dated 1899 (Dortu III, P. 684).

After his release from the clinic in May 1899 Lautrec first travelled to Albi, then went to convalesce at Le Croty on the Channel coast, and in the course of July he also stayed at Le Havre. From the Hôtel de l'Amirauté there he wrote on 11 July to Joyant in Paris, 'Dear Sir [in English], We acknowledge the receipt of the painting materials. Today I did a sanguine drawing of an English girl from the Star which I'll send you tomorrow by registered post.'[1] Lautrec had not yet recovered his old sureness of line as a draughtsman; the profile and the shadows are rather timidly drawn. One can feel how much he was struggling over details to give proof of his former skill.

1 Joyant 1926, p. 229.

SOURCES: Comtesse Adèle Zoë de Toulouse-Lautrec, Toulouse.
BIBLIOGRAPHY: Alexandre 1902, p. 10 Ill.; Joyant 1926, pp. 229f.; Joyant 1927, p. 77, p. 231; Jedlicka 1929, p. 366; Joyant 1930, No. 62 Ill.; Lassaigne 1939, p. 25 Ill.; Julien 1942, p. 51 Ill.; Jedlicka 1943, p. 288; Delaroche 1948, p. 10 Ill.; Perruchot 1958, p. 355; Julien (1959), p. 53, p. 76 Ill.; Focillon 1959, No. 47 Ill.; Zinserling 1964, p. 42, Ill. 56; Cionini-Visani 1968, Ill. 71; Dortu III, p. 418 with P. 684; Dortu VI, pp. 798f. D. 4445 Ill.; Polasek 1972, p. 45, No. 57 Ill.; *Cat. Musée Toulouse-Lautrec* 1973, p. 88 with No. 201, pp. 146ff. No. D. 142 Ill.; Huisman-Dortu 1973, p. 62; Devoisins 1980, p. 15 Ill.; Keller 1980, Ill. 60; *Cat. Musée Toulouse-Lautrec* (1985), p. 157 with No. 203, p. 222 Ill., pp. 224f. No. D. 165.
EXHIBITIONS: Paris 1902, No. 125; Paris 1914, No. 138; Paris 1931, No. 239; Basel 1947, No. 101; Brussels 1949, No. 212; Albi 1951, No. 156; Nice 1957, No. 43; Paris 1958–1959, No. 61; London 1961, No. 86; Paris 1975–1976, No. 63; Tokyo (etc.) 1982–1983, No. 79.

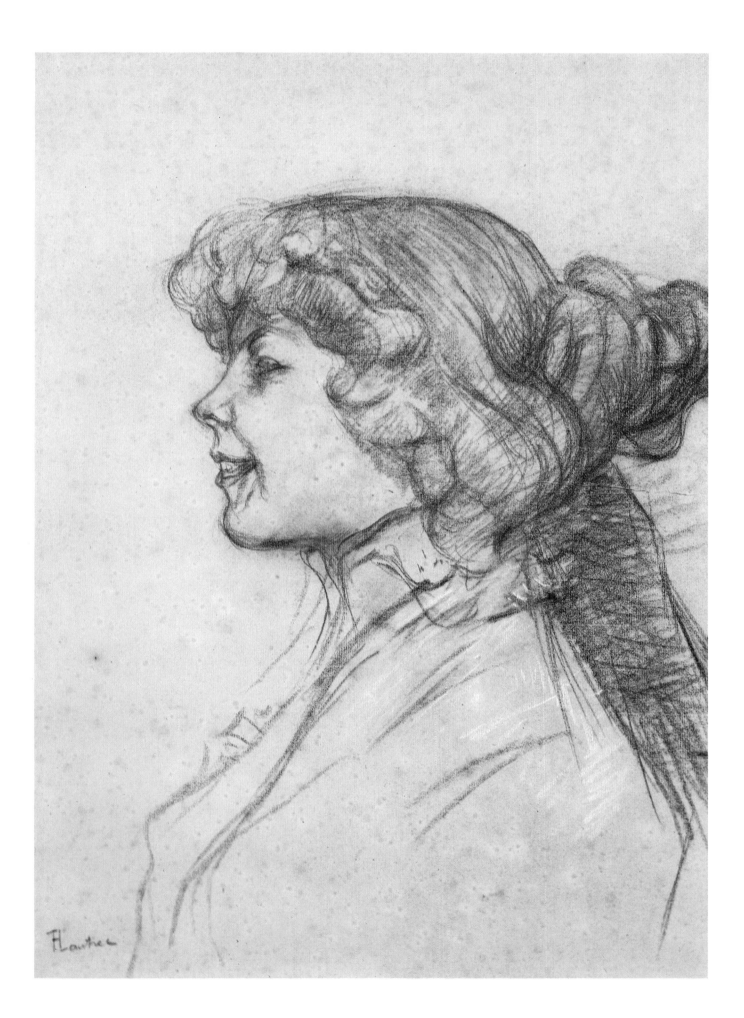

120 ROMAIN COOLUS 1899

Dortu III, P. 686
Oil on cardboard, 56.2 × 36.8 cm
Monogram in blue paint, lower left
Musée Toulouse-Lautrec, Albi

Lautrec got to know the poet Romain Coolus (his real name was René Weill, 1868–1952) through the circle centred around Thadée Natanson's magazine *La Revue Blanche*. Between 1896 and 1899 he made several portrait sketches of him,[1] and he also illustrated the stories *Le Bon Jockey*, *La Belle et la Bête* (No. 85) and *Les Soeurs Légendaires* for his friend. In this portrait he has regained the former strength of his draughtsmanship and painting, and his peculiar skill in characterization. There is no scenic background which could have contributed to an understanding of the character type. Attention is concentrated entirely on the face, in which individual character emerges from apparently incidental features. The distinctive nuance of a raised eyebrow, the angular profile of the nose, the position of one corner of the mouth and the furtive curiosity of the eyes are sufficient to express the sitter's individuality.

1 Dortu VI, D. 4249, D. 4250, D. 4608–D. 4613, D. 4630, D. 4631; Adriani 1986, 163.

SOURCES: Romain Coolus, Paris.
BIBLIOGRAPHY: Coquiot 1913, p. 184, pp. 187f. Ill.; Duret 1920, p. 49; Coquiot 1921, p. 65, p. 122; Coquiot (1923), p. 33; Astre (1926), pp. 81f.; Joyant 1926, pp. 202–203 Ill., p. 240, p. 298; Joyant 1927, p. 38; Lapparent 1927, p. 50; Jedlicka 1929, pp. 350f. Ill.; Coolus 1931, p. 139 Ill.; Schaub-Koch 1935, p. 212; Mac Orlan 1941, p. 119; Jedlicka 1943, p. 102, pp. 276–277 Ill.; Vinding 1947, p. 173; Kern 1948, p. 14; Bellet 1951, p. 17; Natanson 1951, p. 177, pp. 256–257 Ill.; Jourdain-Adhémar 1952, p. 90, p. 113; Lassaigne 1953, p. 105; Dortu-Grillaert-Adhémar 1955, p. 37; Perruchot 1958, p. 363; Julien (1959), p. 69; Bouret 1963, p. 168; Fermigier 1969, p. 192 Ill.; Dortu III, pp. 420f. P. 686 Ill.; Josifovna 1972, Ill. 137; *Cat. Musée Toulouse-Lautrec* 1973, pp. 89ff. No. 202 Ill.; Caproni-Sugana 1977, Ill. LVI, No. 501 Ill.; Dortu-Méric 1979, II, p. 80 No. 594 Ill.; p. 87 Ill.; Chicago 1979, with No. 107; Arnold 1982, p. 63; *Cat. Musée Toulouse-Lautrec* (1985), p. 156 Ill., pp. 158f. No. 204; New York 1985, p. 67.
EXHIBITIONS: Paris 1902, No. 80; Paris 1914, No. 93; Paris 1914 (Galerie Rosenberg), No. 3; Paris 1931, No. 179; New York 1937, No. 26; London 1938, No. 13; Paris 1938, No. 42; Basel 1947, No. 196; Amsterdam 1947, No. 55; Brussels 1947, No. 55; Paris 1951, No. 79; Albi 1951, No. 113; London 1961, No. 69; Albi-Paris 1964, No. 77; *Autour de la Revue Blanche 1891–1903*, Galerie Maeght, Paris 1966, No. 37; Kyoto-Tokyo 1968–1969, No. 52.

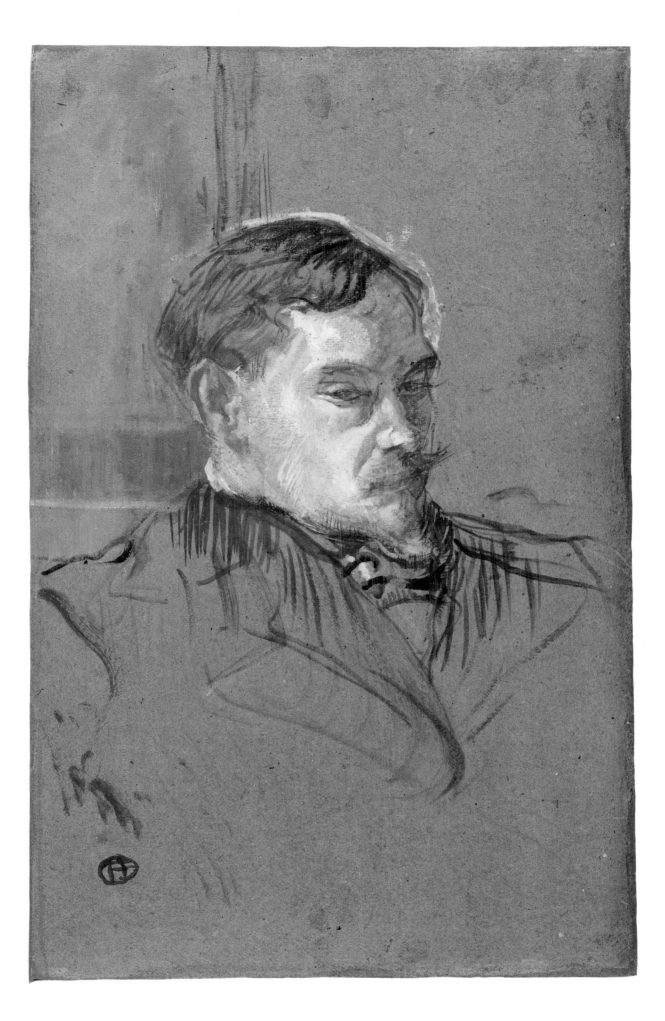

121 JANE AVRIL 1899

Dortu VI, S.D. 29
Pencil on white paper, 55.8 × 37.6 cm
Inscribed in pencil (partly on the drawing itself), above: 'Rouge / bleu roi / noir'
Private Collection

One of the most compelling coloured posters that Lautrec ever designed was commissioned by Jane Avril at the beginning of 1899 (see No. 50); she remained faithful to him to the end. It was printed in the same year by Henri Stern the lithographer,[1] but for unknown reasons it was never released. It is possible that the artist, who was still in very poor health, entrusted this impulsively zestful drawing to the printer along with colour notes, so that the latter could then transfer it to the stone with a few changes in colour.[2]

1 Adriani 1986, 354.
2 In a small sketchbook the sixteen-year-old Lautrec drew a study of an elegant lady in a broad-brimmed hat with a long fur boa wound round her body (Dortu IV, D. 1723), similar to the spiralling snake design printed on the close fitting full-length dress worn by Jane Avril in the poster exactly twenty years later.

SOURCES: Otto Gerstenberg, Berlin.
BIBLIOGRAPHY: Dortu VI, pp. 930f. S.D. 29 Ill.; Adriani 1976, p. 281 with 360; Adriani 1986, with 354.
EXHIBITIONS: Ingelheim 1968, No. 235; New York 1985, No. 297.

122 THE GYPSY WOMAN (LA GITANE) 1900

Dortu III. P. 718
Oil on cardboard, 80 × 53 cm
Red monogram stamp (Lugt 1338), lower left
Musée Toulouse-Lautrec, Albi

The actress and *chanteuse* Marthe Mello was married to the publisher Alfred Athis Natanson. Her roles included the lead in Jean Richepin's drama *La Gitane* which had its première at the Théâtre Antoine on 22 January 1900. It was for this play that Lautrec designed his last poster.[1] Here she is vividly sketched as an impetuous gypsy woman in a few contour lines and some swift hatching.

1 Adriani 1986, 355; *cf.* also the sketches Dortu VI, D. 4659–D. 4663, D. 4672.

SOURCES: Comtesse Adèle Zoë de Toulouse-Lautrec, Toulouse.
BIBLIOGRAPHY: Joyant 1926, p. 301; Landolt 1954, pp. 23f. No. 32 Ill.; Dortu III, pp. 440f. P. 718 Ill.; *Cat. Musée Toulouse-Lautrec* 1973, p. 93 Ill., p. 95 No. 211; Caproni-Sugana 1977, No. 507b Ill.; New York 1985, p. 76 Note 129; *Cat. Musée Toulouse-Lautrec* (1985), p. 164 No. 213, p. 167 Ill
EXHIBITIONS: Paris 1914, No. 1 Albi 1951, No. 120; Paris 1958–1959, No. 51; Munich 1961, No. 94; Cologne 1961–1962, No. 94; Ingelheim 1968, No. 237; Paris 1975–1976, No. 41; Tokyo (etc.) 1982–1983, No. 52.

123 MADEMOISELLE COCYTE 1900

Dortu II, A. 265
Watercolour over pencil on white paper, 62 × 48 cm
Red monogram stamp (Lugt 1338), lower left
Verso: MASKED BALL IN BORDEAUX
(BAL MASQUÉ À BORDEAUX) 1900–1901
Dortu VI, D. 4645
Purple chalk on white paper
Musée Toulouse-Lautrec, Albi

Lautrec, now seriously ill, spent the autumn of 1900 with his mother at the Château de
Malromé. He then decided not to return to Paris for the winter months but to stay in the
south at Bordeaux. There he rented an apartment at 66 Rue de Caudéran and a studio in the
Rue Porte-Digeaux. A few visits to the Grand Théâtre, where the productions that
December were Jacques Offenbach's operetta *La Belle Hélène* and Isidore de Lara's opera
Messalina, resulted in a brief return to his old productivity. The outcome of this short burst
of activity was this pithy watercolour, some drawings from *La Belle Hélène* (*cf.* No. 124) and
six paintings from *Messalina* (see Nos. 125, 126). 'I'm working hard,' he wrote to Joyant in
Paris on 6 December 1900. 'Here we are enjoying *La Belle Hélène* which is admirably staged.
I have recorded the thing. Hélène is played by a fat whore called Cocyte.'[1] The accuracy of
the artist's unflattering characterization of the operetta star is made very evident in this
watercolour of the so-called 'beautiful Helen'. The full-bosomed 'beauty' is presented as a
bright, iridescent bird of paradise in the merciless stage footlights.[2]

1 Joyant 1926, p. 233.
2 *Cf.* the portrait studies Dortu VI, D. 4640–D. 4642, D. 4671.

SOURCES: Comtesse Adèle Zoë de Toulouse-Lautrec, Toulouse.
BIBLIOGRAPHY: Joyant 1927, p. 241; Joyant 1930, Ill. 65; Julien (1959), p. 69, p. 81 Ill.; *Toulouse-Lautrec* 1962 p. 175 Ill.;
Huisman-Dortu 1964, p. 231 Ill.; Zinserling 1964, p. 42, Ill. 58; Keller 1968, p. 76 Ill.; Cionini-Visani 1968, Ill. 74; Fermigier
1969, p. 231 Ill.; Dortu III, pp. 524f. A. 265 Ill.; Dortu VI, p. 902 with D. 4645; *Cat. Musée Toulouse-Lautrec* 1973, p. 149 Ill.;
p. 151 No. D. 151, with No. D. 152; Caproni-Sugana 1977, No. 508 Ill.; Adriani 1978, p. 93 Ill. 12; Morariu 1980, Ill. 61;
Cat. Musée Toulouse-Lautrec (1985), pp. 227f. No. D. 174 Ill. with No. D. 175.
EXHIBITIONS: Paris 1914, No. 137; Nice 1957, No. 45; London 1961, No. 88; Munich 1961, No. 120; Cologne
1961–1962, No. 120; Ingelheim 1968, No. 40; Munich 1972–1973, No. 281; Paris 1975–1976, No. 65; Tokyo (etc.)
1982–1983, No. 84.

124 La Belle hélène 1900

Dortu VI, D. 4670
Black chalk on white paper, 35.8 × 23 cm
Monogram in pencil, lower right
Private Collection

This powerful and arresting scene must be derived from Offenbach's *La Belle Hélène*. The operetta was performed in Bordeaux in December (see No. 123).[1]

1 A similar scene is found on the sheet Dortu VI, D. 4643.

SOURCES: J. Wild, Paris; Otto Gerstenberg, Berlin.
BIBLIOGRAPHY: Joyant 1930, No. 68 Ill.; Mack 1938, p. 214, p. 356; Huisman-Dortu 1964, p. 230 Ill.; Dortu VI, pp. 910f. D. 4670 Ill.; Huisman-Dortu 1973, p. 68 Ill.

125 MESSALINA DESCENDING THE STAIRS FLANKED BY THE CHORUS
(MESSALINE DESCEND L'ESCALIER BORDÉ DE FIGURANTES) 1900–1901

Dortu III, P. 704
Oil on canvas, 99.1 × 72.4 cm
Red monogram stamp (Lugt 1338), lower left
Los Angeles County Museum of Art (Mr and Mrs George Gard de Sylva
Collection), Los Angeles

Lautrec's last attempts to capture the spirit of the theatre date from between December 1900 and the spring of 1901 at Bordeaux (*cf.* Nos. 123, 124, 126). His very draughtsman-like painting technique had by now developed an almost leaden heaviness with an emphasis on chiaroscuro contrasts. The openness of structure found in his earlier pictures is now counteracted by more homogeneous colour surfaces. In six paintings after Isidore de Lara's opera *Messalina*[1] we find figurines whose emotive volumes are delineated with much black and move in a stiff choreography. Madame Gannes's majestic entrance as the notoriously dissipated Roman empress, dressed in blood-red, is presented with ponderous baroque stage-setting, surrounded by striking repoussoir figures.

Yet the artist was very involved with his subject. He wrote to Joyant in Paris in December 1900, 'Have you any good or bad photos of *Messalina* by Lara? I am working on the piece and the more documents I have about it the better'; and on 23 December, 'Send me without delay programmes and texts of *L'Assommoir* and *Messalina* and above all the "dough" which we need in order to appear in public.' Finally, on 16 April shortly before his return to Paris, he was able to report, 'I am very satisfied [in English]. I hope you will be even more pleased with my new paintings about *Messalina*.'[2]

1 Dortu III, P. 703–P. 708.
2 Joyant 1926, pp. 234, 236.

SOURCES: G. Bernheim, Paris; L. C. Hodebert, Paris; Adolphe Lewisohn, New York; George Gard de Sylva, Los Angeles.
BIBLIOGRAPHY: Alexandre 1914, pp. 14f. Ill.; Duret 1920, Ill. XXXVI, p. 122; Coquiot 1921, p. 144; Brook 1923, p. 145 Ill.; Astre (1926), p. 91; Joyant 1926, p. 237 Ill., p. 300; Lapparent 1927, p. 56; Schaub-Koch 1935, p. 203; Mack 1938, pp. 212–213 Ill., p. 356; Mac Orlan 1941, p. 165 Ill.; Jourdain 1948, Ill. 50; Kern 1948, Ill. 50; Dortu 1952, p. 10 Ill. 61; Dortu-Grillaert-Adhémar 1955, p. 33; Perruchot 1958, p. 367; *Sammlung Emil G. Bührle*, Kunsthaus, Zurich 1958, with No. 209; Huisman-Dortu 1964, p. 233 Ill.; Novotny 1969, p. 57 Ill. 124; Dortu III, pp. 430f. P. 704 Ill.; Dortu VI, p. 900 with D. 4637; Caproni-Sugana 1977, No. 518A Ill.; Adriani 1978, p. 157, Ill. 53; Dortu-Méric 1979, II, p. 88 No. 613 Ill.; Morariu 1980, Ill. 65; Arnold 1982, p. 99; Lucie-Smith 1983, No. 48 Ill.; New York 1985, p. 77 Note 155.
EXHIBITIONS: Brussels 1902, No. 281; Paris 1914, No. 37; New York 1931 (Lautrec-Redon), No. 34; Philadelphia-Chicago 1955–1956, No. 76; New York 1956, No. 44; New York 1964, No. 55; Vienna 1966, No. 32, with No. 64; Chicago 1979, No. 102 with No. 100.

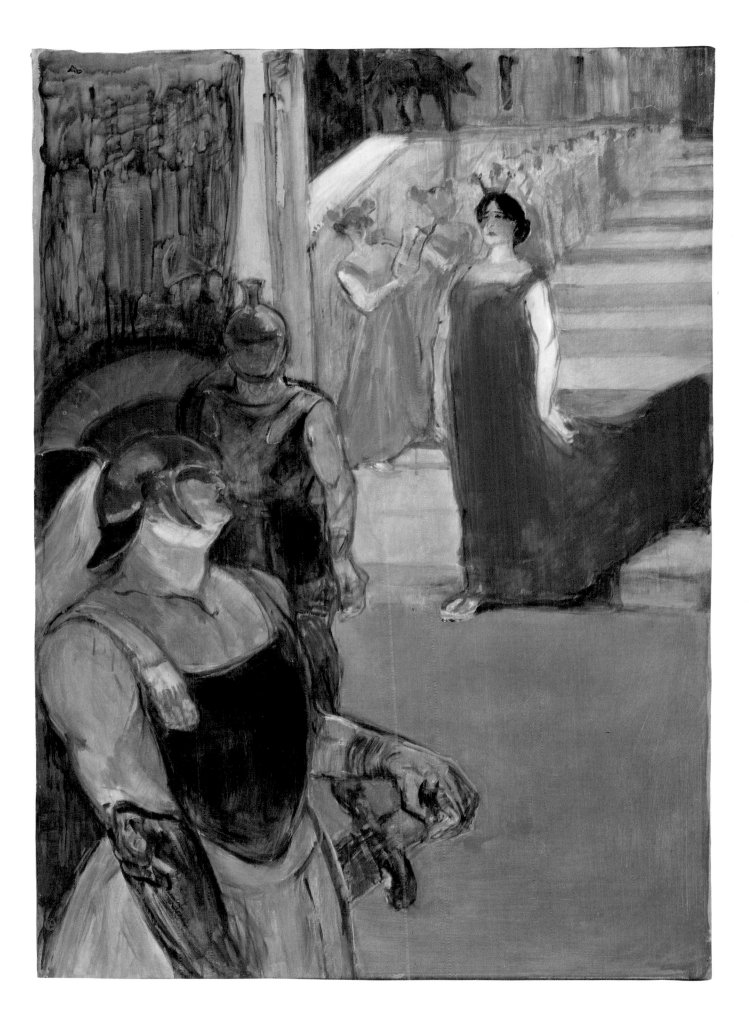

126 MESSALINA 1900–1901

Dortu III, P. 703
Oil on canvas, 92.5 × 68 cm
Red monogram stamp (Lugt 1338), lower right
Stiftung Sammlung E. G. Bührle, Zurich

Two of the six *Messalina* pictures painted in Bordeaux (see No. 125) show the empress enthroned in her palace and surrounded by courtly pomp.[1] In both these scenes appear two minor characters who are made the central subject of the present composition. Together with a third lady-in-waiting, they fill the picture space to the back, while on the right, on a high pedestal set against a deep red background, the lower part of a statue can be seen trying awkwardly to decide which leg it should be standing on. The tension in the distribution of masses, the masterly treatment of lighting effects and the boldness with which the figures are cut off by the picture frame, once again reveal the painter's consummate skill.

1 Dortu III, P. 705, P. 707.

SOURCES: Bernheim-Jeune, Paris; Paul Cassirer, Berlin; M. Lévêque, Paris; Georges Viau, Paris; Paul Cassirer, Berlin; Estella Katzenellenbogen, Berlin; Walter Feilchenfeldt, Zurich; Emil G. Bührle, Zurich.
BIBLIOGRAPHY: Alexandre 1914, p. 15; Duret 1920, p. 122; Coquiot 1921, p. 144; Coquiot (1923), Ill. 34; Astre (1926), p. 91; Joyant 1926, p. 299; Lapparent 1927, p. 56; Schaub-Koch 1935, p. 203; Mack 1938, p. 214, p. 356; Dortu 1952, p. 10 Ill. 67; Perruchot 1958, p. 367; Julien (1959), p. 80 Ill.; *Toulouse-Lautrec* 1962, p. 233 Ill. (Detail); Keller 1968, p. 55 Ill., p. 73; Fermigier 1969, p. 230 Ill.; Dortu III, pp. 430f. P. 703 Ill.; Caproni-Sugana 1977, Ill. LXIII, No. 518B Ill.; Dortu-Méric 1979, II, p. 88 No. 612 Ill., p. 91 Ill.; Chicago 1979, with No. 102; Henze 1982, p. 79 Ill.; Arnold 1982, p. 99; New York 1985, p. 77 Note 155.
EXHIBITIONS: Paris 1914, No. 35; *Impressionisten*, Galerie Paul Cassirer, Berlin 1925, No. 59; *French Art*, Royal Academy, London 1932, No. 547; Zurich 1933, No. 98; Rotterdam 1933–1934, No. 80; *Chefs d'Œuvre de l'Art Français*, Palais National des Arts, Paris 1937, No. 426; *French Art from David to Toulouse-Lautrec*, Metropolitan Museum of Art, New York 1941, No. 117; New York 1946, No. 34; Vevey 1954, No. 110; *Sammlung Emil G. Bührle*, Kunsthaus, Zurich 1958, No. 209.

127 HEAD OF A CHILD IN FRONTAL VIEW (TÊTE D'ENFANT DE FACE) 1900–1901

Dortu VI, D. 4649
Red chalk on blue-grey paper, 39 × 33.8 cm
Signed in red chalk, lower right: 'T-Lautrec'
Museum Boymans-van Beuningen (Cat. No. F. II 146), Rotterdam

This very conventional portrait of the daughter of a certain Madame Marthe V., together with another showing her in profile (Dortu VI, D. 4650), was drawn in Bordeaux.

SOURCES: Vente Hôtel Drouot, Paris 27 February 1919, No. 140; Le Garrec, Paris; Vente *Collection Miss P.*, Hôtel Drouot, Paris 6 February 1928; M. Gobin, Paris; Paul Cassirer, Berlin; Franz Koenigs, Haarlem.
BIBLIOGRAPHY: Joyant 1927, p. 242, p. 261; Hoetink 1968, pp. 146f. No. 249 Ill.; Dortu VI, pp. 904f. D. 4649 Ill.
EXHIBITIONS: *Meisterzeichnungen Französischer Künstler von Ingres bis Cézanne*, Kunsthalle, Basel 1935, No. 238; Amsterdam 1946, No. 180; Amsterdam 1947, No. 108; Brussels 1947, No. 108; *Le Dessin Français dans les Collections Hollandaises*, Institut Néerlandais, Paris – Rijksmuseum, Amsterdam 1964, No. 197.

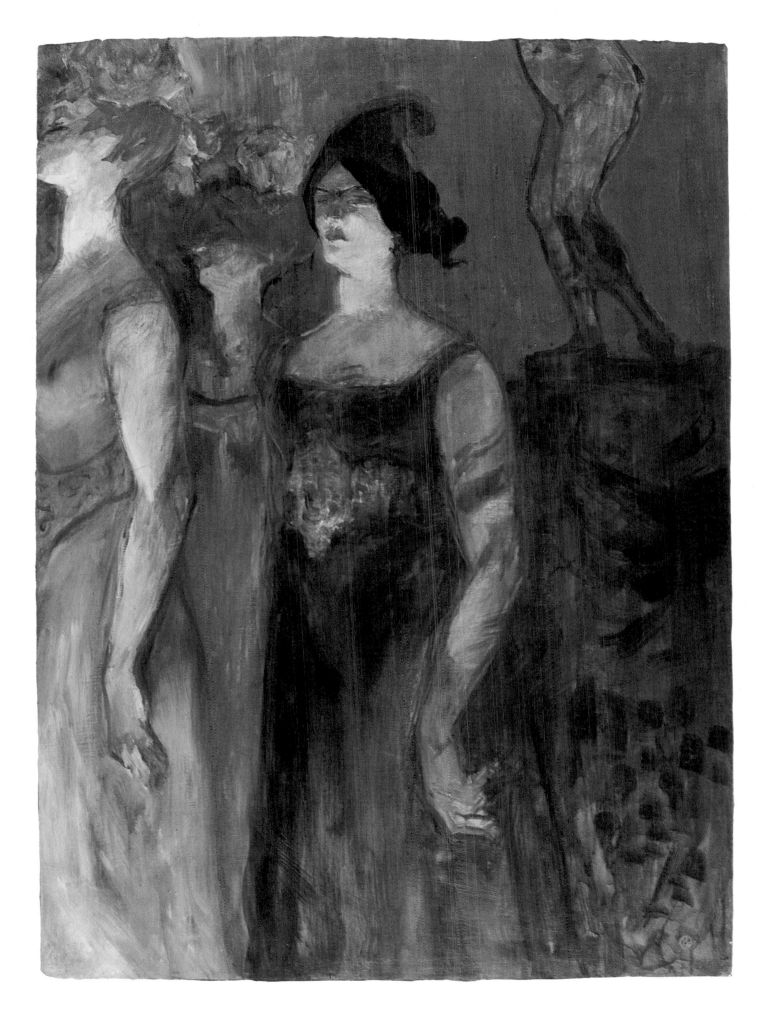

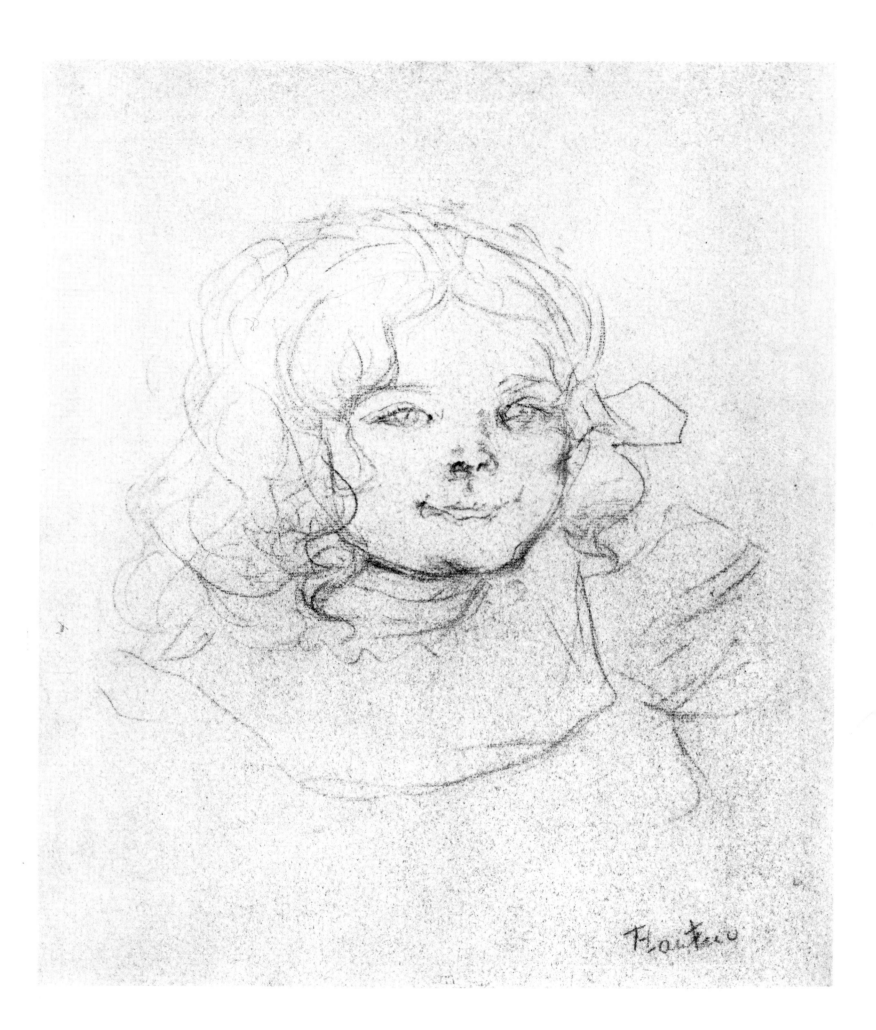

128 On the Quays of Bordeaux, Guilbert Pursuing a Bordelaise (Sur Les Quais de Bordeaux, Guilbert Poursuivant une Bordelaise) 1900–1901

Dortu VI, D. 4646
Purple and black chalk on white paper, 47.8 × 61.7 cm
Monogram in purple chalk, lower right
Musée Toulouse-Lautrec, Albi

Besides the theatre themes from Bordeaux (see Nos. 123–126), the artist was also observing scenes from daily life during his stay in the south-western French port between December 1900 and the end of April 1901. Here he mercilessly criticizes the fat Maurice Guilbert (1856–1913), an amateur painter and agent of the champagne firm Moët et Chandon. The economy of line seems to anticipate the bitingly satirical style of George Grosz.

SOURCES: Comtesse Adèle Zoë de Toulouse-Lautrec. Toulouse.
BIBLIOGRAPHY: Coquiot 1921, p. 184; Coquiot (1923), p. 42; Joyant 1926, p. 238; Joyant 1927, p. 241; Cooper 1955, p. 90; Perruchot 1958, p. 369; Dortu VI, pp. 902f. D. 4646 Ill., Polasek 1972, p. 46, No. 61; *Cat. Musée Toulouse-Lautrec* 1973, p. 150 No. D. 149; *Cat. Musée Toulouse-Lautrec* (1985), p. 228 No. D. 173.
EXHIBITIONS: Paris 1914, No. 161.

129 At the Café de Bordeaux (Au Café de Bordeaux) 1900–1901

Dortu VI, D. 4647
Black chalk on white paper, 48 × 62 cm
Monogram in black chalk, lower left; inscribed, lower right: 'à haute voix / Antoine un amer / Tout bas (avez-vous dix francs jus / qu'à demain?)'
Musée Toulouse-Lautrec, Albi

The sharpness of this satire, which was drawn in Bordeaux (*cf.* No. 128), is underlined by the text added by the artist: '(aloud) "Antoine, a bitters" – (*sotto voce*) "Have you got ten francs you can lend me until tomorrow?"'

SOURCES: Comtesse Adèle Zoë de Toulouse-Lautrec, Toulouse.
BIBLIOGRAPHY: Duret 1920, p. 122; Coquiot 1921, p. 184; Coquiot (1923), p. 42; Joyant 1926, p. 238; Joyant 1927, p. 242; Julien 1942, p. 59 Ill.; Julien 1951, Ill. 16; Dortu-Grillaert-Adhémar 1955, p. 39; Huisman-Dortu 1964, p. 232 Ill.; Dortu VI, pp. 904f. D. 4647 Ill.; Polasek 1972, No. 60 Ill.; *Cat. Musée Toulouse-Lautrec* 1973, pp. 149f. No. D. 147 Ill.; *Cat. Musée Toulouse-Lautrec* (1985), pp. 226f. No. D. 171 Ill.
EXHIBITIONS: Paris 1914, No. 149; New York 1937, No. 39; London 1938, No. 42; Paris 1938, No. 45; Basel 1947, No. 104; Amsterdam 1947, No. 130; Brussels 1947, No. 130; Paris 1951, No. 121; Dallas 1957; London 1961, No. 89; Munich 1961, No. 119; Cologne 1961–1962, No. 119; Albi-Paris 1964, No. 128.

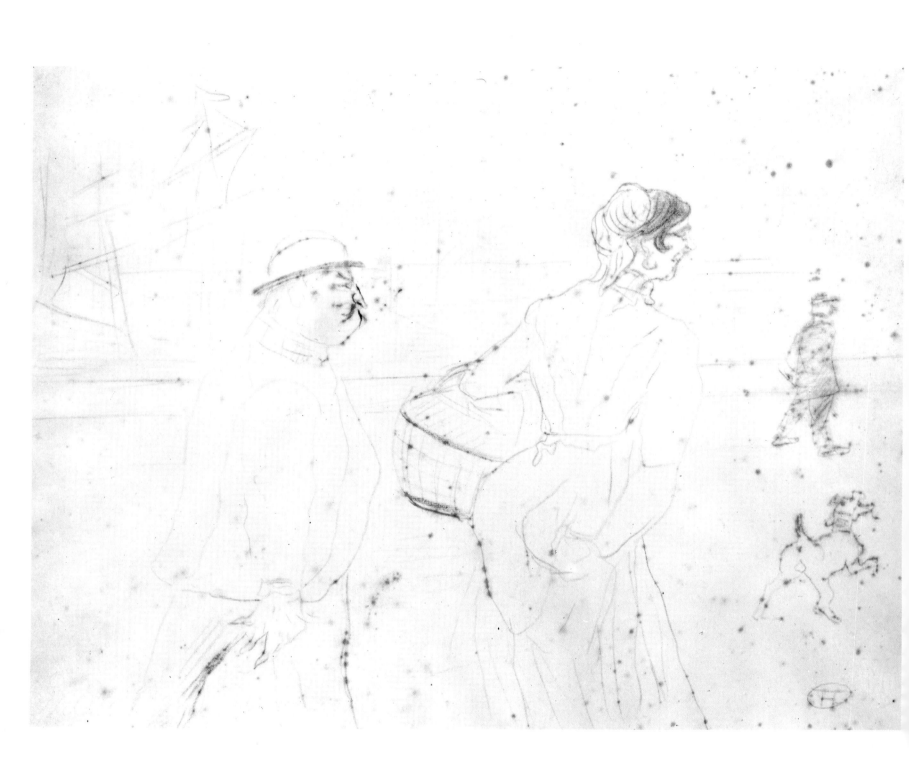

130 AN EXAMINATION AT THE PARIS FACULTY OF MEDICINE (UN EXAMEN À LA FACULTÉ DE MÉDECINE DE PARIS) 1901

Dortu III, P. 727
Oil on canvas, 65 × 81 cm
Signed and dated in grey-blue paint, upper left: 'T-Lautrec / 1901'
Musée Toulouse-Lautrec, Albi

This heavyweight group portrait was Lautrec's last painting, completed in Paris between the beginning of May and mid-July 1901, shortly before his death. The presentation of the heads is reminiscent of portraits of Dutch rulers of the seventeenth century, and the dark, heavy application of paint, with only a few bright lights, is closer to the Baroque than to the concise, colourful reflections of movement and gesture with which the artist had so accurately depicted his world. The main characters, flanked by two subsidiary figures, confront each other rather awkwardly; the emphasis on the grouping of the hands corresponds to the arrangement of the three persons. The occasion for this late work was the doctorate conferred in 1899 on the artist's cousin Gabriel Tapié de Céleyran (1869–1930), who is shown during the oral examination, sitting in the right foreground, his face red with nervousness – like one of Daumier's criminals before his judges. The eyes of Professor Fournier and Professor Wurtz[1] (on the right wearing the black and red gown) are turned critically on the candidate, whose doctoral thesis, dedicated to Dr Péan the surgeon, was entitled *Sur un Cas d'Elytrocèle Postérieure*.

Tapié de Céleyran, who compensated for his shyness by an exaggeratedly distinguished appearance, had come to Paris to continue his medical studies. Since then he had been an inseparable and very compliant companion of the artist, who liked the cruelly picturesque contrast created when he was accompanied by the strikingly gaunt, gangly figure of 'Tapir de Céylon' or 'Tapir de scélérat' – who was more than a head taller than him. In the painting Lautrec left a last memorial to this companion of many years, his confidant and blood-brother in the truest sense (for their parents were brothers and sisters).

1 Robert Wurtz is portrayed alone in the profile study Dortu III., P. 726.

SOURCES: Robert Wurtz, Paris; Henri Wurtz, Paris.
BIBLIOGRAPHY: Alexandre 1914, pp. 14f. Ill.; Duret 1920, p. 53, Ill. XXXVII; Coquiot 1921, p. 124, p. 200; Coquiot (1923), p. 34, p. 54; Astre (1926), p. 89; Joyant 1926, p. 242, p. 302; Lapparent 1927, p. 56; Jedlicka 1929, pp. 389f.; Schaub-Koch 1935, p. 194; Mack 1938, p. 236, p. 359; Mac Orlan 1941, p. 161 Ill.; Julien 1942, p. 16; Jedlicka 1943, p. 97, pp. 303f.–305 Ill.; Jourdain 1948, Ill. 52; Kern 1948, p. 18, Ill. 52; Frankfurter 1951, p. 125 Ill.; *Toulouse-Lautrec* 1951, Ill.; Jourdain-Adhémar 1952, No. 127 Ill., p. 105, p. 107, p. 114; Lassaigne 1953, pp. 108f. Ill.; Julien 1953, p. 40; Landolt 1954, p. 15; Cooper 1955, p. 47, p. 112; Perruchot 1958, p. 370; Julien (1959), p. 69, p. 87, p. 89 Ill.; Focillon 1959, p. 61; *Toulouse-Lautrec* 1962, p. 26 Ill.; Bouret 1963, p. 253; Huisman-Dortu 1964, p. 234 Ill.; 'Lautrec et le Croxi-Margouin', in: *L'Oeil Galerie d'Art*, Paris 1964, Ill.; Cionini-Visani 1968, Ill. 78; Goldschmidt-Schimmel 1969, p. 94 Note 3; Zenzoku 1970, Ill. 65; Dortu III, p. 444 with P. 726, pp. 446f. P. 727 Ill.; Devoisins 1972, p. 16; Polasek 1972, p. 46; Josifovna 1972, Ill. 145; *Cat. Musée Toulouse-Lautrec* 1973, pp. 96ff. No. 213 Ill.; Huisman-Dortu 1973, p. 71, p. 81 Ill.; Muller 1975, Ill. 89; Caproni-Sugana 1977, Ill. LXIV, No. 526a Ill.; Dortu-Méric 1979, II, pp. 92ff. No. 634 Ill.; Morariu 1980, Ill. 66; Arnold 1982, p. 99; Cooper 1983, p. 10; *Cat. Musée Toulouse-Lautrec* (1985), pp. 165ff. No. 216 Ill.; New York 1985, p. 38.
EXHIBITIONS: Paris 1902, No. 95; Paris 1914, No. 105; Paris 1931, No. 187; Albi 1951, No. 122; Paris 1958–1959, No. 52; London 1961, No. 72; Munich 1961, No. 96, Cologne 1961–1962, No. 96; Albi-Paris 1964, No. 81; Paris 1975–1976, No. 42; Chicago 1979, No. 109; Tokyo (etc.) 1982–1983, No. 53.

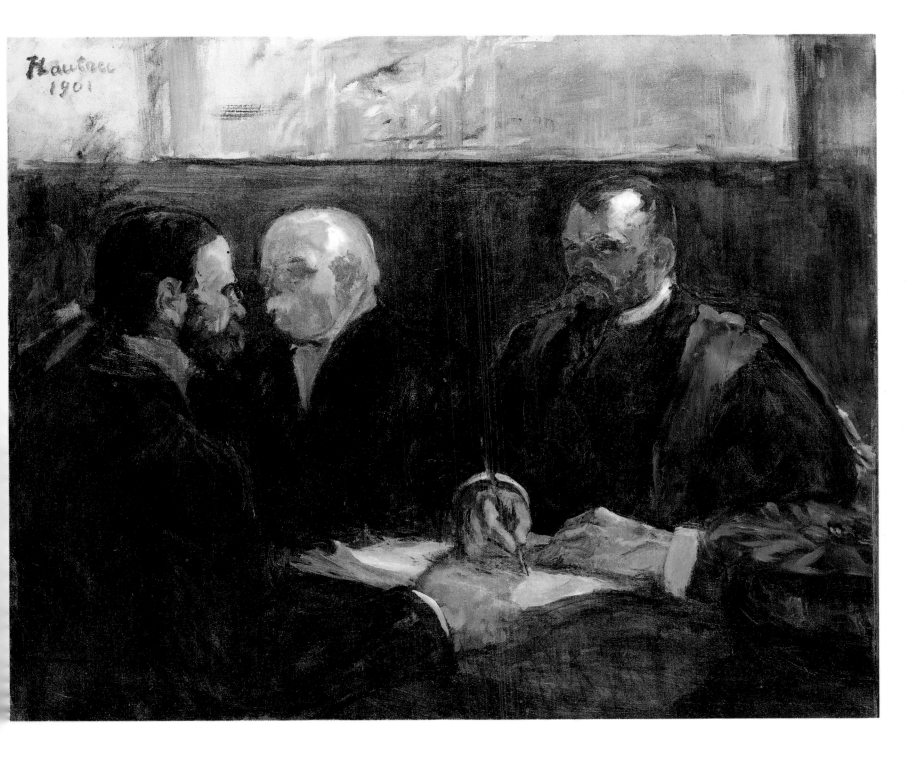

BIOGRAPHICAL DOCUMENTATION

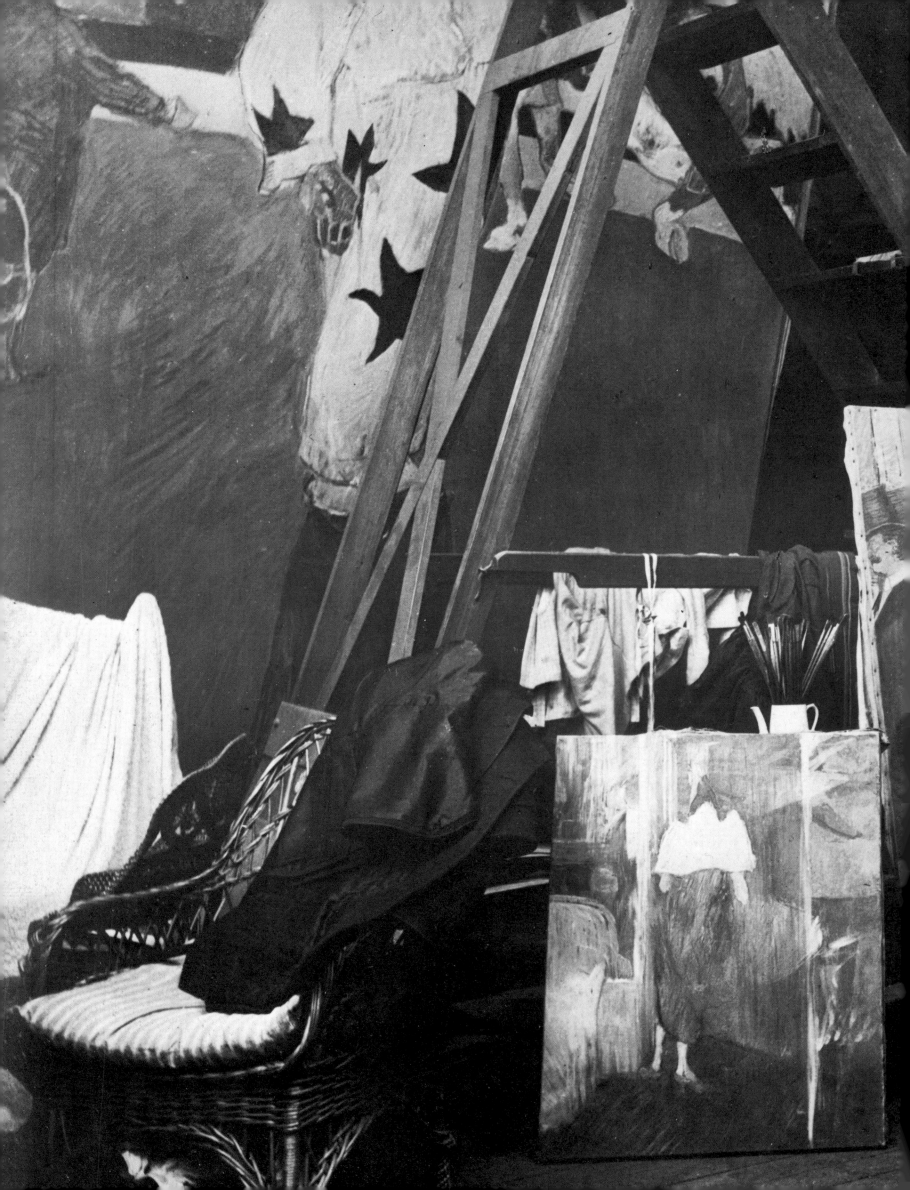

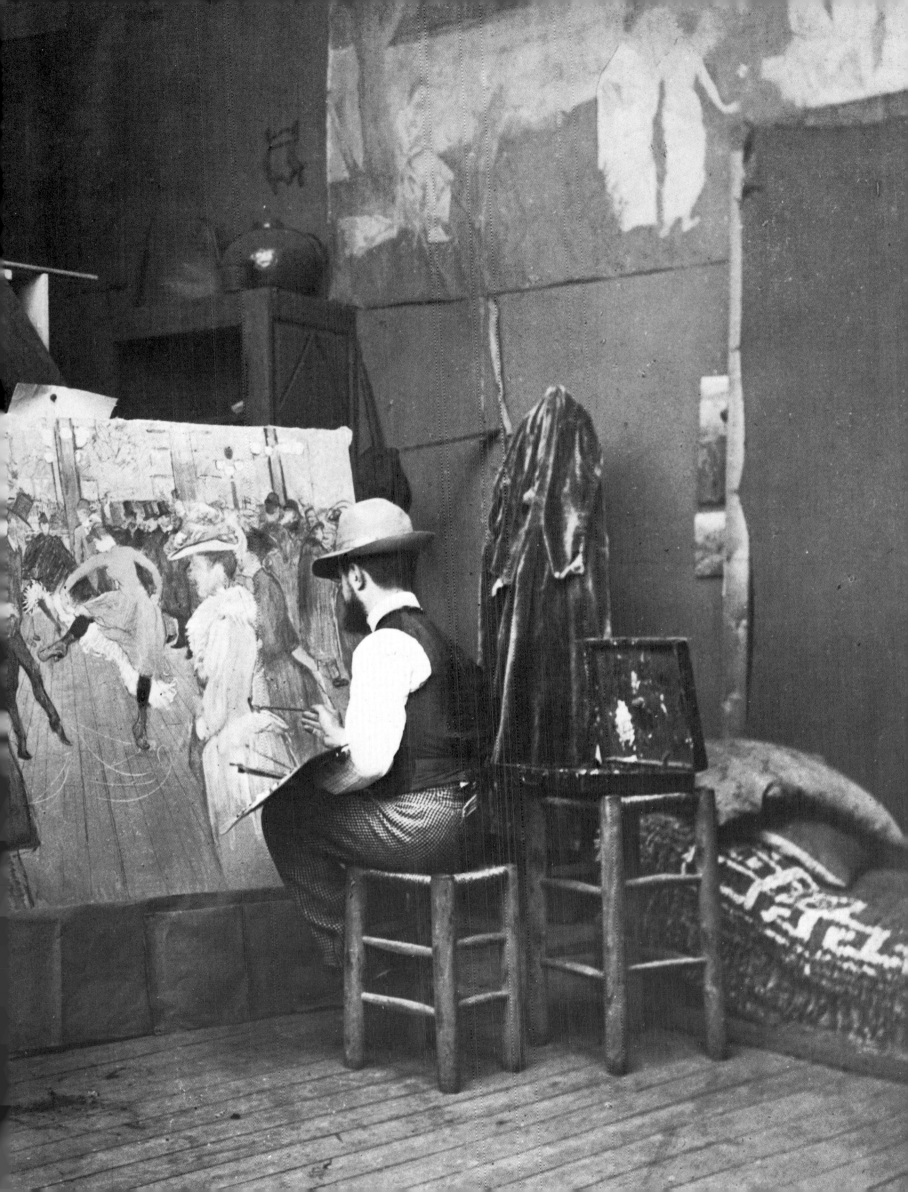

Hôtel du Bosc and
Cathedral, Albi, *c.* 1864

Archiepiscopal Palace and
Cathedral, Albi, *c.* 1864

1864

Henri Marie Raymond de Toulouse-Lautrec-Monfa was born early in the morning of 24 November 1864 in the southern French city of Albi, the son of Count Alphonse Charles Jean Marie (1838–1913) and his cousin Countess Adèle Zoë Marie Marquette *née* Tapié de Céleyran (1841–1930). His birthplace was the battlemented Hôtel du Bosc, situated between the town ramparts and the former 14 Rue de l'Ecole Mage. The mansion belonged to his grandmothers' family, d'Imbert du Bosc, and was later transferred to the possession of his parents. He was christened Henri after the Comte de Chambord, who was regarded by Henri's father as the only legitimate Bourbon pretender to the throne; and as the first-born son, he was given the name Raymond, which had been borne by so many of his illustrious ancestors.

Apart from the Hôtel du Bosc in Albi, the country seat at Céleyran in the region of Narbonne, and the smaller estate of Monfa near Castres, the family's main residence was the Château du Bosc, not far from Albi, high above the Viaur valley, and home of the Count's father, Raymond Casimir, the legendary 'Black Prince'. Protected by his mother and his two grandmothers – who were sisters from the d'Imbert du Bosc family – Henri grew up in the bosom of an extended family. Life was governed by the rhythm of the hunt, by horses and hounds, whippers-in, weapons and equipages. The rest of the time was spent drawing, painting in watercolours or modelling. Alphonse and his brothers Charles and Odon were very passable amateur artists, who could produce skilful scenes of horses and hunting.

1867–1868

On 28 August 1867 Henri's brother Richard Constantine was born. On 27 August 1868 his brother died; in the same year his parents separated.

1872

In order to ensure that her eight-year-old son would receive a suitable education, the Countess moved with him to Paris in 1872, once the political situation had relaxed after the disturbances of the Commune. They rented one floor of the Hôtel Pérey at 5 Cité du Retiro, in the best quarter near the Faubourg Saint-Honoré, with a small studio in the basement. This studio was often occupied by the Count when he stayed in Paris on his way back from hunting. Henri attended the Lycée Fontanes (later Condorcet) at 8 Rue du Havre with Maurice Joyant (1864–1930), later to be his closest friend, adviser, collector of his work, dealer, biographer and executor. Occasionally his father would take him to the Duphot riding school, for a ride along the Allée des Poteaux in the Bois, to the racecourses or to the zoo. Henri admired his father; from his childhood onwards he was familiar with his father's love of animals, his passion for hunting and above all his extravagance, so they seemed to him as natural as he later claimed the excesses of his own way of life to be. But his father was also distinguished by his friendship with artists who were highly regarded at that time. Henri often went with him to visit their neighbour, the deaf and dumb painter and connoisseur of horses, René Princeteau (1839–1914), whose studio at 233 Faubourg Saint-Honoré was part of a small artists' colony. There Henri also got to know Jean Louis Forain (1852–1931), whom the Count often helped out of pressing financial difficulties and whose habitually sarcastic graphic manner Henri admired all his life. He also met successful exhibitors at the Salon, the great annual Paris exhibition forum, such as John Lewis Brown (1829–1890), a genre and hunting painter who had been much esteemed by Napoleon III; Edmond Petitjean (1844–1925); Ulysse Butin (1838–1883), the marine painter; Charles Busson (1822–1908), and Charles Marie du Passage (b. 1843), the animal sculptor. 'Le petit', as Princeteau called him in a fatherly way, was already drawing incessantly – the earliest scenes of hunting and horses date from 1871 – and his experienced mentor did what he could to set this enthusiasm on a solid foundation of craftsmanship.

Comtesse Adèle Zoë de
Toulouse-Lautrec, *c.* 1861

Comte Alphonse de
Toulouse-Lautrec in
medieval fancy dress

Comte Alphonse de
Toulouse-Lautrec in
Scottish dress

Château du Bosc

Avenue de l'Opéra, Paris,
c. 1880

1874

Henri was delighted with life in the
metropolis; he would look at the vast
shops with their alluring display windows,
the carriage parades on the broad avenues,
the dense traffic of equipages, landaus and
cabriolets, the cabs and double-decker
omnibuses, the crowds of pedestrians
passing right in front of the Hôtel Pérey,
and the busy cafés and exclusive
restaurants where he would dine in the
care of his father. 'I think you would have
an awfully good time seeing all the dolls
here dressed in blue, white, pink, etc.,' he
wrote to his cousin Madeleine in Albi on
29 March 1874; 'I'd be glad to pick one
out for you but they cost too much for my
purse. Raoul would enjoy watching all the
thousands of omnibuses and carriages
rolling along, while Gabriel [Tapié de
Céleyran (1869–1930) – later, when a
medical student, he was Lautrec's constant
companion] would prefer the sweet shops'
(Goldschmidt-Schimmel 1969, p. 35
[248]).

There was continual worry about
Henri's slow rate of growth and his state
of health. The doctors advised lengthy

swimming cures, repeated stays in bed and
electric shock treatment on his legs; these
are frequently mentioned in his letters. Yet
the patient was so unconcerned that his
grandmother could write reassuringly to
her daughter on the occasion of a visit to
the Château du Bosc, 'Henri does not
suffer too much from the damp and in
such mild weather he can go out for long
rides with Urbain, the outrider. You don't
know who is the more proud, the teacher
or his pupil. When he cannot go out
riding he spends his time drawing or
doing watercolours under the guidance of
his Uncle Charles. His joyful disposition
means that he remains happy and in good
spirits even when he is alone. He is still too
young to accompany the gentlemen in the
hunt, although he is so bold and skilful
that he would not shy away from
obstacles that are far too difficult for him.
We have no cause to worry about such a
cheerful little fellow' (Huisman-Dortu
1973, p. 15). But it was to prove
otherwise.

1878

In the previous year Henri had grown

Henri with his Uncle Charles (left) and his father (holding a falcon, right), Château du Bosc, *c.* 1876

Henri de Toulouse-Lautrec, 1878

only a little. He was the smallest among the younger cousins, of which there were many on the Tapié side of the family. He often needed a walking stick, and with the onset of the upheavals of puberty, which were soon to pass, the weakness of his constitution could no longer be talked away. Brittleness of bone tissue, probably the result of the close kinship between his parents, eventually led to the failure to heal of two fractures of the femur. Shortly before 22 May 1878 there occurred the first of the serious accidents which were to turn the boy into a cripple. On a visit to his grandmother in Albi he slipped as he was trying to raise himself from a low chair with the help of his stick, and fell so badly that he broke his left femur. Although he was in plaster for weeks, the break mended only gradually. There were high hopes of recovery through cures which lasted several months, at Barèges, Amélie-les-Bains and Nice; but in vain. The doctors waited. To stave off boredom Lautrec drew and painted intensively. Sometimes Princeteau came to the South with the Count to visit his protégé. In the middle of July 1878 he signed a letter from Albi to his grandmother, 'Your crutch-walking godson, Henry de Toulouse'; with self-irony he added in August, '. . . although the personage who had the inopportune idea of breaking his leg

cannot be with you to express his best wishes with his big ugly voice . . . his heart will be with you on the Day of St Louis' (Goldschmidt-Schimmel 1969, p. 46 [251]).

1879
In August 1879 he was at Barèges again. While out walking with his mother he fell a second time and broke his right femur. The futile round of cures began again. He had to spend weeks in bed at Barèges: 'I'm very much alone all day. I read a little but, in the long run, it gives me a headache. I draw and paint as much as I can, indeed, until my hand grows tired with it, and when night begins to fall I hope Jeanne d'Armagnac [a cousin] will come to my bedside. She does so sometimes, and cheers me up by chatting and playing with me. I listen to her talk, without daring to look at her. She is so tall and so beautiful! And I am neither tall nor beautiful' (Perruchot 1960, p. 53).

1880
By the winter of 1880 in Nice, Henri had recovered to the extent that he could move himself along, though with difficulty. But there was a great change. He was no longer the 'Petit Bijou' but an ungainly, mis-shapen figure who was to remain barely five foot tall, with a heavy torso that rested on stiff, fragile, short legs. By the age of fourteen, when he wrote of himself that he was neither tall nor beautiful, he was aware that the fateful accidents had ended for ever his childhood dreams of a life of chivalry, and that there was nothing he could do but face up to the pitiable challenges of his illness.

'As for me,' he wrote on 30 December 1880, 'I'm just fooling around with Saint Palette and the dogs' (Goldschmidt-Schimmel 1969, p. 57 [253]). Drawing and painting were means of asserting himself, and Henri pursued them whenever the opportunity arose – at Albi, in Paris, on holiday at Nice, on the country estate at Céleyran or at the Château du Bosc under the guidance of his Uncle Charles. He tried his hand at all branches; since 1871 he had filled albums, school exercise books and sketchbooks with nearly 2400 studies

in lead pencil, graphite and pen. He sketched small landscape views, depicted the manoeuvres that took place in the district around Céleyran and Le Bosc, and sea views on the Riviera. He painted members of the family and servants, and was always returning to the world of the hunt in which he could only participate as a bystander. Even at this stage his preference for studies of movement and his particular gift for observing the characteristic details of a physiognomy are striking.

1881
Lautrec's talent was fostered as much as possible by Princeteau, who recognized that his protégé had developed in the last few years into a very promising draughtsman. Lautrec returned to Paris early in 1881 to take his *Baccalauréat* (unsuccessfully) in July. The 'baby of the studio' (Coquiot [1923], p. 6) spent too much of his time with the artists in the Rue du Faubourg Saint-Honoré or with his father's friend in the theatres or the Cirque Fernando at 63 Boulevard Rochechouart, where he was enthralled by the perfect training of the performers, the clowns, the skilful equestriennes, the acrobats and the jugglers. His determination to follow the profession of an artist was increasingly taking shape in his mind; it was a career that must have seemed to promise much success in this company of be-medalled Salon heroes, in whose work meticulous truth to detail had triumphed over any powers of invention.

At this time he was interested chiefly in

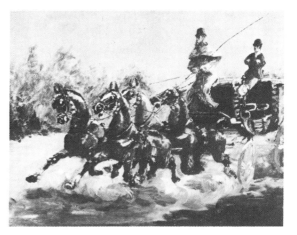

FOUR-IN-HAND AT NICE, 1881, Musée du Petit Palais, Paris (Dortu II, P. 94)

AU CIRQUE FERNANDO. — par HENRIOT.

Magazine illustration in the *Journal Amusant*, 1886

academic artists such as the elegant, fashionable portrait painter Alexandre Cabanel (1823–1889), John Lewis Brown, who was extremely helpful to him, and Jules Bastien-Lepage (1848–1884).

In November 1881, after a second attempt in Toulouse, he ended his schooling. Even his mother gave in to his persistent requests to be allowed to train as a painter. Princeteau and his Uncle Charles were important supporters of this wish, but the Count took no interest in these decisions; he must have realized that his son's handicap ruled out any prospects of his involvement in the only important things in life: riding and hunting. In the circumstances, it seemed to him that this choice of career, although not exactly in keeping with his social status, might be the right one, especially if one considered the success of the Vicomte du Passage as a sculptor, the considerable livelihood Cabanel made from his elegant fashionable portraits, and the honours heaped on Bastien-Lepage and John Lewis Brown at the Salon exhibitions.

1882

In mid-April 1882, on the recommendation of Princeteau and Henri Rachou (1855–1944), an acquaintance from Toulouse, Lautrec obtained a place as a student at the studio of Léon Bonnat (1833–1922), the celebrated 'painter of millionaires'. He took his studies seriously. Every morning he was brought by cab all the way from the luxurious Cité du Retiro to 30 Avenue de Clichy. There Bonnat

Fernand Cormon, CAIN FLEEING WITH HIS FAMILY, 1880, formerly Musée du Luxembourg, Paris

had a studio on the edge of Montmartre, a village which had only quite recently been incorporated into greater Paris and which was just being transformed from rural tranquillity to the El Dorado of rakish international society. Lautrec's determination not to be a failure in everything drove him to emulate as quickly as possible the often coarse tone of his fellow students. He did this so skilfully that the scurrilous presence of this descendant of crusading knights was soon much appreciated.

He worked assiduously on a large number of dry academic nude studies and charcoal drawings after plaster casts, which no longer gave any idea of the lively *élan* of his earlier sketches. He conscientiously used the dark, gallery-toned colours which his teacher particularly recommended to students, warning them against the dangers of Impressionist 'daubs'. Bonnat gave up his atelier that summer and Lautrec hoped, in vain, to be able to continue with him when he took up his new position as Academy Professor at the Ecole des Beaux-Arts; Bonnat thought him too poor a draughtsman!

But Lautrec did not allow himself to become disheartened by this bitter disappointment. He was convinced of his own talent as a draughtsman when he wrote in 1882 from Le Bosc, where the family usually spent the summer, to his father in Paris, 'Bonnat has let all his pupils go. Before making up my mind I wanted to have the consensus of my friends, and by unanimous agreement I have just accepted an easel in the atelier of Cormon [1845–1924], a young and celebrated painter, the one who did the famous CAIN FLEEING WITH HIS FAMILY at the

Luxembourg. A powerful, austere and original talent. Rachou sent a telegram to ask if I would agree to study there along with some of my friends, and I have accepted. Princeteau praised my choice. I would very much have liked to try Carolus [Duran (1838–1917)], but this prince of colour produces only mediocre draughtsmen, which would be fatal to me.' On 1 December 1882 he wrote from Paris to his Uncle Amédée Tapié de Céleyran, 'Cormon gave me a warm welcome. He likes my drawings, particularly . . . the one of Uncle Odon with his hands stuck in his pockets [this is either the charcoal drawing Dortu V, D. 2634 or D. 2665], in other words: hip! hip! hurrah! . . . My new boss is the thinnest man in Paris. He often drops in on us and wants us to have as much fun as we can painting outside the studio' (Goldschmidt-Schimmel 1969, pp. 67, 70 [256 f.]).

Fernand Piestre, called Cormon, who received the Legion of Honour, was much more flexible than Bonnat. A creator of large-scale history paintings with themes extending from the Old Testament, and prehistoric times up to the Merovingians and the Nibelungs, he was nonetheless able, on the whole, to appreciate correctly his students' varying points of view. When he encouraged them to paint outside the studio – which went against his own ambitions – it was by no means common practice among official artists of the time. Cormon rented a studio for a few pupils far from the bustle of the city centre, in the heart of Montmartre at 10 Rue Constance, where he did corrections twice a week. He may have been inspired by the atmosphere of the place, where 'windmills, bars and bowers in a country Elysium, quiet alleyways bordered by thatched cottages, barns and overgrown gardens' (Gérard de Nerval) were still to be found in seclusion, while bold Parisian roués and the first English tourists were beginning to seek amusement on the boulevards. (After summer 1883 his studio was at 104 Boulevard de Clichy.) Lautrec eagerly busied himself with sketches of

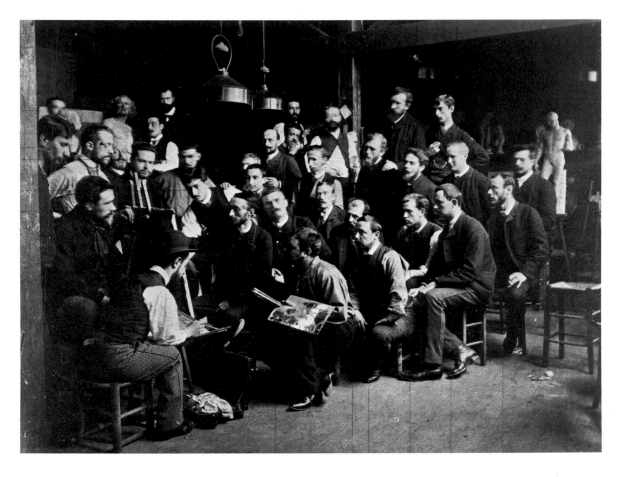

Cormon's studio, Cormon at the easel; Lautrec is seated on the left in the foreground

292

Lautrec's friend GUSTAVE
DENNERY, 1883, Private
Collection (Dortu II,
P. 223)

Léon Bonnat, JOB, 1880,
formerly Musée du
Luxembourg, Paris

Merovingian subjects and studies from flowerpots, and painted allegorical and mythological works such as the two allegories LE PRINTEMPS DE LA VIE (Dortu II, P. 204, P. 205). Indeed, in 1884 he was the only one in the studio who was allowed to help Cormon (for the handsome fee of 500 francs) with his illustrations to Victor Hugo's *La Légende des Siècles*.

1883

Much more far-reaching than Cormon's instruction was the effect on Lautrec of his unfamiliar environment and the friends that he made in his circle of fellow students. Besides Rachou, Adolphe Albert (1865–1928) and René Grenier (1861–1917), a rich dilettante from Toulouse, these included Louis Anquetin (1861–1932) and François Gauzi (1861–1933), and later Emile Bernard (1868–1941) and Vincent van Gogh (1853–1890). These friends were to accompany him for the rest of his life and frequently feature as characters in his pictures. Apparently the budding artist at first felt constricted by all the new impressions he was receiving. He wrote, 'I am leading a Bohemian life and I find it difficult to accustom myself to such a milieu. Indeed, one of the chief reasons why I do not feel at my ease on the Butte Montmartre is that I am hampered by a host of sentimental ties which I must absolutely forget if I want to achieve anything' (Cooper 1955, p. 11).

But increasingly, Montmartre, the world of his friends, gained the upper hand over his familiar refuge in the Cité du Retiro. The stimulating synthesis of village idyll and demi-monde, where depravity went hand in hand with petit-bourgeois contentment, where tarts and their pimps, unrecognized geniuses, wine-growers, ruffians and shopgirls all mixed together so naturally – was it not the ideal place for a cripple who no longer wanted to be spared the harsh realities of life, to immerse himself? Here he could abandon himself without constraint, without even any discrimination, to his imperious youthful desires. He was no longer a coddled invalid but one of a crowd, and his peculiarities were of hardly any consequence.

There was enough time outside lessons to reconnoitre the district with his friends. They would drink a glass of wine in the neighbouring Rue Lepic, where Lautrec rented a studio of his own for a short time; they frequented the cafés in the Boulevard de Clichy, or watched the market for models in the Place Pigalle. Often their

293

paths took them to Anquetin's studio in the Avenue de Clichy or to Rachou's in the Rue Ganneron. Lautrec was always one of the party, and he was indefatigable, for he wished nobody to guess how much he suffered from being 'only a half-bottle', his boyish face disfigured by pince-nez and a repulsively thick lower lip.

1884

In the summer of 1884, in spite of his mother's great misgivings, Lautrec took rented lodgings at the home of René Grenier. Grenier lived with his wife Lili, a former model of Degas's (1834–1917) and of many other famous painters, on the second floor of 19 a Rue Fontaine, very close to the Place Blanche, where the Second Empire's most famous café dance-hall, the Reine Blanche, was soon to give way to the newly built Moulin Rouge.

The wealthy Greniers ran a hospitable house; they were always finding new excuses for holding fancy-dress parties or taking their friends to visit the places of entertainment that had sprung up everywhere. The foremost of these was still Rodolphe Salis's artists' cabaret, the Chat Noir, at 84 Boulevard Rochechouart, which had been one of the first of its kind and caused a sensation even in high society. It was fitted out in Louis XIII style with all sorts of junk and an enormous panel of Pierrots and Colombines by Alfred Willette (1857–1926); it became the favourite bar of writers, poets – and those who regarded themselves as such – from Verlaine to Jean de Moréas and Maurice Donnay. Two houses further along, the Elysée Montmartre was just opening its doors. It was here that professionals danced the Naturalist quadrille, a sort of can-can, under the direction of Valentin le Désossé (1843–1907), a genius at improvisation, with the immobile, worried face of an ageing tax inspector. By day Valentin was known as Etienne Renaudin, a respectable wine merchant, but since before the war he had been celebrated as a leading light in the dance-halls of the area. With 'the little hang-tail' in tow, Lautrec's friends would sometimes go down the steep path to the Moulin de la Galette, one of the last of the windmills which had once been so numerous in Montmartre, to watch the laundresses from the suburbs dancing polkas or family quadrilles with their gallants.

Lautrec enjoyed being with people and – at least as a spectator – trying to retain an image of the pulsating rhythm of whirling movements. Between glasses of absinthe or mulled wine with cinnamon and cloves, he impressed the scenes on his memory by noting it all down on small sheets of paper. What else was there for him to do? 'I'd like to go everywhere to get pictorial impressions, but it's terrible to go to bed at 2 o'clock at night, knowing you'll have to get up at 8 by candlelight. And why??? . . . I feel pretty well and have a desire to work. The deuce with everything else. I kiss you, a disillusioned old man, yours, Henri' (Goldschmidt-Schimmel 1969, p. 86 [261]). In these moments, at the age of just twenty, it must have become clear to him how much life had let him down. Not even his mother's affection could save him from moments of depression, especially when he signed his letters sarcastically as her 'unworthy son' or later as 'this

Lautrec with friends in the garden of the Moulin de la Galette

Moulin de la Galette, Rue Lepic, Paris, *c.* 1885

horribly abject being' (Goldschmidt-Schimmel 1969, pp. 90, 117 [262, 268]). Perhaps the girls at 2 Rue de Steinkerque, just round the corner next to the Elysée Montmartre, knew how to cheer him up; there at least he could hope to find a woman who had an even uglier lover.

The year 1884 had begun with the great memorial exhibition for Manet (1832–1883) at the Ecole des Beaux-Arts. Shortly after this, the Salon des Indépendants made its first appearance. Founded on the initiative of Seurat (1859–1891), Signac (1863–1935) and Redon (1840–1916) it was a non-jury organization directed against the official Salon. Meanwhile, various of Cormon's pupils had rebelled against the ideals of academic teaching, the ultimate aim of which was still to gain recognition from the Salon jury. Though he never spoke out directly against his teacher, Lautrec too went his own ways. Cormon's contribution to the Salon this year, the painting RETURNING HOME FROM THE BEAR HUNT, aroused mockery. He had clung too long to accepted trends, ignoring the contemporary search for style.

Lautrec's mother was kept informed about the 'revolution' in the Cormon atelier. 'Cormon has fired the student in charge and plans to appoint another. All this has stirred up more excitement than you can imagine. Rachou is our boss. I think I mentioned that before. No wonder I'm writing nonsense; I haven't been down from Montmartre for five days. I'm painting a woman whose hair is pure gold.' – 'The atelier is up in arms; they want to name a "student in charge". They'd like to give me this tiresome job, but I'm stubbornly refusing. I'm happy that you're satisfied with what I'm doing.' – 'I've just come out of one o'clock mass after having lunch at Lucas's. This has civilized me a little, because these days I hardly ever budge from my heights. I saw Cormon this morning. He rather congratulated me, at the same time making me conscious of my ignorance. Anyway, it bucked me up a little. In a word, we haven't been wasting our time.' – 'Nothing important to report. . . . Studio

Lautrec (in front) with his friends Claudon and Nussez in Oriental fancy dress, *c.* 1884

in the morning with Rachou correcting, and he's not easy, the brute. Afternoons are spent outdoors with Rachou and evenings in the bar, where I wind up my little day.' This last letter is signed, 'Your offspring, darling of the Graces' (Goldschmidt-Schimmel 1969, pp. 79f., 83, 86f. [259ff.]).

He very wisely omitted to mention in the letters that he only sporadically turned up at Cormon's, and that the allegorical-mythological subjects were having to give way to other sources of inspiration and other models. Lautrec was aware of the fact that his new orientation – in every respect – would scarcely be approved of by his family: 'I'd like to talk to you a little about what I'm doing, but it's so special!!!', he wrote in a letter to his grandmother in August 1884 (Goldschmidt-Schimmel 1969, p. 82 [260]).

'As a journalist, and still more as a gallant flâneur', Lautrec described with the sarcastic exuberance of his twenty years various exhibitions held in 1884, including the Salon and the Cercles. 'There is democracy at the Salon. Equality, overcrowding. There is nothing missing; universal suffrage has invaded even those blessed spheres where Cabanel reigns, and the medal of honour will be awarded according to the choice of the majority. Reaction, reaction! cried the young dandies of painting, and they have opened a little church in the Rue de Sèze under the patronage of Monsieur Petit, where one reverently enters in subdued lighting, walking over muffled carpeting, to adore distinction in painting. Last year Messieurs Gérôme, Baudry, Dupré and others put together the pick of the bunch and, appealing to the élite of foreign artists for contributions, they opened a truly international exhibition. Yet this was a real treat, only because it was so tiny. Was it really worth the bother of opening the Petite Salle again and hanging there the monstrous inventions of a group of young people? The only merit of this exhibition lies in the fact that it is as international as its predecessor. Alongside works of real quality, such as LA FORGE by Monsieur

Bastien-Lepage, the portrait and study by Monsieur Boldini and two sculptures by Monsieur Saint-Marceaux, we had to suffer the morbid fantasies of Béraud and the fashionable engravings of Toffano. . . . Monsieur Princeteau seems to have a proper appreciation of the value of the Cercles exhibitions. He hangs up the first sketch that comes to hand, but that does not prevent him from ensuring a prominent and honourable position for his own works. . . . Place Vendôme, opposite the column, the Mirliton! What confusion! Lots of people, lots of women, lots of foolishness! It is a crowd of gloved hands adjusting their tortoiseshell or gold pince-nez, but it is still a crowd. These are the observations I have gathered in the midst of so many elbows. First, an exquisite study by Jacquet and a well powdered portrait by the same. Here is a special mention for you, Monsieur Jacquet! An old man by Monsieur Cabanet; another old man by Monsieur Cormon, who makes up for the problematic nature of the pose with the perfection of the hands; a portrait of a young girl by the same painter, which is the last word on the understanding of anaemia, the eyes a sparkling reddish-brown, the skin a little floury; everything is rendered with a sincerity which should serve as a lesson to many, and to the best of us' (Joyant 1926, pp. 62 ff.).

Lautrec was by now fully aware that he could no longer take academic painters like Bonnat and Cormon as his models, but only those artists who were able to depict contemporary themes, such as Pissarro (1830–1903), whose brushwork he imitated; Renoir (1841–1919), whose colours he enormously admired; Raffaëlli (1850–1924), whose technique of applying thinned oils on an unprimed ground influenced him; and Forain, whom he had known since childhood. Above all these he placed Edgar Degas, whom he admired more than anyone. From 1879 to 1886 Degas had a studio very close to the Greniers, in the back rooms of 19 Rue Fontaine, but Lautrec dared not even speak to the unapproachable artist, let alone visit his studio.

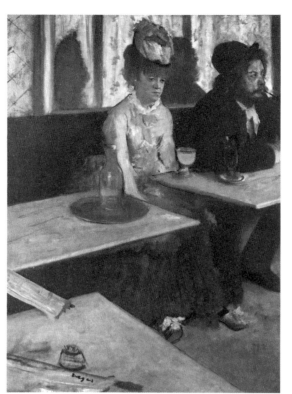

Edgar Degas, L'ABSINTHE, 1876, Musée d'Orsay, Paris

1885

In a letter written in the spring of 1885 Lautrec expressed his lack of interest in landscape painting: 'I'm not giving in to Grenier and Anquetin, who are taking turns at trying to drag me off to the country, for I know only too well, I'd never get anything done there'

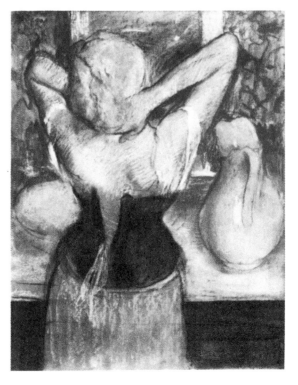

Edgar Degas, WOMAN IN FRONT OF A MIRROR, c. 1883, Private Collection, London

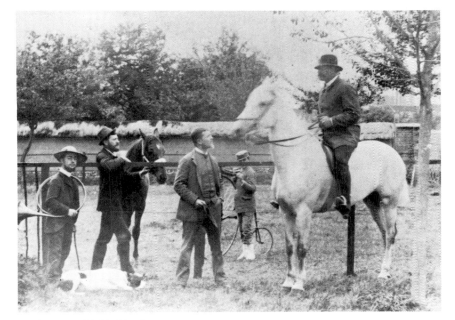

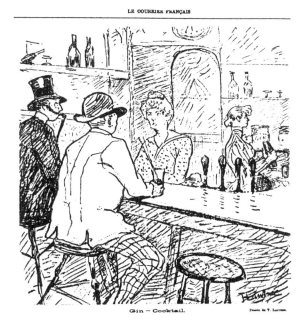

Lautrec with his friends
Louis Anquetin and René
Grenier on an excursion,
*c.*1885

Magazine illustration in *Le
Courrier Français*, 26
September 1886

(Goldschmidt-Schimmel 1969, p. 92
[262]).

Eventually he let himself be persuaded
into spending some time with his friends
at Villiers-sur-Morin near Paris, where the
Greniers had a small house. While the
others dealt with motifs from the
surrounding countryside, Lautrec painted
four murals in Ancelin's hotel (Dortu II,

P. 239–P. 242). These are strongly
influenced by Degas, though an individual
style is already apparent. Here, for the first
time, he showed his preference for the
behind-the-scenes view.

The world of Montmartre provided an
increasing amount of material for his
pictures, in which the symbolic figures of
the Salon – the heroes, geniuses and witty
courtesans – appeared as outcasts, ham
actors, ballad singers and street-walkers.

Lautrec was always on the look-out for
new motifs. He wrote to his mother in
autumn 1885, 'Paris is dark and muddy,
but that doesn't stop me trotting in the
streets after the musicians of the Opéra,
whom I'm trying to charm, so as to sneak
into the temple of the arts and of
boredom. Which is not at all easy.'
(Goldschmidt-Schimmel 1969, p. 95 [263])
This search for motifs continued in the
evenings at Aristide Bruant's (1851–1925)
cabaret, Le Mirliton, which had opened in
June 1885 at the former premises of the
Chat Noir, near the Elysée Montmartre,
84 Boulevard Rochechouart. There
Lautrec soon became a friend of the
proprietor, who was remarkable for his
theatrical familiarity; dressed in a bright
red shirt, a scarf of the same colour
'wound with regal contempt around his
neck' (Tucholsky 1926, p. 82), a black
velvet suit, top boots, a dark cycling cape
and a broad-brimmed floppy hat, he

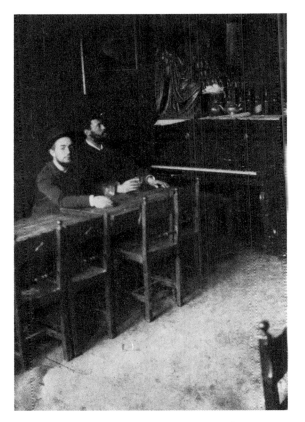

Lautrec with Louis
Anquetin at Le Mirliton,
*c.*1886

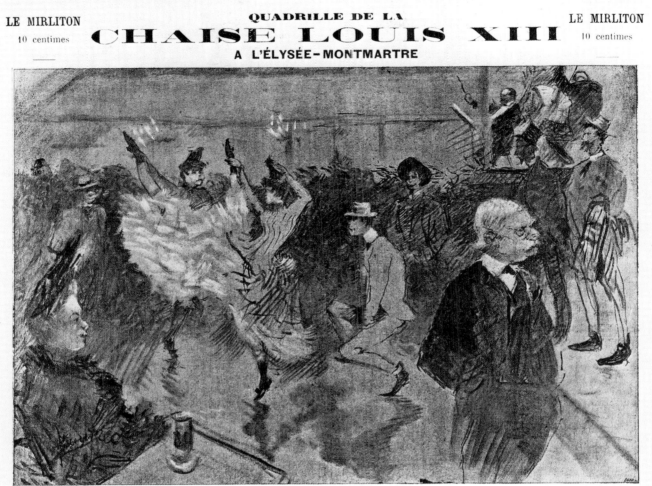

LE MIRLITON
10 centimes

QUADRILLE DE LA
CHAISE LOUIS XIII
A L'ÉLYSÉE-MONTMARTRE

LE MIRLITON
10 centimes

D'APRES LE PANNEAU DE **LAUTREC**
Exposé au Cabaret du **MIRLITON**, 84, boulevard Rochechouart

Magazine illustration in *Le Mirliton*, 29 December 1886

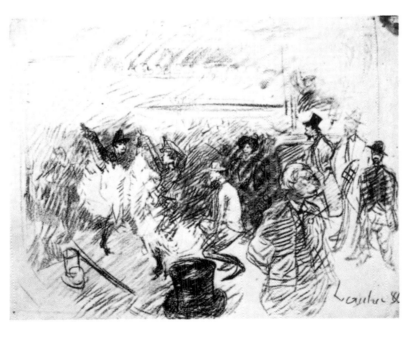

QUADRILLE DE LA CHAISE LOUIS XIII AT THE ELYSÉE MONTMARTRE, 1886, Musée Toulouse–Lautrec, Albi (Dortu V, D. 2973)

Copy attributed to Lautrec, National-Galerie, Berlin (Eas:)

created a sensation by hurling insults at the audience in the tradition of Salis. This former office boy with his aura of vigour and his assumed manner of a wily peasant, who sang of the pariahs, the cheap hotels and pimps of Montmartre, seemed to be made for Lautrec's admiration. Bruant's argot-riddled songs were on everyone's lips.

1886

In the spring of 1886 Vincent van Gogh came to Cormon's studio on the recommendation of his brother Theo van Gogh (1857–1891), who worked for Goupil, the art dealers. Although older than the others, he soon struck up a friendship with Lautrec based on their common sense of being outsiders. When Cormon temporarily discontinued his teaching in the autumn of this year, Lautrec was forced to look for a studio of his own. His father had tried in vain to get his son to come down from Montmartre: 'Papa has spoken to me again about a studio near the Arc de Triomphe and I have explained to him clearly that that would never be anything but a salon. Perhaps he'll take it and leave me mine' (Goldschmidt-Schimmel 1969, p. 98 [264]).

Through Gauzi and Federigo Zandomeneghi (1841–1938), a Venetian artist, Lautrec found a spacious studio on the fourth floor of 27 Rue Caulaincourt, on the corner of 7 Rue Tournaque, which he used until 1897. There, the Italian lived next door to Marie-Clémentine Valade (1867–1938), who was later to call herself Suzanne Valadon. Suzanne had been discovered by Puvis de Chavannes (1824–1898) when she was barely twenty, and since 1883 she had inspired many of Renoir's paintings; she also sat for Lautrec. She had moved to this house after the birth of her son Maurice (1883–1955) – whose acknowledged father was the Spaniard Utrillo – following Degas's advice to take up an artistic career herself.

1888

Lautrec's first successes occurred in 1888. The Société des XX (Les Vingt), based in

Magazine illustration in *Le Courrier Français*, 21 April 1889 (Suzanne Valadon as drinker)

Brussels and founded by James Ensor (1860–1949) and Theo van Rysselberghe (1862–1926) among others, invited Lautrec to take part in their fifth annual exhibition. The Belgian lawyer Octave Maus (1856–1919), secretary of the Society, showed great sensitivity in finding unknown or controversial talented artists for these exhibitions, which continued until 1894 – among them, Rodin (1840–1917), Monet (1840–1926) and Renoir, Redon, Seurat, Van Gogh, Sisley (1839–1899) and Cézanne (1839–1906). Rysselberghe, whose attention had probably been drawn to Lautrec by Theo van Gogh, visited Lautrec's studio in autumn 1887 and wrote appreciatively to Maus, 'The little, short-legged fellow is not at all bad. The lad has talent! Definitely for the XX. Has never exhibited. At the moment is doing some very amusing things: Cirque Fernando, whores and all that. Knows a lot of people. In a word, the right sort! He found the idea of being represented at the XX by a few [brothel] scenes of the Rue de Sèze and Rue Laffitte very chic' (Octave Maus, *Trente Années de Lutte pour l'Art*, Brussels, 1926, pp. 64 f.). In January Lautrec thanked Rysselberghe for this first opportunity to take part in an internationally important exhibition: 'I am writing to thank you for the invitation, which obviously I owe more to your recommendation than to my personal merit. I've made some overtures to Forain, who will very probably send

Fancy-dress ball of *Le Courrier Français*. Lautrec as a choirboy (left), seated in the background, Lili and René Grenier (photograph by Gauzi), 1889

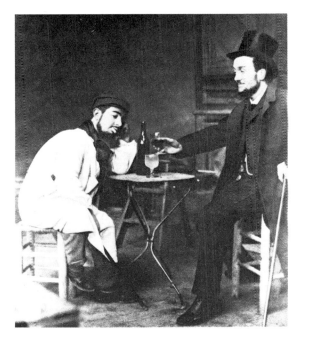

Lautrec with Lucien Métivet in the studio, *c*. 1888

something, and I hope he will, for his works are a real treat'; he went on to ask Rysselberghe also to invite Adolphe Albert, who was very interested in taking part in the Brussels show (Goldschmidt-Schimmel 1969, p. 107 [266]). Together with Signac, Ensor, Whistler (1834–1903) and Forain, Lautrec then went to Brussels, where he was to exhibit five times in all, with eleven paintings mostly done in 1887. The reaction of the public and press was favourable and, as he reported in a letter home, everything seemed to be going very well: 'The sky is unsettled and is sprinkling us with an unconcern that proves how little feeling the Eternal Father has with regard to outdoor painters. Other than that, business is all right. I'm going to

exhibit in Belgium in February, and two avant-garde Belgian painters who came to see me were charming and lavish with, alas, unmerited praise. Besides, I have sales in prospect, though I mustn't count my chickens before they are hatched. I am feeling wonderfully well. . . . Gaudeamus' (Goldschmidt-Schimmel 1969, p. 106 [266]).

But appearances were deceptive. His irregular lifestyle, his lack of sleep, his ever-increasing alcohol consumption and his reckless consorting with street prostitutes were not exactly beneficial to Lautrec's constitution. The warnings of his friends, particularly Adolphe Albert and Henri Bourges the medical student (with whom he had shared lodgings since March 1887 at 19 Rue Fontaine, and after January 1891 at 21 Rue Fontaine), were in vain; his desolately casual response was 'one has to know how to put up with oneself' (Joyant 1926, p. 12). Understandably, he let his family believe that he was leading the hard-working life of an artist at the start of his career. 'I shall see Papa tomorrow, and haven't seen him at all for several days, leading the life of a recluse as I do, and in the evenings only going out just enough to get a little exercise' (Goldschmidt-Schimmel 1969, p. 111 [267]).

1889

On 5 October 1889 the Moulin Rouge was opened with great pomp by an expert in the field of entertainment called Joseph Oller. This 'rendez-vous du high-life' was intended to eclipse all its predecessors. The entrance was crowned by a red, artificial windmill designed by Willette; it was quite an eyecatcher between the rows of houses at 90 Boulevard de Clichy. The enormous dance-hall followed the latest ideas, with an orchestra podium, galleries and mirrored walls. The scene was illuminated by gas chandeliers which shone as bright as day. In a patch of garden at the back one could sit in the open air in front of sales booths, a pavilion and a mighty model of an elephant which had been taken from the Exposition Universelle. Charles Zidler, Oller's partner, was responsible for the dance

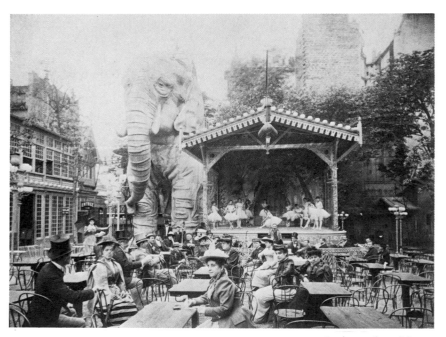

In the garden of the Moulin Rouge, c. 1890

performances. He did his best to lure a number of artists away from their previous engagements, including the stars of the quadrille, Louise Weber, called La Goulue (1870–1929), Môme Fromage, Grille d'Egoût, the slender Nana-la-Sauterelle, ('The grasshopper') La Torpille ('The electric ray') and the red-haired Rayon d'Or. The most famous poster designer of the time, Jules Chéret (1836–1932), was chosen to advertise the Bal au Moulin Rouge with a lively coloured poster.

The impresario's calculations paid off. Anyone who was anyone, or who thought they were – from the Prince of Wales (1841–1910) to roués from the provinces promising themselves a quick adventure – poured in, drawn by curiosity for this new attraction. In the midst of all the trumpery splendour, above the noisy throng in the entrance hall, hung Lautrec's large circus picture AU CIRQUE FERNANDO, L'ECUYÈRE, resplendent against a purple background. Oller had reserved the painting so as to present to a wider public the artist who was already well known in the right Montmartre circles (Ill. p. 305).

For Lautrec, everything now revolved around the Moulin Rouge. Scarcely an evening passed when he did not stop off for some time at the Moulin Rouge on his way home across the Place Blanche from his studio to the Rue Fontaine. At a table

Moulin Rouge, Place
Blanche, Paris, *c.* 1890

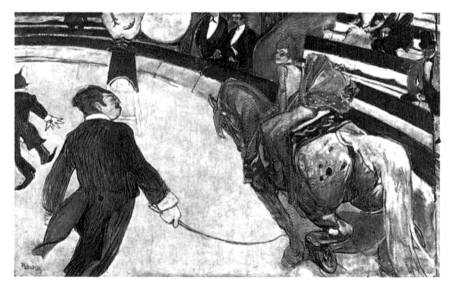

AT THE CIRQUE
FERNANDO, 1888, Art
Institute of Chicago
(Dortu II, P. 312)

305

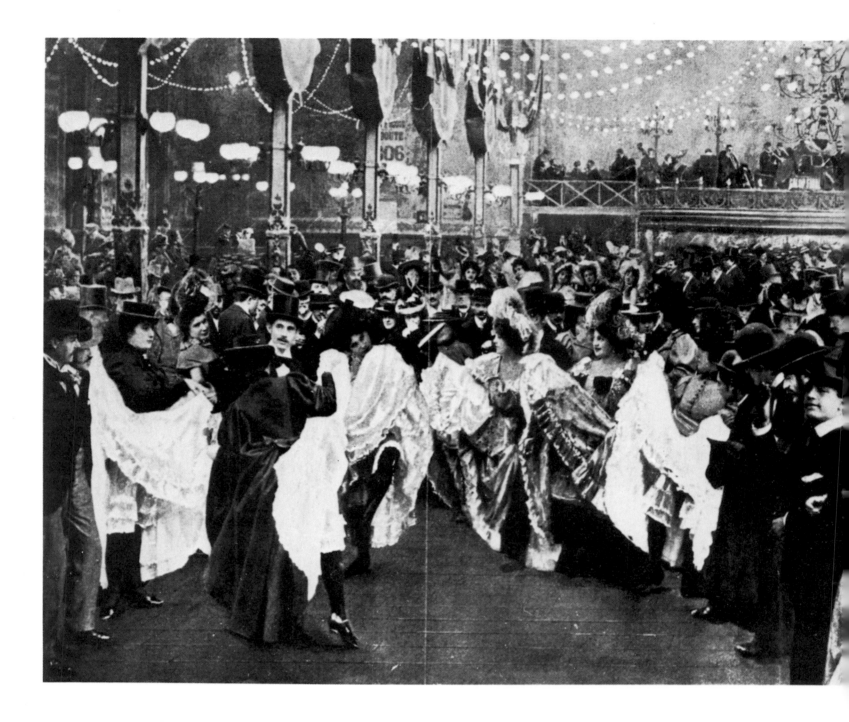

kept especially for him he met old and new acquaintances, who were his equals – at least as regards their thirst. Nevertheless he was still working hard. One of the first results of the new impressions he received there was a dance scene of 1890 with Valentin and an unknown female partner, AU MOULIN ROUGE, LA DANSE (Ill. pp. 282f., Dortu II, P. 361).

The *Guide de Plaisirs à Paris* (1898) provided the following description of the Moulin Rouge: 'The first sight is by no means commonplace: high, enormously vast, it looks like a railway station that has by some miracle been transformed into a dance-hall. The orchestra, big enough for a circus, plays for a battalion of dancing girls who leap around with their skirts lifted up and their legs bare. In the intervals between dance numbers, men and women stroll to and fro, brushing against one another, forming whirlpools in the stream of people, and all this below a confusion of hats of all sorts; the women have huge feathered creations on their heads, while the men wear high silk top

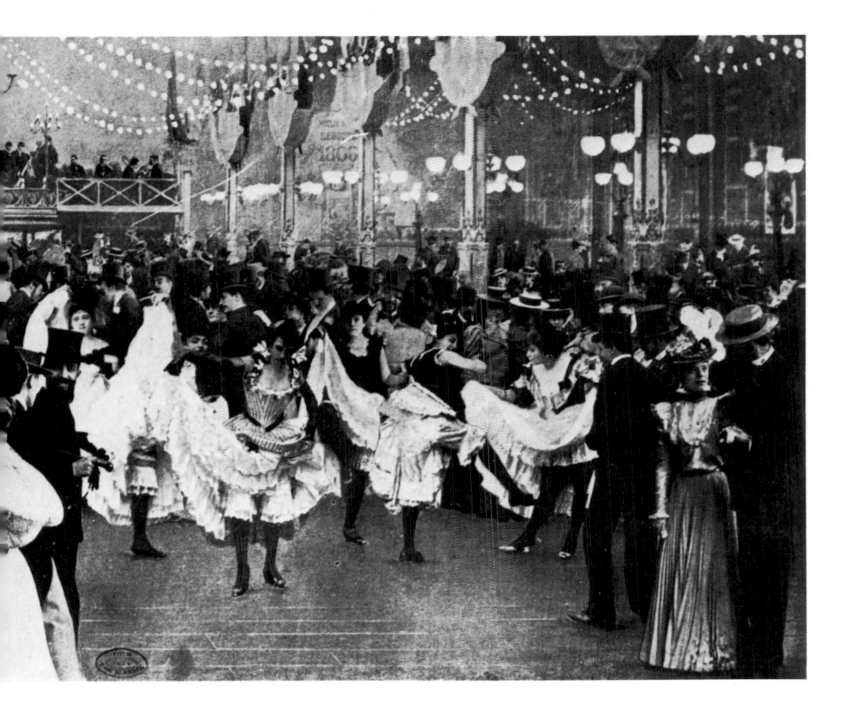

Dancing at the Moulin
Rouge, c. 1890

hats, bowler hats, felt hats and sometimes even flat caps. Smart bodices in cherry red, yellow, white and blue satin with skirts in all colours, are a feast for the eye and entrance the spectator. The odour of tobacco and rice powder envelops the visitor. Seated at little tables to the left are the "petites dames" who are always thirsty and will order themselves a drink in the hope that someone will come along and pay for it. If that happens their gratitude is so overwhelming that they will offer you their whole heart, provided you are

prepared to pay the price for it. Running along every side of the room is a raised, broad, open gallery from which one can observe the dancers at leisure and enjoy the view of all the women strolling through this great marketplace of love, putting themselves on display in all their finery. To the left of the entrance is the garden; around the orchestra podium in the middle one can see a host of young girls who are there to demonstrate the heavenly Parisian Chahut dance as its traditional reputation demands, for which

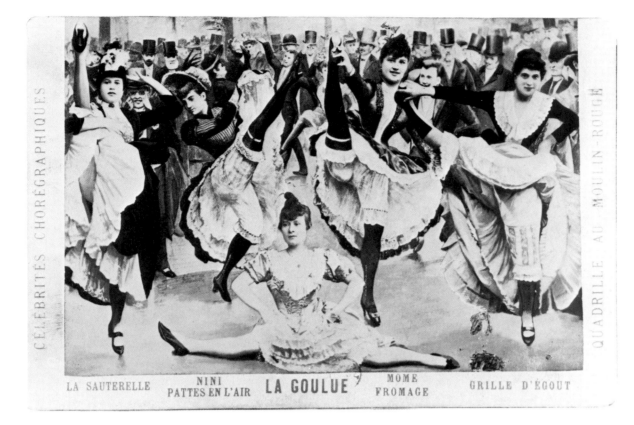

CÉLÉBRITÉS CHORÉGRAPHIQUES

QUADRILLE AU MOULIN-ROUGE

LA SAUTERELLE NINI PATTES EN L'AIR **LA GOULUE** MOME FROMAGE GRILLE D'ÉGOUT

The star dancers at the Moulin Rouge

La Goulue and Valentin le Désossé (?)

they too are paid. People come from all over the world just to experience and enjoy the beguiling splendour of this huge spectacle. A few English families are shocked by the sight of these women dancing alone – without male partners – and with a physical elasticity as they do the splits, which promises just as much flexibility in their morals. Through the lace trimmings of their underclothes and the transparent material of their stockings one can often see a little patch of rosy or white skin, a taster, as it were, displayed by these sellers of love . . .'

1891

In the summer of 1891 Lautrec received from Zidler the commission to design a poster for the beginning of the autumn season at the Moulin Rouge. This was his first involvement in the medium of original graphics. He had come to it relatively late as an artist, but, at least as regards poster design, it now began to ensure his public fame. He at last had an opportunity to work in a field that must

have long attracted him, and to compete in the same area of subject matter with Jules Chéret, the established master of the *fresques du trottoir* (Arsène Alexandre). It was through Chéret that posters began their triumphal conquest of Paris in the 1870s, when the use of mechanical presses could guarantee that they were printed cheaply and in large numbers. Chéret was a skilled lithographer, the inventor of the coloured poster drawn directly onto the stone, with a preference for a large scale; he used a very bold individual graphic style with a colour scheme of yellow, red and blue, that was easy to handle. Pictorial posters now replaced the textual posters that had long been usual, and with the erection of enormous hoardings made necessary by Haussmann's (1809–1891) improvements, they became fixed points in the urban topography. Chéret's designs were unsurpassed for sheer numbers – almost 1200 in all. They had common-place but always pleasing motifs, which were placed obliquely, following standard rules of composition. In 1889 and 1890 retrospective exhibitions of Chéret's work

308

A. BLOCK À PARIS 1892

were held in Paris. Lautrec, who made no secret of his admiration for Chéret and dedicated several lithographs to him, would not have missed these.

Here, then, was a field which promised success and Lautrec took advantage of the opportunity offered to him. He certainly needed courage to compete with Chéret's posters with their impudent, eye-catching colours and their roots in the traditions of the eighteenth century; and this could only be done by using a quite different concept, to make the uncompromising leap straight from the eighteenth to the twentieth century. Lautrec was not prepared to make any concessions to the wishes of patrons, dealers or publishers. With his considerable fund of skill as a draughtsman, he was apparently able to create his first magnificent poster MOULIN ROUGE, LA GOULUE (Ill. right) without very great difficulty.

As soon as passers-by all over Paris were confronted with the unusually large coloured lithograph, its creator became famous overnight throughout the city. This success seems to have contributed to an understanding of his other works. After the opening of an exhibition of works by Lautrec, Anquetin, Bernard and others at the gallery made available to young artists by the dealer Le Barc de Boutteville, he wrote with some satisfaction to Albi on 26 December: 'We've just opened a shop, a sort of permanent exhibition, in the Rue Le Peletier. The newspapers have been very kind to your offspring. I'm sending you a clipping written in honey ground in incense. My poster has been a success on the walls, despite some mistakes by the printer which spoiled my product a little' (Goldschmidt-Schimmel 1969, p. 138 [274]). And on the 25 January he wrote, 'I've just come back from the opening of the Cercle exhibition [Lautrec took part in the group exhibitions of the Cercle Artistique et Littéraire in the Rue Volney in 1889, 1891 and 1892], where my daubs, although hung about as badly as possible, have had a favourable mention in the press. Besides this, they're being very nice to me in the newspapers since my poster. The "Paris", a very Republican paper

Lautrec with Charles Zidler (?) in front of Jules Chéret's Moulin Rouge poster, *c.* 1891

(don't breathe a word to the family) has even seen fit to devote two columns to me, in which they describe me down to the last detail [the article by Arsène Alexandre appeared on 8 January 1892]. I am leaving for Brussels on 3rd February and will be back on the 7th or 8th at the

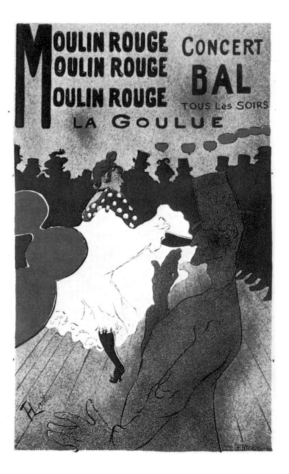

MOULIN ROUGE, LA GOULUE, poster, 1891

310

The star dancers at the
Moulin Rouge

latest' (Goldschmidt-Schimmel 1969, p. 139 [274]).

Lautrec was now regularly represented by his latest works not only at Les XX in Brussels, but also at the Salon des Indépendants and at the Cercle Volney. Important critics began to take an interest in him; they gave favourable reviews, and some, like Roger-Marx (1859–1913), Gustave Geffroy (1855–1926) or Octave Mirbeau, became committed supporters. This sudden recognition encouraged Lautrec to do further work in the field of printed graphics. In the ten years that remained to him he produced a total of 351 lithographs and nine dry-point engravings which are among the most important ever created in this field.

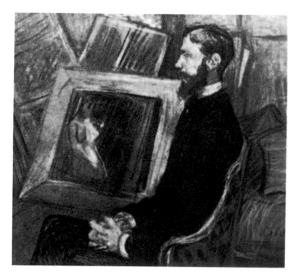

The poet GEORGES-HENRI MANUEL, 1891, Private Collection (Dortu II, P. 378)

1893

The year began promisingly. His old friend Maurice Joyant, a director of the Galerie Boussod, Valadon et Cie., organized Lautrec's first representative exhibition with almost thirty paintings and lithographs. At Lautrec's request, the engraver Charles Maurin (1856–1914) was invited to be a co-exhibitor. This experienced technician, to whom Lautrec owed something, was particularly recommended by Degas to a collector: 'Buy Maurins! Lautrec has a great deal of talent, but he's merely a painter of the period; he will be the Gavarni [1804–1866] of his time. As far as I'm concerned there are only two painters that count, Ingres [1780–1867] and Maurin' (Perruchot 1960, p. 167). The press reaction, however, was more far-sighted. In *La Rapide* of 13 February 1893 Roger-Marx reported that it was a long time since he had come across such a talented artist, and on 15 February in the liberal newspaper *La Justice*, edited by Georges Clemenceau (1841–1929), Geffroy declared that Lautrec's posters for Bruant, La Goulue and, most recently, for the Divan Japonais had conquered the streets with incontrovertible authority (Joyant 1927, p. 22). Even the *Père Peinard*, which had anarchist leanings, was enthusiastic about the first posters on 30 April: 'Confound it all, he is impudent, this

Lautrec. He doesn't mess around in either his drawing or his colour. White, black, red in big patches and simplified shapes; that is his style. There is nobody like him for depicting the mugs of decrepit capitalists sitting at tables in the company of whores, who lick their snouts to make them randy. LA GOULUE, REINE DE JOIE, the DIVAN JAPONAIS and two for a bar-owner called Bruant, that is all Lautrec has done in the way of posters – but they brim over with impudence, willpower and malice, and those who want to eat only

AT THE NOUVEAU CIRQUE, THE FEMALE CLOWN CHA-U-KAO, 1892–1893, Museum of Art, Philadelphia (Dortu II, P. 406)

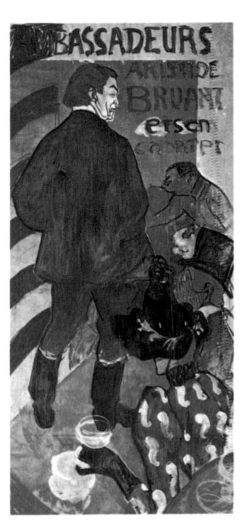

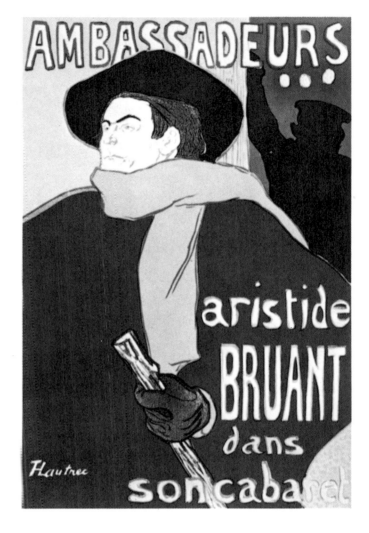

marshmallows stand there quite flabbergasted' (Joyant 1927, p. 105). Who, among the innumerable history painters of the nineteenth century, could have managed as successfully as Lautrec to create such a vital, contemporary image of his hero – and he did this in the medium of commercial graphics, a fact which still roused some critical opposition. 'Who will deliver us from the likeness of Aristide Bruant?', complained *La Vie Parisienne*, for instance; 'You can't go anywhere without finding yourself face to face with him. It has been said that M. Bruant is an artist. How can he consent to appear on the walls side by side with the Bec Auer and the Oriflamme? He must suffer from such propinquity . . . And does he really need to have recourse to the vulgar means of advertising used by sellers of bicycles and sewing machines?' (Perruchot 1960, p. 163).

Montmartre's leading figures were gradually leaving the Butte; and Lautrec too found it had lost much of its attraction. From the autumn of 1893 he was to be found much more in the middle of town, where the places of entertainment on the Champs Elysées, in particular the theatres there, claimed his full attention. Romain Coolus (1868–1952), an enthusiastic theatre-goer whom Lautrec had got to know as a member of the editorial staff at the *Revue Blanche*, had no difficulty in introducing him to this new and almost inexhaustible area of research. Now his evenings were spent at the Opéra or the Comédie Française with Molière's *Ecole des Femmes* or Sophocles' *Antigone*. Lautrec hardly ever missed a première at the Théâtre Libre, the avant-garde Théâtre de l'Œuvre or the Théâtre de la Renaissance, where he was able to admire the divine Sarah

Bernhardt (1844–1923).

But it was not only at the theatres that Coolus was his constant companion; they also visited the *maison closes*, brothels which since the statutes of Colbert had been situated in the broad vicinity of the Opéra in the Rue d'Amboise, the Rue Joubert and the Rue des Moulins. The artist would often retire there with a large amount of luggage for days and weeks at a time to recover from the pressure of work. 'They are the only places where people still know how to polish shoes' (Perruchot 1960, p. 181) was all he would say by way of justification.

1894

Until now Lautrec had been living with friends, but he eventually moved for eighteen months to a ground floor

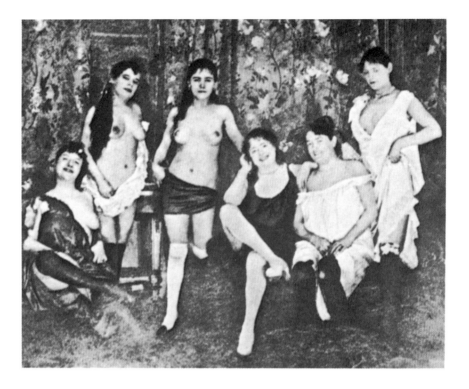

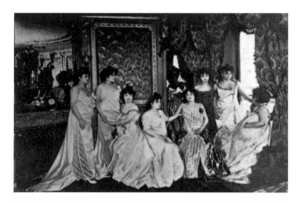

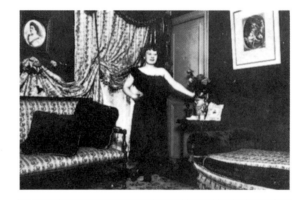

The 'staff' at the Rue des Moulins brothel. Above left, Mireille, the model with her leg bent in the painting In the Salon of the Rue des Moulins (No. 67)

Rooms in the Rue des Moulins brothel (in Moorish, Chinese and Baroque styles)

Rooms in the Rue des Moulins brothel (Gothic torture chamber and entrance)

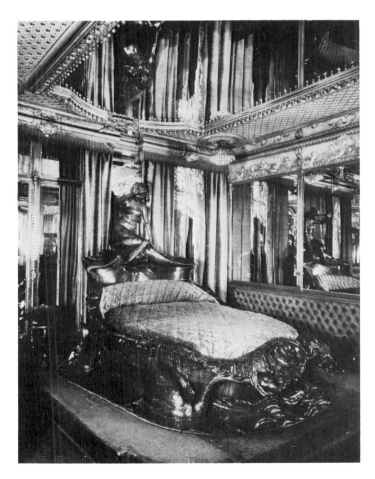

apartment at 27 Rue Caulaincourt. He wrote to his grandmother on 29 December 1893, 'You will be seeing, or have seen, the celebrated Doctor Gabriel [his cousin Gabriel Tapié de Céleyran had gone to study medicine in Paris in 1891], who will have told you about our numerous labours, he bloodthirsty, I a printer. He may have told you, perhaps, that because my friend Bourges is getting married I'm forced to change my apartment, which is not very amusing. But I have found very suitable quarters in the house where my studio is. I shall have the ineffable pleasure of keeping my own household accounts and knowing the exact price of butter' (Goldschmidt-Schimmel 1969, pp. 165 f. [281]).

Once the perils of moving house were over, the artist went to Brussels for the opening exhibition of La Libre Esthétique, the new organization founded by Octave Maus as successor to the Salon des XX. Lautrec took part in its annual exhibitions until 1897. During a meal at the house of Henry van der Velde (1863–1957) he took the opportunity of finding out about the latest developments in interior decoration. His impressions were mixed; in a letter to Joyant he found fault with an aestheticism that extended even to the harmonizing of gastronomic flavours: 'Incredible, isn't it; but basically only the bathrooms, lavatories and nursery, which are painted with white enamel paint, are really successful. As for the rest, it gives one a desire for Menelik's tent with lion skins and ostrich feathers, with naked women, coloured or otherwise, with gold and red, giraffes and elephants' (Joyant 1926, p. 168).

The stay in Brussels was followed by a journey through Holland, from 12 to 20 February, in the company of Anquetin: 'We're travelling, Baedeker in hand, among the wonders of the Dutch masters, which are a mere nothing compared with nature, which is unbelievable. The amount of beer we're drinking is incalculable, and no less incalculable is the kindness of Anquetin, whom I cramp with my small, slow person by keeping him from walking at his own pace, but who

makes believe it doesn't bother him.' – '. . . I have had a fine eight-day lesson with professors Rembrandt [1606–1669], Hals [c. 1580–1666], etc.' (Goldschmidt-Schimmel 1969, pp. 169 f. [282]).

1895
At the beginning of 1895 Lautrec was working on a project that seemed very important to him: 'I have even made my debut in a new rôle, that of stage designer. I have to do the scenery for a play translated from the Hindustani, called *Le Chariot de Terre Cuite* [The Clay Cart]. It's very interesting, but not easy' (Goldschmidt-Schimmel 1969, p. 177 [284]). Unfortunately all that remains of his work for this Sanskrit drama, which opened at the Théâtre de l'Œuvre on 22 January 1895 – apart from one small painted sketch (Dortu III, P. 534) – is the theatre programme and the jacket for the published text.

In spring 1895 La Goulue wrote to the artist, 'Dear friend, I am coming to see you on Monday 8 April at two o'clock in the afternoon. My booth will be in the Trône fair; I am just to the left of the entrance. I've got a very good location, and would be very pleased if you could find time to paint something for me; just tell me where I should buy my canvases and I'll bring them to you in the course of the day' (Joyant 1926, p. 85).

La Goulue's rise to fame had occurred almost ten years earlier; once she left the Moulin Rouge she went rapidly downhill. Her hopes of success as an independent entrepreneuse, performing pseudo-Oriental dances at fairgrounds, were illusory. And even her original idea of asking Lautrec to decorate her booth could not change things. Nevertheless, the artist may have felt flattered when the once-fêted dancer offered him the opportunity of presenting large-scale wall paintings to the public. Unlike his teachers Bonnat and Cormon, he was never commissioned to ornament public buildings with gigantic decorative cycles; he did not belong to the circle of the chosen few – now long forgotten – who were entrusted with this form of

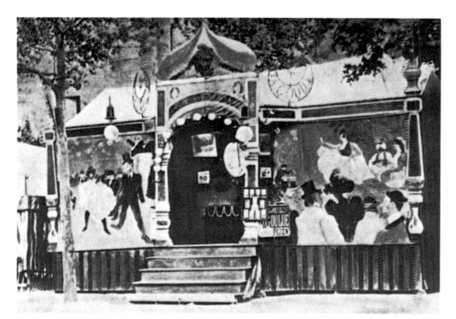

La Goulue's booth in the
Trône fair, Paris, 1895

decorative scheme. His impulse for the
monumental had to be restricted to quasi-
public institutions – the bar at Villiers-sur-
Morin, the sixteen panels which Madame
Blanche d'Eg commissioned from him to
decorate the brothel in the Rue d'Amboise
(Dortu II, P. 442–P. 457), and lastly, the
canvases for La Goulue's fairground
booth. Had not the old Italian masters
painted church banners and did not
Watteau (1684–1721) make the art dealer
Gersaint famous with his shop sign? Why
should not Lautrec also succeed in setting
his particular brand of large-scale history
painting in the open air? He had the
paintings (Dortu III, P. 591, P. 592) ready
punctually at the beginning of June 1895
for the opening of the Trône fair, in what
is now the Place de la Nation. The
brushwork was hasty, with few accents
picked out, intended to create an effect
from a distance. The works decorated the
whole of the display walls to the left and
right of the entrance. The first painting,
with La Goulue and Valentin at the
Moulin Rouge, is related to earlier
compositions (cf. No. 23), but its pendant,
showing La Goulue's Moorish dance,
achieves a thoroughly baroque illusionistic
effect. The viewer of the picture and the
life-size spectators painted in the
foreground together form a single

audience. As so often in Lautrec's work,
his friends appear, at the very front of the
picture, seen from the back, imposing
themselves formally on the passer-by.
From the left are Tinchant, the pianist at
the Chat Noir, Paul Sescau, Maurice
Guibert (1856–1913), Lautrec's cousin
Gabriel Tapié de Céleyran; squeezed in
the middle is the bloated profile of Oscar
Wilde (1854–1900), whom Lautrec had
met fleetingly in London in May 1894 and
then portrayed many times; then, Jane
Avril (1868–1943) wearing a soft monster
of a hat; and finally, the modest figure of
the artist himself, wearing a bowler hat
and his usual striped purple scarf, standing
beside the strikingly dressed figure of Félix
Fénéon (1861–1944), the eloquent
spokesman for the Neo-Impressionists.
This was the last time that this group of
friends were painted together.

In the summer, after yet another change
of address, this time to 30 Rue Fontaine,
Lautrec sailed on *Le Chili* from Le Havre
to Bordeaux with Maurice Guibert.
During the voyage he discovered a fellow
passenger, a young woman in cabin
number 54, who was going to join her
husband, a colonial official in Senegal. He
was so fascinated by her beauty that
despite Guibert's protests he decided at
Bordeaux to continue the journey south.
It was not until they arrived at Lisbon that
Guibert was able to get Lautrec to leave
the ship – he wanted to go all the way to
Dakar. They travelled to Taussat via
Madrid and Toledo, where they visited
the appropriate establishments, as well as
museums and churches, to admire works
by Velázquez (1599–1660), Goya
(1746–1828) and El Greco (1541–1614).
Their journey ended in late summer near
Bordeaux at the Château de Malromé, the
Countess's principal residence which she
had acquired for herself on 20 May 1883.
At the end of the year, using some
photographs taken on board ship, Lautrec
produced the large lithograph LA
PASSAGÈRE DU 54.

1896
Since 1893 Joyant had been working
closely with Michael Manzi (1849–1915),

a specialist in graphic editions, preparing for the second exhibition of Lautrec's paintings and drawings in the newly fitted-out exhibition rooms at 9 Rue Forest. This retrospective went very well indeed, attracting great crowds of visitors and prices far higher than those paid for the works of Cézanne, Van Gogh or Gauguin (1848–1903). An exhibition of lithographs followed on 20 April.

One of Lautrec's major works, the series ELLES, consisting of ten plates with title page and jacket, appeared as a counterpart, in printed form, to the motifs from *maisons closes*, found in the paintings of early 1896. The portfolio was published in an edition of 100 copies by Gustave Pellet (1859–1919), a dealer in art and books, and seems to have closed a particular chapter in the artist's life. He had summed it all up and there was no more to add.

In an attempt to stop Lautrec drinking, Joyant, Geffroy and Edmond de Goncourt asked the artist in 1896 to illustrate Goncourt's novel *La Fille Elisa*. But Goncourt's insights into the milieu of prostitution corresponded so little with the reality that Lautrec had experienced for himself, that he soon lost interest and sketched only sixteen chalk and watercolour studies in Joyant's copy of the novel (Dortu III, A. 237–A. 252). But in a different field Goncourt could have had a great influence on Lautrec. In 1891 he had published *Outamaro, le Peintre des Maisons Vertes*, the first of a projected series on Japanese masters of the woodcut, and shortly afterwards Lautrec had acquired from him the erotic album *Uta-makura (The Pillow Book)* by Utamaro (1753–1806), produced in 1788. It was very probably these Far Eastern pictures of courtesans in the Green Houses of the Yoshiwara quarter of Edo that inspired the artist to create something of a similar kind.

Nothing of what gives the ELLES series its exemplary status corresponded to current bourgeois notions of aesthetic values and charming subject matter. When the portfolios, in their monochrome jackets signed by Lautrec, were displayed at the end of April at the premises of *La Plume*, sales were minimal,

in spite of a positive reaction from the French press. Even a second attempt to promote the work in June 1897, by the art dealer Ambroise Vollard (1865–1939) at his gallery at 41 Rue Laffitte, was almost fruitless, in spite of the relatively low price of 300 francs. Edvard Munch (1863–1944), who after his studies with Bonnat from 1895 to 1897 often stayed in Paris, was one of the few buyers. It was left to a German art historian called Gensel, an assistant at the Berlin Kupferstichkabinett, to put 'the disgust of a healthy popular sensibility' into words in the magazine *Kunst für Alle*: 'There can of course be no talk of admiration for this master of the representation of all that is low and perverse. The only explanation why such filth – there is no milder term for it – as ELLES can be publicly exhibited without an exclamation of indignation being heard, is that one section of the general public does not understand the meaning of this cycle at all and the other is ashamed of admitting that it does understand.'

In August 1896 Lautrec made a second trip to Spain, staying at San Sebastian, Burgos and Madrid. He then travelled via Toledo to Bordeaux and spent the early autumn in Arcachon.

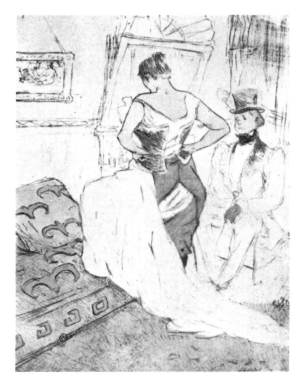

From the ELLES series, A PASSING CONQUEST, 1896

318

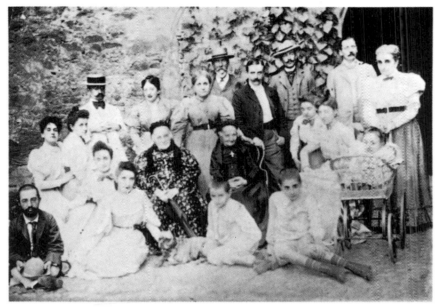

Lautrec in his family circle: in the middle, his mother stands between his two grandmothers, Château du Bosc, 1896

1897

The years between 1892 and 1896 had been a period of intense productivity; now the artist's working ability began to wane. His progress had been the result of an extreme concentration of his creative imagination, and it could not continue when his constitution, worn out over a long period, began to fail him. The ideal places for him to hide this fact from himself were the bars in the Rue Royale: the Weber, where noted literary figures

Rue Royale, Paris, c. 1890

met for an apéritif; the Irish American Bar, where Chocolat the clown from the Nouveau Cirque danced, or the Cosmopolitan American Bar at 4 Rue Scribe, a less exclusive meeting place for English jockeys, stable lads and coachmen, who were indeed no less distinguished than their masters. Realizing his precarious condition, his friends tried everything to keep him away from the world-famous Night or Rainbow cups, gin-whiskies and the barman's other alcoholic refinements. But the more they reproached him, the more touchily he reacted.

Joyant, too, feared for his friend. As a sort of occupational therapy he made Lautrec produce graphics based on his earlier motifs or paintings. Thus, in his more sober moments in 1897, he produced a small series of coloured lithographs that are among the most precious he ever made.

On 11 May Lautrec moved from the studio in the Rue Caulaincourt leaving behind 87 works, which the new tenant either destroyed or gave to his servants, and took an apartment with a small studio at 15 Avenue Frochot, a quiet street with front gardens near the Place Pigalle. He wrote to his mother, 'I've been fooled again by the concierge of the new place, but I have finally found, for 1600 francs, don't tell a soul, an extraordinary apartment, where I hope to end my days in peace. There's a country-sized kitchen, trees and nine windows giving out onto the garden. It's the whole top floor of a little town house next to Mlle Dihau's' (Goldschmidt-Schimmel 1969, p. 191 [287]).

1898

By now Lautrec was hardly capable of working without the euphoria of intoxication. He was rarely sober and when he was, he became extremely irritable and restless. His relatively meagre productivity as a painter and draughtsman bore no comparison with his early years, though he still painted some brilliantly accurate portraits.

On 2 May an exhibition of 78 paintings arranged by Joyant opened in the presence

Lautrec in Maurice
Guibert's garden, *c.* 1898

memory many likenesses of actors he
particularly liked, including such famous
names at Cléo de Mérode (1875–1966),
Sarah Bernhardt and Lucien Guitry (born
1860).

1899

Lautrec's condition was visibly worsening.
Neuroses, outbursts of rage, deep
depressions and hallucinations drained all
his energies. It seems that when the
Countess left her Paris apartment at 9 Rue
de Douai at the beginning of January 1899
to go to look after her mother in Albi, she
was abandoning him to his fate; he was
now in most urgent need of her support.
This may do something to correct the
usual image of her as the self-sacrificing
mother; on the other hand, her action
may be explained by her complete
helplessness and hopelessness when
confronted with her son's self-destructive
behaviour. She received almost daily
reports from Berthe Sarrazin, a servant
who had stayed in Paris, on the progress of
the tragic events: 4 January, 'I told him
that Madame had left [Paris]. He was very
angry. He swore and pounded the floor
with his cane. . . . I went over at eight
o'clock. He was a good deal calmer,
though he keeps saying things that aren't
sensible. . . . He's getting back his memory
a little.' – 11 January, 'Monsieur is still
angry with Madame. He told me this
morning that Madame had left him right
in the middle of work, that he had done
everything to keep Madame but that she
had wanted to go travelling, that her
leaving had upset him and made him sick
. . . but a minute later he had forgotten all
about it. That terrible Calmèse is always
around and never leaves Monsieur.' [The
carriage hirer Edmond Calmèse from 10
Rue Fontaine was one of Lautrec's
drinking companions.] – 17 January (to
Adéline Cromont, Lautrec's old nanny),
'That pig Calmèse, they should put him in
jail. He's going to be the death of poor
Monsieur. . . . I really don't know where
all this will end. My poor Adéline, all
Monsieur's friends blame Madame for
having gone away, for having left her son
in this condition in the hands of strangers.

of the artist at the London branch of the
art dealers Goupil at 5 Regent Street,
where 25 years earlier Vincent van Gogh
had tried unsuccessfully to be a dealer.
Although the Prince of Wales himself
took the opportunity to refresh his
Parisian memories with the help of his
French cousin's paintings, the reviews in
the leading daily papers, *The Daily
Chronicle*, *The Star* and others, were
crushing. On 10 June 1898, for example:
'The art of Monsieur de Toulouse-Lautrec
shows that his only intention is to paint
something that could shock us; the only
idea he has is that of vulgarity. We are not
shocked – only bored!'

However, the London publishers Bliss
and Sands took the risk of publishing on
22 May a portfolio of the new
internationally famous *diseuse* Yvette
Guilbert, in a large edition of 350 copies.
This was intended to coincide with a
London appearance by the artiste in May.
Besides this, Sands also had plans for a
series of actors' portraits. Although
nothing came of this, Lautrec drew from

Lautrec on a picnic, *c.* 1898

Just between us, Adéline, I think they're right. Madame's place is here.' – 18 January, 'If there were some way of stopping him [drinking], if Madame would write. It's true that Monsieur hasn't anyone else. You never see any of his friends any more. There's only Calmèse and Gabrielle [a prostitute], who never leave him. Monsieur is giving everything in his studio, all the knick-knacks, to Calmèse and Gabrielle. . . . Monsieur never comes to the Rue de Douai. He says he'll never set foot there again; when I talk about Madame and say she's going to come back, he says he doesn't want her to return. . . . I don't pay any attention to what he says, but at bottom he's very angry with Madame for not being there. He doesn't work at all any more. . . . All he talks about is money.' – 20 January (to Adéline Cromont), 'As I told you I would, last night, on the way back from posting my letter I went there again. He was at Père François's with Gabrielle and Stern [the lithographer Henri Stern who printed many of Lautrec's lithographs], I wouldn't dare tell you how drunk. This morning I went at 8 o'clock. He wouldn't let me in. The wine-seller's boy told me . . . that he had two women in bed with him, Gabrielle and another one. . . . Everybody is amazed that he can keep up such a life. It would be better if poor Madame doesn't find out about it. Believe me, Adéline, it's an act of charity to keep her in the dark. What can you do? There's nothing to do but wait till he drops, which perhaps will happen before long' (Goldschmidt-Schimmel 1969, pp. 212f., 220, 225ff. [291, 293, 295f., 300]).

After an acute attack of delirium tremens it was decided at the end of February – on the urging of Dr Bourges in particular – that Lautrec should be admitted temporarily to Dr Sémelaigne's lavishly equipped private psychiatric clinic at 16 Avenue de Madrid, Neuilly. The gloating of some newspaper writers was unconcealed; 'Lautrec has been taken to a sanatorium; now that he has been put away, it will be official that these paintings and posters are the work of madness undisguised, stripped of the anonymity it

has worn for so long,' prognosticated Alexandre Hepp in *Le Journal* of 26 March 1899.

This forced denial of freedom hit Lautrec hard. But thanks to a drastic withdrawal cure, the 'prisoner' had already recovered so much by mid-March that on 17th of that month he was asking Joyant for 'lithographic stones, a box of watercolours with sepia, brushes, litho crayons and some good quality Indian ink and paper' (Joyant 1916, p. 216). By the end of April Lautrec could move about relatively freely, meet his printer and take luncheon with his mother at the Rue de Douai as he had done for years. At the beginning of May he wrote to her, 'My workman Stern will come to the Rue de Douai to pick up the studio keys and bring me various things. Have Berthe go along with him. In the state we're in, alas, we can't be too careful. I continue to bear my misfortune patiently. Take care of all my errands and come often. The prisoner. Yours, Henri' (Goldschmidt-Schimmel 1969, p. 203 [290]).

On 17 May 1899 the doctors submitted their final report, concluding that Lautrec's improvement had continued; there had been no further signs of insanity. The symptoms of alcoholic poisoning were now hardly detectable; but because of his insomnia, his restless nature and weak will, it was suggested that Monsieur

Lautrec with Maurice Joyant and Louise Blouet, *c.* 1899

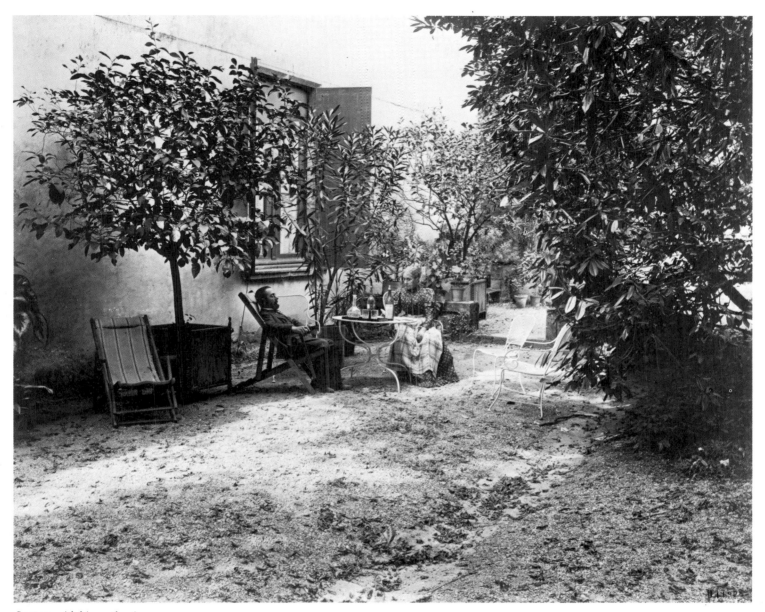

Lautrec with his mother in
the garden of the Château
de Malromé

Henri de Toulouse-Lautrec be provided
with surveillance (Joyant 1926, pp. 220,
222).

Paul Viaud, a distant relation from
Bordeaux and a friend of many years'
standing, was to be his companion, and he
fulfilled this tricky role with a great deal
of tact and sympathy. In June Lautrec
travelled with him from Albi, where he
had arrived with his cousin Louis Pascal on
20 May, to convalesce at Le Crotoy on the
Channel coast. In July they stayed at Le
Havre, in the Star, a sailors' guest house,
where the artist painted the English
performers in all their clumsy originality.
Then the friends sailed via Bordeaux to
Taussat, where they lodged at the Villa

Bagatelle so as to be able to fish, swim and
sail in peace.

In order to get as much fresh air as
possible when he returned to Paris,
Lautrec had himself regularly driven to
the Bois or the racecourses, where he
would examine the equine forms familiar
to him since childhood.

His good intentions regarding his health
and his work lasted for the rest of the year,
but it must have been clear that this was
probably only a short-term postponement
of the final collapse.

1900
The question of whether life has any
meaning when it is simply a matter of

existing, was answered by Lautrec himself. At first in secret and then openly in the presence of the helpless Viaud, he took up his old way of life again, indulging in his old vices with less restraint than ever. Only intoxication could still give him a hint of self-confidence. Listless and embittered as he was, all that mattered to him was to hasten the end. His will to live was broken and he produced work only with difficulty. Within a few months he had become tired of life, an old man who had himself pushed through the Paris Exposition Universelle in a wheelchair when he attended as a member of the jury for the Exposition Centennale et Décennale de la Lithographie.

As soon as the weather was warm again his friends forced him to turn his back on Paris and spend the months from May to September at the less seductive and more healthy seaside towns of Le Crotoy, Le Havre, Honfleur, Bordeaux, Arcachon, Taussat and – in September with his mother – at Malromé.

Lautrec did not follow his usual habit and return to Paris in the autumn of 1900, but decided to spend the winter with Viaud in Bordeaux, where he rented an apartment at 66 Rue de Caudéran and a studio in the Rue Porte-Digeaux.

1901
Not even the positive tone of his New Year's greeting to his grandmother can disguise the fact that Lautrec was at the end of his powers. 'I'm at Bordeaux and wish you a happy New Year. I share your opinion of the fogs of the Gironde, but I'm so busy that I've hardly any time to think about it. I'm working all day long. I'm showing four pictures at the Bordeaux Exhibition and am having some success. I hope that will please you a little. I wish you a prosperous year – and from a ghost like me that counts double – for what my wishes are worth. I kiss you. Your respectful grandson, Henri' (Goldschmidt-Schimmel 1969, p. 207 [290]).

The 'ghost' understood the seriousness of his condition; recovering at the end of March, with the aid of electrotherapy, from a cerebral haemorrhage which had

Lautrec swimming, c. 1899

paralyzed his legs, he explained to Joyant on 2 April 1901 that 'now Bacchus and Venus are barred' (Joyant 1926, p. 236). This forced him back to Paris, where he arrived at the end of April with the works he had completed in Bordeaux, to put his studio in order, complete what had been left unfinished, pick out the less important works and sign what he regarded as the significant ones.

When Lautrec left Paris on 15 July he was never to return. There was little hope that the stays in Arcachon and Taussat could bring about any improvement in his condition. A stroke at Taussat resulted in one side of his body being paralyzed, and he asked to be taken to his mother at Malromé on 20 August. There in the presence of his parents, his cousin Gabriel Tapié de Céleyran and Viaud, he died on 9 September 1901 at the age of 36, the last descendant of the younger line of the Counts of Toulouse-Lautrec-Monfa.

The following day the Count wrote to René Princeteau about the death of his son: 'Your former protégé ... to whom you were so valuable as an example, ... Henri, my son, "the little one", as you used to call him, died last night at 2.15 a.m. I had arrived four or five hours earlier and shall never forget the terrible sight of the kindest soul you could ever have met. ... I saw him though he did not see me, for his wide open eyes could perceive nothing after three or four days of delirium. He was always kind and friendly, never reproached anyone, although he suffered much from his appearance, which made people turn and stare, though usually more in pity than mockery. For him death meant the end of suffering, and we hope for another life where we shall meet again in eternal affection ... where there will surely be no law to separate a father and his descendant, and the attraction of two who truly love each other will not be forbidden and punished in the fruit of the same blood which should never have been allowed to marry' (Julien [1959], pp. 69, 74).

Also on 10 September the following obituary appeared in the *Journal de Paris*, which in large measure does justice to the

325

artist: 'A name, a master who has left us too soon: one of the few who can grip you and make you shudder. His wealthy background gave him freedom from all the hardships of life and he devoted himself to the observation of the world. What he saw is not very flattering to the end of the last century, of which he was the true painter. He sought the reality, disdaining fictions or chimeras which falsify ideas by unbalancing minds. Some people will perhaps say that he was a snooper, a dilettante of rather melancholy originality, to which disposition (characteristic of one who suffers) he naturally felt himself drawn. But this would be mistaken, and all his work proclaims it. He did not overturn reality to discover truth, nor strive to catch something, where there was nothing. He contented himself with looking. He did not see, as many do, what we seem to be, but what we are. Then, with a sureness of hand and a boldness at once sensitive and firm, he revealed us to ourselves. Oh, it was not flattering; there was something in it for all tastes: grand concerts or public balls, theatres, circuses, cafés, racecourses, in fact all those places where the fever of existence drives men and women in search of some kind of pleasure; all these were fixed forever by the artist's pitiless pencil. He was perhaps most attached to a genre in which others before him have tried their hand. Painted faces, provocative underwear, flashing gemstones on fingers and ears, fake jewellery: emblems that speak of unhappy women who hide burning tears behind wan smiles. Toulouse-Lautrec showed us all this. He did not want only to do the work of a painter; he also proved himself to be a profound and powerful psychologist. What he teaches is sad but true. This is why the Master will remain the painter of an age which we do not understand, because, when we were living through it, we were sometimes sceptical and almost always heedless and indifferent.'

Lautrec shortly before his death, Château de Malromé, August 1901

326

BIBLIOGRAPHY

Key to the abbreviated bibliographical references

Adriani 1976: Götz Adriani, *Toulouse-Lautrec. Das gesamte graphische Werk*, Cologne 1976

Adriani 1978: Götz Adriani, *Toulouse-Lautrec und das Paris um 1900*, Cologne 1978

Adriani 1986: Götz Adriani, *Toulouse-Lautrec. Das gesamte graphische Werk, Sammlung Gerstenberg*, Cologne 1986

Alexandre 1902: Arsène Alexandre, 'Le Peintre Toulouse-Lautrec', in: *Le Figaro Illustré*, 145, April 1902

Alexandre 1905: Arsène Alexandre, *Toulouse-Lautrec. Au Cirque, vingt-deux Dessins*, Paris 1905

Alexandre 1914: Arsène Alexandre, 'Exposition Rétrospective de l'œuvre de H. de Toulouse-Lautrec', in: *Les Arts*, 152, August 1914

Alley 1981: Ronald Alley, *Catalogue of the Tate Gallery's Collection of Modern Art other than Work by British Artists*, London 1981

Arnold 1982: Matthias Arnold, *Henri de Toulouse-Lautrec*, Reinbek 1982

Asmodi 1956: Herbert Asmodi, *Toulouse-Lautrec. Moulin Rouge*, Feldafing 1956

Astre (1926): Achille Astre, *H. de Toulouse-Lautrec*, Paris (1926)

Bellet 1951: Louis Charles-Bellet, *Le Musée d'Albi*, Albi 1951

Bernard 1952: Emile Bernard, 'Des Relations d'Emile Bernard avec Toulouse-Lautrec', in: *Art Documents*, 18, March 1952, pp. 13f.

Borgese 1945: Leonardo Borgese, *Toulouse-Lautrec*, Milan 1945

Bouret 1963: Jean Bouret, *Toulouse-Lautrec*, Paris 1963, London 1964

Brook 1923: Alexander Brook, 'Henri de Toulouse-Lautrec', in: *Les Arts*, September 1923

Cabanne 1959: Pierre Cabanne, 'Toulouse-Lautrec', in: *Lecture pour tous*, February 1959

Caproni-Sugana 1977: Giorgio Caproni – G. M. Sugana, *L'Opera completa di Toulouse-Lautrec*, Milan 1977

Cassou 1938: Jean Cassou, 'Toulouse-Lautrec', in: *L'Art et les Artistes*, April 1938, pp. 229ff.

Cat. Musée Toulouse-Lautrec 1973: *Musée Toulouse-Lautrec. Catalogue*, Albi 1973

Cat. Musée Toulouse-Lautrec (1985): *Catalogue Musée Toulouse-Lautrec*, Albi (1985)

Chastel 1966: André Chastel, *Toulouse-Lautrec*, Paris 1966

Cionini-Visani 1968: Maria Cionini-Visani, *Toulouse-Lautrec*, London 1968

Cogniat (1966): Raymond Cogniat, *Lautrec*, Paris (1966)

Colombier 1953: P. du Colombier, *Henri de Toulouse-Lautrec*, Paris 1953

Coolus 1931: Romain Coolus, 'Souvenirs sur Toulouse-Lautrec', in: *L'Amour de l'Art*, April 1931, 4, pp. 134ff.

Cooper 1955: Douglas Cooper, *Henri de Toulouse-Lautrec*, Stuttgart – London 1955 (page refs. to German ed.)

Cooper 1983: Douglas Cooper, *Henri de Toulouse-Lautrec*, New York 1983

Coquiot 1913: Gustave Coquiot, *H. de Toulouse-Lautrec*, Paris 1913

Coquiot 1921: Gustave Coquiot, *Henri de Toulouse-Lautrec ou Quinze Ans de Mœurs Parisiennes, 1885–1900*, Paris 1921

Coquiot (1923): Gustave Coquiot, *Toulouse-Lautrec*, Berlin (1923)

Daulte 1960: François Daulte, 'Plus Vrai que Nature', in: *L'Œil*, 70, October 1960, pp. 49ff.

Delaroche 1948: Marie Delaroche-Vernet-Henraux, *Henri de Toulouse-Lautrec Dessinateur*, Paris 1948

Delteil 1920: Loys Delteil, *Le Peintre-Graveur Illustré X–XI. H. de Toulouse-Lautrec*, Paris 1920

Devoisins 1970: Jean Devoisins, 'Toulouse-Lautrec au Musée d'Albi', in: *Plaisir de France*, Paris 1970

Devoisins 1972: Jean Devoisins, 'Toulouse-Lautrec', in: *Revue Française*, Paris 1972

Devoisins 1980: Jean Devoisins, *L'Univers de Toulouse-Lautrec*, Paris 1980

Dortu 1951: M. G. Dortu, 'Toulouse-Lautrec en Albi', in: *Les Arts*, 322, 10 August 1951

Dortu 1952: M. G. Dortu, *Toulouse-Lautrec*, Paris 1952

Dortu-Grillaert-Adhémar 1955: M. G. Dortu, Madeleine Grillaert, Jean Adhémar, *Toulouse-Lautrec en Belgique*, Paris 1955

Dortu I–VI: M. G. Dortu, *Toulouse-Lautrec et son Œuvre. Catalogue des Peintures, Aquarelles, Monotypes, Reliure, Vitrail, Céramique, Dessins*, I–VI, New York 1971

Dortu-Méric 1975: M. G. Dortu – J. A. Méric, *Toulouse-Lautrec. Le Jeune Routy à Céleyran. Suite Complète de huit Dessins et trois Peintures 1882*, Paris 1975

Dortu-Méric 1979: M. G. Dortu – J. A. Méric, *Toulouse-Laturec. Das Gesamtwerk*, I–II, Frankfurt – 1968

Cognat (1966): Raymond Cogniat, *Lautrec*, Paris (1966)

Berlin – Vienna 1979

Duret 1920: Théodore Duret, *Lautrec*, Paris 1920

Esswein 1912: Hermann Esswein, *Henri de Toulouse-Lautrec*, Munich 1912

Eto (et al) 1973: J. Eto (et al), *Toulouse-Lautrec et Bonnard*, Tokyo 1973

Fermigier 1969: André Fermigier, *Toulouse-Lautrec*, Paris 1969

Focillon 1957: Henri Focillon, *De Callot à Lautrec*, Paris 1957

Focillon 1959: Henri Focillon, *Dessins de Toulouse-Lautrec*, Lausanne 1959

Fosca 1928: François Fosca, *Toulouse-Lautrec*, Les Albums d'Art Druet, Paris 1928

Frankfurter 1951: Alfred Frankfurter, 'Toulouse-Lautrec the Artist', in: *Art News Annual*, XX, 1951

Gassiot-Talabot 1966: Gérald Gassiot-Talabot, *Toulouse-Lautrec*, London 1966

Gauzi 1954: François Gauzi, *Lautrec et son Temps*, Paris 1954

Gauzi 1954 (*Arts*): François Gauzi, 'Les Modèles de Lautrec', in: *Les Arts*, 1 December 1954

Goldschmidt-Schimmel 1969: Lucien Goldschmidt – Herbert Schimmel, *Unpublished Correspondence of Henri de Toulouse-Lautrec*, London 1969

Henze 1982: Anton Henze, *Henri de Toulouse-Lautrec*, Stuttgart–Zurich 1982

Hoetink 1968: H. R. Hoetink, *Franse Tekeningen uit de 19e Eeuw. Catalogus van de Verzameling in het Museum Boymans-van Beuningen*, Rotterdam 1968

Huisman-Dortu 1964: Ph. Huisman –M. G. Dortu, *Lautrec by Lautrec*, New York 1964

Huisman-Dortu 1973: Philippe Huisman – M. G. Dortu, *Henri de Toulouse-Lautrec*, Munich–London 1973 (page refs. to German ed.)

Hunter 1953: Sam Hunter, *Toulouse-Lautrec*, New York 1953

Huyghe 1931: René Huyghe, 'Aspects de Toulouse-Lautrec', in: *L'Amour de l'Art*, April 1931, 4, pp. 143ff.

Jacomet (1932): Daniel Jacomet, *Toulouse-Lautrec. Au Cirque, dix-sept Dessins*, Paris (1932)

Jedlicka 1929: Gotthard Jedlicka, *Henri de Toulouse-Lautrec*, Berlin 1929

Jedlicka 1943: Gotthard Jedlicka, *Henri de Toulouse-Lautrec*, Erlenbach–Zurich 1943

Josifovna 1972: Nina Josifovna, *Toulouse-Lautrec*, Moscow 1972

Jourdain 1948: Francis Jourdain, *Toulouse-Lautrec*, Lausanne 1948

Jourdain (1951): Francis Jourdain, *Lautrec*, Paris (1951)

Jourdain-Adhémar 1952: Francis Jourdain – Jean Adhémar, *Toulouse-Lautrec*, Paris 1952

Joyant 1926: Maurice Joyant, *Henri de Toulouse-Lautrec 1864–1901. Peintre*, Paris 1926

Joyant 1927: Maurice Joyant, *Henri de Toulouse-Lautrec 1864–1901. Dessins, Estampes, Affiches*, Paris 1927

Joyant 1927 (*L'Art et les Artistes*): Maurice Joyant, 'Toulouse-Lautrec', in: *L'Art et les Artistes*, 14, 25 February 1927

Joyant 1930: Maurice Joyant, *70 Dessins de H. de Toulouse-Lautrec*, Paris 1930

Julien 1942: Edouard Julien, *Dessins de Toulouse-Lautrec*, Monaco 1942

Julien 1951: Edouard Julien, *Dessins de Lautrec*, Paris 1951

Julien 1953: Edouard Julien, *Pour connaître Toulouse-Lautrec*, Albi 1953

Julien (1959): Edouard Julien, *Toulouse-Lautrec*, Cologne–Milan (1959)

Jullian 1977: Philippe Jullian, *Montmartre*, Oxford 1977

Keller 1968: Horst Keller, *Henri de Toulouse-Lautrec*, Cologne 1968

Keller 1980: Horst Keller, *Aquarelle und Zeichnungen der französischen Impressionisten und ihrer Pariser Zeitgenossen*, Cologne 1980

Kern 1948: Walter Kern, *Lautrec*, Munich 1948

Landolt 1954: Hanspeter Landolt, *Henri de Toulouse-Lautrec. Farbige Zeichnungen*, Basel 1954

Lapparent 1927: Paul de Lapparent, *Les Maîtres de l'Art Moderne Toulouse-Lautrec*, Paris 1927

Lassaigne 1939: Jacques Lassaigne, *Toulouse-Lautrec*, Paris 1939

Lassaigne 1953: Jacques Lassaigne, *Henri de Toulouse-Lautrec*, Geneva 1953

Lassaigne 1970: Jacques Lassaigne, *Toulouse-Lautrec and the Paris of Cabarets*, New York 1970

Leclerq 1958: Paul Leclerq [sic], *Henri de Toulouse-Lautrec*, Zurich 1958

Longstreet 1966: Stephen Longstreet, *The Drawings of Toulouse-Lautrec*, Alhambra 1966

Lucie-Smith 1983: Edward Lucie-Smith, *Toulouse-Lautrec*, Oxford 1983

Lugt: Frits Lugt, *Les Marques de Collections de Dessins & d'Estampes*, Amsterdam 1921

Mack 1938: Gerstle Mack, *Toulouse-Lautrec*, New York 1938

Mac Orlan 1941: Pierre Mac Orlan, *Lautrec. Peintre de la Lumière Froide*, Paris 1941

Morariu 1980: Modest Morariu, *Toulouse-Lautrec*, Bucharest 1980

Muller 1975: Joseph Emile Muller, *Toulouse-Lautrec*, Paris 1975

Natanson 1951: Thadée Natanson, *Un Henri de Toulouse-Lautrec*, Geneva 1951

Negri 1964: Renata Negri, *Toulouse-Lautrec*, Milan 1964

Newton 1953: Eric Newton, 'Henri de Toulouse-Lautrec', in: *Apollo*, March 1953

Novotny 1969: Fritz Novotny, *Toulouse-Lautrec*, London–Cologne 1969

Paret 1969: Pierre Paret, *Lautrec-Femmes*, Paris 1969

Perruchot 1958: Henri Perruchot, *Toulouse-Lautrec. Eine Biographie*, Esslingen 1958, *Toulouse-Lautrec*, London 1960

Pigasse 1907: Jules Pigasse, *Toulouse-Lautrec*, Albi 1907

Polasek 1972: Jan Polasek, *Toulouse-Lautrec. Zeichnungen*, Vienna 1972

Rewald 1967: John Rewald, *Von van Gogh bis Gauguin. Die Geschichte des Nachimpressionismus*, Cologne 1967, *Post-Impressionism – from Van Gogh to Gauguin*, London 1956

Sakai 1979: Tadayasu Sakai (et al), *The Book of Great Masters 23. Toulouse-Lautrec*, Tokyo 1979

Sakon Sou 1975: Sakon Sou, *Toulouse-Lautrec*, Tokyo 1975

Schaub-Koch 1935: Emile Schaub-Koch, *Psychoanalyse d'un Peintre Moderne. Henri de Toulouse-Lautrec*, Paris 1935

Schmidt 1948: Georg Schmidt, *Henri de Toulouse-Lautrec*, Basel 1948

Shone 1977: Richard Shone, *Toulouse-Lautrec*, London 1977

Toulouse-Lautrec 1951: 'Toulouse-Lautrec', in: *Art et Style* 19, May 1951 (with textual commentaries by Michel Florisoone, M. G. Dortu, Edouard Julien)

Toulouse-Lautrec 1962: *Toulouse-Lautrec. Collection Génies et Réalités*, Paris 1962 (with textual commentaries by Jean Adhémar, Gérard Bauer, Paul Colin, Jean-Gabriel Domergue, M. G. Dortu, Edouard Julien, Pierre Mac Orlan, Henri Perruchot, Maurice Rheims, Claude Roger-Marx)

Tourette 1938: Gilles de la Tourette, *Les Trésors de la Peinture Française au XIXème Siècle. Lautrec*, Geneva 1938

Tucholsky 1926: Kurt Tucholsky, 'Einer aus Albi' (1926), in: *Panther, Tiger & Co.*, Hamburg 1972

Venturi 1947: Lionello Venturi, 'Henri de Toulouse-Lautrec', in: *Les Arts Plastiques*, 7, Brussels 1947, pp. 3ff.

Vinding 1947: Ole Vinding, *Toulouse-Lautrec*, Copenhagen 1947

Werner-Helms (1977): Wolfgang Werner – Sabine Helms, *Alfred Walter Heymel 1878–1914, Geschichte einer Sammlung*, Bremen (1977)

Zenzoku 1970: Nobuyuki Zenzoku, 'Lautrec', in: *The Zauho Press*, Tokyo 1970

Zinserling 1964: Liselotte Zinserling, *Henri de Toulouse-Lautrec*, Leipzig 1964

Exhibitions and catalogues

Albi 1951: *Toulouse-Lautrec. Ses Amis et ses Maîtres*, Musée Toulouse-Lautrec, Albi 1951

Albi – Paris 1964: *Centenaire de Toulouse-Lautrec*, Musée Toulouse-Lautrec, Albi – Musée du Petit Palais, Paris 1964

Albi 1969: *60 Œuvres Inconnues de Toulouse-Lautrec*, Musée Toulouse-Lautrec, Albi 1969

Amsterdam 1946: *Tekeningen van Franse Meesters 1800–1900*, Stedelijk Museum, Amsterdam 1946

Amsterdam 1947: *Henri de Toulouse-Lautrec*, Stedelijk Museum, Amsterdam 1947

Amsterdam – Otterlo 1953: *Van Gogh's Grote Tijdgenoten*, Stedelijk Museum, Amsterdam – Rijksmuseum Kröller-Müller, Otterlo 1953

Basel 1947: *Henri de Toulouse-Lautrec*, Kunsthalle, Basel 1947

Berlin 1924: *Gemälde und Zeichnungen von Henri de Toulouse-Lautrec*, Galerie Matthiesen, Berlin 1924

Bern 1953: *Europäische Kunst aus Berner Privatbesitz*, Kunsthalle, Bern 1953

Bremen 1909: *Gemälde, Zeichnungen und Bildwerke aus bremischem Privatbesitz*, Kunsthalle, Bremen 1909

Brussels 1888: *V. Exposition des XX*, Brussels 1888

Brussels 1902: *La Libre Esthétique. Hommage à la Mémoire de Toulouse-Lautrec*, Brussels 1902

Brussels 1947: *Toulouse-Lautrec 1864–1901*, Palais des Beaux-Arts, Brussels 1947

Brussels 1949: *Dessins Français*, Palais des Beaux-Arts, Brussels 1949

Brussels 1973: *Henri de Toulouse-Lautrec*, Musée d'Ixelles, Brussels 1973

Chicago 1979: *Toulouse-Lautrec. Paintings*, The Art Institute, Chicago 1979

Cologne 1961–1962: *Henri de Toulouse-Lautrec*, Wallraf-Richartz-Museum, Cologne 1961–1962

Copenhagen 1967: *Hommage à l'Art Français*, Statens Museum for Kunst, Copenhagen 1967

Dallas 1957: *Toulouse-Lautrec*, Museum of Fine Arts, Dallas 1957

Humlebaek 1968: *Toulouse-Lautrec*, Louisiana Museum, Humlebaek 1968

Ingelheim 1968: *Henri de Toulouse-Lautrec*, Ingelheim 1968

Kyoto–Tokyo 1968–1969: *Toulouse-Lautrec*, Musée National d'Art Moderne de Kyoto – Musée National d'Art Occidental de Tokyo, Kyoto 1968

London 1938: *Henri de Toulouse-Lautrec*, Knoedler Gallery, London 1938

London 1951: *Henri de Toulouse-Lautrec 1864–1901*, Matthiesen Gallery, London 1951

London 1961: *Toulouse-Lautrec 1864–1901*, The Tate Gallery, London 1961

Liège 1978: *Toulouse-Lautrec*, Musée Saint-Georges, Liège 1978

Marseilles 1954: *Toulouse-Lautrec. Peintures, Dessins, Lithographies, Affiches*, Musée Cantini, Marseilles 1954

Munich 1961: *Toulouse-Lautrec*, Haus der Kunst, Munich 1961

Munich 1972–1973: *Das Aquarell, 1400–1950*, Haus der Kunst, Munich 1972–1973

Munich 1985: *Henri de Toulouse-Lautrec. Ausstellung anläßlich einer vom Ernst von Siemens-Kunstfonds unterstützten Neuerwerbung der Neuen Pinakothek*, Bayerische Staatsgemäldesammlungen, Munich 1985

New York 1931: *The Circus by Toulouse-Lautrec*, Knoedler Gallery, New York 1931

New York 1931 (*Lautrec-Redon*): *Lautrec-Redon*, Museum of Modern Art, New York 1931

New York 1937: *Henri de Toulouse-Lautrec*, Knoedler Gallery, New York 1937

New York 1946: *Toulouse-Lautrec*, Wildenstein Gallery, New York 1946

New York (etc.) 1950–1951: *Toulouse-Lautrec*, Knoedler Gallery, New York 1950 (the exhibition was also held at the museums of Minneapolis, Cleveland, San Francisco and Houston)

New York 1956: *Toulouse-Lautrec*, The Museum of Modern Art, New York 1956

New York 1964: *Toulouse-Lautrec*, Wildenstein Gallery, New York 1964

New York 1985: *Henri de Toulouse-Lautrec. Images of the 1890s*, The Museum of Modern Art, New York – Munich 1985

Nice 1957: *Toulouse-Lautrec*, Palais de la Méditerranée, Nice 1957

Oslo 1953: *Henri de Toulouse-Lautrec*, Kunstnernes Hus, Oslo 1953

Paris 1890: *Exposition du Cercle Artistique et Littéraire. Rue Volney*, Paris 1890

Paris 1890 (Indépendants): *VI. Salon des Indépendants*, Paris 1890

Paris 1891: *Exposition du Cercle Artistique et Littéraire. Rue Volney*, Paris 1891

Paris 1891 (Indépendants): *VII. Salon des Indépendants*, Paris 1891

Paris 1902: *Henri de Toulouse-Lautrec*, Galerie Durand-Ruel, Paris 1902

Paris 1903: *Œuvres de Toulouse-Lautrec*, Galerie Barthélémy, Paris 1903

Paris 1904: *Salon d'Automne*, Grand Palais, Paris 1904

Paris 1908: *Toulouse-Lautrec*, Galerie Bernheim-Jeune, Paris 1908

Paris 1909: *Exposition des Humoristes. Toulouse-Lautrec*, Galerie Georges Petit, Paris 1909

Paris 1914: *Exposition Rétrospective de l'Œuvre de Henri de Toulouse-Lautrec*, Galerie Manzi, Joyant et Cie, Paris 1914

Paris 1914 (Galerie Rosenberg): *Exposition d'Œuvres de Toulouse-Lautrec*, Galerie Paul Rosenberg, Paris 1914

Paris 1928: *Henri de Toulouse-Lautrec*, Galerie Marcel Guiot, Paris 1928

Paris 1931: *Henri de Toulouse-Lautrec*, Musée des Arts Décoratifs, Paris 1931

Paris 1931 (Galerie Castel): *Toulouse-Lautrec. Œuvres de Jeunesse*, Galerie Jeanne Castel, Paris 1931

Paris 1938: *Henri de Toulouse-Lautrec*, Galerie Knoedler, Paris 1938

Paris 1938 (Galerie des Beaux-Arts): *La Peinture Française du XIXe Siècle en Suisse*, Galerie des Beaux-Arts, Paris 1938

Paris 1951: *Toulouse-Lautrec*, Orangerie des Tuileries, Paris 1951

Paris 1958–1959: *Toulouse-Lautrec*, Musée Jacquemart-André, Paris 1958–1959

Paris 1960: *Les Amis de van Gogh*, Institut Néerlandais, Paris 1960

Paris 1960–1961: *Les Sources du XXe Siècle*, Musée National d'Art Moderne, Paris 1960–1961

Paris 1975–1976: *Toulouse-Lautrec. Chefs d'Œuvre du Musée d'Albi*, Musée Marmottan, Paris 1975–1976

Paris 1976: *Toulouse-Lautrec. Salon d'Automne*, Grand Palais, Paris 1976

Philadelphia-Chicago 1955–1956: *Toulouse-Lautrec*, Museum of Art, Philadelphia – The Art Institute, Chicago 1955–1956

Rennes 1963: *Toulouse-Lautrec et son Milieu Familial*, Musée des Beaux-Arts, Rennes 1963

Rotterdam 1933–1934: *Schilderijen van Delacroix tot Cézanne en Vincent van Gogh*, Museum Boymans, Rotterdam 1933–1934

San Francisco 1916: *L'Art Français*, San Francisco 1916

Schaffhausen 1963: *Die Welt des Impressionismus*, Museum zu Allerheiligen, Schaffhausen 1963

Stockholm 1967–1968: *Toulouse-Lautrec*, Nationalmuseum, Stockholm 1967–1968

Tokyo (etc.) 1982–1983: *Toulouse-Lautrec*, Musée d'Art Isetan, Tokyo 1982 (the exhibition was also held in Fukushima, Fukuoka and Kyoto)

Toulouse 1907: *Toulouse-Lautrec*, Palais du Télégramme, Toulouse 1907

Toulouse 1932: *Toulouse-Lautrec. XXIII. Exposition des Artistes Méridionaux*, Palais des Arts, Toulouse 1932

Venice 1948: *Gli Impressionisti alla XXIV Biennale di Venezia*, Venice 1948

Vevey 1954: *Paris 1900*, Musée Jenisch, Vevey 1954

Vienna 1966: *Henri de Toulouse-Lautrec 1864–1901*, Österreichisches Museum für angewandte Kunst, Vienna 1966

Williamstown 1960: *Toulouse-Lautrec*, Sterling and Francine Clark Art Institute, Williamstown 1960
Winterthur 1924: *Henri de Toulouse-Lautrec*, Kunstmuseum,

Winterthur 1924
Winterthur 1955: *Europäische Meister 1790–1910*, Kunstmuseum, Winterthur 1955
Wolfsburg 1961: *Französische Malerei von Delacroix bis Picasso*,

Stadthalle, Wolfsburg 1961
Zurich 1933: *Französische Maler des XIX. Jahrhunderts*, Kunsthaus, Zurich 1933
Zurich 1943: *Ausländische Kunst in Zürich*, Kunsthaus, Zurich 1943

SOURCES OF THE ILLUSTRATIONS

Götz Adriani, Toulouse-Lautrec – Das gesamte graphische Werk, Cologne 1976 Ill. p. 310 below, p. 311 above right
Thomas Ammann Fine Art, Zurich No. 85
Ashmolean Museum, Oxford No. 46
Bayerische Staatsgemäldesammlungen, Neue Pinakothek, Munich No. 96
Georges Beaute, Henri de Toulouse-Lautrec, Geneva 1964 Ill. p. 111, p. 286 above left, p. 289 below, p. 295, p. 303 below, p. 319 above
Bibliothèque Nationale, Paris Ill. pp. 280/281, p. 286 above right, p. 287, p. 290 below, p. 296, p. 303 above, p. 304, p. 305 above, pp. 306/307, p. 308, p. 309, p. 311, p. 314 below. p. 315, p. 320, p. 321, p. 323, p. 324
Sterling and Francine Clark Art Institute, Williamstown No. 48
J. Digwzaide, Toulouse Nos 28, 87
The Fogg Art Museum, Cambridge No. 111
Studio Georges Groc, Paris No. 20
Studio Grünke, Hamburg Nos 77, 102
Klaus Hegenreich, Hamburg No. 7
E. Heuker of Hoek No. 16
Fotostudio H. Humm, Zurich No. 97
Ph. Huisman/M. G. Dortu, Lautrec par Lautrec, Paris 1964 Ill. p. 299 below left

Ralph Kleinhempel, Hamburg Ill. p. 202
E. W. Kornfeld, Bern Nos 109, 114
Galerie Jan Krugier, Geneva No. 30
Kunsthalle, Bremen No. 29
Kunsthaus, Zurich No. 107
Kunstmuseum, Basel Ill. p. 106 right
György Leitgib, Wallisellen No. 126
Los Angeles County Museum of Art, Los Angeles No. 125
Musée d'Orsay, Paris Ill. p. 106 left, p. 110
Musée du Petit Palais, Paris Ill. p. 190 above left and below
Musée Toulouse-Lautrec, Albi Nos 8, 12, 23, 27, 34, 47, 49, 54, 57, 62, 65, 67, 72, 74, 88, 119, 123, 129; Ill. p. 284 below, p. 299 above
Museo Correr, Venice Ill. p. 162 left
Museu de Arte, São Paulo Ill. p. 101
Museum of Art, Carnegie Institute, Pittsburgh No. 44
Museum of Art, Rhode Island School of Design, Providence (Thornton) No. 112
Museum Boymans-van Beuningen, Rotterdam Nos 33, 81, 127
National Gallery, London Ill. p. 152, p. 190 right
Rijksmuseum, Amsterdam Ill. p. 162 right
Rijksmuseum Vincent van Gogh, Amsterdam No. 26

H. Roger-Viollet, Paris Ill. p. 288, p. 294, p. 319
Peter Schibli, Basel Nos 115, 116
Galerie Schmit, Paris Nos 12, 31, 100
Heinpeter Schreiber, Cologne Nos 1, 2, 4, 10, 11, 13–15, 18, 19, 22–25, 37–41, 45, 47, 50, 51, 53, 55–57, 61, 65, 67–71, 73–76, 79, 82, 83, 86, 88, 89, 95, 98, 99, 101, 103, 104, 106, 117, 120, 122, 123, 128, 130; Ill. p. 300
Staatliche Graphische Sammlung, Munich No. 9
Staatliche Museen zu Berlin, National-Galerie, Berlin (East) p. 301 below
Statens Museum for Kunst, Copenhagen Nos 17, 110, 118
Stedelijk Museum, Amsterdam Ill. p. 73
Joseph Szaszfai, Yale University Art Gallery, New Haven No. 84
Szépmüvészeti Múzeum, Budapest Nos 60, 90
The Tate Gallery, London No. 64
Mr. and Mrs. Eugene Victor Thaw, New York No. 78
John Webb, London No. 21
Paul Vogt, Was sie liebten . . . Salon-malerei im XIX. Jahrhundert, Cologne 1969 Ill. p. 290 above, p. 293
Elizabeth Winterstein, Munich No. 6

All other illustrations are from the archives of the author and the DuMont Buchverlag.

INDEX OF PERSONS

ACKNOWLEDGMENTS

In the programme of the Kunsthalle, Tübingen, the exhibition of the work of Toulouse-Lautrec followed exhibitions of watercolours by Cézanne (1982), pastels, oil sketches and drawings by Degas (1984) and Picasso (1986). He thus stands alongside Degas, whom he admired and emulated, and Picasso, whose first decisive influences came from Lautrec's work. The aim of this book has been to show the continuing relevance of Lautrec's vision of humanity. The often problematic task of reclaiming Lautrec for some current concept of Modernism has been deliberately dispensed with. Lautrec's modernity has survived even in our post-modern times and will remain in the future.

A definitive Lautrec retrospective would not have been possible without the help of the Musée Toulouse-Lautrec in Albi, where thanks to a gift from the artist's mother a large part of his work is kept. For the quite exceptional support received from there, including the loan of a large number of outstanding examples of the artist's work, we are particularly indebted to the Director of the Museum, Jean Devoisins, the President of the Société des Amis du Musée d'Albi, Jean-Alain Méric, and the Mayor of Albi, Michel Castel. The exhibition benefited greatly from their interest and help. For much information and negotiation of loans we must thank in particular Peter Nathan, who gave his advice and assistance to the project from the beginning, Robert Schmit and Thomas Ammann; and finally, we are most grateful for the friendly help of Marianne Feilchenfeldt and Walter Feilchenfeldt.

Besides the many lenders who wish to remain anonymous, our thanks go to the following colleagues, collectors and friends for their helpful understanding and generous support: Felix Baumann (Kunsthaus, Zurich), Alan Bowness (Tate Gallery, London), J. B. J. Bremer (Rijksmuseum Kröller-Müller, Otterlo), David S. Brooke (Sterling and Francine Clark Art Institute, Williamstown), H. van Crimpen (Rijksmuseum Vincent van Gogh, Amsterdam), W. H. Crouwel (Museum Boymans-van Beuningen, Rotterdam), Richard S. Field (Yale University Art Gallery, New Haven), Erik Fischer (Statens Museum for Kunst, Copenhagen), Eberhard W. Kornfeld (Bern), Dieter Kuhrmann (Staatliche Graphische Sammlung, Munich), Ronald de Leeuw (Rijksmuseum Vincent van Gogh, Amsterdam), A. W. F. Meij (Museum Boymans-van Beuningen, Rotterdam), Ferenc Merényi (Szépmüvészeti Múzeum, Budapest), Denis Milhau (Musée des Augustins, Toulouse), Konrad Oberhuber (Harvard University Art Museums, Cambridge [Mass.]), Nicholas Penny (The Ashmolean Museum, Oxford), Franklin W. Robinson (Museum of Art, Rhode Island School of Design, Providence), Siegfried Salzmann (Kunsthalle, Bremen), Scott Schaefer (Los Angeles County Museum of Art), Erich Steingräber (Bayerische Staatsgemälde-sammlungen, Munich), Eugene Victor Thaw (New York), E. Vuilleumier (Museum of Art, Carnegie Institute, Pittsburgh).

We are grateful to the Bibliothèque Nationale, Paris, for providing photographic material, some of which has never before been published. Last but not least we are indebted to the publisher Ernst Brücher and his assistants at DuMont Buchverlag, especially Karin Thomas, Rudolf Sommer, Peter Dreesen and Winfried Konnertz, whose excellent work has made this publication possible.

G.A.